Feminine Focus **W9-CWS-929**

Feminine Focus

The New Women Playwrights

Edited by
ENOCH BRATER

New York Oxford
OXFORD UNIVERSITY PRESS
1989

Oxford University Press

Oxford New York Toronto
Delhi Bombay Calcutta Madras Karachi
Petaling Jaya Singapore Hong Kong Tokyo
Nairobi Dar es Salaam Cape Town
Melbourne Auckland

and associated companies in
Berlin Ibadan

Copyright © 1989 by Oxford University Press, Inc.

Published by Oxford University Press, Inc.,
200 Madison Avenue, New York, New York 10016

Oxford is a registered trademark of Oxford University Press

Library of Congress Cataloging-in-Publication Data
Feminine focus : the new women playwrights [edited by] Enoch Brater.
p. cm. Includes index. ISBN 0-19-505788-0
1. American drama—Women authors—History and criticism.
2. American drama—20th century—History and criticism. 3. French
drama—Women authors—History and criticism. 4. French drama—20th
century—History and criticism. 5. English drama—Women authors—
History and criticism. 6. English drama—20th century—History and
criticism. 7. Women and literature—History—20th century.
8. Women in the theater—History—20th century. I. Brater, Enoch.
PS151.F46 1989 812'.54'099287—dc 19 88-30284

2 4 6 8 9 7 5 3 1

Printed in the United States of America
on acid-free paper

Contents

For my daughter,
Jessica Syl Brater,
who loves the theater

Introduction

Enoch Brater

After a talk she gave in 1972 about *Another Part of the Forest,* Lillian Hellman responded to a question on the obstacles she might have faced as a woman writer for the stage: "Listen, I don't write with my genitals. Why should I have been at a disadvantage? Let me tell you one thing. The New York theater is so hard up for good plays, they'll take it from anywhere they can get it." "Besides," she continued while puffing on a cigarette, "there was a vogue of lady playwrights at the time."[1] What she did not say was that her own tough-minded scripts were a far cry from the genteel conventions embraced by her "lady" playwright colleagues. Her first play, *The Children's Hour,* presented the scoundrel time of an accusation of lesbianism, while the play for which she is most famous, *The Little Foxes,* posited a "top girl" as ruthless as any of her male counterparts.

Despite Hellman's caveat about her underdog status as a writer who happened to be female, she was indeed the only major playwright of her gender to emerge from the heyday of Broadway theater that lionized Clifford Odets, Arthur Miller, Tennessee Williams, William Inge, Robert Anderson, Thornton Wilder, Maxwell Anderson, Robert Sherwood, S. N. Behrman, William Saroyan, and, of course, Eugene O'Neill—standard fare for a survey of the American theater from the thirties through the fifties.

Several decades later the situation would be quite different. Any anthology of plays shown in New York in the seventies and eighties would be certain to focus on the work of the new women playwrights, most conspicuously Tina Howe, Beth Henley, Emily Mann, Rosalyn Drexler, Rochelle Owens, Wendy Kesselman, Honor Moore, Joan Schenkar, Ntozake Shange, Karen Malpede, Susan Yankowitz, Eve Merriam, Holly Hughes, Susan Sandler, Wendy Wasserstein, Cindy Lou Johnson, Julie Bovasso, and Marsha Norman. In 1983 Mel Gussow wrote in the *New York Times Magazine* that Norman, the author of *'night Mother,* was "at the crest of a wave of adventurous young women playwrights—a pro-

liferation that is the most encouraging and auspicious aspect of the current American theater."[2] What Manhattan made visible, Hollywood soon made spectacular in a series of major motion pictures designed for popular consumption and studio profit. Writers from the long-ago sixties—and, in some cases, even earlier than that—were being rediscovered all over the country. The work of Maria Irene Fornes, Megan Terry, Sonia Sanchez, Alice Childress, Adrienne Kennedy, and Joan Holden of the San Francisco Mime Troupe was gaining recognition not only in the regional theaters but in the academic community as well. Women playwrights were "in." In 1988 the First New York International Arts Festival featured the work of fourteen women from China, Argentina, Mexico, France, India, Norway, Jamaica, Japan, and South Africa. At the Apple Corps Theatre Phyllis Klotz directed Tobeka Maqhutyana, Nomvula Qosha, and Poppy Tsira in *You Strike the Woman, You Strike the Rock,* presented by the Vusisizwe Players in association with the Market Theater of Johannesburg. The play derives its title from a protest song commemorating the 1956 demonstration against the inclusion of women in South African pass laws, which regulated the movement of black Africans in white areas. (The regulation was replaced by still other exclusionary laws in 1986.) *You Strike the Woman* was one of several events presented by the Women's Project and Productions as part of the "festival within a festival" called "Mapping Theatrical Territories."

This phenomenon was something rather different from the polite "vogue of lady playwrights" Hellman remembered. Feminism—or, more accurately, *feminisms*—was being taken quite seriously, the focus, in fact, of what would have to be characterized as a whole new movement in the theater. Playwrights, to paraphrase the suggestive title of Michelene Wandor's book, were looking back in gender.[3] And what they found there was anything but encouraging. Hellman was indeed the exception to the rule—and the only one at that. What had happened to all the other female voices? Theater history seems to have canonized only part of the story, the much-maligned *his*tory. Where was the tragedy of the "common woman" to stand beside Arthur Miller's "tragedy and the common man"?[4] Why were there no plays about the *Linda Lomans* of this world, a subject for dramatic discourse that might interest us considerably? Attention of a rather different sort needed to be paid.

Hellman's generation wrote for a populist theater where feminism was not yet common currency, though the issue is clearly at stake in her own work. The figure of Regina Giddens both demonstrates and exploits the familiar politics of repression: racial, economic, *and* sexual.

Little foxes like this one don't come from nowhere. Though Regina is clearly as rapacious as her "brothers," the methods she is forced to employ reveal the limitations imposed by the "secondness" of her sexuality. Hellman's woman rises above these unacceptable conditions, but she does so by achieving no new consciousness and no new sense of her world. The grapes are there to be seized, not shared. Regina becomes one of the primal spoilers, a Southern, white male, patriarchal figure in drag. As another Hellman female figure—who, significantly, is black—says, "There are people who eat the earth and eat all the people on it like in the Bible with the locusts. Then there are people who stand around and watch them eat it. . . . Sometimes I think it ain't right to stand and watch them do it."[5] But Addie's hesitant suggestion of a new order, which the script tells us is murmured *"softly,"* is a strategy for survival Hellman has not chosen to pursue.

When *The Little Foxes* opened at the National Theatre in New York on February 15, 1939, Tallulah Bankhead portrayed Hellman's Regina as the prototypical bitch, never challenging the sexist implications that lay behind her professional persona. Bette Davis' film adaptation appealed to the viewer's similar fantasies. Years later Elizabeth Taylor finished a weak third in a vain attempt to foster yet another male myth, that of the femme fatale. Not one of these productions took the figure of Regina—or that of her daughter, Zan, or her sister-in-law, Birdie—seriously. Issues of patriarchy and sexuality, of class, feminism, and racism were glossed over or completely ignored and remain so in most revivals. Worse still, the play has been far too easily dismissed as melodrama, a lesser form which allows critics to pass over the work's more threatening implications.

A younger generation of dramatists has been far more direct in confronting the issues which trouble the surface texture of Hellman's best work. Nourished by their own immediate concerns for the theater, and inspired by the popularization of premises raised in French feminist criticism, the new women playwrights display an entire range of responses to a shared legacy of lost opportunity. "The theater culture in England is superb," observed Gloria Parkinson recently, "but it's the boys' culture."[6] Marguerite Duras, who began publishing in the forties, and Hélène Cixous, working in the theater in Paris, had already begun to make us think about the possibility of writing "on the body," a specifically female language to counter an inherited and exclusively male perspective.

London theater provides us with an interesting case study of this not necessarily quiet revolution. The angry young men who changed the

shape of British theater in the fifties were precisely that: angry young *men*. And though the sensibility was strictly to the Left, plays like John Osborne's *Look Back in Anger* offered their audiences little insight into the female figures they attempted to portray, who were—with the possible exception of Beatie in Arnold Wesker's *Roots, "articulate at last"*— nearly always in a minor role. The conventions which emerged from "kitchen sink" drama were—with such notable deviations as Shelagh Delaney's *A Taste of Honey* or Ann Jellicoe's *The Knack*—essentially developed through masculine eyes. Harold Pinter's theater was perhaps even more disturbing; here woman was fetishized in a great cloud of unknowing. Ruth, in *The Homecoming,* is the ultimate mystery indeed:

> You've forgotten something. Look at me. I . . . move my leg. That's all it is. But I wear . . . underwear . . . which moves with me . . . it . . . captures your attention. Perhaps you misinterpret. The action is simple. It's a leg . . . moving. My lips move. Why don't you restrict . . . your observations to that? Perhaps the fact that they move is more significant . . . than the words which come through them. You must bear that . . . possibility . . . in mind.[7]

Earlier in the play she cauterizes Lenny with a simple sentence: "If you take the glass . . . I'll take you."[8] Saint? *Magna mater?* Virgin? Whore? Every attempt by Pinter's family of men to define Ruth ensnares them in one more trap of their own female iconography. Like Hellman's Regina, Ruth succeeds in beating the men at their own insidious game. But who *is* Ruth? By playing out a succession of male fantasies, the homecoming she wins for herself is a dubious prize at best.

Nor have women fared particularly well in the hands of a younger generation of male playwrights. Though David Hare's *Plenty* uses a female figure to structure the drama, the psychological motivation of Susan Traherne is explored more from without than within. An emblem for the collapse of ideals in postwar England, the female figure's femininity is subordinated by the playwright to his "larger" thesis.[9] Hare's 1988 play *The Secret Rapture,* starring Jill Baker and Penelope Wilton in Howard Davies' National Theatre production, portrays two sisters who try to come to terms with their father's death. But what begins as an examination of two female characters develops into another sort of play: a painful but nonetheless representative diagnosis of the impact of 1980s pragmatism on human emotions. And in some of Hare's other plays—*A Map of the World* and *Pravda* (written in collaboration with Howard Brenton)—female figures have been even more narrowly drawn. One notices a similar tendency even in the otherwise liberated dramatic

world of Hanif Kureishi. His impressive scenario for *My Beautiful Laundrette,* written in 1985 as a television play for "Film on Four,"[10] explores the male prerogatives of father, son, uncle, brother, street-gang member, enterpreneur, and homosexual lover. Woman, finally abandoned on the lonely platform of an inner-city BritRail station, gets relatively short shrift. The same might be said of *Sammy and Rosie Get Laid.* Here Kureishi's perspective is almost aggressively heterosexist; but it is nonetheless a father-son relationship—told from a male point of view—that reduces every other "coupling" to a voyeuristic subplot.

While it is perhaps not altogether fair to take the measure of a given playwright solely from the balance of believable characters drawn from both sexes, a traditional bias toward one particular gender is not likely to pass us by. Speaking of her own early plays, Caryl Churchill recently said: "I think originally I wasn't really interested in gender ideas at all. I probably made main characters men without thinking of it consciously at all, but just because main characters tended to *be* men. . . . Now . . . once you've become conscious of gender, it's hard not to be always aware of what gender you've chosen for a character."[11] Less doctrinaire than her French counterparts' writing "on the body," Churchill's work has been no less committed to the theatricalization of authentic female portraits. In this regard her drama is primarily concerned with formal questions of mood, situation, and characterization. Politics insinuates itself through performance, not external intervention. A play in Churchill's hands is first and foremost a play. She wears the mantle of Britain's leading woman playwright with justifiable unease:

> I remember *way* back somebody writing about one of my radio plays, and saying that you wouldn't know it had been written by a woman. The writer clearly meant this as praise, and that gave me pause. Most of the time I didn't think about it, but there were little moments of realization. If, for example, a critic refers to you as one of the best women writers, and you feel there's any possibility that he thinks of that as a *lesser* category, you resent the use of the term. If it means women themselves thinking about things that they haven't thought about before, then you feel very positive about the idea of being a woman writer, and obviously this is attractive and powerful.[12]

As Tina Howe observed from the other side of the Atlantic, ultimately "writing for the theater has to do with facing your own demons."[13]

Extending the repertory of some distinctly female perspectives, Churchill is the most conspicuous of the new women playwrights striving to bring a sense of purpose as well as excitement to the British stage. Even

the most casual London theatergoer of the eighties would have been certain to notice some of the following: *Neaptide,* Sarah Daniels' play at the National Theatre, in which a lesbian mother fights for the custody of her child; Pam Gems' *Aunt Mary* at the Donmar Warehouse, a "comedy" which explores feminine stereotypes through the sensitive portrayal of a male transvestite; Nell Dunn's *Steaming* at the Comedy Theatre, where the set, from the point of view of theater history, was an uncharacteristically *female* changing room; Louise Page's *Golden Girl* at the Barbican Pit; Catherine Hayes' *Skirmishes* at the Hampstead Theatre; Claire Luckham's cartoonlike *Trafford Tanzi* at the Mermaid; Andrea Dunbar's youthful *The Arbor* and the 1980 *Rita, Sue and Bob Too* at the Royal Court Theatre; and the work of Sharman MacDonald, whose *The Brave* and *When We Were Women* opened, respectively, at the Bush Theatre and the Cottesloe of the National Theatre after her initial London success with *When I Was a Girl I Used to Scream and Shout.* On the Barbican mainstage one could see *The Danton Affair,* which Pam Gems based on a stage chronicle by Stanislawa Przybyszewska, as well as Timberlake Wertenbaker's adaptation of Ariane Mnouchkine's *Mephisto,* both lavishly produced by the Royal Shakespeare Company. Even Aphra Behn was making a comeback: in 1984 *The Lucky Chance* played on the stage of the Royal Court Theatre in a production by the Womens Playhouse Trust. Two years later John Barton directed Jeremy Irons in *The Rover* at the RSC's new Swan Theatre in Stratford. The stages in this revolution[14] had long since passed from the Fringe to the West End—and beyond.

Lists of productions, however, have a curious way of making the situation seem much brighter than it actually is. A survey made in 1982 and 1983 on the status of women in the British theater revealed that of the six hundred or so plays put on by all the national and regional companies, only forty-two were by women. "Twenty-two of those," noted Susan Croft, the director of the New Playwrights Trust in London, "were by Agatha Christie." In 1988, when Gloria Parkinson's own play, *Conversations,* was presented in Cambridge, Massachusetts, as part of the fourth Women in Theater Festival, she commented: "Nationally women playwrights have a meager seven percent of the stage."[15] The reality seems to be not much better in France or North America. Nevertheless, that small fraction of stage time allotted to women forces us to reconsider just what constitutes a reliable definition of contemporary theater. "There are lots of women playwrights coming through now," Susan Croft reminds us. "What we have to do is get those voices heard." The Nigerian playwright Zulu Sofola established herself in her own country

by directing and staging her own plays. She came to the United States thinking that Nigeria was a very backward country because of this. Instead, as Anna Kay France reports, she found that "it was the same all over. The Dramatists Guild found, for instance, that few if any women's plays are done at Broadway or regional theaters. As you go down the line, to Off Broadway and Off Off Broadway and staged readings, you find more women's works."[16] The essays written for this volume represent a modest attempt to draw our attention to a new dramatic moment, to "get those voices heard." This feminine focus also displays a healthy tension between matters strictly theoretical and questions of dramatic style, performance, and enactment. The dialogue that emerges, broader than it would be in any single essay, is as welcome as it may be surprising; it places the scripters under scrutiny at the center of a debate concerning the proper role of theater criticism as it is being practiced today. Taken together, the essays help us understand once again how the work of a progressive group of creative writers resists marginalization. For theater has always been this: a forum for the exploration of the *full* dimensions of that greatest collective of all—our own humanity.

Notes

1. Speech by Lillian Hellman delivered at the Annenberg Center in Philadelphia.

2. Mel Gussow, "Women Playwrights: New Voices in the Theater," *New York Times Magazine,* May 1, 1983, p. 22.

3. Michelene Wandor, *Look Back in Gender* (London: Methuen, 1987).

4. See Arthur Miller, "Tragedy and the Common Man," in *The Theater Essays of Arthur Miller,* ed. Robert A. Martin (New York: Viking, 1978), pp. 3–7.

5. Lillian Hellman, *"The Little Foxes"* and *"Another Part of the Forest":* *Two Plays by Lillian Hellman* (New York: Viking, 1966), p. 110.

6. See Gloria Parkinson, "Center Stage," *Harvard Magazine* 90, no. 5 (May–June 1988), 120.

7. Harold Pinter, *The Homecoming* (New York: Grove Press, 1965), pp. 52–53.

8. Ibid., p. 34. For a discussion of the role of women in Pinter's plays, see Elizabeth Sakellaridou, *Pinter's Female Portraits* (London: Macmillan, 1988).

9. For a different view of Hare's portrait of Susan Traherne in *Plenty,* see Mel Gussow, "A British Hedda," New York *Times,* April 18, 1980.

10. See Hanif Kureishi, *"My Beautiful Laundrette" and "The Rainbow Sign"* (London: Faber, 1986), p. 41.

11. See the interview of Caryl Churchill by Geraldine Cousin published as "The Common Imagination and the Individual Voice," *New Theatre Quarterly* 4, no. 13 (February 1988), 5.

12. Ibid. Emphasis in original.

13. Tina Howe as quoted by Leslie Bennetts, "Five Top Playwrights in a Dialogue, with Arthur Miller Adding Drama," New York *Times,* June 18, 1988, p. 12.

14. See Catherine Itzin, *Stages in the Revolution: Political Theatre in Britain Since 1968* (London: Methuen, 1980).

15. See Mervyn Rothstein, "Near Buffalo, Playwrights Talk About Not Being Heard," New York *Times,* October 22, 1988, p. 11; and Parkinson, "Center Stage," 120.

16. See Rothstein, "Playwrights Talk About Not Being Heard," p. 11.

Feminine Focus

Images of Women
in Modern English Theater

Katharine Worth

"Women deserve a better role on screen and stage," declares British Equity, noting that there not enough parts for women, stereotyping is rife, and most actresses are "dreadfully familiar" with directors' instructions that "You play his wife/mistress/daughter/secretary." Women have difficulty in getting their plays put on, announces Pam Gems (one of those who has managed it) because they lack the "connections" men enjoy. Peter Hall provided unsolicited confirmation that women occupy a back seat in the theater by failing to allocate to a woman even one of the five semi-independent groups into which the National Theatre Company was divided in 1984. Photographs of the company lineup published in the press at the time show serried ranks as at an old boys' dinner. And the cursory attitudes toward their women characters taken by at least some male playwrights is brought out amusingly by Simon Gray in a tale against himself: "Oh Christ. Just noticed I left Marigold off my list of characters," he groans, recording in his journal his casting choices for his play *The Common Pursuit:* "The only woman in the play, and what in lit. crit. essays they call the catalyst. And yet Graham McTavish, two brief scenes and about five lines, got on my list. What does this mean?"[1]

One of the things it means, evidently, is that actresses are likely to have a thin time in so male-oriented a theater. Gray's tongue-in-cheek observation on his curious neglect of his woman character could be applied in a more serious way to a dozen plays, not excepting those by severe social critics such as Howard Brenton and David Edgar. There is often little room for women in their dramatic world, and those who do get in tend to have somewhat subordinate roles. This question of opportunities for actresses is closely linked to that of opportunities for women playwrights. Fringe groups and theater collectives such as the Joint Stock Company (formed in 1974) and Monstrous Regiment (formed

3

in 1975) have offered women actors more scope, and women play-wrights such as Caryl Churchill have profited from the energy and ini-tiative released in this new kind of performance situation. Male actors and playwrights, too, of course, have shared in the collective and fringe experience. Joint Stock, after all, was founded by three men, one of whom—David Hare—stands out among the politically minded play-wrights of his generation as someone who is not only sympathetic to women characters but willing to give them a more central role, as in *Plenty* or *Licking Hitler*. But women, because they find it more difficult to get into the theater at commanding levels, have drawn the greatest benefit from the antihierarchical arrangements of the new companies.

The question then arises: what kind of new perspectives have been made possible by the wider opportunities opened to women in the last decade or so? Out of many possible approaches to that question, I want to pursue one in particular: that is, the interest women playwrights show in deromanticizing and "earthing" the images of women they have in-herited from the theater and culture of the past. Earthiness has been seen as a distinguishing aspect of women's imagination by Pam Gems, who suggests, "Women are very funny, coarse, subversive. All good qualities for drama."[2] Women actors now seem more ready than of old to give performances in the vein indicated by Gems. Siobhan Mc-Kenna, for instance, brought to strange life the figure of the tyrannical, tale-spinning grandmother in Tom Murphy's *Bailegangaire* (1986), holding audiences fascinated by the coarse vigor of the old woman, entirely bedridden through two acts except for one necessary journey to the chamber pot. By the end of the play, against the odds (given the small-scale obsessiveness of her narrative), the character had been invested with a rough kind of mythic power. It is just this quality in actors which the women playwrights need and are trying to use for their explorations in deglamorizing or earthing in modern soil the more romantic images of women long prominent in the European conscious-ness.

One play that looks very directly to a traditional source is Maureen Duffy's *Rites* (1969), a rewrite of Euripides' *Bacchae* in terms of the rituals attending routine physical necessity. Duffy sets her action in a women's public lavatory, an automatically deglamorizing choice of set, one might say. Everything is seen from the woman's angle, necessarily: we are in a real sanctum, granted the inside view of the hidden rites denied to the audience of Euripides' play as to his central character, the neurotically curious Pentheus. The amusing point about these modern rites is that, initially at least, they are so ordinary. The priestess of the

lavatory, Ada, is a perfectly believable figure, with her strict sense of decorum, her way of offering tantalizing glimpses of her engrossing sexual life, her concentration on the ritual of makeup. Believable, too, for much of the time is the chorus of office girls, moving from naturalistic giggles about men friends—"He never! What in the pictures? Right in the front row . . ."—to increasingly stylized and synchronized explosions of sexual aggressiveness: "Only men, only men, only men do that." Even Dionysus finds his way in by this mundane route, brought in by two women as a life-sized boy doll, a cherubically smiling figure, which first causes disquiet—"He's too big to be brought in here"—and then curiosity about the "boy's" ambiguous sexuality, which leads the women to investigate and then in effect adore the revealed masculinity:

FIRST OFFICE GIRL:	Well, he's lifesize.
	(*They laugh loudly but forcedly.*)
NORMA:	Made to measure I'd say.
THIRD OFFICE GIRL:	Tailored with you in mind.
NELLIE:	Just like my Willy.

"Women worship images,"[3] says Duffy in Yeatsian vein. She manages to establish this theatricality in the half-comic, half-sinister style which is a distinguishing feature of the play. From the doll episode on, the action moves from the natural toward increasing strangeness; in Duffy's phrase, it should seem "As real as a vivid dream and it need be no more real than that."

With intermittent accompaniment from ritual sounds like toilets flushing in unison, a more somber action develops in the still hidden area of the cubicles, the uttermost arcana. Blood trickles on the floor from an attempted suicide; the other women respond to the distraught girl's despair with rising fury against men. To cries of "We don't need them. We can do without them," they break into a maenad dance, at which point a sexually ambivalent figure emerges from a cubicle and is taken by them for a man. With considerable ingenuity, Duffy has brought her action to the predetermined climax. It is as high priestess of an esoteric order that Ada declaims:

Look a bloody man. In here. Spying on us. . . . You think you can get away with murder, that we've no place to call our own. Coming down here to see what we get up to when we're alone. Bastard Men!

They set upon the anonymous figure, who is killed in the assault. Only then do they find it is a woman, a significant twist to the Euripidean plot which had Pentheus, the voyeur, disguised in woman's clothing.

This woman is "disguised" as a man. But, of course, she is legitimately there. The modern women have been taken in by the masculine-looking suit and style of the unfortunate "intruder," a mistake which places responsibility on them for self-destructive sexual stereotyping. The dream turns nightmare with this death and the disposal of the body in the incinerator, an "impossible crematorium/altar incinerator," as Duffy calls it. Whether this savage episode strikes us as more impossible than the rending of Pentheus by his own mother under the impression that he is a wild beast might be hard to say. Duffy seems to be keeping her original in mind when at the start of the play she has the humble attendant, Meg, draw attention to the incinerator, characteristically using the wrong word: "And now we've got the cremator I wouldn't trust anyone to have charge of that. . . . Sometimes I think I can hear it roaring like a great furnace, a wild beast." The preparation is ingenious; but, clearly, much depends on production to capture a "real dream" effect. In any event, however, the play is a striking illustration of the urge among women playwrights to dig up the old myths about women and reroot them in the new soil of our time.

A playwright who seems to have dedicated herself to this purpose is Pam Gems. Favored subjects with her are the lives of passionate women who have been turned by literature, stage, and screen into romantic legends: Guinevere, Queen Christina, Piaf, and Camille among them. She also rewrites existing plays under the general rubric of translating or adapting, thus bringing some renowned heroines under her influence, including the first breakaway heroine on Ibsen's stage, Nora of *A Doll's House*. Gems cuts her heroines free of the romantic context in which they have been enclosed and returns them to the rough realities of common life. Sometimes the material works against her. In *Piaf* (1978), for example, even though Gems risked annoying audiences by omitting from *her* chanteuse's repertoire nostalgic favorites such as "La Vie en rose," the songs that Jane Lapotaire did sing created their own romantic aura, placed as they were in sharp, spotlit contrast with increasingly pitiful episodes from the singer's hectic and lonely private life. The emphasis on bodily realities—Piaf urinating as a defiant gesture or "having" sex with casual gusto—did not really change significantly the inherited image of the brave little sparrow, maintaining her integrity as an artist in the face of every sort of personal problem, from initial poverty to drugs, unsatisfactory lovers, and insensitive managers in the later years.

Gems' line of intention can be seen rather more clearly in *Queen Christina* (1977) and *Camille* (1984), plays which have a strongly purposeful relationship with celebrated romantic prototypes, one from film,

the other from stage and film. In the background of *Queen Christina* hovers one of the most romantic of all screen images of women: a Queen Christina with the poetic lineaments of Greta Garbo. Identifying the Garbo movie as her source, Gems comments that the image she carried away was that of "a shining, pale, intellectual beauty, who had romantically chosen freedom." Generations of filmgoers would no doubt endorse this summary. Two or three potent images have embedded themselves in film mythology. Who could forget Garbo in man's dress, the incognito "King" of Sweden who shares a bedroom in a country inn with an unaware John Gilbert. Her true sex is discovered only when she removes her jacket. Both fall instantly in love. At a later stage in their idyll, there is an image of Garbo lying on the floor, opening her mouth to the cherries Gilbert dangles over her; the mannish, masterful ruler is metamorphosed into a queen of love, a playful Venus. Her final image is that of the tragic beauty gazing from the ship that carries her and her dead lover to a freedom they can no longer share. This is an image of pain, certainly, conveyed almost unaided by the classic beauty of Garbo's face and her strong personality, with its conventional masculine elements—commanding intelligence, deep voice notes, capacity for rough fun—and its profoundly alluring femininity. She made it just possible to believe in her as a woman who had been brought up as a man and trained to be a king, and who then renounced it all the moment she met her "real" destiny, to be a beautiful woman adored by the man she adored. It was probably obvious that the historical reality must have been more complex, probably much harsher, as Gems indeed found it: "The real Christina was a dark, plain woman with a crippled shoulder, daughter of a beautiful mother whose health and nervous system had been ruined by yearly pregnancies in the effort to provide a male heir."[4] Central to Gems' interpretation is the assumption that in seventeenth-century Sweden a woman brought up as a man in practical ways would also have imbibed a male outlook, notably contempt for women. Add to this her association of pregnancy with the destruction of her mother's health and it would be psychologically impossible for her to accept the duty, as her counselors saw it, of taking on the woman's role in order to produce an heir to the throne.

That outcome is prepared for in the opening scene of the play, where the child Christina listens to the offstage shrieks of a mother who has given birth to yet another stillborn son. Her father, pressed hard by his chancellor to get a male heir at all costs and aware that another pregnancy would finish his wife, departs for the war (one reason for the obsession with male heirs), putting his daughter into the chancellor's

care with the ominous instruction: "Make a man of her then." The next episode shows the result of that strategy. A German prince who has come wooing the adult Christina thinks he is meeting her when an elegant young woman in riding dress enters, pale ringlets falling about a "beautiful but thoughtful face." This vestigial trace of the Garbo image is rudely dismissed when a slouching "Man" with a crooked shoulder makes clear "his" ownership of the lovely girl: "he" is the real Christina. "She," or "he"—for it is easy to forget which persona is speaking at a given moment—rubs salt in her own wounds, mocking the idea of marriage by placing herself by the prince (she is the taller of the two) and inviting the company to observe the grotesquerie of such a match.

It becomes clear that the plainness of Christina (*ugly* is her mother's word) is a keynote in Gems' treatment of the story. Where Garbo's Christina could easily shed her masculine role and, simply by looking herself, attract the man who attracts her, Gems' Christina has to work hard for any kind of sexual fulfillment. She is bisexual, seeking pleasure with compliant girls but with part of her still craving the love of a man, one handsome young man in particular. He is in love with her own Ebba, the girl with the pale ringlets; the pain is unbearable. Gems conveys in crude, bold terms the agonized writhings of the woman/man, who jeers at a timid assertion of love from her most likely suitor, her cousin Karl, on the curious ground that his bad taste rules him out:

Love? Do you think I want to be desired by the likes of you? A man who fancies a long-nosed cripple?

The suitor is plain, too, which does not help him. This Christina suffers from ugliness almost as though she knew the image against which she is matched, the Garbo image of beauty which any audience coming newly to Gems' play would know best. Perhaps the shocking discrepancy between the two images was thought too much for filmgoing audiences by the management of the Royal Court Theatre. They rejected the play as "sprawling, unattractive" and claimed that it would appeal more to women than to men.

The Royal Shakespeare Company thought otherwise: they produced it in 1977 at the Other Place in Stratford-upon-Avon, where Sheila Allen established a Christina who suggested something of the intellectual vigor associated with the historical original: she was a bluestocking interested in art, theology, and philosophy. In the play these aspects of the character are shown, but always in relation to her tormented sexuality. A scene with Descartes, for instance, engages with philosophy in strictly practical terms: the philosopher's reasoning calms a woman

distraught at being "betrayed" by the proposed marriage of the two she has loved. Still, she is capable of responding to Descartes' existentialist reasoning on the nature of choice: "But with choice there is possibility. For change. And the concept of change implies the very world within our grasp. It is we who decide." She proceeds to set radical change in motion. Adamant about refusing to bear children, she rejects another arranged marriage with Karl and abdicates in a scene which, as her mother hysterically announces, is like a wedding. It ends, however, with a symbolic expression of freedom. Christina, left alone, tears off the white wedding-style dress to reveal riding clothes beneath—the reversal of the Garbo transference from dashing male attire to a "bejewelled, befrilled feminine vision of loveliness."[5]

The second part of the play fills in the blank in which Garbo's Christina was left: instead of tragically gazing into an empty postabdication future, Gems' Christina romps through Europe, disconcerting everybody: the French bluestockings because she is jocular about feminism and likes men; the pope (who receives her following her conversion to Catholicism) because she refuses to accept a necessary connection between procreation and sexual intercourse. Gradually, the mood darkens as a life without work begins to pall. A church-supported bid for the throne of Naples fails; she kills the traitor within her ranks, her paid lover, and is plunged into a state of nervous apathy from which only the unthinking advances of a small child rouse her. At this late stage, in the closing scene of the play, when a sympathetic cardinal urges her to campaign for the Polish throne, she arrives at the modern moment of recognition which Gems has been planning from the start. Why should she, a woman, play a man's warlike part which works against women? Why should she have been denied her right to have children (as she now sees it) and at the same time her right to possess an active life of the mind?

> You offer me the whole world . . . for nothing. The privilege of action . . . at the cost of oneself. What sort of bargain is that?

The play moves to its somber conclusion with Azzolino backing away as Christina hysterically entreats him to give her a child—"I want my children . . . where are they? . . . where are my children?"—and drives him around the room with a whip in a grotesque gesture of sexual and emotional confusion. The curtain line returns us to the rock on which the talented, unlucky woman's emotional fortunes have apparently foundered: her lack of physical beauty. Left alone on the stage, Azzolino and the waiting woman, Julia, discuss Christina pityingly. "A

great brave woman. Fine intellect," he says, and she agrees, adding, as she pats her own hair approvingly: "Nothing to look at, of course."

The suddenness of Christina's desire for a child may not be altogether convincing in dramatic terms, coming so late and so unprepared. Perhaps it is too clear at such moments that Gems is shaping the Christina image to allow a modern dilemma to emerge. Despite some straining in places, however, she creates a dynamic image of Christina. It offers effective resistance to the romantic image from which it drew its charge, reshaping the audience's view to allow for understanding of different agonies; above all, the agony of a woman who is *not* Garbo but just the reverse; whether she lives as man or woman, queen or private person, life cannot compensate for that initial handicap.

A romantic image of a different kind receives the "earthing" treatment in *Camille*. Once again the shade of Garbo glimmers in the background, but in this case the film image was not the first to stamp itself on the consciousness of audiences. Garbo's Camille continued a theatrical tradition stretching back to 1852–53, when the novel by Dumas *fils, La Dame aux camélias,* made its swift way onto the European stage and audiences responded emotionally to its heady mixture of glamor, immorality, and romantic heartbreak. The consumptive courtesan, Marguerite Gautier, who belied her mercenary calling by giving up her true love for his own good, was immortalized on the stages of Paris and London by Sarah Bernhardt and Stella Patrick Campbell and, as Violetta, on the musical stage in *La Traviata*. Verdi's opera was very early off the ground in 1853; some of the critics' reactions to the work when it was new curiously anticipated the tone of moral outrage familiar in early responses to Ibsen's *Doll's House* and *Ghosts*. Like those plays, *La Traviata* was performed in modern dress, perhaps bringing too near for comfort the realities of the nineteenth-century demimonde. Comments like "Foul, hideous and immoral" may well have related also to the sympathetic portrayal of the courtesan, allowed to die in an odor, if not of sanctity, at least of romantic poignancy. What was immoral about *La Dame aux camélias* in the eyes of Bernard Shaw was its hypocritical evasion of the real problems of the "courtesan." He wrote *Mrs. Warren's Profession* in 1894 to show that prostitution is caused not "by female depravity and male licentiousness" but simply by underpaying, undervaluing, and overworking women so shamefully that the poorest of them are forced to resort to prostitution to keep body and soul together.[6] The play was instantly banned by the Lord Chamberlain—which suggested that a live nerve had been touched. "Plays about prostitution were allowable," wrote Shaw sardonically, on condition that the

members of Mrs. Warren's profession shown on stage "shall be beauti-
ful, exquisitely dressed and sumptuously lodged, also that they shall, at
the end of the play, die of consumption to the sympathetic tears of the
whole audience." Shaw offers us an accurate plot outline of *La Dame
aux camélias, La Traviata,* the Hollywood *Camille*—and Pam Gems'
play! In this respect Gems is in tune with her romantically minded
predecessors rather than with Shaw, who despised the consumption
motif as a mere pious form, designed "to save the Censor's face." The
girls in the gallery would not be taken in by it: what they *would* register
would be the beauty and luxury of a prostitute's life. The Lord Chamber-
lain was, in effect, recruiting for Mrs. Warren's profession. Shaw's unspar-
ing, unsentimental approach was modern in 1894 and still seems so
today—so much so that it might even be questioned whether there was
a need for a new deglamorization treatment of the nineteenth-century
"courtesan" image.

In fact, of course, Shaw does not deal at all with the life experience
of the prostitute, only with its repercussions in afteryears. Sexual passion
is not part of his theme. He moves the whole courtesan action into an-
other sphere, where its social implications can be explored and stereo-
typed moral attitudes exploded. Gems, too, aims to replace unwanted
stereotypes with fresh imagery, but she works from within the Camille
story rather than annihilating it as Shaw did. There is no attempt at a
Shavian style of analysis: the distribution of responsibility for the fate
of Camille at the end of her play is one of its weaker links. What Gems
does bring out in *Queen Christina* is the inescapability of fate dictated
for a woman in a brutal, man's world by the accidental fact of her
physical appearance. Beauty rather than plainness is now the determin-
ing factor, but the fate is equally tragic.

Gems keeps closer to the novel's structure than earlier plays had
done, framing her action with dark scenes set after Marguerite's death.
In the first, Armand revisits his dead lover's rooms, now taken over by
the auctioneer, who salaciously enumerates the most desirable items:

> And now . . . the lot you've all been waiting for, lot one hundred
> and thirty. The bed. Decorated with—ah . . . (*He consults his list*)
> . . . camellias. What was it . . . twenty-three days of the month she
> wore white camellias and for the other five days she wore red.

"No," says Armand quietly, in a futile attempt to resist the legend in
which the real woman is now encased. In the last scene he makes the
same effort on his own behalf, accusing Marguerite's friend, Prudence,
of wanting men to be keepers: "You make me ugly. Unpleasant. Very

well. If that's what you want." Women are to have their share of determining the sexual stereotypes, so Gems appears to suggest through the character of Prudence and others of the motley crew who make up Camille's social world. But the strongest emphasis is on the exploitation of social facts by men in their buying of women. The biggest change in the plot provides just such an emphasis. In the original, Marguerite renounces her one chance for happiness at the entreaty of Armand's father, who interrupts her rural idyll with her lover to beg her to give up his son. If she does not, the marriage prospects of Armand's younger sister will be destroyed by his association with so notorious a courtesan. Camille's heart is touched; she breaks with Armand, pretending she no longer loves him. The father is touched; the audience is touched. As Shaw said, the audience weeps sympathetic tears for the fallen woman who redeems herself by her self-sacrifice. She may now be allowed to die of consumption in an odor of guarded moral approval.

Gems, of course, will have none of this. In her play the father is an ogre, the very marquis who had seduced Marguerite as a fifteen-year-old maid in his household. She tells this to Armand earlier in the play, not knowing then that she is speaking of his father:

> After two years Monsieur le Marquis took me into his bed. It was his habit with the younger maids. It kept him young. A year later I had his son.

This same marquis descends on her not to plead but to threaten and—when he discovers the boy and sees how much the child means to Marguerite—to blackmail. If she gives up Armand, her child will be provided for, educated, given the chance of a civilized life. If she persists in refusal: "I shall get a magistrate's order that you are an unfit mother. What do you think you're playing at? Have you forgotten your place?"

The episode adds another layer of melodrama to the original, but at the same time it thickens the harsh reality which Gems wants to reveal behind the romantic image of the glamorous consumptive. There was nothing glamorous about the coughing of Frances Barber, playing Marguerite in the Royal Shakespeare Company's production (1984): those painfully real paroxysms were far from the softened version audiences of the past heard (certainly in the opera house!). Gems takes pains to show that her heroine's hard life has inevitably made her in some ways hard. The girl who was raped by her own uncle when still a child and has been able to escape the horrors and rigors of poverty only by selling

herself cannot but be marked by her experiences. "I'm surprised you don't hate us," says Armand after she has told him of the traumatic affair with her uncle: "He made me get a bucket of water after to clean up the blood in case the dogs came sniffing." "Hate . . . love," she shrugs. She has no such generalized feelings. Her passion for Armand is real, but so is her mercenariness, which has been the condition of her survival. It causes her, even in the rapture of reconciliation with her lover at the end of the play, to order her maid to admit the drunken Russian prince who intends to buy her with emeralds. "Rivers of them," she exults. "They'll buy us a lifetime of freedom! You see? I bring you a dowry!" She really cannot understand Armand's revulsion when he throws money in her face—a celebrated insult from the original play which Gems makes more violent by placing it immediately after a scene of sexual ecstasy. In such a context Marguerite's passion for Armand has to be seen as something of a miracle, like Piaf's gift of pure song. In reforming the image to give it a new, coarse vigor, Gems is actually claiming more, not less, for her heroine. She invites us to notice what she is doing by using three of the names associated with the courtesan image: Marguerite, Camille (in the title), and Marie. The last one, used in contempt of the marquis (a servant's name for him), is also the name of the real-life prototype, Marie Duplessis, with whom Dumas was in love. So the harsh reality of the marquis episode in the play touches a far-off reality that inspired the male creator of the image and has now been reimagined by a woman, in this case, Pam Gems.

A playwright known for her grittily naturalistic studies of contemporary life, Sarah Daniels, has also turned to legendary imagery in her play *Neaptide* (1986). Perhaps it was already clear from her celebrated *Masterpieces* (1983) that the intensity of her concentration on women as victims could take her at any time into the sphere of myth. The characters in *Masterpieces* are a commonplace enough set of people; everything about them is banal—except for their reactions to the plague the play excoriates, the terrifying spread of pornography in their society. During the action a great gulf opens up between the male characters, who tolerate or shrug off the malign effects of pornography, and the women, who become increasingly conscious of the connection between violence to women and the existence of pernicious films and magazines (such as those read by male pupils in a school where one of the female characters teaches). The play ends with a graphic account of a "snuff" film in which a woman performer is actually mutilated and "snuffed out" in front of the cameras. The horrific tale is told by Rowena while she awaits sentence for the death of a man she had pushed away when

he accosted her on an underground station; he fell on the line and was killed. Shortly before, she had seen the sadistic film; a connection between the events is offered to the audience, though it is clear from the court scene we witness that an unsympathetic judge will not be likely to lighten her sentence on that account. As she says to the policewoman waiting with her, she will have plenty of time to think about why men hate women so much that they can enjoy the bestiality of the actual British film called *Snuff*. Sensitive men in the audience have been known to leave performances of *Masterpieces* feeling guilty about being men, so blistering is the attack on the sex as a whole. It is not easy to dismiss the play as one-sided and unfair (though in a way it is) without seeming to discuss the actuality of the horror it responds to. Daniels makes clear that she owes much of her material to documentary evidence: *Snuff,* for instance, was actually distributed in England until feminists brought about its withdrawal.

In *Neaptide,* again, actuality is the keynote, though this time the play ends happily, perhaps because Daniels has turned to myth and legend, using a neutral kind of "woman" myth in an aggressively feminist way to strengthen her victimized women characters. The myth of Demeter and Persephone came conveniently to hand for the author of *Masterpieces*. It has a rape at its core: a young girl, innocently at play in a flowery meadow, is abducted by a ruthless middle-aged man to live with him in his kingdom underground. Demeter's grief over her daughter's rape and her successful strategy for reclaiming the girl gives Daniels the main line of action in her play. What she does not take over from the myth is its acceptance of the rape as a necessary part of a cyclic seasonal process: Persephone comes back to her mother in the spring but must pass the winter underground. For Daniels there are no such half measures.

Her Demeter does not have goddess powers; in fact, she is a somewhat comical figure, derided by her daughters for her old-fashioned, cliché-ridden ideas, especially about sex and marriage. Yet, like the goddess, she saves one of those daughters, Claire, from having her own small daughter snatched from her by a man, and the play ends with an ingenious scene in which Claire's escape with Poppy (to the sister in America) fuses with the arrival of Joyce/Demeter at the hospital from which she is escorting yet another daughter—back to life, it is implied. The Demeter myth is unashamedly tailored to fit the domestic situation in the play and the feminist argument of its author. We hear of it first when Claire reads the story to young Poppy, who likes to see herself

as "Pepsi-phone." In Claire's version Demeter has four daughters: Psyche, Athena, and Artemis as well as Persephone. Poppy makes the necessary connections for the audience, identifying the mythological roles of the aunts and grandparents as they arrive for a family get-together on Mother's Day. Joyce is Demeter, the grandfather (a suitably shadowy figure), Zeus; her mother and aunts, Artemis and company. The audience are left to work out these last analogies for themselves, Poppy merely pointing to the appropriate pictures in her storybook. Whether they would feel an urge to do this, assuming they had the knowledge, may be doubtful. The myth is appliquéd to the contemporary situation rather than embodied in it. Its main line will be clear, however, and for those who do know the source, so will Daniels' determined reshaping of it to give her threatened and bullied women a more total victory than Demeter was allowed in the original.

"I don't know which side she's on," Claire says of her mother early in the play. Poppy's confident reply—"Mine"—is well justified by what follows. Joyce feels utter distaste for her daughter's private life, divorce, and entry into a lesbian relationship, which is what gives the ex-husband his chance to demand full custody of the child. But Joyce dislikes even more the idea of a girl-child being taken from her mother. It is for her, as for the militant feminist Claire, a "rape" which is being practiced with the backing of the law and the approval of society. "I'm still your mother," she proclaims, "and nothing is going to be able to change that for either of us"—a flat echo from the mythic tale told at the start: "Persephone belonged to her mother. That was Demeter's gift to herself." Seeing that the court case must end in the blackening of Claire's name ("Nobody would believe that anyone above those appointed to sit in judgement could ask such filthy questions") and the loss of Poppy to the father, Joyce smuggles mother and daughter off to a third daughter in America, handing over her life savings to keep them out of the law's reach. Since they have to play by somebody else's rules, they must take care not to be caught in them. Perhaps, after all, the triumph is not total: like her august predecessor, Joyce/Demeter has to part for a time—at least with her daughter and her daughter's daughter. But the male has been more thoroughly cheated of his prey, an ending denied to the women of *Masterpieces* who had no confident life force to support them.

The playwrights I have been discussing have all chosen to explore images of women laid down in particular plays, films, and myths of the past. Other women writers have used images derived in part from such

sources without referring specifically to individual predecessors. I want to glance at one or two plays of this kind to show how strongly the tide is flowing in the direction of highly conscious revising and reshaping.

The image of the glamorous courtesan, the lady with or without her camellias, floats in the mental air around the two women in Michelene Wandor's *Whores d'Oeuvres* (Ormoro Theatre Group, 1978). This amusing conversation piece by one of the leading figures in British feminist theater presents two prostitutes (or "whores," as they call themselves) in a fantastic situation, floating down the Thames on a raft in the wake of a freak hurricane. They fill in the time until their rescue by improvising little scenes which add up to a kind of Prostitute's Progress. One tiny episode showing a young girl newly arrived in London (and snapped up for the "trade" by a businesslike older woman) gallops into the next, showing the recruit soliciting, then to an encounter with the police, and so on. The two women, Tina and Pat, play around with the stereotypes and images of their trade, Pat at one point evoking a contemporary version of the glamorous image derided in *Mrs. Warren's Profession* and shaken to bits in Pam Gems' *Camille:*

> I wish I was reclining on the back seat of my Silver Cloud, flanked by my Tibetan sheep-dogs, my Amazon chauffeur in her leopard-skin bikini feeding me champagne.

Tina's response—"I didn't understand a word of that"—is one of the many small ways in which the two women are established as distinctive personalities, despite the emphasis throughout on their common experience. In their mimicry of their own lives, they change gender, take turns in the role of boss, sketch in fantasies, build up in revue style a cartoon mythology of prostitution—and probe into the real attitudes underlying it, their own and those of society. Pat likes to straighten out Tina's confused ideas:

> TINA: I'm not doing it for the money.
> PAT: Tart with a heart of gold?
> TINA: Well—I mean it *is* for the money—Look, it's a job. If we could get better jobs we wouldn't do it.

Shaw would have approved of that line, as he presumably would have approved of Pat's businesslike feminism. She is engaged in circulating a leaflet on behalf of prostitutes as exploited workers, a serious commitment despite her jokey way of putting it in "media" terms:

> We could sell our story to the papers when we get back. Make a fortune, eh? Two plucky tarts to organise other fallen ladies.

The old images—tarts with hearts of gold, "fallen" ladies—are decidedly undermined by the pressure of all this irony. Of course, the episode occurs out of daylight time in a limbo invaded by dreams and fantasies. The real life which rumbles on in the background has many of the old problems in it: Tina is anxious about her child's future, and the otherwise clear-eyed Pat prefers not to see that her "bloke" is playing games of his own behind her back. Whatever their troubles, however, these women are determined not to be victims, destroyed, like Camille, by the tyrannical stereotypes in social use. The play ends with a jovial event—rescue by a ship full of sailors. As they climb up rope ladders to board, it seems that Pat will be returning to the task of improving her lot and that of her fellow workers, while Tina may be striking out on a new line. It is not a very enticing alternative she envisages: going on the dole. "You'll be back on the game inside a week," comments Pat drily. Tina's response—"We'll see"—promises nothing but holds the future open. With the new flexibility of image making goes at least an increased *possibility* of change.

The writer often considered strongest among English women playwrights, Caryl Churchill, is especially interested in this possibility. She is also interested in the opposite, liking to show how images and stereotypes acquire depressive power over people—the "morphrodite" image, for instance, in the bleak, inward-looking society of *Fen* (1983) or the malign "witch" image of *Vinegar Tom* (Monstrous Regiment, 1976) which destroys quite ordinary women. But usually in her plays there is a sense of continual struggle to maintain individuality, whether by contesting the image or using it to release forces in the personality that would otherwise find no outlet. *Top Girls* (1982) bursts with the latter kind. The "ladies" from history who gather as guests of the modern woman, Marlene, did in their various ways carry through their determination to be what they wanted to be, even though their stories may have ended disastrously. The remarkable transvestite known as Pope Joan ended by being burned at the stake, but in telling her story she is more concerned with the achievement of being herself to the full—in the "disguise" of the most powerful man in the world, the pope. Another woman from the Middle Ages tells how she found it easy in her youth to conform to a ruling image of her society—that of the submissive, cosseted Japanese courtesan. When the passage of time widened the gap between herself and that image, she lost her role but had sufficient strength to pursue another image—her own opposite or antiself. It took her, like Pope Joan, into a male world: the part of her personality that had never before been recognized found expression when she embraced the austere

image of the traveling monk. In the second half of the play, the figments of the past have gone and the modern woman is left struggling to achieve a self-expression which is now seen to be far from complete, despite her success as the director of an employment agency. As Pope Joan's career was brought to an end when she spectacularly gave birth during a papal procession (the story she told), so Marlene's is shadowed by a difficult relationship with the daughter she has not acknowledged as her own. The child is "simple" or "thick," euphemisms for an affliction which adds to the problem of unifying the maternal self with the image of the "top girl."

In *Top Girls* there is no resolution: the play ends with the child's cry of despair. A more confident and elated note is struck in *Cloud Nine* (Joint Stock, 1979), which, perhaps for this reason, is one of Churchill's most popular plays. Its first half presents a set of rigid nineteenth-century sexual and social images to which the family of Clive, a colonial administrator, is expected to conform, however far removed from their own needs and natures. In the second half Clive's "ideal wife," Betty, who along with others of the family comes by some time warp into our era, discovers that she no longer needs to force herself into false unity with the images to which she paid lip service. She can enjoy disconcerting new freedoms like earning her own money and seeking the company of men even when they turn out to be homosexual, an image of man not admitted into her former way of thought. The play ends with her recognition that her own son, Edward, is gay, and the man she thought she was "picking up" is not just Edward's friend but also his lover. It is a measure of how complete the work of iconoclasm has been that she is able to embrace even this new (and for her strange) image of sexual freedom:

GERRY: I could still come and see you.
BETTY: So you could, yes. I'd like that.
 I've never tried to pick up a man before.
GERRY: Not everyone's gay.
BETTY: No, that's lucky isn't it.

An air of freedom blows through the very structure and style of *Cloud Nine,* with its casual switches of idiom, its anarchic song—"You're upside down when you reach Cloud Nine"—and its multiple role-playing. Transvestite casting adds an extra layer of irony, laid on amusingly in the opening set piece when Clive and family introduce themselves, and Betty, played by a man, declares:

I am a man's creation, as you see
And what Clive wants is what I want to be.

Through such bold devices, Churchill unsettles and changes our perspective. Boldest of all is the great leap between the first and second acts, in the course of which almost a century has gone by: yet Betty continues, older by only so much as is necessary to let her children grow up. The strategy works as Churchill intends it to: the continuance of a personal Betty is remarkably easy to take, while the awareness of how long a time actually separates the first and second Betty makes more believable the profound change of sensibility that comes about.

Churchill is acutely more aware of the tyranny of the image when that kind of long-term perspective is not available. In a recent play, *A Mouthful of Birds* (Joint Stock, 1986), written with David Lan, she too, like Duffy and Gems, goes back to a play of the past to use a given set of tragic images. Again the model is *The Bacchae,* a play from antiquity that so haunts the modern imagination. In a note on the collaborative piece, Churchill explains that the authors' intention was not to do a version of *The Bacchae* but "to look at the same issue of possession, violence and ecstasy." The myth exerted its usual power, it seems, for a ghostly Euripidean shape emerges from the unconventional modern material. Like his classical predecessor, the Pentheus of Churchill and Lan makes his foredoomed way to the mountain, dressed in woman's clothes, to die at the hands of his mother in her bacchic frenzy. "I broke open his ribs," she says, "I tore off his head." This is closer to the plot line of *The Bacchae* than is Maureen Duffy's *Rites.*

The route taken by Churchill and Lan to the given finale is a very unlikely and interesting one. The action at first looks entirely episodic, a sequence of seven apparently self-contained small dramas involving groups of unconnected modern people: unemployed men lifting weights, a husband and wife talking at breakfast, a department store switchboard operator practicing as a medium in her private life. An opening series of quick flashes gives the audience clues to the particular kind of "possession" each episode is to explore. The flash which shows Lena shrinking from the idea of skinning a rabbit her husband casually dangles before her leads into an expressionist exploration of her physical revulsion. In a sequence of breakfast scenes, the husband talks complacently about commonplace matters while she, on one level responding in kind, on another is listening to the Spirit that crouches by her, muttering obscenely against the husband's physicality: "He's disgusting. . . . His

hair smells. His eyes have got yellow in the centre." In her dark communication with the Spirit (expressed at one point in a dance of protean animal transformations), she receives the malign instruction "The solution is to drown the baby." An ambiguous mime (when Lena washes a shawl in a baby bath) suggests that she may have carried through the act. The scene ends with her quietly telling her husband, "I think Sally's drowned" and "I poured the teapot and blood came out." It may all be happening in the fantasy world of the mind, but that makes the process no less fearful. She has taken up in some way a prompting from a dark abyss, as at the end of the play when the original characters each reappear to speak a sentence or two and Lena appears to acknowledge, "I remember I enjoyed doing it. It's nice to make someone alive and it's nice to make someone dead. Either way. That power is what I like best in the world. The struggle is every day not to use it."

A tide of desperation surges through most of these scenes. "In fact I am desperate" is the Trinidadian medium's first line. This is followed by a weird alternation of a refined switchboard voice taking calls for "Continental Lingerie" while a West Indian voice is talking privately. The potentially dangerous split in personality suggested by this switching of voices is later embodied in the sinister relationship between Marcia in her role as medium and as the white, middle-aged woman, Sibyl, the persona who sits by while Marcia performs for her clients. This persona scorns Marcia's West Indian "control" and all his "Voodoo. Juju. Tomtom." Gradually, she takes over substituting for the deep West Indian tones of "Baron Sunday" a voice that can do anything, from dictating in a German accent to a musicologist ("D natural! Vot you tink I'm writink? Gypsy dances?") to smooth talk with a white and middle-aged client. While she talks, Marcia struggles, agonized, unable to produce any sound at all from her own throat.

Another episode, "Hot summer," shows murderous violence erupting from trivial irritation over a noisy radio. Doreen, a woman driven by her anger (she is seen at the start of the sequence receiving a massage for indefinable nervous tension and nausea) enters a noisy battle with her neighbor. The stage is filled with a mounting volume of sound as homely objects—radio, furniture—become weapons of hatred. Finally, Doreen attacks her neighbor with a knife. Later she turns her rage on a male neighbor who calls in with a seemingly harmless request for a teabag. She overwhelms him with all the loathing and resentment she feels about the physical atrocities people practice on one another: "My sister lives with a man who poured boiling water over her and she

thinks it's her fault." "You are a crazy, you know that," he says, baf-
fled by the apparent inconsequentiality of her attack.

Through it all there runs also, however, a vein of ecstasy and realized
possibilities. The medium's terrifying loss of voice produces a spirit
voice which, though frighteningly independent of her, is also something
she needs. Doreen, who only wanted peace and quiet (so she tells us at
the start of her scene), does in fact achieve it after she has exhausted
her rage. When she lets her friends persuade her to turn her energies to
nonviolent persuasion, magical things happen: the intrusive male neigh-
bor is bounced off the walls with a quiet "no"; a lamp comes flying
through the air into Doreen's hand as the women laugh with delight.
So does the audience; this ecstasy is made amusingly infectious, a
pleasingly unexpected way into a new mental dimension. The individual
ecstasies are sometimes bizarre, as in the businessman's infatuation with
a pig. Others are more accessible, like the ballet in which all join,
representing moments of extreme happiness, or the fruit ballet which
expresses the sensuous pleasure of eating and "the terrors of being torn
up." Sensuous ecstasy and horror alike are presided over by the am-
biguous, mute god who opens the play with a dance, establishing his
possession of the stage. A male, nude to the waist and in a flounced
petticoat, this Dionysus (represented by two interchangeable dancers)
flaunts his ambivalent sexuality with smiling ease. The dancers also have
"ordinary" parts to play in two separate episodes (as Dan and Paul).
But in the Dionysian role they are master of events, whether dancing
out the spells they are casting or lounging with indifference by the tree,
which grows fantastically out of the staircase of the otherwise mundane
upstairs/downstairs set.

It is at the point where Dionysus moves the characters out of their
mundane context into their legendary roles that the radical break with
those roles becomes most clear. The change is seen most subtly and
movingly in the opening scene of act 2 when a strange sexual transfer-
ence occurs. Two actors hold the stage: a male actor, Derek, standing
silently by, while an actress dressed in the clothes of the nineteenth-
century Frenchman Herculine Barbin tells the story of "her" life, hand-
ing to Derek as she talks objects representing her past. It was a life
that began as a woman's and was forced, by physiological necessity, to
become a man's: "Hermaphrodite, the doctors were fascinated, how to
define this body, does it fascinate you, it doesn't fascinate me, let it die."
The medical sex change that was effected cut Herculine off from the
self that had seemed most natural: "All the girl's bodies, Sara's body,

my girl's body, all lost, couldn't you have stayed?" Her telling of the story generates an atmosphere of lyrical pain. The change had to be—but it is too much for the person suffering it. We can see for ourselves that she is not really a man but a woman in man's clothes, with feelings quite divided: "At least I'm not a man like the men I see." Suicide is the implied ending of Herculine's story.

But the story has not ended. She hands it over—from the nineteenth-century, as it were, to the modern man, Derek. He dresses himself in the shawl and petticoat, objects of the past, sits on her chair while she stands in his place, and tells the story again, word for word the same, though it seems very different now it really *is* a man who tells it. He is both more cut off and more fully adjusted. A quite extraordinary sense of sexual fluidity and complexity is created by this bizarre but delicate and touching scene. It offers a profoundly modern interpretation of what follows, the story of *The Bacchae* at the point where Pentheus puts on woman's clothes and goes to the mountain in search of the women.

The ordinary modern people under the "touch" of Dionysus take up the roles that have been waiting for them throughout the play. Doreen is given over to her rage again, easily possessed by Agave; a chorus of bacchants forms itself through the repetition of earlier movement sequences, moments of extreme happiness—and of violence. The two states cannot be separated in the mythic catastrophe any more than they could be in the individual lives: the consistency achieved between those lives and the myth is one of the play's most striking features. Finally, Pentheus is torn apart, and the others can leave the magic mountain:

AGAVE: Where are you going?
LENA: Home.
MARIA: I'm late for work.
YVONNE: I have to look after someone.

Only Agave, it seems, is trapped in her rage and nausea. "There's nothing for me there," she says on hearing Lena's "Home"; "There never was. I'm staying here." She closes the play with the last of seven summaries by the characters of their states of mind. Hers is still a dark state: horrible images in her head, the sensation of crunching a mouthful of birds—a warning, perhaps, rather than a final judgment. We did see her once in a liberated state, when she managed to turn her mental force away from aggression. Still, the violence is there, but stronger is the sense of new directions for the force that is in them all.

The man who was torn apart has become "comfortable" in the life of

a woman: "I've almost forgotten the man who possessed this body. I can't remember what he used to be frightened of." The two men who played Dionysus in women's skirts affirm that there has been an achievement. One of them, Dan, revels in the creative change he brought about in a desert: "I can't tell you what a day it was when I woke up and saw the first green." It is a measure of the play's achievement that we can accept this image despite the horrors inherent in the characters' experience. Men have been freed to become more like women, and women have found new powers in themselves; for both, the freedom and the power have terrors as well as ecstasies. This is not quite how Euripides saw it, yet the authors of this play come closer to him than any other users of *The Bacchae* in their capacity for radically rewriting myth.

It seems appropriate to end my discussion of women playwrights at the point where it began, with a reworking of *The Bacchae*. It is, even, curiously appropriate that this radical new version should be written by a woman playwright in collaboration with a man, not a very usual arrangement but one in tune with the shift of attitudes their play presents as necessary. From *Rites* in 1969 to *A Mouthful of Birds* in 1986, women playwrights have displayed remarkable theatrical inventiveness in reshaping the images of women handed on to them by their male predecessors. Women actors, too, have contributed significantly to the process, both in England's experimental and fringe groups and in its subsidized theater. Maureen Duffy records how *Rites* resulted from encouragement by the actress Joan Plowright, who was "intensely aware from her position within the National Theatre Company of the shortage of contemporary roles for actresses."[7] The plays I have been discussing help to correct that notorious imbalance—and in so doing cast a strong new light on the "roles" that have been imagined for women by male playwrights in the past.

Notes

1. Simon Gray, *An Unnatural Pursuit* (London: Faber, 1975), p. 28.

2. Pam Gems, in *Plays by Women*, ed. Michelene Wandor (London: Methuen, 1982), vol. 1, pp. 72–73.

3. This and the subsequent comment by Maureen Duffy appear in Victoria Sullivan and James Hatch, eds., *Plays by and about Women* (New York: Vintage Books, 1973), pp. 349–51.

4. For this and other comments on the play by Pam Gems, see *Plays by*

Women, ed. Michelene Wandor (London: Methuen, 1982), vol. 5, pp. 47–48.

5. Ibid., p. 8.

6. George Bernard Shaw, Preface to *Mrs. Warren's Profession* in *Plays Unpleasant* (London: Penguin, 1946), pp. 179–210.

7. Maureen Duffy, in *Plays by Women,* ed. Michelene Wandor (London: Methuen, 1982), vol. 2, p. 26.

Stereotype and Prototype: Character in the Plays of Caryl Churchill

Austin E. Quigley

When England's National Theatre opened on the South Bank of the Thames in 1976, it was greeted with mixed reviews. The structure of the building itself was an immediate subject of concern, but more important was controversy over the theater's social function. Originally conceived more than a century earlier as a shrine to honor all that was best in canonical English culture, the theater opened to confront a society noisily obsessed with its internal divisions. The absence of a firm social consensus on contemporary values had large consequences for a theater uncertain of the nature of its audience, uncertain of the status of the inherited drama canon, and uncertain of its relationship to the emerging future. At a time when alternative theater was much in vogue, when small groups were forming community theaters all over the country, the National Theatre found its very title subject to dispute. Proponents of alternative theater argued that there were now two national theaters in existence:

> One stands on the South Bank of the Thames, cost £16 million to build, is subsidised to the tune of £2 million per year and will eventually employ 500 staff and just over 100 actors. The other exists in workshops, community centres and short-life premises all over the country. It performs everywhere and anywhere from parks and art galleries to schools, trades union halls and art centres, taking theatre to people where they want to see it, helping them to celebrate, to organise campaigns, to enjoy themselves, bringing old and new ideas to their notice. This national theatre, using existing buildings often many years old, is subsidised to the tune of £700,000, employs over 1,000 people and is still expanding.[1]

25

The plays of Caryl Churchill emerge not from the context of England's canonical culture but from its other culture; not from the National Theatre on the South Bank but from the national theater in the suburbs and provinces.

The political orientation of alternative theater in England is, of course, decisively to the left, and a major book on the contemporary alternative theater movement, by Catherine Itzin, is provocatively entitled *Stages in the Revolution: Political Theatre in Britain Since 1968*. The presence of the calendar year in the title is no accident. This was the year of the Soviet invasion of Czechoslovakia, of the student-worker riots in Paris, of the Tet Offensive in Vietnam, of the assassinations of Robert Kennedy and Martin Luther King in the United States, and of antiwar marches in many parts of the world. The urgency of political issues on the international scene served to lend new power to those voicing, on the national scene, support for the underprivileged, disenfranchised, and ignored. The year 1968 was one in which many who previously were politically skeptical became politically motivated and committed. It is, however, a dangerous simplification to put too much emphasis on the events of a single year. And it is equally dangerous to assume that, because there are urgent problems in the world, they are all clearly related, all initially justifying the same revolutionary anger, and all finally susceptible to the same logical analysis and programmatic solution. The worst plays of the alternative theater movement made precisely those mistakes, but the best, like those of Caryl Churchill, struggle to get beyond them.

As Itzin points out, Caryl Churchill's political consciousness emerged more from personal experience than from any sense of outrage at public political events.[2] But uncertainty over the relationship between the two has persisted throughout her career. Dissatisfaction with her roles as wife and mother sufficed to generate the early plays, which were written in the sixties largely for radio (at that time the only readily available forum for alternative theater). These plays, as Churchill describes them, "tended to be about a bourgeois middle-class life and the destruction of it."[3] What generated the need for such destruction and what lay beyond it were not so clear. Churchill, to this day, is uneasy about relating her life and career to political labels and political programs, and though prepared to travel under the banners of socialism and feminism, she remains wary of what those labels might imply.[4] In interviews this wariness often comes across defensively: "I combine a fairly strong political commitment—an antipathy to capitalism—with a

fairly wobbly theoretic grasp";[5] but in her plays this uncertainty is a source of strength. She is constantly searching for possibilities that have yet to emerge. Aware of and sympathetic to the reformist personal ideals and revisionary social goals of left-wing theorists, Churchill retains sufficient distance from them. She knows, she says, "what kind of society I would like: decentralized, nonauthoritarian, communist, nonsexist—a society in which people can be in touch with their feelings, and in control of their lives. But it always sounds both ridiculous and unattainable when you put it into words."[6]

It is this capacity to retain a sense of the potentially ridiculous that allows Churchill to explore urgent social issues without sliding into strident polemic or strained prophecy. And it is interesting to note that when writing an introduction to the recent collection of her plays, she selected as key moments in her life not the years of political crisis, but the years which marked major transitions in her career as a playwright.[7] After years of writing plays largely for radio and largely alone, Churchill broke into the commercial theater in 1972 with *Owners*. She found her way into collaborative theater four years later with *Vinegar Tom* and *Light Shining in Buckinghamshire*.[8] These key experiences had a catalytic effect on an imagination that emerged as genuinely theatrical as well as genuinely political. The dramatist who had earlier focused on "the awfulness of everything" gave way to a dramatist who focused on "the possibilities for change."[9]

This interest in "the possibilities for change" provokes questions that are addressed simultaneously to self, society, the drama, and the institutionalized theater. And it is important to note that what concerns Churchill are "possibilities," not programs. In her recent plays the certainties of the Marxist Left and radical feminism provide starting points for thought, not conclusions. Refusing to be bound by the strictures of socialist realism or the urgencies of contemporary social problems, Churchill looks to larger contexts that reveal analogies and insights. Her complex use in *Traps* (1976) of multiple character, shifting context, and changing reality displays her interest not just in social utility, but in the aesthetic and epistemological consequences of experimentation in the theater. The play, she notes,

> is like an impossible object, or a painting by Escher, where the objects can exist like that on paper, but would be impossible in life. In the play, the time, the place, the characters' motives and relationships cannot all be reconciled—they can happen on stage, but there is no other reality for them . . . the characters can be thought of as liv-

ing many of their possibilities at once. There is no flashback, no fantasy, everything that happens is as real and solid as everything else in the play.[10]

The playwright demands of the audience a sophisticated form of participation. Her major instrument is not the ideal character, the revolutionary relationship, or the prophetic message but the regenerating image that confers new structural significance on issues, events, and circumstances that are otherwise quite familiar. In such contexts it is possible to see Churchill struggling beyond stereotypes to highlight the very movements which brought those stereotypes to prominence. These are now seen to be more heterogeneous, more subject to self-criticism, more sensitive to the possibility of failure, and more open to change than we might have initially realized.

To see Churchill as part of an alternative theater is thus to see her not only in terms of social radicalism, but also in terms of theatrical innovation; more important, however, is recognition of the ways in which the two interact. In *Vinegar Tom* (1976), for example, a familiar preoccupation with the exploitation of women is obvious enough. But the play is concerned less with illustrating a topical concern than with exploring its nature through an example drawn from the past. The play is ostensibly about seventeenth-century witches, but what lingers in the memory is not the suffering of any particular character or the peculiarity of any specific historical situation. What we remember, instead, is the unsettling contemporary relevance of an image, apparently archaic, that is forcefully and disturbingly reconstituted. No one who has seen the play will ever think about witches or women in quite the same way again.

The play's setting is a small English village in the seventeenth century, "the time of the last major English witchhunts."[11] But the songs interspersed throughout the action are set in the present and should "be sung by actors in modern dress" (p. 133).[12] The telescoping of time makes this a play not about witches, but about how contemporary women acquire and confront the images governing their lives. As Churchill puts it: "I wanted to write a play about witches with no witches in it" at all.[13] Witches there may not be, but the possibilities and provenance of witchcraft dominate the play.

The action begins in a roadside ditch where an unnamed man characterizes himself and his amorous partner as devil and witch. Their shared interest in otherworldly phenomena is partly a consequence of their boredom with provincial life, partly a consequence of underinformed

imaginations contemplating the forbidden, and partly a consequence of their desire for erotic experience. The scene concludes, however, with their exotic terminology converted into abusive imagery. The couple, their romantic ardor cooled, resort to insulting each other:

ALICE: Go to hell then, go to the devil, you devil.
MAN: Cursing is it? I can outcurse you.
ALICE: You foul devil, you fool, bastard, damn you, you devil!
MAN: Devil take you, whore, whore, damned strumpet, succubus, witch! (p. 137)

The humor here is tempered by a report, voiced earlier in the scene, that violent social action was precipitated by the same images and stereotypes. As the man puts it: "One of my family was burnt for a Catholic and they all changed to Protestant and one burnt for that too" (p. 136). He also recalls seeing a witch burned at the stake in Scotland and confesses, as does Alice, to the exotic appeal of punishment as public ritual.

This opening scene establishes the context for subsequent action: the key image displays its social possibilities and punitive powers. A middle-aged couple, Jack and Margery, search for scapegoats when their farm runs into trouble. Their suspicions about their neighbor, Alice's mother, Joan, suffice to bring her to trial as a witch, where she is joined by Betty, a teenager willful enough to resist an arranged marriage; Susan, who is desperate enough to procure an abortion; Ellen, who is unwise enough to provide it; and, of course, Alice, whose attractions for the opposite sex suffice to turn her into a public danger. Seen initially as simply unusual, these characters inadvertently incite the worst prejudices of their friends and acquaintances. Churchill, in conducting her research for the play, had been struck by "how petty and everyday" the offenses of the accused witches were, and how often the accusations of witchcraft were directed at "those on the edges of society, old, poor, single, sexually unconventional."[14]

It would be easy, of course, for Churchill to settle for the simple equation between witches then and female outcasts now as examples of the general oppression of women—easy but unproductive. Churchill instead chooses to reconstruct our understanding of the relationship between female image and female identity in the seventeenth century as a means for reconstructing our understanding of the relationship between image and identity now. Even before the accusations of witchcraft begin to accumulate in the play, a choric song registers a lament that will dominate the action:

Nobody ever saw me
She whispered in a rage.
They were blinded by my beauty, now
They're blinded by my age.
 Oh nobody sings about it,
 but it happens all the time.

(p. 142)

The "nobody" singing "about it" is, of course, an emblematic female. What nobody has been prepared to sing about are all those aspects of being female that failed to make it into canonical literature or public consciousness, particularly those to do with reproduction, exploitation, and complex sexuality. "Nobody ever saw me," goes the song, and Churchill, looking beyond the distortions of stereotypes, is determined to make us see.

But what Churchill wishes us to see is not an alternative world constituted by alternative stereotypes. That would be to replicate the procedures, if not the precise substance, of a world she wishes us to see and see beyond. Her aim is to explore the insidious power of alien images that are not only forced upon women, but, at times, embraced by them. Several of the accused witches in the play come to regard themselves as witches as a result of persuasion, coercion, fear, or guilt. Alice first finds the image enticing in the midst of a sexual encounter. Betty finds persuasive the notion that her antisocial behavior might result from having been bewitched; Susan, guilt-ridden over her abortion, comes to believe "I was a witch and never knew it" (p. 174); Joan, under the pressure of supposed proof, confesses her witchcraft at length; and the other female figures in the play, like Margery and Goody, are as ready as the men to discover this evil in women and accept that it is there to be rooted out. The play rounds off this pattern by concluding with a female reading of excerpts from a seventeenth-century handbook on witches and women, *Malleus Maleficarum: The Hammer of Witches*. The excerpts are read by its authors, Kramer and Sprenger, professors of theology, but Churchill's use of female performers for the male roles serves to interweave accusation with self-accusation (p. 134).

This disturbing final scene is presented as if it were a performance in an Edwardian music hall, with the reiteration of inherited clichés sufficing to leave them perilously suspended between reinforcement and ridicule.

SPRENGER: Why is a greater number of witches found in the fragile feminine sex then in men?

KRAMER: "All wickedness is but little to the wickedness of a woman." Ecclesiastes.

SPRENGER: Here are three reasons, first because

KRAMER: woman is more credulous and since the aim of the devil is to corrupt faith he attacks them. Second because

SPRENGER: women are more impressionable. Third because

KRAMER: women have slippery tongues and cannot conceal from other women what by their evil art they know.

SPRENGER: Women are feebler in both body and mind so it's not surprising.

KRAMER: In intellect they seem to be of a different nature from men—

SPRENGER: like children

KRAMER: Yes.

SPRENGER: But the main reason is

KRAMER/

SPRENGER: she is more carnal than a man

KRAMER: as may be seen from her many carnal abominations.

SPRENGER: She was formed from a bent rib

KRAMER: and so is an imperfect animal.

SPRENGER: Fe mina, female, that is fe faith minus without

KRAMER: so cannot keep faith

SPRENGER: A defect of intelligence.

KRAMER: A defect of inordinate passions.

SPRENGER: To conclude.

KRAMER: All witchcraft

SPRENGER: comes from carnal lust

KRAMER: which is in woman

SPRENGER: insatiable

KRAMER: It is no wonder there are more women than men found infected with the heresy of witchcraft.

SPRENGER: And blessed be the Most High, which has so far preserved the male sex from so great a crime.

 (pp. 177–78)

A play which repeatedly demonstrates the prejudicial power of a projected image concludes with the ironic recognition that it is indeed "no wonder" that women have disproportionately been accused of, and accused themselves of, being witches. Churchill asks us to revise our understanding of witchcraft, to see it as a projection upon women of a society's more general ills, and to see it as emblematic of an array of discrediting images that our culture has likewise imposed upon women. The problem, as Churchill's illuminating use of images presents it, is

not that women are evil, and certainly not that they are more evil than men, but that there is, from the beginning of our recorded history, an interest among men in regarding women as evil, an interest that suffices both to engender and reinforce a tendency among women to regard themselves in similar terms. The creature nobody sees in her youth because she is beautiful and nobody sees in old age because she is ugly is a creature seen, if seen at all, through the distorting images of a culture that finds no place for her bodily functions and desires, much less for her psychological needs and personal development.

The witch image is a selective one; it distorts our culture (which has other images to offer) just as it distorts the potential of women. Although the one distortion helps us recognize the distortion of the other, it also helps us recognize the social currency of both. Women seen in this light and women who see themselves in this light are indeed danger-ous, to themselves and to others. But in a world dominated by projected images, the responsibility for the images lies more with those projecting them than with those projected upon, a point made graphically apparent in the various tests for witchcraft which the play describes. Uniformly, these are tests which allow the witch no possible means of escape or re-buttal. If she displays the devil's mark she is a witch, but "having no mark is no sign of innocence for the devil can take marks off" (p. 173); if she fails to bleed in a certain spot when pricked, she is a witch, but if she bleeds wherever she is pricked, it is only a sign that the witchfinder has yet to find the right spot; if she floats in water she is a witch, but if she doesn't, she is dead. The projected image serves as accusation, trial, and verdict; for Churchill, this makes the power of the witch image em-blematic of the power of other images that govern women's lives. The play, having vividly rendered this disturbing point, concludes with ac-cusatory questions to counter the accusatory image:

> Evil women
> Is that what you want?
> Is that what you want to see?
> In your movie dream
> Do they scream and scream?
> Evil women
> Evil women
> Women. (p. 179)

To conclude the play with such questions is to register in the play's structure a concern that runs through all of Churchill's best work. The unease she displays in interviews about labels that might appropriately

be assigned to her is recapitulated in a wariness displayed in the plays about prescribing for characters new labels to replace the old ones she discredits. Her political imagination maintains a supply of images to be opposed, but her theatrical imagination is committed more to exploring than to recommending alternatives. Fascinated by the power of projected images in social life, images which so often tend to close things down, Churchill is equally fascinated by the power of theater images to open things up. As her work progresses the images multiply in number and become more complex in their effects.

In *Cloud Nine* (1978) Churchill complicates her images by making central a technique that in *Vinegar Tom* was marginal: setting the image of the actor/actress against the image of the role. The result is a constant visual tension between a character's personality and public role.[15] The first act of *Cloud Nine* is set in a British colony in Africa in Victorian times, with Clive, a colonial administrator, taking care of his immediate family (wife Betty, son Edward, and daughter Victoria), a larger family that includes several other British colonials, and an even larger family made up of the country's "native" population. As the play begins, various members of the "family" gather on the veranda in the evening to rally round the British flag and watch the sun setting in the distance.

CLIVE: This is my family. Though far from home
 We serve the Queen wherever we may roam.
 I am a father to the natives here,
 And father to my family so dear.
 [*He presents Betty. She is played by a man.*]

 My wife is all I dreamt a wife should be,
 And everything she is she owes to me.
BETTY: I live for Clive. The whole aim of my life
 Is to be what he looks for in a wife.
 I am a man's creation as you see,
 And what men want is what I want to be.
 [*Clive presents Joshua. He is played by a white.*]
CLIVE: My boy's a jewel. Really has the knack
 You'd hardly notice that the fellow's black.
JOSHUA: My skin is black but oh my soul is white.
 I hate my tribe. My master is my light.
 (p. 251)[16]

The surprise of finding Clive's wife played by a man and his black servant by a Caucasian is followed quickly by others: Edward, his son, is played by a woman, and Victoria, his daughter, is played by a life-sized

dummy. The situation is complicated further in the second act when several of the same characters reappear. This time the characters are played by performers of the same sex as the characters, but many of these performers had been playing other characters in the first act. This is confusing enough, but Churchill adds one further twist: the second act takes place in contemporary London some seventy-five years after the events of the first act; for the characters, however, only twenty-five years have passed.

The effect of these techniques is unsettling. Initially, the point is obvious enough: Clive's wife, Betty, wants to be what he wants her to be, making her, in effect, a projection of the male imagination, and Churchill uses a male actor to make that point nicely; Clive's servant, Joshua, wants to be what the colonists want him to be, so he is played by a white actor. In both cases the clash between performer and character reminds us of what is being gained and what is being lost when proffered images are accepted and embraced. But more important is the recognition that adopted roles in general do not necessarily fit the natural character; they have to be acquired. The part, whether it is personal, familial, social, or political, has to be learned. Furthermore, the proffered image is not necessarily less distorting because it seems at first glance more creatively appropriate. Edward, Clive's son, is played by a woman not because Clive wishes him to be female, but because Edward is unwilling to accept the narrow image of masculinity that is thrust upon him. The alternative image of the female seems, however, no more likely to accommodate his personal possibilities. He is, nevertheless, slightly better off than his sister, Victoria (played by a dummy), in that people do think him important enough to be trained for something so he is thus at least paid attention to.

By the time we get to the second act, however, the issues become even more complex. The telescoping of time serves to show how persistent are the Victorian values that might have become more remote from our minds as they became more remote in time. A similar telescoping of gender issues progresses until the problems of one sex become inextricably intertwined with the problems of the other. And this point, suitably registered in the redistribution of performers and roles in the second act, serves also to remind us of the larger implications of the gender problems exemplified in the first act by the confusion of male and female roles.

The gender disorder in the play emerges from Churchill's concern with the family, which functions as both social institution and social im-

age. For Churchill it is primarily the family that transmits on a local level the principles of order that govern society at large. It is this conception of family that connects the oppression of "dangerous" natives in the colonies with the oppression of "dangerous" women at home.

CLIVE: You can tame a wild animal only so far. They revert to their true nature and savage your hand. Sometimes I feel the natives are the enemy. I know that is wrong. I know I have a responsibility towards them, to care for them and bring them all to be like Joshua. But there is something dangerous. Implacable. This whole continent is my enemy. I am pitching my whole mind and will and reason and spirit against it to tame it, and I sometimes feel it will break over me and swallow me up. . . . Women can be treacherous and evil. They are darker and more dangerous than men. The family protects us from that. . . . We must resist this dark female lust, Betty, or it will swallow us up. (p. 277)

The family, however, instead of bringing things to an optimum order, seems to impose a distorting and unacceptable form of order. As the first act gives way to the second, the colonies have revolted and reasserted their independence, and the women likewise have made their move for freedom. But no new ideal of family has emerged. The first act is presented humorously, as a manifestly archaic mode of proceeding, but the second presents a new world whose claims to progress are not commensurate with its claims to bravery and novelty. The concealed homosexuality that characterized a Victorian world gives way to the overt homosexuality of a modern world. In neither world does there seem to be emotional space for a mutually satisfying heterosexual relationship. Betty, characterized in the first act as "a mother. And a daughter. And a wife" (p. 268), is presented in the second as bewildered by her children, independent of her mother, and separated from her husband. The woman who once lived only to be all her husband wished her to be has progressed to the point at which she wishes primarily to be herself, but this seems to lead no further than to uncertainty about her goals, dislike of work, and enjoyment of solitary sex. This brave new world seems as sadly disordered as the one it succeeds, and the family no less a locus of unresolved tensions between public roles and private lives.

The relationship between the two acts, however, has generated some confusion. Irving Wardle, in a review of the London production, nicely summarizes the apparent problem:

> I think Miss Churchill disregards the crude facts of audience psychology by starting the evening with some uproariously coarse jokes at the expense of Victorian pieties, and then modulating into something altogether gentler and non-satirical. Long into last night's second half, there were uneasy giggles from spectators trying to view a study in sexual evolution as if it were another ludicrous chapter in the history of the White Man's Burden.[17]

This confusion is certainly there, but it is not necessarily a miscalculation on Churchill's part. The play does not present the first act as a norm that the second act must follow; nor does it present the first act as a problem to which the second is the solution. Both possibilities exist in the play, and the audience has to decide whether the events of the second act merit the easy laughter earned by the events of the first, or whether the events of the second act are supposed to merit a sympathetic response to a more sophisticated form of social existence. The answer is, of course, that Churchill seeks to suspend both possibilities in our minds; the world of liberated women in the second act seems, at times, alarmingly like the world of duty-bound men in the first. We laugh uproariously at the manifestly ridiculous in the behavior of our parents and grandparents, but we laugh more uneasily at the incipiently ridiculous in the world precipitated by our own revisionary consciousness. And that unease is testimony to the problematic nature of progress in general. The image of the family, which serves to sustain role distortion in the world of the white man's burden, continues to serve a similar function in the world of the white woman's burden.

The second act begins in a family context, with the action located in a children's play center in a park in modern London. Victoria and Lin (a new character) are mothers, and Cathy, Lin's four-year-old daughter, is played by a man. All the other characters, in an age of sexual self-consciousness, are played by performers of the more obviously appropriate sex. With sex roles becoming more a matter of personal choice and less a matter of social imposition, much of the dialogue is devoted to discussion of how this new freedom should be exercised. The emerging action, however, quickly revives the issue of not how but whether it can usefully be exercised. Cathy, the noisy, undisciplined, foulmouthed child of a broken marriage and the daughter of a lesbian mother, becomes emblematic of a new freedom to engage in renewed confusion by loving war toys and pretty dresses. She will not wear jeans to school because her friends taunt her about being a boy, but she greets the news of the death of her uncle (a soldier in Ireland) with a query about whether she might inherit his gun. The adults seem no more clear about what is

being achieved by their redistribution of affections or their decisions on matters of sex. Victoria is thinking of leaving her husband (Martin), Betty has just left Clive, and Lin left her husband a couple of years ago. Edward, now determinedly homosexual (and played by a man), cannot find a male who is willing to treat him as a good old-fashioned wife. When Victoria is propositioned by Lin, she cannot locate a satisfactory context in which to respond, and her reaction is in terms of remembered rather than instinctive values. And Lin's powers of persuasion and her pursuit of novelty disappointingly fail to embrace contexts larger than the immediate and local.

> LIN: Will you have sex with me?
> VICTORIA: I don't know what Martin would say. Does it count as adultery with a woman?
> LIN: You'd enjoy it. (p. 296)

The new freedoms seem to bring with them not some refreshing problems on a new frontier, but some tiresome variations on old complaints. Edward is sick of men because they cannot cope with his feminine form of homosexuality, and Victoria is sick of men because they cannot cope with her aggressive form of heterosexuality. Martin, one of the men in the firing line, is so much at a loss that he is devoting his time to "writing a novel about women from the women's point of view" (p. 302). As the modern understanding male, he has read *The Hite Report*, knows his responsibility to women in bed, accepts his wife's sexual curiosity along with her experiments in bisexuality, and encourages her to build a career, even if it means she must leave home to do so. All this to no avail. Victoria is much too confused to make up her mind about what freedom might be or to grasp at its image even when it looms before her. And Martin is as constrained as she is by the misplaced certainties of the Victorian past and the mislaid certainties of the experimental present. He is able to give only a feeble manifestation of achieved freedom by voicing his rejection of male dominance in characteristically dominant terms: "Whatever you want to do, I'll be delighted. If you could just let me know what it is I'm to be delighted about" (p. 299). But he is also vulnerable enough to resent his inability to make Victoria happy no matter how flexible, informed, and understanding he aspires to be.

> MARTIN: I'm not putting any pressure on you but I don't think you're being a whole person. God knows I do everything I can to make you stand on your own two feet. Just be yourself.

> You don't seem to realise how insulting it is to me that you
> can't get yourself together. (p. 301)

Martin's ironically authoritative command, "Just be yourself," rever-
berates through the second act of the play. The urge to be oneself offers
an elusive goal. It seems incompatible with one's social history and with
the future one tries to form through a traditional family. The attempt to
re-form the family simply replaces old conflicts with new ones. Not
easily defeated, Edward, Victoria, and Lin set up a ménage à trois,
along with the two children, but Victoria quickly recoils at the prospect
of extending this experimental family structure to include her mother.
Confusion over the biological and sociological meanings of the word
mother registers the confusion of characters seeking to locate a context
in which selfhood might legitimately emerge:

VICTORIA: I don't want to live with my mother.
 LIN: Don't think of her as your mother, think of her as Betty.
VICTORIA: But she thinks of herself as my mother.
 BETTY: I am your mother.
VICTORIA: But mummy we don't even like each other.
 BETTY: We might begin to. (p. 317)

That "might" is all that Betty and the rest of the searching characters
have to offer. They have no programmatic solution to offer. Confusion
over nature and nurture is as endemic in this new world as it was, in
different ways, in the one that preceded it. The persistence of Victorian
values in the modern world serves both to subvert a new urge for free-
dom and to raise alarming questions about the reasons for their durabil-
ity. The one major advance of the new generation is its acceptance of al-
ternative life-styles, but it is an advance that promises more than it
seems able to deliver.

For the women, in particular, the gains are hard to evaluate. Victoria,
the young girl of act 1, is played by a dummy. Cathy, the young girl of
act 2, is played by a man. A young girl who might just "be herself"
never appears. But the tactic of playing the character against the per-
former in such cases serves only to underline the divisions in the charac-
ters not so portrayed. The public roles of individual characters are a
constant source of concern. Betty captures the basic spirit of the second
act of the play when she remarks that "if there isn't a right way to do
things you have to invent one" (p. 319). The challenge, however, is not
only to find the courage and the imagination to do that, but to do it in
a way that is valuable to others. The individual released from previous
social constraints seems rightly reluctant to institute new ones, yet that

reluctance simply precipitates other constraints. This dilemma is encountered in various ways by the characters; Churchill has no prepackaged solutions to offer. Her aim is to move characters away from the dangers of inherited stereotypes, but she seems less convinced about having them function as potential prototypes. Wardle is generally right when he concludes that "beyond the laughs, the real dramatic interest lies in the double approach to character as a fixed or fluid thing. The triumph of the play . . . is that this point is inscribed in the casting."[18] It is, indeed, a triumph, for it registers the fundamental and irreducible tension in the play. The key point is more subtle yet: the double approach to character as fixed or fluid opens up a realm in which not just double, but multiple, options are available. The performers and the audience, not just the dramatist, must make choices among them.

Cloud Nine is very much a play that focuses on "the possibilities for change,"[19] and Churchill is keen neither to prescribe the best possibilities nor to limit them any more than she can help. In her introduction to the play she is unwilling to decide precisely which actors/actresses from act 1 should play which characters in act 2. Rather, she notes, the doubling can be done in any way that seems right for any particular production: "Some doublings aren't practicable, but any way of doing the doubling seems to set up some interesting resonances between the two acts."[20] The options of the director, like the options of the characters, are limited but open. The world of the production, like the world of the play and the world offstage, is one of possibilities to be explored, not one of truths to be illustrated or advocated. The light of inquiry is turned as much upon contemporary assumptions as upon those of the Victorian era. The major danger to characters struggling to be just themselves is not one of opening things up, but one of prematurely closing things down, on the grounds that something useful has seemed to work for a while. Today's solution is likely to be tomorrow's problem, and that, not some enduring new solution, provides the framework for the new world of exploration and change that characterizes the second act of the play.

> The wife's lover's children and my lover's wife,
> Cooking in my kitchen, confusing my life.
> And it's upside down when you reach Cloud Nine.
> Upside down when you reach Cloud Nine.
>
> (p. 312)

The characters in the play, poised between stereotypes to which they do not wish to succumb and prototypes they feel powerless to prescribe,

do indeed find themselves turned "upside down." But Churchill, by focusing on the former option as one of social and political inheritance and on the latter as one of individual and theatrical potential, constructs from their interaction a compelling dramatic experience. The two acts of the play provide, for both characters and audience, two worlds that resonate without ever becoming reconciled. The images of entrapment that dominate women and witches in *Vinegar Tom* are succeeded in *Cloud Nine* by interacting images of entrapment and escape. The escape, however, is very much a matter of escaping *from* rather than escaping *to;* as a consequence, escape is never fully achieved.

In *Top Girls* (1982) Churchill's theatrical imagination grapples with images of female success as a means of exploring further the "possibilities for change." The images Churchill invokes in this play are, however, highly unpredictable. The play begins with a dinner party hosted by a successful woman of the present for guests who are an odd collection of historical and legendary figures from the past. Each has her own claim to fame, but each would describe and embody success so differently that the image of "top girls" quickly becomes diffuse. Failing either to follow or to initiate conventions of success, the characters at the party are located in that strange Churchillian zone, suspended between stereotypes they failed to follow and prototypes they failed to initiate. They float before us as images of possibilities pursued and potentiality preempted. Their collective representativeness justifies their presence at the party, but their individual presences serve only to raise questions about what they collectively represent. Their sporadic interaction displays not so much the convergence of a community of successful women, but rather the divergence of almost any group of individuals. The dinner party offers a social occasion which substitutes for, rather than summarizes, a sense of community achievement.

The tension in the scene is emblematic of similar conflicts elsewhere in Churchill's dramatic work. The dominance of images in Churchill's plays is such that character constantly verges on the representative rather than the unique. The problems the female characters confront are women's problems; attention is repeatedly redirected toward women's problems in general and away from the idiosyncratic problems of individual women. Churchill's depiction of men is often similar. Alisa Solomon describes this as "a telescopic rather than a traditional microscopic approach to dramatic characters,"[21] citing as a paradigm case *Light Shining in Buckinghamshire* (1976). There, many characters come and go, not always played by the same performer. None of them

is central to an action of war and revolution whose social scope is too large to allow attention to focus upon particular individuals. There is, of course, an inherent paradox in attempts to approach problems of particular individuals through their representativeness. Churchill is shrewd enough to exploit it rather than succumb to the problems it presents. This is true whether the issue emerges in a play about large historical processes or in one about local community events. In the complicated world of Churchill's imagination, the selfhood that is to be rescued from the repression of historical stereotyping has a way of converting from the subject of repression to its new instrument. The individuals who escape inherited social constraint quickly find themselves, as they achieve representative status, distorting the lives of other individuals who are trying to do the same. *Top Girls,* like other Churchill plays, focuses initially on a variety of examples, but unlike her other major plays, it focuses increasingly on the experience of a single individual.

The narrowing of focus has a daring beginning and a daring conclusion: the conclusion, because it turns out to be the earliest chronological scene of the play, and the beginning, because it situates a modern top girl, Marlene, at a dinner party for less modern top girls from the recent and distant past. As the play begins, Marlene is celebrating her appointment as managing director of an employment agency by holding a dinner for a collection of similarly successful predecessors. These top girls from the past consist of Isabella Bird, a nineteenth-century Scottish lady noted primarily for the international traveling she undertook in later life; Lady Nijo, a thirteenth-century Japanese courtesan, who subsequently became a Buddhist nun; Dull Gret, the subject of a Breughel painting, which depicts her in an apron and armor leading women into battle against the devils in hell; Pope Joan, the apocryphal ninth-century female pope; and Patient Griselda, who emerged from the work of Petrarch and Boccaccio to become the obedient wife in Chaucer's *Clerk's Tale.* This remarkable collection of women suggests initially the emergence of a prototype of female success. But the issue of representativeness that has remained implicit in the earlier plays here becomes an explicit thematic concern.

The dinner party demonstrates neither the common attributes of these top girls nor their common achievements, nor even their common interest in each other. Though they converse politely enough, the women interrupt each other with regularity and seem more interested in their own stories than in those of others. This self-concern is, of course, born of achievement, but in a context in which success required a readiness to

ignore social disapproval. For a dramatist interested in the "possibilities for change," these characters portray female achievement as a welcome but not necessarily ennobling experience. The question that arises is whether that is not only a historical but also a contemporary dilemma. The dinner party culminates in Marlene's toast to individual success, a toast ironically undermined by the absence of sustained community that such success might have engendered: "We've all come a long way. To our courage and the way we changed our lives and our extraordinary achievements" (p. 13).[22] These unusual characters have indeed changed their lives, but at such various times and in such diverse ways that it is difficult to abstract from their several experiences anything other than a commitment to change as an individual rather than a social goal. The scene concludes not with an event emblematic of achieved community, nor with an emerging common vision, but with a summarizing image of isolated and temporary achievement, focused, ironically, on a world dominated by men:

> *Nijo is laughing and crying.*
> *Joan gets up and is sick in a corner.*
> *Marlene is drinking Isabella's brandy.*

ISABELLA: So off I went to visit the Berber sheiks in full blue trousers and great brass spurs. I was the only European woman ever to have seen the Emperor of Morocco. I was seventy years old. What lengths to go to for a last chance of joy. I knew my return of vigour was only temporary, but how marvellous while it lasted. (p. 29)

The recurring images of this unusual scene are those of journeys, changes, and transient achievements, all set in the context of a bewildering variety of social environments. The dialogue offers a dazzling mosaic of crosscut speeches which never quite come into focus. The women lack any common agreement on beliefs, goals, ideals, and responsibilities to family, friends, or each other. There is no unifying image of the successful woman visible here, for the world of women seems historically a heterogeneous one which offers many centers of attention but no emerging locus of attention. Having established the historical context for her play with this image of self-absorbed heterogeneity, Churchill moves Marlene away to more localized situations. The context of legendary and historical figures is succeeded first by the narrower contemporary context of her professional career and subsequently by the still narrower context of her immediate family. The failure of the historical and legendary figures to offer ennobling models of successful behavior leaves

open the question of what they and Marlene might nevertheless represent in these more local contexts.

It quickly becomes obvious that the grand achievements of the legendary women have not precipitated any grander achievements for women in general. But their legacy does seem to have been to precipitate a widespread determination among women to improve their lot in life. The clients Marlene advises in her employment agency are women still struggling with sexual prejudice, still trying to establish a foothold on a career ladder, but all determinedly trying to keep open possibilities for change in a world of oppressively constructed order. Marlene's agency might well be seen as an enabling instrument of social change, but its limitations quickly become apparent. Marlene's colleagues, Win and Nell, seem to have earned a place in the inherited order only by replicating the behavior of aggressive, career-oriented males. Their optimistic and occasionally idealistic customers are fed not a program for self-realization but a cynical how-to-get-ahead message that is vociferously opposed only by the wife of Howard Kidd, the man Marlene bested when she won the position of managing director. As the family woman confronts the career woman, we are offered the fleeting, but striking, image of a limiting stereotype of the past confronting a limiting prototype of the future. Mrs. Kidd, reminding Marlene that Howard has three children to support, angrily accuses her of being "one of these ballbreakers, that's what you are. You'll end up miserable and lonely. You're not natural" (p. 59).

The accusation is lent a certain dubious authority by the subsequent collapse of Howard with a heart attack and by Nell's laconic reaction: "Lucky he didn't get the job if that's what his health's like" (p. 66). But the accusation gains greater credence from the fact that it is delivered in the presence of Marlene's slow-witted daughter, Angie, farmed off to live with Marlene's sister many years earlier. Angie, who has been deceived into thinking that her aunt is her mother and her mother is her aunt, is beginning to suspect otherwise; like several of the top girls in the play's opening scene, she has set out on a journey to a distant place in pursuit of change. But Marlene, whose professional role it is to advise on such potential change, is more than ready to treat a slow-witted daughter as firmly as she would treat any other client whose talents are not immediately suited to those of the professional rat race.

MARLENE: Is she asleep?
WIN: She wants to work here.
MARLENE: Packer in Tesco more like.
WIN: She's a nice kid. Isn't she?

MARLENE: She's a bit thick. She's a bit funny.
WIN: She thinks you're wonderful.
MARLENE: She's not going to make it. (p. 66)

As the play's focus narrows from historical to contemporary figures, the larger representativeness of the top girls' successes becomes disturbingly apparent. The individual achievements have done little to alter the framework of achievement; the price of success is the movement from one kind of sacrifice to another, sometimes sacrifice of self, sometimes of others—a point made in more extended form by Churchill's depicting Marlene in a variety of contexts that display the many selves she has available for sacrifice.

Marlene's dismissal of her daughter is the final chronological statement in the play. The rejection of her daughter for failing to have career talent sufficient to assure her own success replicates the earlier rejection of her daughter for restraining the development of Marlene's talents. But talents in this context are rather narrowly conceived. The play moves backward in time and some distance in space to a working-class area of a provincial town. Joyce, Marlene's sister, is the substitute mother for Angie. She tends their father's grave, visits their mother regularly, and takes care of all the family ties that Marlene broke when she left home for London and her career. Conversation between the sisters reveals the background of Marlene's life: a mother exploited and ignored, a drunken father worked to exhaustion in the fields, an early pregnancy for the unmarried Marlene, infertility for the then-married Joyce, an uneasy arrangement of transferring Angie to Joyce. Conflict between Joyce, the child who stayed home, and Marlene, the child who left to achieve success, merges with the political conflicts and class consciousness of an England unprepared for and unable to cope with the commitment to change that allows top girls to emerge and flourish.

MARLENE: I knew when I was thirteen, out of their house, out of them, never let that happen to me,/ never let him/ make my own way, out
JOYCE: Jealous of what you've done, you're ashamed of me if I came to your office, your smart friends, would you. I'm ashamed of you, think of nothing but yourself, you've got on, nothing's changed for most people/ has it?
MARLENE: I hate the working class/ which is what you're going
JOYCE: Yes you do
MARLENE: to go on about now, it doesn't exist any more, it means lazy and stupid./ I don't like the way they talk. I don't
JOYCE: Come on, now we're getting it.

MARLENE: like beer guts and football vomit and saucy tits/ and brothers and sisters
JOYCE: I spit when I see a Rolls Royce, scratch it with my ring/ Mercedes it was.
MARLENE: Oh very mature— (p. 85)[23]

These contrasting images of the repugnant and unacceptable finally focus, approriately enough, on the value of the image of the nation's first female leader. For Marlene, Margaret Thatcher is a welcome sign of top girls bringing about a better future: "She's a tough lady, Maggie. I'd give her a job. She just needs to hang in there. This country needs to stop whining. . . . First woman prime minister. Terrifico. Aces. Right on" (p. 84). For Joyce, Margaret Thatcher offers an appalling image of a top girl bringing about a worse future: "What good's first woman if it's her? I suppose you'd have liked Hitler if he was a woman. Ms Hitler. Got a lot done Hitlerina. Great adventures" (p. 84). This clash between the sisters brings to the foreground the issue of representativeness that underlies the earlier action (and is implicit in the action of Churchill's previous plays). Their disagreement recapitulates a major division in British (and international) politics between social solidarity and individual achievement. Each sister sees only the advantages of one side and the disadvantages of the other, but their disagreement has major consequences for a dramatist torn between exploring the individual and examining the type. The play situates us where we must grapple with both. A major context of the play is the historical and the political, but the key context is the personal one in which Marlene must come to terms with her daughter and with herself as a mother.

Marlene, committed to the virtues of self-reliance and individual achievement and convinced of the debilitating consequences of social solidarity, stresses her belief "in the individual" and offers her own status as a persuasive example: "Look at me" (p. 84). But this example of the success of the strong is compromised for Joyce not only by the price Marlene has paid but also by the limited application of an example offered to a world constituted as much by the weak as by the strong. For every top girl, like Marlene, at the head of the ladder, there must be many more, like Angie, lower down. For every example of Marlene's kind of female success, there must be many more of comparative failure. The responsibility of each to the other provides the implicit challenge to Marlene's conviction that her celebration dinner is justified because she has fulfilled her responsibility to herself. What she represents to herself is as much at odds with what she will represent to Angie as Marlene's image of Margaret Thatcher is at odds with Joyce's.

MARLENE: I don't mean anything personal. I don't believe in class.
Anyone can do anything if they've got what it takes.
JOYCE: And if they haven't?
MARLENE: If they're stupid or lazy or frightened, I'm not going to
help them get a job, why should I?
JOYCE: What about Angie?
MARLENE: What about Angie?
JOYCE: She's stupid, lazy and frightened, so what about her?

(p. 86)

Marlene has no answer that she is willing to voice, but the implicit an-
swer, which she is subsequently to supply, has already been given in the
play's preceding scene: "She's not going to make it" (p. 66). Angie,
awakened by the noises around her, confronts a mother who still claims
to be her aunt; the nervous and anxious child can only repeat in unsym-
pathetic ears the helpless comment "frightening" (p. 87). The play's
final tableau, characteristically multifaceted and characteristically di-
viding individuals from roles and each role from another role, presents
us with a complex image of multiple representation: of a child rejected
by an adult, a daughter rejected by a mother, an unsuccessful person re-
jected by a successful person, a woman rejected by another woman, and
one individual rejected by another individual. It is an image not of
achieved but of aborted community.

The play portrays, in the disagreements between Joyce and Marlene,
two radically different attitudes toward the relationship between individ-
ual progress and community progress. But the action supplies a condem-
nation of neither Marlene nor Joyce. The play advocates neither the pri-
ority of the social over the personal nor of the personal over the social.
It portrays the necessity for personal growth and change and the price
they exact, along with the need for community stability and support and
the price they, too, exact. In the background of issues to do with indi-
vidual choice, social responsibility, women's rights, political commit-
ments, and historical understanding are the polarities forced upon mod-
ern consciousness by the clash between Marxist and capitalist ideologies,
with their contrasting concerns for the priority of the community and
the individual. Churchill neither brings these to the fore nor thinks in
terms of their programmatic formulations, but their unresolved tension
is a major dynamic of her drama. It may well be the case that the per-
sonal must always involve the political, but fighting for its place is the
accompanying recognition that the political must find a way of accom-
modating, and not just absorbing, the personal.

In a characteristically Marxist world, it is natural enough to depict

individuals defined by their social being, but Churchill constantly struggles to establish the appropriate relationship between the two. In a predominantly social context, how can individuals set about achieving what Martin recommends in *Cloud Nine*—just being themselves? In a predominantly dramatic context, how should characters be distributed between their roles as selves, stereotypes, and prototypes? In either case the social context slides uncertainly between being symptomatic of a disease and symbolic of a potential cure. Churchill seems inclined to go further than Brecht in giving priority to individual experience, but even Brecht, as John Simon points out, was regularly shrewd enough, in spite of his dramatic theories, to provide the audience with a central and charismatic figure or two.[24] Churchill's multiple-character and multiple-role plays repeatedly turn attention to the general that constrains the particular case, to the image that both locates and summarizes character. But Churchill is also prepared to give individuality its due, to look at social change in the context of individual consequence, without neglecting the need to view individual success in terms of its contribution to social change. She rightly recognizes that to treat social problems only socially is to close off one possible but problematic escape route— the one in which social alternatives arise from individuals' exercising whatever degree of freedom they may yet retain in their socially contaminated imaginations.

The degree of social contamination can, however, be extensive, not least in a world in which a single kind of individual creativity becomes a widespread social obligation. When, in *Serious Money* (1987), Churchill explores the social dynamics of a world in which a limited vision of limitless success is shared equally by both sexes, the "frightening" implications of Marlene's careerism are exhaustively exemplified. The play begins with a scene from Thomas Shadwell's seventeenth-century play *The Volunteers or the Stockjobbers,* in which the buying and selling of fraudulent stocks is symptomatic of the social relations that have emerged from the upheavals of England's civil war and its aftermath. Interest in building a better mousetrap, finding an authentic flea killer, or discovering a successful device to promote flying is subordinated to an interest in buying shares in these projects before prices rise and selling them again before prices fall. This brief historical vignette is the prelude to a play that portrays the world of the London financial markets after their mideighties deregulation. The London stock exchange, previously the preserve of England's upper classes, opens its doors to modern technology and to anyone prepared to put time and money into financial specuation. The key issue is, however, whose time and whose

money, as the various jobbers, brokers, and bankers compete to exploit each other and the focus of dramatic and social concern shifts to the image of "man [as] a gambling animal" (p. 23).[25]

Once again Churchill is keen to explore the possibilities the image provides rather than to criticize it directly. Her technique is one of enabling the shortcomings to emerge, even as she appears to be treating this image and the world it generates sympathetically. It quickly becomes apparent that life in these terms has "serious" limitations. Individuality is expressed more in the context of pragmatic competition than of considered conviction. The boundaries of the possible are established more by the legal and investigative powers of the Department of Trade and Industry than by any tradition of moral authority or community concern. In a world in which the game of life is like "a cross between roulette and space invaders" (p. 54), the only ethical issue is whether "you can be greedy and still feel good about yourself" (p. 45). The answer appears to be a qualified yes. But all of the irony in this "city comedy" is mediated through the varied exemplification of the many things that qualify that implicit affirmation.

A play that begins by linking twentieth-century England to seventeenth-century England continues by extending its scope in space just as it initially extended its boundaries in time. The world of the stock market embraces both sexes, all classes, and all countries. There is room here for those previously marginalized: females, foreigners, and former members of the lower classes; there is space enough in this domain for the Old World, the New World, and the Third World. This social, temporal, and geographical inclusiveness is not, however, matched by a similar breadth of moral vision. The fast-moving world of financial speculation has its own peculiar rules whose complex implications have serious social consequences:

> [The IMF] can't be namby pamby.
> [Poor] countries must accept restricted diets.
> The government must explain, if there are food riots,
> That paying the western banks is the priority. (p. 68)

There are also important lessons to be learned:

> One's based in London so one's operation
> Is on the right side of exploitation.
> One thing one learned from one's colonial masters,
> One makes money from other people's disasters.
>
> (p. 69)

And there are special techniques to be mastered:

> There's ugly greedy and sexy greedy, you dope.
> At the moment you're ugly which is no hope.
> If you stay ugly, god knows what your fate is.
> But sexy greedy *is* the late eighties.
>
> (p. 92)

And there are unusual satisfactions to be savored:

> Maybe I should retire while my career is at its pinnacle.
> Working in the City can make one rather cynical.
> When a oil tanker sank with a hundred men the lads
> cheered because they'd make a million.
> When Sadat was shot I was rather chuffed because I was
> long of gold bullion.
> Life's been very good to me. I think I'll work for Oxfam.
>
> (p. 104)

These ironic comments on a world in which individual freedom has degenerated into social irresponsibility are precipitated from an action in which suicide, murder, intrigue, and revenge protrude but never predominate. The laughter the play invites is the laughter of the insider observing shortcomings and foibles, not that of the outsider expressing ridicule and resentment. The play invites us to be sorry not for the characters during the action but for ourselves when it concludes. The play ends with an ironic rendering of the Conservative party's anthem; this humorous comedy about "serious money" registers both the humorous nature of a single-minded pursuit of money and the serious implications of such a pursuit for any community that allows itself to be dominated by it. The heroic individualism implied in the image of man as a gambling animal is steadily undermined by the emerging image of man as a uniform creature whose word is worth no more than his junk bond (p. 105).

Such use of the word *man* to designate all of humanity is not, in this play, inadvertently anachronistic. Throughout the play, indeed throughout the span of history invoked and the scope of space embraced, there is a leveling going on. Although characters exchange from day to day their places on the financial ladder, their stylized utterances display their tendency to become increasingly alike in every other respect. Whether it is the equating of one era with another, one culture with another, one class with another, or one sex with another, the issue is the same. And it matters little whether we regard this leveling as a leveling up or a leveling down. A narrow pursuit of a single mode of success reduces to the ironic margin all of those differences that make

eras different, cultures different, sexes different, and people different. While watching the play, we laugh because we must; at the end, we laugh only if we still can. For what we lose along with the differences that divide us are the differences that make significant social and individual change possible. With a series of one-line summaries of the characters' subsequent fates, the play registers the trivialization of personal lives in a world in which the voice of individualism has become disturbingly predictable. Among the characters in this play, the individual voice is also the representative voice, for one kind of individualism has increasingly been embraced by all. The action concludes with idiosyncratic voices suppressed, a chorus of combined voices singing in unison, and a song celebrating yet another political victory for the forces of financial speculation.

Although Churchill here, as much as anywhere, explores a world through a single ideological perspective, she is careful to allow that world to exemplify its own limitations. She cleverly dramatizes the ways in which the pursuit of a single kind of individualism converts into another kind of social conformity. As the prototype becomes a stereotype, it loses its capacity to facilitate either individual freedom or social change. Though Churchill focuses here on the limitations of a single major image, she is more ready elsewhere to match one image with another, to explore alternatives without committing herself to them, to set the limitations of one way of life in the context of the limitations of another. But in play after play she is interested less in rehearsing political commonplaces of the Left or Right than in examining the need to explore the nature of genuine "possibilities for change." In one context after another she clarifies the issues that emerge and the questions that arise when the limitations of the past give way to the limitations of the present. When Angie makes her final comment in *Top Girls* ("frightening"), she might well be speaking not just to, but for, her equally frightened mother and for the many characters Churchill has portrayed who find the world they have inherited and the world that is emerging both challenging and daunting.

Churchill's strength as a dramatist is that her imagination is engagingly theatrical as well as disturbingly political; it portrays the individual in social contexts that emerge as the source of most problems and the necessary site of their potential solution; it confronts history in a contemporary perspective and the modern world in the context of historical examples; and it looks to the theater as the source of therapeutic images that might help us combat the debilitating images our culture has regularly transmitted to us. Conflict between the inherited and the emerging

image provides the site of character conflict in plays that pose, politically and theatrically, problems of representation. The audience is offered no prefabricated solutions and no prophetic visions. Churchill's concern is for clarification, not for resolution of problems confronted by characters who find themselves torn between the stringency of the stereotype and the problematics of the prototype.

Resolutions to the large social problems Churchill explores are not hers to provide, and the conflicts she dramatizes between social and individual constraint and social and individual success are conflicts of complex moral choice, not those of programmatic political rhetoric. It is her achievement, in the context of alternative theater, to portray them so. In this respect, at least, she finds her voice in tune with that of another social analyst whose characteristic style and personal commitments were otherwise of a very different stripe. In this context, if in no other, proponents of canonical and alternative culture encounter a common concern: "Those conditions, which flatter hope and attract desire, are so constituted, that, as we approach one, we recede from another. There are goods so opposed that we cannot secure both, but by too much prudence may pass between them at too great a distance to reach either."[26] Those who congratulate themselves on being older, sadder, and wiser might find this rueful acknowledgment regrettable but inescapable. Those with less to lose and more to gain will rightly follow the struggles of the national theater in the suburbs and provinces to supply what neither the National Theatre on the South Bank nor the larger theater of Western culture has been able to supply: a method of analysis and a mode of social conduct that will take us further.

Notes

1. Press release from the ITC/TACT Joint Action Committee, 1976 (The Independent Theatre Council/The Association of Community Theatres), quoted by Catherine Itzin, *Stages in the Revolution: Political Theatre in Britain Since 1968* (London: Methuen, 1980), p. 268.

2. Ibid., p. 279.

3. Caryl Churchill, quoted in Itzin, *Stages,* p. 281.

4. Interview (1979) with Catherine Itzin, quoted in Itzin, *Stages,* p. 279.

5. Caryl Churchill, interview with Judith Thurman, *Ms.,* May 1982, p. 54.

6. Ibid.

7. Caryl Churchill, *Plays: One* (London and New York: Methuen, 1985), p. xii.

8. Churchill has worked alternately with the Joint Stock Company and the Monstrous Regiment theater company. Both stress collaborative playwriting and performance, with everyone involved in the production contributing their views. Itzin discusses the evolution of both (*Stages*, pp. 220–27, 274–78). Helen Keyssar characterizes the former as "political without being doctrinaire" and the latter as a "feminist-socialist theater company (dominated by women but including men)." See "The Dreams of Caryl Churchill: The Politics of Possibility," *Massachusetts Review* 24 (Spring 1983), 207, 210.

9. Churchill, interview with Judith Thurman, p. 54. Note that Churchill remains fond of her earlier radio plays and retains a "desire to have them published in a collection" (quoted by Keyssar, "Dreams," p. 202).

10. Caryl Churchill, Introduction to *Traps* in *Plays: One*, p. 71.

11. Caryl Churchill, Introduction to *Vinegar Tom* in *Plays: One*, p. 130.

12. All page references to *Vinegar Tom* are to the text in *Plays: One*.

13. Churchill, Introduction to *Vinegar Tom*, p. 130.

14. Ibid.

15. As Keyssar points out, Churchill's use of this device "politicizes the theatrical convention of transformations, initiated in experimental theater in the sixties and potently adapted by many feminist playwrights in the seventies" ("Dreams," p. 209).

16. All page references to *Cloud Nine* are to the text in *Plays: One*.

17. Irving Wardle, review of *Cloud Nine* in *The Times* [London], September 10, 1980, p. 10.

18. Ibid.

19. Churchill, interview with Judith Thurman, p. 54.

20. Caryl Churchill, Introduction to *Cloud Nine* in *Plays: One*, p. 247. (Spring 1981), 54.

21. Alisa Solomon, "Witches, Ranters and the Middle Class," *Theater* 12 (Spring 1981), 54.

22. All page references are to *Top Girls* (London and New York: Methuen, 1984).

23. Note that Churchill uses the slash (/) to indicate an interruption at the point at which the next character begins to speak.

24. John Simon, "Soft Centers," *New York* magazine, vol. 17, June 13, 1983, p. 77.

25. All page references are to *Serious Money* (London and New York: Methuen, 1987).

26. Samuel Johnson, *Rasselas,* in *Dr. Johnson: Prose and Poetry,* ed. Mona Wilson (London: Rupert Hart-Davis, 1963), p. 444.

Ariane Mnouchkine: Playwright of a Collective

Ruby Cohn

The designation "playwright" might surprise Ariane Mnouchkine, animator of the Théâtre du Soleil, but "dramatist" is even less suitable for that member of a collective theater who chooses particular scenes to be performed for an audience. "Guiding and deciding eye" might be more accurate, if somewhat unwieldy. When improvised exercises are fixed in published texts, the problem of signature arises. Both the San Francisco Mime Troupe and the Théâtre du Soleil published their early texts anonymously, but the trouper Joan Holden now signs her publications, which are available to other theaters. Mnouchkine's pieces remain more problematic.

In 1959 twenty-year-old Ariane Mnouchkine, daughter of an English mother and French film producer father, returned to her Paris home from Oxford University, where she had expended more energy on theater than on classes. In loose affiliation with the Sorbonne, she formed a student theater group that produced Lorca's *Blood Wedding*—to general indifference. In 1961 Mnouchkine directed—for the first time—a sprawling, forty-strong cast of *Genghis Khan* in the Roman ruins of Left Bank Paris. Mnouchkine's ebullience was soon tempered not only by sparse audiences at the five performances but by an abrupt awareness of her professional inadequacies. Leaving the university milieu, she traveled far and wide to observe and absorb theater. (Kabuki and kathakali would, two decades later, leave their imprints on her Shakespeare productions.)

In 1964 Mnouchkine returned to her Paris friends, now ex-students, to found a theater collective whose name reflected its aspiration. Le Théâtre du Soleil, literally "theater of the sun," resonates warmth and energy; the name was intended to pay homage to light-conscious film directors George Cukor, Max Ophuls, and Jean Renoir. The forty founding members were not admitted to French theater unions, so they

incorporated as a workers' cooperative, planning to raise sheep in the country while they rehearsed for eventual Paris performance.

Selecting Arthur Adamov's recent translation of Gorki's *Petits bourgeois,* the company drew upon their own petit bourgeois backgrounds, but the group shrank under the arduous schedule of sheep rearing by day and rehearsal by night. Barely reviewed in its formal Paris debut, the company faithful found odd jobs in the city and renounced its sheep. For its second production, group member Philippe Léotard adapted scenes from the popular nineteenth-century novel *Captain Fracasse* by Théophile Gautier; the group improvised upon the fiction, and it fell to Mnouchkine to select a few of them for public performance. In 1966, in a theater rented for the occasion, the production went unappreciated, although it incorporated collective creation, unscripted material, and an ambience of fairground theater whose traditions went back to the Middle Ages.

While the group existed marginally on part-time work, Mnouchkine herself enrolled in Jacques Lecoq's mime school, which was hostile to French theater rhetoric. Each evening Mnouchkine taught her day's physical exercise to the Soleil actors. Wanting to try these hard-won skills on a modern text, Soleil selected Arnold Wesker's *Kitchen,* where the overpowering rhythms of kitchen tasks dominated the individual roles. Each actor rehearsed all the roles while observing the kitchen of a large Paris restaurant; eventually, the whole group was coached by a chef. Once the actors could perform kitchen duties as second nature—carrying trays, sprinkling flour, peeling potatoes, slicing carrots, pounding dough, carving meat, but without actual trays, flour, potatoes, carrots, dough, or meat—they stylized the merciless tasks for a huge playing space in a disaffected circus. By and large, it again fell to Mnouchkine to select scenes for performance. Somewhat to Soleil's surprise, spectators came in droves to applaud what they perceived as slice-of-life realism in the honorable French lineage of Zola and Antoine.[1] The success of *The Kitchen* enabled company members to draw modest (and equal) salaries and to leave their odd jobs, including occasional kitchen service.

Euphoric, Soleil basked for a while in *A Midsummer Night's Dream,* adapted by Léotard to foreground the play within the play, shading it with the eroticism of Jan Kott's interpretation. Again Soleil played in the large circus space, but soon after opening the company was engulfed in the political furor of May 1968. Taking to the streets, Soleil shelved Shakespeare for skits of greater immediacy. Then, retreating for the summer to a large country house, the forty-odd group members pon-

dered their political and professional situation, even while investigating Greek, Chinese, and commedia masks.

The clown was common to these three cultures, and the fifteen actors in the company, each wearing a red, bulbous nose, began to fashion his or her own caricature, replete with costume. Gradually, the actors distanced themselves from specific clown traditions while retaining clown techniques of vocal distortion, large gestures, and simple phrases. One improvisation triggered another in a fever of fecundity, and the resultant clown collage would have played for six hours. Again it was Mnouchkine's prerogative to cut and cull, often over vehement protest. *Clowns* opened in 1969, immediately attracting large crowds. *The Kitchen* had aroused admiration for work (although condemnation was the group purpose), but *Clowns* hailed play. The huge kitchen ovens gave way to ubiquitous mirrors rimmed by colored lights; the company was conscious of its own theatricality. Although the verbal text originated in the mouths of the actors, it was recorded and eventually shaped by Mnouchkine.

By 1970 Soleil was secure in its clown virtuosity but insecure in the sociopolitical context of performance. Seeking a spectacle based on familiar material, the company first improvised on folktales, into which it incorporated the structural analyses of the Russian formalist Propp. Soon it shifted to the French Revolution, itself a virtual folktale as taught in French primary schools. Rather than accepting the Western theater habit of an actor playing a character for the spectator, however, Soleil posed as eighteenth-century fairground actors narrating and enacting revolutionary scenes for a contemporary audience in festive mood. Although left-wing in sentiment, the performance was not agitprop but dialogic, through the medium of theater.

As rehearsals progressed, it became clear that the performance would run toward eight hours. Instead of cutting, Soleil decided to divide the material, the first part climaxed by the Revolution, and the second part (which became *1793*) treating the so-called Reign of Terror.

Highly physical and technological, *1789* (as it came to be called) was finally rehearsed at a large sports arena where the group arranged the most telling lights for the trestle stages built with eighteenth-century techniques. The costumers worked from materials worn by the actors during improvisations. Since formal theater lighting was inimical to the fairground atmosphere, strings of bulbs were arranged on dimmers for a complicated crossplay that never isolated a single trestle. Projectors focused only a few scenes, but four follow spots illuminated certain characters at crucial points.

Rehearsed to precision, *1789* still lacked performance space until the Piccolo Theater of Milan invited Soleil to that city's sports arena. This fraternal charity became the European theater sensation of 1970. Critics and audiences were rhapsodic, and the (conservative) French government offered Soleil an unused munitions storehouse just outside of Paris (the Cartoucherie of Vincennes). The company cleaned and repaired the vast structure during the winter of 1970–71, then divided it into shop, rehearsal area, and performance space. Substituting brains, brawn, and sheer grit for money, Soleil converted the Cartoucherie into its theater home and gradually converted Paris audiences to the long journey to performances.

Because *1789* is so firmly inscribed in Continental theater history it is difficult today to appreciate the sheer bravado of the enterprise. Living frugally on borrowed money, without a theater at its disposal, without a text on which to rely, Soleil was nevertheless unlimited in ambition. First the company approached the Revolution as scholars—books, films, a formal course by Marxist historian Elizabeth Brisson. Since Soleil had experienced the fervor of May 1968 in Paris, analogies brushed against history. Having formulated the quasifiction of its status as a fairground company, Soleil improvised with Brechtian distance rather than actor-character identification. Although it improvised in makeshift spaces, it planned in dimensions of basketball courts. Mnouchkine set the work pattern early on: a holiday spirit would pervade five trestle stages connected by catwalks. On each of these trestles a group of actors improvised on a common theme with different techniques; the final choice of scenes for performance would result from a daily critique by the entire company. Mnouchkine, nevertheless, probably made the *final* final choice.

Since theater people were coming to grips with history, Soleil also drew upon theater history. Basic was Brechtian epic narration. Lighting and balladry were influenced by the Bread and Puppet Theater. A freely circulating audience (between five trestle stages) was inspired by Ronconi's *Orlando Furioso*. Quick shifts of roles and open exchanges with the audience stemmed from the Open Theater. And the Living Theater lived on in Soleil, as in most radical theater groups of the West.

The plays *1789* and *1793* were first published anonymously in *L'Avant-Scène* (October 15, 1973), with historical quotations in bold face type—over twice as many for *1789* as for *1793*. Despite fidelity to documents, however, it is unlikely that *1789* will be taught as a school text. Deliberately disjunctive, it enfolds "facts" into conversation,

parody, and popular legend. The fairground actors woo a miscellaneous audience to their view of that fateful birth year of modern France.

The performance opens on the naïveté of the oppressed, their loyalty to their insensitive king, his dismissal of moderate ministers. Once they convey the political background, the actors lead us toward the Bastille: "You mustn't think that the idea just struck us one fine day: 'Hey, today we'll storm the Bastille.' No, it happened after a whole lot of incidents and troubles that I have to tell you." Rising from whispers of actors planted among the dispersed spectators, the Revolution gains momentum. In semidarkness groups of spectators gather about a spotlit actor. As the pace of his speech quickens, voices and lights brighten gradually until the Revolution blazes forth on the trestle stages. The assault of the Bastille is a celebration, with all lights on full force, as marionettes on the five trestles play scenes of the people's uprising, the nobles' flight, and drunken revelry in the streets of Paris. Spectators throng from threstle to threstle, often with wineglass in hand. When the nobles are stripped of power, some actors are literally stripped to reveal a trembling cowardice not taught in French history primers. Americans view a different Lafayette from Washington's friend, for he was commander of the antirevolutionary militia. Upon the traditional three knocks that indicate the start of French shows, the nascent capitalists take plush seats to watch the spectacle of their own successful machinations. After some four hours of color, lights, music, movements, juggling, acrobatics, and puppets—a merry kaleidoscope—the final moments of *1789* are sober. Instead of revolutionary triumph, "Evil has reached its limit; it couldn't be worse. It can be conquered only by a complete revolt. Let's see social goals, let's see widespread happiness, and after a thousand years let's change these obscene laws." The original Soleil audiences thought, and were intended to think, of post-1968 laws of constraint, as well as those of 1791.

Soleil's *1793* stages the attrition of the Revolution in one corner of Paris, and again it was Mnouchkine who shaped the performance, including the verbal text. The trestle stages of *1789* give way to a (fictional) deconsecrated church where Soleil actors play a group of sansculottes meeting during crises. Since we are no longer at a fair but in a meeting hall, the environment is less colorful. The performance takes place on three large platforms, one at each end of the long playing space of the Cartoucherie and one against a wall at the center. Along the opposite wall runs a two-story balcony that is alternately filled with either actors or spectators. Contemporary costumes, worn through the

two-month rehearsal period, achieve a patina, as in Brecht's produc-
tions at the Berliner Ensemble. But unlike Brecht's harsh white light,
that of *1793* is nuanced for each scene. The play begins with a parade in the rehearsal area of the Car-
toucherie, inviting the audience to a performance of a radical reexam-
ination of history. More linear than *1789, 1793* follows a group of
commoners through the post-Revolution famine, the pillage of supplies,
the taking of the Tuileries, as well as the trial and execution of the
king. Insurrections arise outside of Paris, Marat is assassinated, and
France is invaded. Robespierre opposes the divestiture of Church
power, and the people are stripped of their power. Through narration
rather than enactment runs the double thread of people's misery along
with events celebrated in history. Striking scenes show citizens learning
to use guns, women washing clothes with stones, people lined up for
bread, the illiterate learning to read, and a last banquet of sansculottes.
Toward the end of the performance the commoners force the distribu-
tion of food, but immediately afterwards each of the actors announces
the unhappy fate of the character he or she plays; no one escapes arrest
or conscription. Darker than *1789, 1793* closes on a tribute to the
French Revolution—by Immanuel Kant.

By its tenth birthday in 1974, Soleil could look back on impressive
achievements in collective creation, actor-audience rapport, and radical
performance within bourgeois society. Acclaimed for its inventiveness,
the company was so burdened with debts that it began selling tickets
for a production as yet unconceived. Five thousand people bought on
faith (I among them), and in 1975 *L'Age d'or* (*The Golden Age*)
opened in visual splendor. Again the text was a product of collective
creation and Mnouchkine's selection, and again it was published anony-
mously.

The basic presupposition of this performance is that we live in a
golden age in the twenty-first century, but an Arab woman narrator
invites us to look back a half century. The narration/enactment of
scenes from daily life continues a technique of *1793,* but the frank
theatricality of performance stems from *1789,* and masks are carryovers
from *Clowns.*

Typically, Soleil made no effort to climb out of debt but sank deeper
into it through the most lavish of its environments. The large perfor-
mance space was walled off into four rooms, a huge, irregular mound
built in each one. These mounds were carpeted in sand-golden sisal,
upon which actors and audience clambered under a copper ceiling fes-
tooned with light bulbs. Rather than having crowds throng around

trestles or beneath platforms and balconies of Parisian neighborhoods, actors and audience terminated each scene by moving into another room. A festive spirit prevailed throughout.

Brecht and Artaud haunt *L'Age d'or*—the narration of the former and the plague of the latter. As prologue, the audience sees in the Cartoucherie rehearsal space a modified commedia scene: in 1720 in Naples a plague rages, and the prince asks Arlecchino its source. Far from Artaudian mystery, however, this plague germinates in a way well understood by Arlecchino; Pantalone owns the ship that brought the plague to Naples, and in full knowledge of the epidemic aboard, the mayor gave the ship permission to dock and unload its profitable cargo. In the fashion of oppressors in Brecht's plays, the two powerful men threaten Arlecchino with dire consequences if he reveals his knowledge to the prince. So, with somersaults and comic cowardice, Arlecchino leaves the blame unvoiced, to hover over the subsequent scenes in the playing area proper.

These may be roughly divided into Pantalone scenes (the selfish life of the bourgeois class, comically caricatured) and the Arlecchino scenes (the French life of the Algerian worker Abdallah). Unlike in Brecht's plays, where the ruling class alone wears masks, all social classes wear them in *L'Age d'or,* forcing the actors to express emotion corporeally. Even though the capitalists are caricatures, they too have their problems—hangovers, cramps, tachycardia. In one lyrical scene, however, they appear as monsters when they descend upon nude adolescent lovers on a moonlit beach—a ranting French version of the Moral Majority.

Lighting for *L'Age d'or* is more intricate than for *1793*—the false candles of a capitalist banquet, a moonlit beach, the dim room where television robotizes a bourgeois family, the dank room where Abdallah and his fellow workers are piled, layer upon layer, to snatch a few hours of sleep.

In the final scene Abdallah labors on a building site owned by Pantalone, who drives his foreman to drive the workers, despite danger. In a horrendous storm that shakes the whole Cartoucherie, the workers refuse to climb the (imaginary) scaffolding, and the foreman offers a premium to anyone who dares to mount. Insouciant Abdallah volunteers, and we hang upon his acrobatic feats as he negotiates the frail structure. The storm thunders on, lightning explodes Abdallah's support, and he falls—slowly, in the rhythm of Verdi's *Requiem.* When he lies prostrate, there is a sudden utter silence. In a rush, workers then turn against Pantalone and his forces of law and corruption, who try to

save themselves by climbing the back white wall of the Cartoucherie.
There they flail like pinned insects. A sudden radiance then shines
through giant windows; although it is midnight, we have the impression
of the bright dawn of a golden age.

From the future in 1975, Soleil turned to the past in 1978—for the
life of France's most popular playwright, Molière. Starting with the de-
sire to improvise scenes from a novel—Bulgakov's *Life of M. Molière*—
the company became convinced that only a film could adequately seize
the specificity of actor/director/playwright Molière in his own time,
and Ariane Mnouchkine took six months to prepare a shooting script.
As in *1789,* Soleil played a theater company, and as the earlier produc-
tion undermined history primers, the Molière movie undermined liter-
ary history primers. The film traces Molière's progress from bourgeois
child to fairground actor to king's favorite, with an implicit question as
to whether it *is* progress.

Never believers in "Small Is Beautiful," the company built a seven-
teenth-century Paris street on the Cartoucherie grounds, and a seven-
teenth-century theater within its own playing space. (Knowing nothing
of the movie, I saw Molière's *Don Juan* at that theater, which made an
indelible physical impression on me—the discomfort of sitting on a
narrow board with poor sight lines, the odor of candle smoke, the back-
ground chatter competing with the stiff declamations from the stage.)

The Molière film became Mnouchkine's project rather than a collec-
tive endeavor, but, of course, she enlisted her colleagues, and each
member of the cast received about two hundred dollars a week. Running
some four hours, the film divides into Molière's childhood and pre-
Paris wandering, about which little is known, and his Paris years, for
which there is ample documentation. Most viewers prefer the first half,
with scenes so vivid that one comes to know intimately the inhabitants
of a bourgeois seventeenth-century household, the farceurs on the Pont
Neuf, the inhuman doctors and primitive remedies, the acting troupes
in the provinces sharing food with strangers, even when that food is the
flesh of one's horses. The film went far over its budget—about five
million dollars—and Mnouchkine was fortunate to be bailed out by
Claude Lelouch, German Cinema, and American Educational Televi-
sion. Ingmar Bergman saw the film twice, sending orchids to Mnouch-
kine.

Mnouchkine rests neither on laurels nor orchids. In 1979 the Théâtre
du Soleil followed a path of other sixties groups in returning to texts,
but Soleil's text was adapted by Mnouchkine from Klaus Mann's novel
Mephisto, an adaptation for which she learned German and which she

acknowledges in the published text. Not only was it a return to texts, but after the lavish theatricality of recent Cartoucherie productions, it was a return to the sobriety of the company's origins in *Les Petits bourgeois.* And it was graphic in theme—the impact of fascism on artists.

Klaus Mann wrote *Mephisto* in 1936 after he fled Nazi Germany. Subtitled *The Story of a Career,* Mann's book indicts his former lover and brother-in-law Gustaf Gründgens, whose greatest role was Mephisto in Goethe's *Faust.* The novel was not published until 1965, after the death of Gründgens, but his heirs brought suit against the publisher. The novel was banned in West Germany when Soleil insisted on selling it during its Munich performances.[2]

As created at the Cartoucherie, *Mephisto* is almost conventional in seating the audience on benches, but all four sides of the long room contribute to the environment. In front of the audience in rows of benches is a large, opulent proscenium stage, replete with red velvet curtains and marble columns. Behind the audience rows is a bright, makeshift cabaret curtain. On the left wall is a monumental battle scene with German officers in full regalia. The right wall is marked off by a barbed-wire fence. But the audience benches have movable backs; the audience can face the large stage or, shifting backs and changing benches, the small cabaret stage.

Mnouchkine's adaptation is faithful to the main line of Mann's novel, while clarifying details, condensing time, and eliminating minor characters.[3] The Soleil action follows three main characters—ambitious actor Hendrik Höfgen, Communist actor Otto Ulrich (another portrait à clef), and Fascist actor Hans Miklas. Other characters are based on members of the Mann family and the artistic milieu of the Weimar Republic. The first half of Mnouchkine's play is set in the heady climate of the twenties, with political clouds in the distance. We switch focus from the Hamburg State Theater to the midnight cabaret with its left-wing satire, for which Erika Mann actually wrote skits. This half of the performance closes on the Mann family reciting the final lines from Chekhov's *Cherry Orchard*—their way of predicting the destruction of their civilization.

The second half of Soleil's *Mephisto* takes place a decade later, with the Nazis in power. The cabaret has vanished and we are relentlessly fixed to the main stage, where we witness characters being spied upon, arrested, murdered, driven to suicide. Determinedly blind to these events, the actor Höfgen becomes the darling of those in power. He never joins the Nazi party and he sometimes helps former colleagues hunted racially or politically, but his single-minded ambition accommo-

dates itself to power. His excuse is the last sentence spoken in the novel as in the play: "I'm only an actor." But after the velvet curtain is lowered on the proscenium stage, projections appear on the right wall behind its barbed wire—the names of artists whom the Nazis destroyed, a long list of names with a terse statement on how each one died. The list ends with the suicide of Klaus Mann in 1949 in exile.

By coincidence Hungarian filmmaker Istvan Szabo based a movie on Mann's novel. In linear fashion, Szabo traces the career of Höfgen, rendering him "more ambivalent so that the audience could identify with him on occasions and thus be more deeply moved by the contempt which we feel towards him when he becomes a fascist mouthpiece," in the director's own words.[4] As played mercurially by Klaus Maria Brandauer, Szabo's Mephisto is a tantalizing creature, but I felt neither identification nor contempt for this able actor who permitted events to rule his life. In Szabo's striking filmic end, Mephisto is summoned by the Göring character to Berlin's Olympic Stadium. He is ordered to pick his way through the dark, empty rows of the amphitheater until he is impaled on a cross of powerful searchlights. Bleached and blinded, he cries out: "What do you want of me? I'm only an actor." And so pitifully is—in the film.

The West German government felt no embarrassment at backing Szabo's film, whereas the Théâtre du Soleil played in Munich despite the active discouragement of West German and French diplomatic officials. In France and abroad Soleil played *Mephisto* to sometimes hostile audiences in this period when the Nazi past is being reviewed with oily and indulgent eyes. Mnouchkine has spoken out publicly: "People are surprised that we couldn't find a more flamboyant and seductive form to tell such a sombre story. I wonder whether they understand what story we are telling?"[5] (In French *histoire* means both story and history.) It is a story of theater people and how they behave under a despotic regime. Soleil has been scrupulous about marrying a particular story to a particular form, and this story seemed to the company most deeply understood in a formal theater, whose four walls could also designate a prison or a coffin.

A filmmaker's daughter who has herself made two films, Mnouchkine has devoted most of her adult life to theater, an art that examines historical events through story and live performance. What could be more inevitable than her arrival at Shakespeare's history plays? Although earlier Soleil publications do not acknowledge Mnouchkine as playwright, *Richard II* and *Henry IV* state: "Traduction Ariane Mnouchkine."

Notes

1. These are my generalizations based on eavesdropping at the performance.

2. This information relies mainly on the informative Royal Shakespeare Company program for the Timberlake Wertenbaker English translation of *Mephisto*, which played at the Barbican Theatre in London in 1986.

3. See Bernard Dort, "Le Théâtre du soleil à l'âge d'acier," *Théâtre/public* 31 (1980), 51–57, and Wolfgang Sohlich, "The Théâtre du Soleil's *Mephisto* and the Problematics of Political Theatre," *Theatre Journal* 38, no. 2 (May 1986), 137–53.

4. Quoted by Martyn Auty, "A Fascist Faust," *Time Out,* November 6–12, 1981, p. 22.

5. Quoted by Hervé Guibert, "A qui appartient l'histoire?" *Le Monde,* June 19, 1980, p. 21. My translation.

Benmussa's Adaptations: Unauthorized Texts from Elsewhere

Elin Diamond

When Simone Benmussa's *Appearances* was published in *Gambit* (1980), the lead editorial attempted to account for her success in a British theater that traditionally "dislike[s] . . . subtlety and theorizing." The article continued: "Simone Benmussa has broken through in Britain, not because she is a good writer (all her plays so far have been adaptations of the literary material of others), but because she is a superb director with a personality that makes good actors want to work with her."[1] Leaving aside the uncertain connection between superb direction and "personality," I am interested in the assumption underlying the first part of this statement: the opposition between authoring and adapting, the former signifying authentic creativity, the latter its mere simulacrum, and the more general distinction between writing and directing. I would suggest that Simone Benmussa's theater, her adaptations and productions, both interrogate and collapse these categories. Her process of adapting "the literary material of others" is never ideologically innocent but rather functions as a critique of that material, and her directing aims at the density of writing, with the effect that spectating becomes a kind of reading, an activity of self-conscious interpretation. This essay will focus on Benmussa's *Appearances,* her adaptation of Henry James' tale "The Private Life," but much of what I have to say applies to her adaptation/direction of Hélène Cixous' *Portrait of Dora,* of George Moore's "Albert Nobbs" (her *Singular Life of Albert Nobbs*), and of Nathalie Sarraute's *Childhood.*[2] All Benmussa's adaptations involve a critique of image-making systems, particularly in the signifying of female experience. All involve an interrogation of the place of the text in what she calls the "great edifying and reproducing machines"—the collusion of theater and representation.

Most Western theater is, of course, in the business of representation—of turning living beings, objects, and other stage elements into readable signs. While representation in the theater may be inescapable, Benmussa's particular *écriture théâtrale* belongs to the post-Derridean moment in which textual authority and the sovereign subject have been relentlessly attacked. Derrida's *Dissemination* links representation to mimesis and Plato's abhorrence of the false copy, that which undermines its absent original. The presence-absence binary in the distinction between "being-present" and "appearance"[3] is inseparable from "the order of truth":[4] "what is imitated is more real, more essential, more true . . . than what imitates."[5] Thus, while Platonic representation is a false double, a falling off from full presence, it is also the condition that assumes originary presence and, by extension, transcendent authority. As Paul de Man puts it, representation "conceived as imitation . . . confirms rather than undermines the plenitude of the represented entity."[6]

For Derrida, the equation of authentic being with presence grounds Western thought from Plato through Saussure (and beyond), and accounts for the privileging of speech over writing. The act of speaking not only affirms the presence (truth, reality) of the self to the speaker, it establishes the speaker as the origin of her or his own representations. Representation presupposes, then, not only an absent referent, a truthful source that can be copied, but also a stable knowing subject who can authorize meaning. Hence, the identity in contemporary critical discourse between representation and the act of invoking authority, claiming mastery. It is the putting into view of one version of experience while excluding, repressing, appropriating, or erasing all possible others.[7] French women theorists (we call them "French feminists") often stake their analysis of patriarchy and "otherness" in a critique of representation. Luce Irigaray, through her Lacanian reading of Freud, ties representation to phallomorphism, "the *one* of form, of the individual, of the (male) sexual organ": what the culture sees—what is put in view—is the reproduction of the male, the assertion of phallic law (see note).[8] This tyranny of the single and the specular also underlies Roland Barthes' trope for representation: the theatrical tableau that cuts off, frames an image, whose "point of meaning is always the Law."[9]

Conventional theater (Benmussa's "reproducing machine") enforces the law of representation by mystifying its own signifying practices. In what Derrida calls the "theological" space of representation,[10] actors establish self-presence—not to mention identity and gender—through speech and gesture, the authority for which is the absent god: the

author. That is, actors enter a discursive space, the space of the author's text, but pretend they have invented it—crudely analogous to the human subject who enters and is structured by the signifying practices of culture, but who imagines that she controls her own meanings and messages. The seeming spontaneity of the actor's speech masks the authority of the text; indeed, most theater dissimulates that authority, for isn't the goal of performance to mark itself as immediate, present, what's happening now?

Laying siege to the representation apparatus and the illusionism that fuels it, Brecht argues that a unitary vision dominates theater writing and subdues the creative authority of the spectator: "This way of subordinating everything to a single idea, this passion for propelling the spectator along a single track where he can look neither right nor left, up nor down. . . ."[11] Brecht appropriates the mechanisms of representation—the gestic tableau, for example—but injects contradiction, opposition, and estrangement into the writing and acting of his epic theater. This undermining of audience passivity constitutes Brecht's greatest contribution to the understanding of the processes of representation: simply, in his smoker's theater, wide-awake spectators are empowered, at least theoretically, to see *through* theatrical mystifications and, by extension, through the mystifications of political institutions and of history itself. However, epic theater does not, cannot do away with the illusionism built into theatrical representation. As Herbert Blau puts it: "Brecht . . . tries to dispel the mystery in performance by looking at it from a distance, while not at all depreciating just how stubborn the mystery is."[12]

Simone Benmussa's theater revels in the mysteries and pleasures of illusionism even as she queries its processes. Her work is not a rejection of the theater of representation but a reading of it—to be explicit, an adaptation of it. To adapt (from *adaptare,* "to make fit") refers to an arrangement between unequal partners, the original work, which is fully present, and its adaptation, that which modifies the original "to fit" a new medium. The adaptation exists independently, but never replaces the original—the French *adapté d'après* marks the temporal spacing between the two. The text of adaptation, then, as Brecht well knew, dismantles the presumption of textual authority. But Benmussa goes further: she insists on her belatedness. In *Appearances,* for example, whole passages from Henry James' "Private Life" occur not only in the dialogue of the characters but in the italicized stage directions, conventionally the space where the author speaks directly to the reader. Who, then, is the author?

In Benmussa's text authorship loses authority; the single becomes double, a scandalous hybrid. Moreover, rather than masking the authority of her model, Benmussa playfully deconstructs it. That is, she dismantles the presence-absence binary (which assures the power of the absent author) by putting the author's name in circulation. "Henry James" appears as a character in *Appearances;* an unseen voice called "George Moore" penetrates and directs the action in *The Singular Life of Albert Nobbs;* "Freud" moves through Dora's painful dream world in *Portrait of Dora;* and the recorded voice of Nathalie Sarraute becomes the interlocutor for the actress who embodies one of the narrative voices of *Childhood.* A Benmussa production dramatizes its belatedness; it is always already a deferral from the immediacy of an original, never a copy of it. If representation is tied to the reproduction of the same, adaptation, by definition, proposes difference and deferral—and, consequently, alternative modes of theatrical inscription.

Specifically, within the space of representation, the space she cannot leave, Benmussa effects a textuality that breaks down the boundaries between script and performance, thus freeing the signifiers (words, gestures, sounds, etc.) that in both forms have congealed into conventional signifieds. In her detailed introduction to *Benmussa Directs,* Benmussa explores this point and its implications:

> I thought it would be interesting to start with a text that was not theatrical, as it would enable us to avoid the habitual theatrical joke that constricts the actor's freedom and forces them to keep on the rails of theatrical language. The text came from elsewhere. If this kind of theater is to succeed in upsetting the everyday, restrictive ordering of space and time imposed on us by the powers that be, then it must exist and assert itself as political theater. It is radically opposed to the great edifying and reproducing machines that we see all around us at the moment.[13]

The foreignness of the adapted text, the fact that it is from the "elsewhere" of prose, with its own literary history, its innocence from theatrical signification, frees the theater worker from "pre-established structure."[14] More importantly for Benmussa, the anterior text "keep[s] its tone of something coming from the exterior."[15] By retaining the sense of exteriority, even as she transgresses boundaries, Benmussa achieves an intertextuality that "radically oppose[s]" the mechanisms of the "great edifying and reproducing machines" of traditional theater and other media. Offering "truthful" representations of human experience, these image-making systems invariably flatten difference; to oppose

them, Benmussa says, is to create a "political theater." To be sure, Benmussa's adaptation exists within the reproducing apparatus, within the theater of representation, but the adaptation is intentionally un-stable, un-authorized, penetrated at all levels by the knowledge and authority of other texts.

Using texts from "elsewhere," Benmussa herself remains elsewhere, a "place" French theorist Luce Irigaray valorizes in "The Power of Dis-course." Given that patriarchal thought tends to "reduce all others to the economy of the Same [the self-representing masculine subject]," women need "to listen (psycho)analytically to its [philosophy's] pro-cedures of repression, to the structuration of language that shores up its representations, separating the true from the false, the meaningful from the meaningless."[16] The strategy for the female inserting herself into patriarchal discourse is, for Irigaray, "mimicry," a "playful repeti-tion" which might uncover "a possible operation of the feminine in lan-guage." What makes this a tantalizing proposition is that feminine mimics can repeat without becoming recuperated. Says Irigaray: "They also remain elsewhere."[17]

Benmussa's adaptations might be called subversive mimicries of the tightly woven discourses of representation. In a carefully written perfor-mance text of light, sound, image, word, and gesture, she dislodges the actor from her "character," time from chronology, and space from its bondage to the present. Her actors seem to move through a dense medium, embodied at one moment, then blurred; they appear, leave traces and visual echoes, then disappear before reappearing once more. Interestingly, the opening lines of the passage from which I have been quoting indicate the degree to which Benmussa herself has been listening "(psycho)analytically" to the discourses of representation:

> The stage is the reflecting surface of a dream, of a deferred dream. It is the meeting place of the desires which can only make signals to us and which, although deformed and interwoven, both accumulate and cancel each other out as they succeed one another, change their medium, pass from word to gesture, and from image to body. It is through this kind of arithmetic which, though precise, yet contains a multiplicity of heterogeneous elements, that we must be shown the "obviousness" of something that is not there. . . . I sometimes show certain details just as they are: a prop, a hand, or a profile. . . . They concentrate a desire very powerfully, but they create around them a nebulous zone which allows the spectator to divine the other, distant, ever-widening circles in which other desires are lying in wait.[18]

The "obviousness" of something that is not there (the quotation marks refer to a comment by Freud) recalls the teeming domain of the unconscious which is there and not there in the deferred, scrambled, and fragmentary writing of dreams, jokes, and slips of the tongue. The hand, the profile are like the "nodal points" in Freudian dreamwork, on which an indeterminate number of dream elements converge,[19] and by such image fragments the spectator follows the traces of unrepresentable desire. In Benmussa's theater, the awareness of "reading" visual and verbal traces becomes an integral part of spectatorship. The introduction to *Benmussa Directs* refers constantly not to the truth of performance but to the complexity of reading and writing. The "levels of memory, of the real, of the dream, and of fantasy" in *Portrait of Dora* "must always remain readable"; moments must be "legible."[20] But this readable performance text is not, as Barthes would say, "readerly"; it does not close on a signified. Rather, the movement of the signifier in Benmussa's text, as in Barthes' text, can be understood only in its "connections, overlappings, and variations."[21]

In the textuality of her productions, with their "nebulous zones" and oscillating desires, Benmussa's adaptations both focus on and make problematic a particular cultural and historical moment: bourgeois society from the midnineteenth to the first decade of the twentieth century, when social awareness of the "new woman" converged with the new science of psychoanalysis, and when the technologies of photography and film would soon suggest new ways of reading and expressing human desire. Often using filmic projections as metaphors for memories and unconscious processes, Benmussa attends particularly to the shifting ground of female experience during this period—the frustrated and misguided desires of Dora and Albert Nobbs, imprisoned in patriarchal self-definitions; the child/woman's acts of memory in *Childhood;* and for the actress Blanche Adney in *Appearances,* the lure of the "great part," which beckons but remains elsewhere.

Appearances

It is not difficult to understand Benmussa's attraction to Henry James' "Private Life," one of his "ghost stories" set in a resort in the Swiss Alps where a small company of artists and aristocrats have gathered. Written in the first person, the story is filtered through the consciousness of one of the party, an unsuccessful writer who, with the help of an

actress in the party, makes an alarming and exciting discovery. The writer whom all admire, Clarence Vawdrey (modeled after Robert Browning), has a ghostly double, a shadowy projection of his powerful imagination, who sits in the hotel room writing while his social incarnation, a likeable but banal society figure, takes tea and chats. In contrast to this "double" figure is Lord Bellifont (modeled after Sir Frederick Leighton), an urbane, witty aristocrat who is identical with his social performance: he has no being beyond the appearance he presents to the world and is virtually absent unless perceived. As the actress Blanche Adney puts it, "If Clare Vawdrey's double—and I'm bound to say I think the more of him the better—his lordship there has the opposite complaint: he isn't even whole."[22] The narrator summarizes this opposition in appropriately balanced syntax: "He [Lord Mellifont] was all public and had no corresponding private life, just as Clare Vawdrey was all private and had no corresponding public" (p. 246). In a crucial scene, the narrator entertains the Vawdry of public life while Blanche visits the embodied imagination, hoping that in his new play he will give her her "great part," one "truer to the conditions that lay near her" (p. 248). However, the reader is not permitted to witness Blanche's interview with the ghostly Vawdrey, but remains instead with the frustrated narrator and the social Vawdrey. The "real" Vawdrey, whom the narrator admires and admits loving, is, though present, absent; the social version is a poor simulacrum, an adaptation to fit the medium of social relations. What Blanche experiences offstage, out of the representational frame, would seem to be something like unmediated presence, the longed-for contact with the creator. When she is reunited with the narrator, she exults as though transfigured: "He saw me!" However, her exquisite new identity comes to nothing. The narrator closes Blanche's story with studied insouciance: "He finished his play, which she produced. I must add that she is still nevertheless in want of the great part" (p. 266). He then goes on ruefully to imagine himself in the greater writer's shoes: "I've a beautiful one in my head, but she doesn't come to see me to stir me up about it. Lady Mellifont always drops me a kind word when we meet, but that doesn't console me" (p. 266).

James' narrator would seem to be one of his "lucid reflectors" whose account and interpretation of the events become the reader's experience of the fiction. It is in the activity of the narrator's perception that the action or, as James would say, the "drama" takes place: "To lift our subject out of the sphere of anecdote and place it in the sphere of drama, liberally considered, to give it a dignity by extracting its finest importance, causing its parts to flower together into some splendid

special sense, we supply it with a large lucid reflector, which we find only . . . in that mind and soul . . . that have at once the highest sensibility and the highest capacity, or that are, as we may call it, most admirably agitated."[23] To attain the "sphere of drama," to obtain the illusion of lived experience, James needs a "large lucid reflector" capable of powerful perception and subtle feeling or "admirable agitation." (James called Lambert Strether, the narrator of *The Ambassadors,* "a mirror verily of miraculous silver.")[24] The self-injunction throughout the prefaces to "Dramatize! Dramatize!" refers to the texture and intensity of perception. However, as Stephen Donadio suggests, there is an anxiety about authority in James' concept of the lucid reflector, for this "vessel of consciousness" might be presumed to possess total knowledge, and thus break the vessel of realism. Hence, James insists on the ultimate power of the author, claiming that

> a large part of the very source of interest for the artist . . . resides in the strong consciousness of seeing all for himself . . . there can be for him only one truth and one direction—the quarter in which his subject most completely expresses itself. The careful entertainment of how it shall do so, and the art of guiding it with consequent authority— since this sense of "authority" is for the master-builder the treasure of treasures, or at least the joy of joys—renews in the modern alchemist something like the old dream of the secret of life.[25]

What is fascinating is the degree to which James as authorial master builder smooths over the "admirable agitations" in his own text. In the preface to "The Private Life" (and other stories), he insists that the tale proceeds by "contrast and antithesis"[26] (between the double Vawdrey and the less-than-single Mellifont), and leaves the reader to sort through the predicament of his narrator, who displaces his homoerotic desire for Vawdrey into self-absorbed, pathetic flirtations with the actress Blanche Adney. However, as Virginia Woolf observed, the mystery of human desire is one of James' subjects in his ghost stories: "James's ghosts . . . have their origin within us. They are present whenever the significant overflows our powers of expressing it; whenever the ordinary appears ringed by the strange."[27] For James the ghost stories reveal not only the *sense* of the dead in the living but also, as he says in an earlier preface, "the nearer distances and the clearer mysteries, the marks and sign of a world we may reach over to as by making a long arm we grasp an object at the other end of our own table."[28]

These "nearer mysteries" that blind the authorial eye (of both James and his narrator), the layering of perception, the possibility of ghostly

appearance in the ordinary ringed by the strange—all these recall Benmussa's predilection for "the obviousness of what is not there," sensed but not seen at the end of the table. Neither present nor absent, James' ghosts will not be recuperated into representation, but like desire itself will haunt the space of consciousness and, in the most extreme (and inevitable?) scenario, lure it toward extinction. In her adaptation, Benmussa dismantles the antithesis that James keeps in place; in "The Private Life," Vawdrey is either all public or all private, and the story's title indicates that James privileges the creator over the social dilettante. By titling her text *Appearances,* Benmussa suggests that such oppositions may not obtain, or at least can be deferred by the "connections, overlappings, and variations" of theatrical writing.

Appearances opens with a self-reflexive nod to the practices of adaptation, writing, and reading: a Hollywood-style film projection shows a disembodied hand that opens a book, turns the first page, and then fades. Evidently, this theater piece about ghostly appearances comes from the "elsewhere" of prose and film, an elsewhere that provides no spatial or temporal markers; we are urged to contemplate and anticipate only the act of reading. The head waiter who doubles as stage manager emerges from the audience and manipulates in full view the theatrical paraphernalia of lights and sound, then parts venetian blinds revealing characters in realistic Edwardian dress gazing at a painted diorama of the Swiss Alps. (Interestingly, the slats of the blinds open both vertically and horizontally: the first stage image, then, is of dismembered bodies, a visual echo of the filmic hand. But when the blinds are raised completely, the characters become whole, representation in full operation.) This multimedia opening produces an unstable if readable layering of "reality": the head waiter, in Pirandellian fashion, merges the audience area with the privileged space of illusion; presumably, he is more real than the characters, who in turn are more real than the painted landscape. Yet in their opening lines the characters refer to the freshness of the air, the color of the scenery, and how "human" they feel.[29] With referentiality thus elided or mocked, Benmussa produces the theatrical version of what James calls the "thickness of human consciousness."[30] That is, the spectator's perception assumes the density of a Jamesian narrator's perspective as she reads the textural messages in the first seconds of the play.

Of course, this reading includes the deliberate representation of someone called "Henry James." No longer an unseen presence, "James" in Benmussa's hands becomes an instance of textuality no more or less substantial than the *"sound of cowbells . . . heard in the distance."*

Failed playwright in life, he rehearses that same failure in Benmussa's play, but she wreaks other havoc with the concept of authorship. Benmussa (or the translator? the editor? the printer?) consistently misattributes the title of James' story, not "The Private Life" but "A Private Life." More intriguingly, she doubles the presence of James' works. *Appearances* contains not one but *two* James stories: the second, a true ghost text, appears without warning or citation inside the adaptation of the first. As the characters assemble for dinner, Lord Mellifont begins to tell a story about a man and a woman who have both seen ghosts and through his agency try to meet. He leaves his story unfinished, though he resumes the telling later on. This narrative fragment comes not from "The Private Life" but from "A Friend of the Friends," which is anthologized in the same volume of the New York edition. Did that cinematographic hand of the opening depict Benmussa herself leafing through volume 17? The stage image reinforcing this sleight of hand is a lit revolving table in which Lord Mellifont and his listeners appear and disappear one by one, like the ghosts of the stories and the fragments of James' writing. A passing servant offers echoic commentary on sliding texts and textual doubles: "Could Mr. James have been born twice?" (p. 23).

Adaptation permits Benmussa another crucial change. The double Clarence Vawdry (with the bilingual punning on "clear" in the first name and the French *vaudrait,* "could be worth," in the second) is renamed Clarence Dorimont, recalling the Restoration gallant in Etherege's *Man of Mode* and a period in theatrical history known for its love of artifice and dissimulation. James' writer-character becomes an instance of intertextuality, not just the double in the diegesis but doubled again in the text of theater history.

Adapting the scene that reveals Vawdrey's double life, Benmussa gestures again at her own theatrical writing. When her "Henry James" discovers the ghostly Dorimont writing at his table, he can see (as James' narrator cannot) the other Dorimont standing on the terrace with Blanche. The perspectives are deliberately confusing here. Blanche on the terrace wears a man's overcoat which causes her to resemble the man to whom she speaks, and that same man at the writing table is only faintly backlit by a passing maid holding a light. Appearances are deceiving, but the stage directions state that *"we can see"* both Dorimonts, the writer and the "character."

The binary opposition of creator versus gentleman, with its implied valorization of the genius author, breaks down in Benmussa's adaptation, for her writer assumes no authority over his "other self." Rather,

as doubles they are simultaneously characters and instances of writing, both part of the illusionism of the theater. When James apologizes for disturbing the shadowy figure, Benmussa draws attention once again to her own writing: "I thought you were elsewhere" (p. 23).

The indistinctness of the moment preserves the sense of nearer mysteries favored by both Benmussa and the historical Henry James. Not so the scenes with Lord Mellifont. If Dorimont is an unstable signifier oscillating between different appearances, Lord Mellifont is the static signified, representation itself. In other words, without spectators Lord Mellifont disappears, but framed by the regard of others he assumes the authority of perfect presence, as Benmussa says, "the perfect actor," or, as James' narrator puts it in proto-Derridean fashion, "a plenitude of presence." Neither James nor Benmussa takes a moral view of the lack of private self in this public character, yet both see the presence-absence opposition as a kind of death. When no longer performing, Lord Mellifont is "reabsorbed into the immensity of things," fully absent, but when fully present he assumes lordly authority, filling the stage, canceling out all others. Moreover, like the Creator, he is master of all he sees: "I select my point of view, and I take possession of it at the very moment I measure it with my pencil." When the storm clouds rise, Blanche's line clearly alludes to the Lord's omnipotence: "There was nothing to fear till your sketch was finished" (p. 38).

But the perfect performance, while it amuses Henry, enthralls Blanche, and in this she resembles other Benmussa females through whose experience the most perplexing questions of the plays are posed. In *Portrait of Dora,* Dora is both victimized by and subversive of what Benmussa calls the "united front of social class, of aestheticism and charm in which her family, their friends, and Freud live at this end of the nineteenth century."[31] Her "hysterical" mutterings and shrieks attack the smooth discourse of her elders, but, as Benmussa puts it, "she hasn't the theoretical means to *think* what she represents."[32] In *The Singular Life of Albert Nobbs,* the brutalities of Victorian patriarchy are carried out on the body of a woman who takes on the privilege of the male by dressing like one. Soon she cannot extricate herself from her performance; she is imprisoned in her costume and in culture—and in a "true" story narrated by an unsympathetic "George Moore."[33] Thus bound, Albert, like Dora, cannot *think* what the woman represents. Blanche Adney, as an actress, traffics in appearances and hovers on the edge of thinking through the predicament of her situation. Seeking the "great part," the one that will express her *true* self, she feels haunted by the prospect of merging with it. Lord Mellifont, having merged into the role

of perfect peer, suffers none of Blanche's anxieties since his particular "part" is identical with power and privilege. Significantly, when Lord Mellifont sketches the landscape, he copies a painting—representation reduced to mere reproduction, making Mellifont a resonant example of what Benmussa has called the "great edifying and reproducing machines" of culture.[34]

Blanche Adney's distress over loss of being echoes Albert Nobbs' predicament—a point Benmussa makes explicit when the actress who played Blanche (Susannah York) makes reference to her playing the character of Albert Nobbs:

> The more perfect the performance, the more you run the risk of your own disappearance. (*Pause*). Do you know, Henry, that I once played the part of a woman, who, in order to earn her living, dressed as a man, as a head-waiter? It was a true story. (p. 39)

This is more than coy self-reflexiveness on the part of a director who frequently works with the same actors. Benmussa needs to borrow a bit of the feminist vision of *Albert Nobbs* to show that Blanche's fear of extinction is a function not only of her chosen profession but of her gender. The issues and vocabulary of theater reflect the larger arrangements of culture; in fact, they mimic them: "the edifying and reproducing machines *that we see all around us*" (my italics). Blanche understands, or at least suspects, that ideal representations are the stuff of these reproducing machines, and while Lord Mellifont controls his representations, she herself could not. In Lacanian terms, she lacks the necessary biological "part," that which she could exchange for phallic power.[35] The part she desires, her "true self," belongs to the apparatus of representation which she will never control. She may find herself in "a woman's story," but Dorimont, not she, will be telling it.

Blanche is the only principal character who is not textually doubled. Through most of the play she is the consistent representation of a character called Blanche Adney—until the actress who plays her is implicitly named. The Blanche–Susannah York doubling does more than comment on the illusionism of theater; it underlines the material conditions of that illusionism, the body of the performer. That a female character and actor should receive this double signification suggests that Benmussa remains as concerned here as she was in *Albert Nobbs* with the place of women in work and in representation.[36]

Blanche Adney's work as an actress brings her dangerously close to the reproducing machines of culture, but the "question" of her role is never answered; she leaves the stage. For "Henry James" Benmussa

assigns a different fate. The displacements of desire James adumbrates in "The Private Life" are eerily rerouted in Benmussa's adaptation: in the closing image "Henry," desiring Dorimont, becomes his exact copy. Sitting side by side with backs to the audience, the two men gesture at the same time and *we should suddenly imagine that they are identical* (p. 47). "Henry" has been absorbed into the reproducing machine. This last—and most concrete—image of male doubling refers back, as always, to the processes of representation. The copy, the sign of perfect repetition, shows us that representation remains intact. Should we be surprised, then, given Benmussa's unraveling of textual authority, given her subversive "feminine mimicry" of theater conventions, that at this point in the play Blanche Adney is elsewhere?

Notes

1. See unsigned editorial in *Gambit* (London: John Calder, 1980), p. 4.

2. Benmussa's theater work is as follows (titles, theaters, and dates from first French productions): *Portrait de Dora* (Hélène Cixous), Petit Orsay, 1976; *La Plage* (Severo Sarduy), Petit Orsay, 1977; *La Vie singulière d'Albert Nobbs* (Simone Benmussa, adapted from George Moore's "Albert Nobbs"), Petit Orsay, 1977; *Apparences* (Simone Benmussa, adapted from Henry James' "The Private Life"), Petit Orsay, 1979; *La Mort d'Ivan Illitch* (Simone Benmussa, adapted from Leo Tolstoy's "The Death of Ivan Ilyich"), Petit Rond-Point, 1981; *The Revolt* (Villiers de l'Isle d'Adam), London, 1979, 1980 (French production not known); *Virginia* (Edna O'Brien), Petit Rond-Point, 1981; *Caméra Oscura* (Simone Benmussa, adapted from Gertrude Stein's works), Petit Rond-Point, 1982; *Freshwater* (Virginia Woolf), Centre Georges Pompidou, 1982; *Enfance* (adapted from novel by Nathalie Sarraute), Théâtre du Rond-Point, 1984; *Le Vallon* (adapted from Agatha Christie's *The Hollow*), Théâtre Renaud-Barrault, 1988. Many of the above have toured to London and New York; many have been published in French. English translations exist only for *The Singular Life of Albert Nobbs* and *Portrait of Dora,* both available in *Benmussa Directs* (London: John Calder, 1979) and *Appearances* in *Gambit* (London: John Calder, 1980). (At last inquiry [January 1988], *Benmussa Directs* was out of print). Benmussa has for years edited the *Cahiers Renaud-Barrault* (Paris: Gallimard); a recent issue appeared in March/April 1988. She has directed a film, *Portrait d'écrivain: Nathalie Sarraute* (1978), and collaborated with Sarraute in *Nathalie Sarraute, Qui êtes-vous?: Conversations avec Simone Benmussa* (La Manufacture, 1987). Benmussa's first critical book, *Eugène Ionesco* (Seghers), appeared in 1966. She translated Edward Bond's *Lear* in collab-

oration with Marie-Claire Pasquier (Bourgois, 1974) and has published numerous articles. Her novel *Le Prince répète le prince* (Seuil) appeared in 1984. For more information on Simone Benmussa, see Ruby Cohn, "Benmussa's Planes," *Theater* 13, no. 1 (Winter 1981–82), 51–54.

3. Jacques Derrida, *Dissemination,* trans. Barbara Johnson (Chicago: University of Chicago Press, 1981), p. 191. See also Derrida's discussion in "The Theater of Cruelty and the Closure of Representation," in *Writing and Difference,* trans. Alan Bass (Chicago: University of Chicago Press, 1978), in which he conflates the German *Repräsentation, Vorstellung, Darstellung* in his discussion of Artaud's "nonrepresentation . . . i.e. the origin of representation." See also Derrida's more recent discussion, "Sending: On Representation," trans. Peter Caws and Mary Ann Caws, *Social Research* 49 (1982), 294–326; for a helpful summary of the political and critical implications of the representation debate, see Jonathan Arac's Introduction to *Postmodernism and Politics* (Minneapolis: University of Minnesoa Press, 1986), ix–xliii, especially xx–xxviii.

4. Derrida, *Dissemination,* p. 192.

5. Ibid., p. 191.

6. Paul de Man, *Blindness and Insight* (New York: Oxford University Press, 1971), p. 123.

7. See Alice A. Jardine's account of these theoretical debates in *Gynesis: Configurations of Woman and Modernity* (Ithaca, N.Y.: Cornell University Press, 1985), pp. 118–44ff.

8. Luce Irigaray, *This Sex Which Is Not One,* trans. Catherine Porter with Carolyn Burke (Ithaca, N.Y.: Cornell University Press, 1977), p. 26. See also Hélène Cixous and Catherine Clément, *The Newly Born Women* (*La Jeune Née*), trans. Betsy Wing (Minneapolis: University of Minnesota Press, 1986), particularly Cixous' "Sorties," in which she appropriates the Derridean binary opposition, with its repressive first term (identity/difference; speech/writing), to unveil the binaries underlying gender oppositions. Julia Kristeva, in "La Femme, ce n'est jamais ça," states that women, excluded from "the order of being," cannot enter representation. See excerpt from Kristeva in Elaine Marks and Isabelle de Courtivron, eds., *New French Feminisms* (New York: Schocken Books, 1981), pp. 137–38. For more on the idea of "phallic law," see n. 9.

9. Roland Barthes, *Image, Music, Text,* trans. Stephen Heath (New York: Hill and Wang, 1977), pp. 76–77. Barthes refers to the "Law," but he could also say the "power of the phallus" or the "Name-of-the-Father," all key terms in Jacques Lacan's theory of the symbolic order, that which structures gender identity and governs signification at all levels of cultural expression. Barthes and Irigaray are using Lacanian terms to insist on the phallic nature of any representational system.

10. Derrida, "The Theatre of Cruelty," p. 235.

11. Bertolt Brecht, *Brecht on Theatre,* ed. and trans. John Willett (New York: Hill and Wang, 1964), p. 44.

12. Herbert Blau, "Universals of Performance," in *Sub-Stance* 37/38 (1983), 152.

13. Benmussa, *Benmussa Directs*, pp. 10–11.

14. Ibid., p. 18.

15. Ibid.

16. Irigaray, *This Sex*, pp. 74, 75.

17. Ibid., p. 76.

18. Benmussa, *Benmussa Directs*, p. 9.

19. See Sigmund Freud, *The Interpretation of Dreams*, trans. James Strachey (New York: Avon, 1965), pp. 317–18.

20. Benmussa, *Benmussa Directs*, pp. 12, 15.

21. Barthes, *Image, Music, Text*, p. 158.

22. Henry James, "The Private Life," in *The Novels and Tales of Henry James*, vol. 17 (New York: Scribner's, 1961), p. 226. All story references in my text are to this edition.

23. Cited in Stephen Donadio, *Nietzsche, Henry James, and the Artistic Will* (New York: Oxford University Press, 1978), p. 123 (my ellipses). See also Henry James, *Notes on Novelists* (New York: Scribner's, 1916), pp. 405–6.

24. Henry James, Preface to *The Princess Casamassima*, in *The Art of the Novel* (New York: Scribner's, 1934), p. 70.

25. Henry James, Preface to *The Spoils of Poynton*, in *The Art of the Novel*, pp. 122–23.

26. James, *The Art of the Novel*, p. 251.

27. Virginia Woolf, "The Ghost Stories," *Henry James: A Collection of Critical Essays*, ed. Leon Edel (Englewood Cliffs, N.J.: Prentice-Hall, 1963), pp. 52–53.

28. James, *The Art of the Novel*, p. 164.

29. Simone Benmussa, *Appearances*, trans. Barbara Wright, in *Gambit* (1980), p. 23. All page references in my text are to this edition.

30. James, *The Art of the Novel*, p. 256.

31. Benmussa, *Benmussa Directs*, p. 14.

32. Ibid., p. 15.

33. See my article for an elaboration of this point: "Refusing the Romanticism of Identity: Narrative Interventions in Churchill, Benmussa, Duras," *Theatre Journal* 37, no. 3 (October 1985), 273–86. See also Sharon Willis, "Cixous's *Portrait of Dora:* The Unseen and the Un–scene," *Theatre Journal* 37, no. 3 (October 1985), 287–301.

34. Benmussa, *Benmussa Directs*, p. 11.

35. See Kaja Silverman's reading of Lacan's theory of the phallus, the female, and signification in *The Subject of Semiotics* (New York: Oxford University Press, 1983), pp. 185–86ff.

36. See Benmussa's comments about *Albert Nobbs* in *Benmussa Directs*, pp. 22–26.

The Reverse Side of a Portrait: The Dora of Freud and Cixous

Rosette C. Lamont

In *Fragment of the Analysis of a Case of Hysteria,* published by Sigmund Freud in 1905, we find the intriguing diagram of a detective novel or a movie script. Beneath a surface of professional detachment, the reader perceives at once the complex network of the investigator's emotions as he begins to decipher and translate the dream material entrusted to him. One also senses the uneasiness of an adult male confronted by the brimming sexuality of an eighteen-year-old girl. The latter, having been taken to Doctor Freud by her father when she experienced acute coughing and choking attacks, finds her malady impervious to treatment. Her symptoms (fits of coughing, aphonia, extreme lassitude, a mysterious limp) might not in themselves be serious were it not for extreme depression, culminating in a threat of suicide. The girl also formulates an ultimatum: a complete break in relations between her family and the K. family.

The patient's father claims not to understand either his daughter's demands nor her condition. He admits to the doctor that Ida's (Dora's real name) state might have been brought on by an imaginary incident dating two years back. At that time the young girl had accompanied her father to an alpine lake. They had gone to join Mr. and Mrs. K. and the couple's children. Ida was supposed to spend a few weeks with her parents' friends when, all of a sudden, she decided to cut her stay short and return home with her father. A while later she admitted to her mother that Mr. K. had made "a dishonest proposition" in the course of a stroll they had taken together. However, she failed to add that this was not the first time Mr. K. had behaved in this manner. In point of fact, he had attempted a seduction in his office, where he had lured the

Text translated by Adelia Williams. Quoted material translated by Rosette C. Lamont.

79

fourteen-year-old girl on the pretense of viewing a religious procession in the street below.

Four years earlier Freud had treated Ida's father for a semiparalysis, possibly caused by a venereal infection contracted before his marriage. Mr. Bauer (the girl's father) and the lovely Mrs. K. (his friend's wife and daughter's confidante) had become lovers. Such was the viper's knot hidden beneath the veneer of the bourgeois patriarchal order imposed upon a sensitive and highly intelligent young woman.

When Ida began treatment, she came under the influence of her doctor. She realized that he did not hesitate to turn his patient into a guinea pig for his experiment. Thus, she managed to maintain a distance between them to safeguard a zone of mystery. She resisted the process of transference, permanently blocking it off.

Having become impatient, in the full sense of the word (lacking patience and refusing to be treated), Ida eventually stopped her therapy. The haunting question "Was will das Weib?" ("What do women want?") remains unanswered. Feminist theoreticians view Dora's rejection of the process of analysis as an awareness of the patient's exploitation by the psychiatrist. The latter attempts to encircle and verbalize what should perhaps be perceived by instinct and sensitivity. In other words, two forms of learning confront one another: Mephistophelean reason and the art of sorcery. The power of Mephistopheles fails in the face of enchantment. The young woman dismissed her doctor, giving him two weeks' notice. Freud actually complained: "You're firing me as though I were a maid."

It was precisely when the analyst began to reach the deeply buried truth of Ida's adolescent bisexuality—the ambiguous nature of her love-hate feelings in regard to Mrs. K.—that the girl fled. Was her escape triggered by the emergence of something she was hiding from herself, or by her horror of being observed and judged? What is clear today is that, by interrupting her analysis, Ida blocked access to the reverse side of the picture. In fact, it could be said that she protected the hidden face at the price of her own moral and physical suffering.

Freud's Dora has become a heroine of new feminist criticism. The latter proposes to reveal the true Ida, the victim of a decayed, corrupt society which demanded that she bend to a vitiated, vicious order. In his introduction to *Dora: An Analysis of a Case of Hysteria,* Philip Rieff makes the following statement: "Freud bypassed the patient's insight into the rot of her human environment as part of the misleading obvious, when it was . . . the most important single fact of the matter; he suspected her insight as an instrument of her neurosis instead of as the

promise of her cure. Years later, still unable to brook disagreement, Freud was to call this tenacious and most promising of all forms of resistance 'intellectual opposition.' "[1] Indeed, what could be more unusual and provocative at the turn of the century than a woman possessing intellectual independence and fine judgment? For a girl of a so-called good famliy background, these traits of character constituted scandalous behavior.

For feminist theoreticians Freud is guilty in that he considers women solely from a male, patriarchal point of view. Not being lawmakers or lawgivers in that society, women must remain essentially silent, passive. They are inferior creatures, lacking in the outward sign of male power, the scepter/phallus. Simone de Beauvoir makes a strong statement in regard to Freud's theory of the castration complex.

> The Freudians . . . assert that the castration complex is a given. I am utterly opposed to this idea. I have reread the most recent texts on the Freudian psychology of women (1964), which assume a subconscious penis envy on the part of the adolescent female. This idea that girls feel deprived, maimed, lacking in something essential is pure myth. It is a myth of Freud's invention. Yet Freud admitted that he understood next to nothing about women. . . . I consider him worthless in this field of study. This applies in fact to all Freudians, men and women alike.[2]

In the course of the above interview with Francis Jeanson, Simone de Beauvoir makes her viewpoint clear on more than one occasion. For her Freudianism is the product of a particular man, himself shaped by a reactionary society. She recalls, for example, that he did not grant his wife permission to ice-skate for fear her ankles would show. Beauvoir's most ardent wish is "that in the future women will take over the psychoanalysis of their own sex, but not along the traditional Freudian lines of docility."[3]

In expectation of the development of this anti-Freudian movement in the field of psychoanalysis, some feminists have pored over the Dora case and given it a new reading. In the theater a work has emerged which is a model for this kind of reassessment, namely, Hélène Cixous' play *Portrait of Dora*.

Who was this Ida whom Freud was to call Dora "for reasons of professional discretion"? And why this pseudonym chosen from among many possible names?

Ida was the daughter of a wealthy Austrian industrialist, Philip

Bauer. Refined and cultured, her father was, however, in poor health. He was suffering from sequelae of a venereal disease, a touch of tuberculosis, a detached retina, and a series of anxiety attacks which had culminated in a nervous breakdown. It is perhaps not surprising that Ida's mother had become over the years a shrewish, bitter wife. Her sense of inadequacy was reflected in a mania for polishing furniture which, although a perfectly acceptable bourgeois activity, expresses with eloquent muteness irrational feelings of guilt, a desire to wipe off the stain of a tainted body. Nor did the woman's assiduous visits to the spas in vogue succeed in curing her. She passed on her hidden anxiety to her daughter, who was expected to accompany her mother to these thermal treatments. Ida began to complain of abdominal pains and a suspicious vaginal discharge.

In itself Ida/Dora's story is a banal, turn-of-the-century situation: a cuckolded husband finds some excitement and consolation in the company of his closest friend's pubescent daughter. There were also two governesses (one per family), both of whom were in love with their respective employers. Two wives complete the picture, one half mad, the other ill at first, then able to regain some strength and health with the acquisition of a measure of independence. The scenario could be drawn from a Henry Bernstein play were it not for the sordid touches redolent of Strindberg and Schnitzler.

As to Ida, she was no pure, timid virgin. Her bedside books were treatises on sexuality borrowed from Frau K.'s private library. Moreover, the intimate secrets the lovely Mrs. K. had whispered into her young confidante's ear had impressed fiery images upon the theoretical subject matter of Mantegazza's text. The young Viennese girl found herself amply informed not merely about "normal" relations between men and women but about a good number of "variations" as well. The analyst found himself facing a deeply troubled yet strangely wise girl. Nothing seemed to surprise her. She was able to read between the lines of the questions raised by the doctor. In addition, it became clear that these verbalizations of the events served further to awaken her sensuality. In fact, as Ida came to realize that the spoken word could be a powerful sexual instrument, the relationship between analyst and analysand grew increasingly ambivalent. It is Freud who, in these pages, appears to be blind to the shifting boundaries between himself and his patient.

Another curious feature of the Dora case lies in Ida's willingness to compare herself to governesses and servants. She spends time looking after Herr K.'s children. Could this activity be attributed to her sup-

pressed love for their father, as the learned physician suggests? Or does the girl identify with Frau K., who, however, neglects her progeny?

Freud believed that he had discovered in Dora a hidden desire to bear K.'s children. In fact, the patient tells him of her imaginary appendicitis attack, shortly after the death of her favorite aunt and exactly nine months after the abortive seduction at the lake. Even when the abdominal pain has subsided, Ida continues to feel a cramp in her right leg and develops a limp. For her psychiatrist these are telltale signs: a lame woman is a tainted being, guilty of a "faux pas." Thus, Freud suggests that Ida actually longed for the seduction to have taken place, including its possible consequence: conception. The imaginary appendicitis and the accompanying abdominal pains would in this case constitute the hysterical body language of a woman in the throes of a fantasized pregnancy. Yet, to demean herself in this manner, to allow a married man to have his way, could hardly be called appropriate behavior for a girl from a respectable family. It is, in fact, the typical behavior of a household servant.

It was the K. family's governess who had behaved in such a manner. She yielded to her employer's advances and became pregnant by him. Rejected by her indignant parents, she was dismissed by her seducer, who had tired of her. Why then should Ida, who was aware that the very terms of Mr. K.'s proposition were couched in the terms he had used to lure the governess ("You know that I no longer get anything from my wife"), contrive to play the nanny? During the period she assumed this role, her own father had become Frau K.'s lover.

A feminist rereading of the Dora case allows us to see aspects which escaped Freud himself. On the one hand, Ida declares, both by her conduct and by the words she uses, that servitude is the very essence of the female condition in her society. While outwardly indignant at being treated like a maidservant, she assumes the role of the humble creature subjugated by her employer. Later, she will take her revenge by dismissing her analyst "like a maid." In the meanwhile, Ida dreams that her mother has written her to inform her of her father's death and to urge her to come home at once. This dream is the reverse image of the servant's reality; unlike the pregnant governess, Ida can return home.

Strangely enough, Freud seems to enter into Dora's game when he elaborates the notion of woman's acquiescence to the condition of servitude. The pseudonym chosen for Ida happens to be that of his sister's nursemaid, Rose. Since Freud's sister was called Rosa, the family decided to avoid any possible confusion—a distasteful one at that since the similarity between the two names bridged the gap between the social

classes—by renaming the servant Dora. Thus, if one called for Rosa, only the family's daughter would respond. New feminist criticism provides an interesting interpretation of the psychiatrist's choice of the name Dora for Ida Bauer. It views it as a readiness to equate the female gender with servility.

Freud assumed that his patient would behave like a proper bourgeois "young lady." This meant that she had to accept her inferior situation as patient, as a sick female, within the confines of his office. Her subservient role would only be an extension of the one she played within her parents' home, or even in that of her parents' friends. Beneath the declared motive of professional discretion—masking Ida Bauer's identity—a hidden impulse can perhaps be detected. In Freud's Vienna, indeed in all of Western culture, men had the double power to confer a name or conjure it away. Women had no name other than the one they received at birth from their father, relinquishing it only to assume that of their husband. Today's feminists say that the name was a mask placed over a woman's face; it made of her existence an eternal disguise. What's in a name? An independent person's identity. Depriving a woman of her name is a way of displacing her identity, indeed of effacing it altogether.

The question that arises as one studies the Dora case has to do with Freud's deep-seated ambivalence. Did the learned physician desire, in fact, to free his patient, or might he not have been intent on pursuing at all cost his study of what Anna O. called "the talking cure"? According to the method instituted by Breuer and Freud, the verbalization of a pathogenic event was supposed to release one or more symptoms constituting the state of hysteria. It was less a matter of arriving at the truth than of reaching the patient's particular truth, his or her view of the sequence of events. Thus, the psychiatrist's approach was reminiscent from the start of that of the poet, the novelist, the creative artist. The spoken word gave birth to a subjective verity while, in turn, the subject was gradually restructured through discourse. The psychiatrist's task was to maintain a strictly neutral position in order to guide the patient's progress. As to the analysand, he or she projected the past as a succession of rapidly shifting images and apprehensions arising on the spiral of a constantly evolving construct of words.

Initially, Dora appeared to be the ideal analysand. Her quick intelligence, her rich dream life, and her straightforwardness were the perfect combination for a starring role on the private stage of the psychoanalyst's office. However, despite an auspicious start, something went wrong. Dora withdrew, depriving her doctor of the triumph he was certain of reaching: the completion of the process of transference. Feeling

betrayed, Freud would later accuse himself of having failed to implement the process in time. The Dora case remained for him a puzzle both on the personal and professional levels. As René Major explains in *Rêver l'autre,* "by thwarting the immediate success with which the Master could win acceptance from his colleagues and the scientific world at large, Dora, who was to remain unknowable, raised her condition to a heroic level. She became the inspiration for a series of developments in psychoanalytic theory, starting with those dealing with the process of transference, and going on to the split within the subject."[4] By virtue of her curt dismissal of her analyst, the young woman tied the latter's destiny to her own.

Fragments of the Analysis proves to be a highly revealing text. The reader grows aware of Freud's identification with two male contemporaries: the girl's father, who brought her in for treatment, and Herr K., who had advised Philip Bauer to make this move. Thus, three older men are joined together over the body and mind of a young girl. They pass this submissive body from one to another, as though tossing an inanimate object, a thing to be transacted. In Doctor Freud's office this body seems to be at last in a safe place as it lies upon a couch, abandoning itself in order to be healed, set free. Yet this security is an illusion, one that the sensitive young woman will quickly demystify. Freud's own account of this scientific adventure pulsates with an underlying erotic drive. Perhaps no one decoded it more clearly than the French analyst Jacques Lacan in his "Intervention sur le transfert": "As to Dora, her personal involvement in the interest she inspires is made obvious in numerous parts of the text. She makes it vibrate in such a way that it transcends theoretical considerations. The classically tragic rhythm of the account raises it to the level of Madame de Lafayette's seventeenth century novel, *La Princesse de Clèves.* It is as though the princess' confession to her husband were stifled by some infernal muzzle."[5]

Freud, as Lacan proclaims, identified too completely with Mr. K. A fourteen-year-old girl is not likely to consider a man her father's age as overwhelmingly seductive. Ida Bauer may have experienced a certain giddiness when faced with this determined, brutal man, but, as she maintains throughout her analysis, her feelings were mostly a justified disgust. Increasingly, Ida will resist her doctor's confident phallocentrism.

By cutting short her analysis, Ida gives her doctor a moral slap, not unlike the one she administered to Mr. K. following his proposition. This moral blow is also self-defeating, since she condemns herself to enduring the dyspnea which has been tormenting her. Yet in this fleet-

ing instant she enjoys to the full her position of command. Seen through the prism of the Hegelian master-slave relation, one could say that Ida is not afraid to affront a mortal danger which will bring about her own annihilation.

Ida/Dora will remain for Freud an insoluble enigma. René Major writes: "Hysteria offers the analyst the illusion of power. Yet this power will be wrested from him. He will be the victim of his prejudice and his desire to travel to the core of mystery. What is this mystery? It is that of femininity, or, if you prefer, bisexuality."[6]

How do we transcend these controversies over Freudian transference and countertransference? A new path lies in the direction of feminist criticism, particularly in its attempt to deal with the Dora case as literary text.

In her enjoyable and witty book *Les Fils de Freud sont fatigués,* Catherine Clément, a novelist and philosopher, demystifies psychoanalysis: "Nothing but words. All day they listen to words, and sometimes they deign to answer. They never address the matter which has just been exposed, but one that was brought up long ago. They have an astonishing and mysterious kind of memory. It is upon this memory that Freud rests his theory of the communication between the unconscious of the patient and that of the analyst."[7]

For Clément psychoanalysts are our new gurus, basking in the warm sunlight of chitchat. They write, give lectures, grant interviews, fabricate culture. Patients are nothing but a pretext, the pre-text of their own text. If men and women of letters write with a certain hesitation, psychoanalysts do not seem to suffer from any such hesitation. Speech and writing are their special preserve. Clément reproaches the entire tribe for failing to utter the word *happiness.* Psychoanalysts, she explains, aim to teach their patients to be reasonably happy, to transform their hysteria into acceptable behavior by accepting the permanence of human misery.

Official psychoanalytic practice is based on nonintervention. The patient must be transformed, yet his analyst is essentially an interpreter and a judge. This judge is at times a failed poet who substitutes for truth a myth of his own fabrication. In a recent and very comprehensive article, "Freud's Dora, Dora's Hysteria: The Negation of a Woman's Rebellion," Maria Ramas demonstrates why it is impossible for an analyst to view his patients objectively. She states:

My intention is not to use feminism to explain away the unconscious meaning of Dora's hysteria, or to deny psychoanalytic discoveries. I

will argue, however, that Freud's analysis is only partly true—intriguing fiction and flawed analysis—because it is structured around a phantasy of femininity and female sexuality that remains misunderstood, unconscious if you will. This phantasy continues to be an essential part of psychoanalytic explanations of hysteria, forcing the recognition that psychoanalysis is not simply the theory of the formation of gender identity and sexuality in patriarchal society, but is profoundly ideological as well.[8]

How can women escape this judgment whose very foundation seems immutable? How do they liberate themselves from the myth which imprisons them, or covers their faces with the Janus-faced mask of a madonna and a sorceress? Is it possible to find flaws in this discourse which indicts women, pins them like butterflies on display? Clément maintains that women must become thieves: thieves of thoughts, of terminology, of words. Little by little this stolen discourse will become their own, and they will be able to fly up. She writes: "Thief, until the word turns into its opposite without changing fundamentally: Thief, she who steals away."[9]

Hélène Cixous goes one step further. She praises the strange power of hysterical women and sorceresses: "These women, in order to escape from the adversity of their economic and domestic exploitation, have chosen to suffer publicly, as on a stage, before a male public. The spectacle is in itself a crisis which turns into a celebration."[10]

For Cixous, Freud "found himself, like everyone else, a prisoner of the family circus which attempts to ascribe to its various members pathogenic guilt."[11] Nor did he succeed in eluding the family structure of his time and culture. Yet, while Dora's illness is clearly the symptom of a girl's acute lucidity within a repressive and unbalanced society, the clever doctor never comes to grips with this fact since he is an accomplice of the social order. As Philip Rieff points out: "Dora does not want to hold hands in this charmless circle, although Freud, at one point, indicates that she should."[12]

What makes this fragment of analysis still interesting and timely today? The question is particularly important since both the situation and the illness itself have become obsolete. Nonetheless, Dora's story extends beyond the case of Dora; Freud's document has become a literary text, one which peculiarly anticipates the investigations of the modern novel. The submersion into a girl's subconscious, the uncannily Proustian flashbacks, the complex meanderings through time, and the imaginary spaces still fascinate us and inspire contemporary writers.

For feminists there is the problem of Dora, the pampered child of a

well-to-do family which did not seem to have been predestined for ad-
versity and sickness. Ida, an intellectually precocious adolescent, tried
to improve her mind by taking courses and attending lectures "for
women." Yet it is precisely this phrase, "for women," which evokes a
stifling atmosphere. No wonder Ida found herself chronically short of
breath; she was literally choking, suffocating.

Hélène Cixous' play *Portrait of Dora* is a text based upon a text. A
politically committed feminist, Cixous took Freud's *Fragment of the
Analysis of a Case of Hysteria* and turned it inside out. The heroine of
her piece is clearly Dora, whose adventure is emblematic of the difficult
path women had and still have to follow in order to gain their freedom
and find their voice.

In her simultaneously lyric and tragic text, Cixous transmits Dora's
gasp for breath. The whole work is a cry of pain, a repressed sob. And
yet, in the end, we witness the young woman's triumph and the scien-
tist's discomfiture. Another Judith, Cixous' Dora severs the head that
thinks too much and yet not enough.

In the play, Dora occupies center stage while Freud is off to the side,
superseded by events he is unable to control. Sitting with his back to the
audience, he recounts what we are about to witness. The plot, however,
will not be structured by the account. On the contrary, events and peri-
peteiae furnish the structure of the narrative and of the narrator. Freud,
the narrator, is a man created by his narration, a man made of words
who, once the latter fail him, will become nothing.

In the course of a lecture delivered at the New York University Maison
Française in the spring of 1972, Simone Benmussa, the director of *Por-
trait of Dora* at Jean-Louis Barrault's theater in Paris, explained that
she had wanted to transmit Dora's message as well as Frau K.'s message
in a play composed of sharply fragmented action. The director went on
to say that she found herself in a marginal situation, "on the fringes of
Barrault's operation." Yet during this period of apprenticeship margin-
ality proved to be an advantage. According to Benmussa, "when the
fringe begins to speak, writing is necessarily fragmentary. The fragment
is a literary piece between silence and the word." Benmussa felt that all
her adaptations were of marginal texts, texts which came from the out-
side. "Mine is a theater of memory," Benmussa asserted,

> a theater which brings to the stage much that is elsewhere. In *Dora*
> the actress plays the unspoken. The problem I was facing was that of
> staging the void, not unlike Calder whose mobiles inscribe an absent

space between the moving parts. Thus in *Portrait of Dora,* Frau K. is there, and simultaneously her image appears as projections onto various parts of the set. I wished to convey all of the woman's aspects, the way in which she lived in other people's minds. The same was true of Dora.[13]

Dora is the center of all the discourses which evolve around her, trying to take possession of her. Her father, Mr. B., declares: "Dora is still a child and Mr. K. treats her like one. He used to send her flowers, give her small gifts. She was like a mother to his children, she gave them lessons, took them for walks."[14] Mr. K. contradicts this claim: "Dora is no longer a child." His wife echoes her lover's statement, yet with an important variant: "Dora is a child, who is only interested in sexual matters" (p. 13).

In truth, Dora is an adolescent, thus both a child and nearly a woman. Her father would like to prolong her childhood in order to dominate her. He does not see, or does not wish to see, any harm in Mr. K.'s gifts. Mr. K. covets the woman about to emerge from the chrysalis. As to the enigmatic Mrs. K., she describes the adolescent's situation perfectly, though with a touch of irony. Dora is the typical adolescent, a living paradox. She can be neither restrained nor possessed—at least not by members of the male sex. Only another woman is capable of exerting influence over her.

Cixous' Dora is keenly aware of the strange quadrille in which she is forced to dance. She literally does not know what the next step is going to be. However, she has guessed "Mr. K.'s intentions" (p. 17). She feels betrayed but cannot give a name to this betrayal. Who has designs on her? Who is attempting to stifle her judgment? Might it be her father, who abandoned her—as she imagines—by taking a mistress? Could it be the mistress herself, who has been more than a friend to her? Mrs. K. has been a combination of the mother she would have preferred to have and the sister she never had. It is she who initiated Dora to dangerous secrets of sexuality. For Dora, the older woman is the incarnation of Beauty, like the Sistine Madonna which she supposedly contemplated for over two hours in the Dresden Museum. There is also her analyst, society's representative and pawn. Most of the time he hides behind a Mallarméan veil of smoke. Cixous fuses all of Dora's unresolved questions in a single cry of terror and outrage:

You have killed me! You have betrayed me! You have deceived me!
Who has abandoned me?
Didn't I write you countless letters?

Didn't I kiss the ground you walked on?
Didn't I let you in?
Didn't I break my heart apart for you?
I did everything to please you.
I followed you.
I caressed, I polished. My right hand was at your service.
I spoke to you when you would listen to me, and even when you
didn't. I surrendered myself, I was crushed by your law. I made your
bed. I turned away the shadow from your bed. Who do you think you
are to abandon me thus?
And now, to whom shall I address this letter?
To whom shall I be silent? To whom shall I kill myself? (p. 42)

The syntactic deviations of this piece serve to accentuate the girl's
bewilderment. Her situation within a hypocritical, decaying society is
unbearable. There are no answers to her questions. Father, analyst,
would-be lover, mistress, and guide, all are included in a plea which
culminates in two interrogations. Dora may not be able to express her
confusion and pain, but she tries to find out how she can direct her
silence. Cixous, a poet in prose, has recreated in this soliloquy Ida's
actual suicide note in which the girl pleaded with her father to break
with Mr. and Mrs. K. "To whom shall I kill myself?" The adoles-
cent knew that her blackmail was useless, yet she had to clamor her
anguish. Cixous' text remains polyvalent, highly allusive and elusive. It
does not merely reflect a problematic father-daughter relationship; it
synthesizes the powerful claim of all young people standing on the
threshold of life.

The only person able to understand Dora is a woman, the beautiful
Mrs. K. Cixous echoes Freud's own words when she evokes this *mundus
muliebris* that Baudelaire had learned to love through his mother's
touch. In a misty bedroom reigns a pearly, underwater aura. A Vien-
nese Venus, Frau K. sweetly radiates warmth. Her young friend is al-
lowed to brush her magnificent blond hair which flows through the girl's
fingertips like a libidinal web. It will capture the adolescent Dora. The
atmosphere between the two women suggests the pre-Oedipal stage char-
acterized by a narcissistic sensuality.

In Cixous' play we do not know whether Dora is addressing Mrs. K.
or if, guided by her therapist, she recreates a magic moment in the past.
She speaks as though she were daydreaming:

Look at me. I'd like to enter into your eyes. I'd like you to close your
eyes.

The way she looks at herself. The way she loves herself.
The way she doesn't suffer. The way she doesn't look at me. The way
she calmly stares. With this smile.
You can't imagine how much I love you. If I were a man I'd marry
you. I'd take you away and marry you. I'd know how to please you.

(pp. 39–40)

This scene which takes place in front of the vanity, with Frau K.
looking at herself in the mirror, is embued with a subtle eroticism. It
echoes Baudelaire's "Femmes damnées," but without damnation or con-
demnation. We witness the mythical return to the *Magna mater*'s vast
body. Love between two women can "transform the world" (p. 40).

If anyone is overwhelmed by what is happening, it is Freud. Cixous
has fun mixing up the deck of cards: all of Dora's well-known dreams
have been changed. No longer able to recognize himself within the play,
Freud has drifted off course.

One of the play's most striking and disturbing dreams concerns the
murder of a man by a woman. The man's identity is not revealed; how-
ever, the dreamer is a second Judith. The knife merges with her hand as
she bends the man backwards, making his body describe the hysterical
arch demonstrated by Charcot to his male audience come to observe
female patients. The man in the dream, a passive victim, seems to have
suffered a sexual change; perhaps he is an androgyne. The woman leans
over him, just as Mrs. K. used to bend over Dora, and slowly cuts off
her head. It is a scene of symbolic castration. Moreover, the severed
head might be that of Dora, who, as we know, will suffer from a chronic
sore throat and cough to the point of losing her voice. The avenger
might be the victim in disguise.

Dora also kills her seducer's voice. She slaps Herr K. and silences her
analyst. She needs to discover her own voice, to be able to express her-
self. Cixous' Freud says: "If only she'd been able to speak. . . ." And
Dora echoes: "When you can't speak anymore, you're dead" (p. 72).
While waiting fully to enter life, Dora writes endlessly. Cixous made the
following statement: "Writing makes love other. It is itself that love.
The other love is writing's name."

Why did Cixous, a modern woman in every sense, choose to write a
play about a sick, rebellious girl from a bourgeois family, the kind of
girl who has vanished into the past? The answer to this question can be
found in Cixous' book, *La Jeune Née,* written in collaboration with
Catherine Clément a year before the composition of *Portrait of Dora.*
One statement in particular yields the key:

Hysterical women are my sisters. As for Dora, I have been all the characters she plays, those who want to kill her, as well as those she fills with her own trembling life. Having been Freud one day, Mrs. Freud the next, as well as Mr. K., Mrs. K., I escaped inside each one of them. I was the wound Dora inflicts on each and everyone. In 1900 I was muzzled desire. I was its rage, its turbulent effects. I stopped the conjugal merry-go-round from spinning, screeching terribly. I saw everything. I sent each one back to his petty plans, detected the lie in every speech, dispatched cowardice back to the subconscious. I said nothing, but let everything be known. I stole their little investments, no matter! I slammed the door and left. I am what Dora would have been had women's history begun then.[15]

Cixous recognizes herself in the Dora who had the courage to "slam the door." As Lacan writes, "Dora distances herself from Freud with the smile of the Mona Lisa, and even when she reappears, Freud will not be naive enough to believe she intends to ever return."[16]

The power of the woman/sorceress is mighty indeed. Ida wished Herr K. dead, and he was hit by a car. She also dreamed of the death of her father and her doctor. Freud felt a kind of fear in regard to this young woman who occasioned his failure. In Cixous' play, Dora has the starring role. No longer a shaman, Freud has become a supporting character. Demystified, demythified, the former guru is nothing but an old man whose last words will be a babble, a revealing slip of the tongue: *"Donnez-moi de mes nouvelles!"* ("Keep me in touch with myself!") [p. 104]. Freud can maintain his reality only through Dora. Thanks to her reticence and courage, he will continue to exist in history.

Hélène Cixous' response to the Dora case is that of a woman poet. In her play the character of the analyst has become a caricature. Perhaps she took her cue from Catherine Clément, who wrote in *Les Fils de Freud sont fatigués:* "All psychoanalysts are simultaneously their own straight man and their clown."[17]

On the reverse side of Dora's portrait, we find the face of all her sisters, oppressed for many centuries but finally clearing a path toward freedom.

Notes

1. Sigmund Freud, *Dora: A Fragment of an Analysis of a Case of Hysteria,* with an introduction by Philip Rieff (New York: Collier Books, 1963), p. 18.

2. Francis Jeanson, "Entretiens avec Simone de Beauvoir," in *Simone de Beauvoir ou l'entreprise de vivre* (Paris: Editions du Seuil, 1966), pp. 259–60.

3. Ibid., p. 260n.

4. René Major, *Rêver l'autre* (Paris: Editions Aubier Montaigne, 1977), p. 18.

5. Jacques Lacan, "Intervention sur le transfert," in *Ecrits* (Paris: Editions du Seuil, 1966), p. 223.

6. Major, *Rêver l'autre*, p. 36.

7. Catherine Clément, *Les Fils de Freud sont fatigués* (Paris: Grasset, 1978), p. 21.

8. Maria Ramas, "Freud's Dora, Dora's Hysteria: The Negation of a Woman's Rebellion," *Feminist Studies* 6, no. 3 (Fall 1980), 473–74.

9. Clément, *Les Fils de Freud*, p. 69.

10. Hélène Cixous and Catherine Clément, *La Jeune Née* (Paris: 1018, 1975), p. 22.

11. Ibid., p. 98.

12. See Philip Rieff's introduction in *Dora*, p. 10.

13. Simone Benmussa, Lecture delivered at New York University, 1972.

14. Hélène Cixous, *Portrait de Dora* (Paris: Des Femmes, 1976), p. 12.

15. Cixous and Clément, *La Jeune Née*, p. 184.

16. Lacan, "Intervention," p. 224.

17. Clément, *Les Fils de Freud*, p. 30.

In Search of a Feminist Theater:
Portrait of Dora

Jeannette Laillou Savona

I have chosen to analyze *Portrait of Dora*[1] by considering the play as a paradigm for the aesthetic and ideological options available to feminist playwrights at the present time. These few investigatory notes are meant to be neither exhaustive nor conclusive, as women writing for the theater constitute a relatively new phenomenon, a fringe activity still tinged with uncertainty. My paper aims at proposing a dual model of theatrical analysis which will reflect a feminist view of theater and literature. It is this vision which I shall first briefly define in the context of feminist research conducted over the past fifteen years. I think that the originality of feminist theories rests partially on their appropriation of concepts belonging to two major streams of Western thought: psychoanalysis and Marxism. My own perspective lies along the same line as studies based on a synthesis of these two trends of thought. Originating in England, these studies first focused on the cinema and revolved around the journal *Screen*.[2] They were subsequently taken up and theorized in North America by such feminists as Kaja Silverman and Teresa de Lauretis, who combined semiotics, psychoanalysis, and the concept of ideology derived from Althusser in order to problematize and discuss the notion of the female subject.[3] Thus, my analysis will focus on this problematization, which appears to me to be inherent in the structure of *Portrait of Dora*.

Freud's *Dora: A Fragment of an Analysis of a Case of Hysteria*,[4] from which *Portrait of Dora* is taken, is a narrative punctuated with theoretical observations which contains avowed hesitations, continual choices, and decisions based on a host of narrative episodes proffered by Dora and Herr B., her father. Freud's narration is one which scrupulously queries its own perspective, while making Dora the subject of the action and of all indirect discourse. This narration, however, is highly

codified in all its narrative options by the theory of the Oedipus complex and sexual difference, a theory which channels the organization of the questions asked and the answers supplied. In Freud's text, two subjects may be perceived, a demiurgic male subject whose analytic eye is ubiquitous and centralizing, and a secondary female subject who speaks often but whose desire is expressed only through the mediating narration of the primary male subject. Here we can recognize the Oedipal model underlying the third-person narrative as it has been clearly elucidated by feminist students of the cinema, especially Teresa de Lauretis. The narrative eye, whether it be that of the camera or the linguistic mechanism of storytelling, avoids defining itself as a desirous, male, heterosexual subject. Moreover, the characters who are constructed by and subjugated to the gaze of the narrator conform for the most part to the tacit rules of the "positive," male, Oedipal narrative model: the hero's quest leads him to a female object. The attempts to assert a female subject and desire, whether through the eye of a female narrator or director, or through the inversion of the actantial subject—a heroine replacing a hero—do not necessarily allow the narrative work, through this modification, to present an autonomous female subject whose desire would show signs of its own specificity. According to de Lauretis, the structure of any narrative, which, according to narratologists, builds its framework around the positions of subject, object, obstacle, or space, is culturally shaped by Oedipus, as is shown in her analysis of the works of Lévi-Strauss and Jurij Lotman.[5] According to psychoanalytic theory, female desire manifests itself only as a lack or as a response to the desire of Oedipus or Orestes. In other words, it is no more than the opposite side of what Luce Irigaray has labeled "an economy of the same."[6] If this is the case, what can and what must we do to escape from the oppressive logic of the narrative and the Oedipal drama? Such is the problematic which seems to underlie Hélène Cixous' play. She has admirably described this in "Aller à la mer": "How, as women, can we go to the theatre without lending our complicity to the sadism directed against women, or being asked to assume, in the patriarchal family structure that the theatre reproduces *ad infinitum,* the position of victim? Who is this victim? She is always the Father's daughter, his sacrificial object, guardian of the phallus, upholding the narcissistic fantasy which helps the Father to ward off the threat of castration."[7]

I will begin with a study of *Portrait* in its relation to theater and the original Freudian narration. Following this, I will analyze the functioning of the Oedipal drama as it interpellates the implicit female and male

spectators. Lastly, I will attempt to explicate the ideological status of the play, taking into account the political problems formulated by its reception.

In Cixous' *Portrait,* the didascalies[8] require a variety of visual techniques of expression: (1) theater with its characters incarnated by living actors; (2) cinema, where the same actors appear in two-dimensional moving images; and (3) the projection of a still shot. The film sequences or still shot, projected onto a silk screen, create a heterogeneous type of vision which participates in the self-division and decentering of characters, especially in the case of Dora, Herr K., and Frau K., in the scenes of the lake, the adoration of the Madonna, and the dance. A lateral stage device also causes the stage to move off-center and become a polyvalent space, out of shift with itself, where the represented times overlap and intertwine, arising from the characters' speech, memory, and desire in no apparent chronological order. The fictional time and space of the theater are thus fragmented into numerous segments rich in repetitions, contradictions, displacements, and condensations. This theatrical language is one of association which plunges the spectators into the world of the unconscious and dreams. The stage device stipulated by the didascalies seems also to aim at avoiding any direct confrontations between the characters. Freud is seen from behind at the beginning of the play (1976, p. 76), and Dora turns her back on him on several occasions. One of the sequences between Dora and Frau K. takes place in such a way that the two actresses cannot see each other and Frau K.'s voice reaches Dora from behind (1976, p. 76). The stage business involving the eyes is thus marginalized in comparison with the voices, whose intensity and effect are minutely described. In theater, as in film, the game of glances stresses the balance of power and reification of some characters by others, while encouraging the masterful voyeuristic control exercised by the spectators.[9] Thus, the didascalies regarding Freud and Frau K. reveal a specific concern to neutralize the power exercised by Freud (the Father, representative of the episteme) as well as its counterpart, that of Frau K. (the Mother, endowed with a "feminine" knowledge). Visual strategies of this kind tend to invest Dora with the right to look and speak in her relation to these two parental figures.

Freud's voice, which is occasionally disembodied and designated as the "Voice of the play," is often challenged by the other voices or by the film sequences. The Voice of the play becomes that of Frau K. in one particular instance (1976, p. 93). By inventing Freud's dream, which is recounted in the third person by the "cold and monotone"

(1976, p. 63) Voice of the play, and by showing simultaneously a different lake scene on the silk screen, Cixous manages to replace all the signifiers of a debased female sexuality in the original Freudian text with that of the white flowers which, through an effect of condensation, designate the very object desired by Freud, the character.[10] The entire dream implies that Freud's desire, the passion concealed beneath learned, institutional discourse, is what in fact constructs and determines Dora's sexuality. The analyst's speech is often undermined from the inside by Dora's silence or by her ironical questions which turn into rebuttals: "What do you want to make me say?" (p. 49), she says. She even goes so far as attempting to confound the master's desirous, supreme gaze: "Why are you looking at me like that? So insistently?" (p. 55). Consequently, the deconstruction of glances and the importance given to the multiple voices contribute to the subversion of the narrative and to the explosion of the traditional, realistic mode of performance.

The performative speeches in the present tense are constantly interrupted by inner narratives, in either the past or present tense, which indicate the intrusion of Dora's dreams and fantasies. The past emerges in the form of dialogues between Dora and Frau K., Dora and Herr K., and Dora and her father. The continual ruptures between the dialogues and the narratives prevent the spectators' eyes and ears from becoming rigidly set in transparent meaning or in the naturalism of bodies. But the entire perspective of this complex theatrical narration remains focused on Dora. She is the character who narrates, imagines, implores, suffers, refuses, and condemns; it is she who feels rejected by everyone; it is she who, in the end, says no to the analyst and refuses the transference. But it must be emphasized that it is not her departure which causes the final break in the theatrical performance. It is the Voice of the play, impersonal and disembodied, which directly addresses the spectators at the end. The final words of the play, "And Freud knew it" (p. 67), sharply emphasize the ambiguous nature of the narrative status of the Voice and the difficulty encountered by playwrights in allowing a female character her voice through the obvious neutrality of the theatrical apparatus. Indeed, even if Dora is given a choice position in the narrative and theatrical structures of *Portrait,* she remains subjected to the impersonal Voice and the gaze of the spectators, both male and female, which turn her into an object to be studied and/or desired.

Cixous acted as a substitute for Freud in writing the play. Her attempt to disrupt the theatrical narrative by throwing it off-center and splitting it up appears as a bold feminist venture aimed at arousing in the audience a new way of looking which is rooted neither in voyeurism nor in

fetishism derived from the male fear of castration. In this regard, it is possible to query why the Voice which has the last word is not that of a woman, for such a shift would certainly disrupt the theatrical apparatus by implying sexual difference at the level of enunciation and artistic discourse. I believe that the success of any production of *Portrait* depends not only on a conscious effort of deconstruction on the actors' part but also on the reeducation of the audience who must become accustomed to experiencing theater through different ears and eyes. Therefore, Cixous' play also raises the question of a new theatrical production and experimentation and suggests the necessity for the kind of exploration carried out by such feminist companies as the Théâtre Expérimental des Femmes (Montréal), the Théâtre de la Carmagnole (France), the Monstrous Regiment or The Gay Sweatshop (London), and the Omaha Magic Theatre or The New York Feminist Theatre Troupe, to mention only a few such ventures.[11]

I now want to deal with the representation of Oedipus as it emerges from *Portrait*. On the one hand, it would seem that the "positive" Oedipal model (the heterosexual one) of the play quite closely follows psychoanalytic theory. The inability to sublimate her incestuous desire—an excessive devotion to her father—appears as one of the major forces behind Dora's inner turmoil. The drama plays with perpetual shifts between the three impossible figures of desire—Herr B., Herr K., and Freud—and the scenes in which Dora's seductive behavior toward Freud asserts itself especially reveal the social mechanism of female heterosexuality. In the episode previously quoted, where Dora becomes conscious of Freud's insistent gaze, she immediately removes her shoes and appears disappointed with the doctor's awkward silence when he sees her bare feet (p. 55). Dora's desire and exhibitionist behavior seem therefore prompted by the male gaze. It is doubtless because Dora knows that Freud cannot respond to her seduction that she ventures to play this traditional feminine game which is supposed to cure her. The female heterosexual Oedipus seems to be symmetrical with the male Oedipus, but its representation is daring because it deconstructs its dependence on the male model, something which seldom happens in the theater.

In Cixous' play, Dora's sexuality block with Herr K. is evidently caused by her homosexuality—that is, the "negative" component of Oedipus. In *Dora: A Fragment of an Analysis of a Case of Hysteria,* Freud had merely alluded to the likely importance of this interpretation in a footnote and has often been criticized for having neglected the relationship between Dora and her mother, and between Dora and Frau K. In *Portrait,* Dora's almost complete refusal of Herr K.'s sexual advances

seems related to her fear of rape and male aggression (this explains the symbolic importance of the door[12]) and her explicit wish to kill men. Her fantasy of the murder committed with a knife, which was added by Cixous, is presented as a legitimate defense against sexual penetration, which Dora perceives as murder: "There will be a murder. It's a law. . . . I want to kill him. He knows it. He wants to kill me. I know it" (p. 36). This fantasy of slitting Herr K./the Father's throat offers another explanation for Dora's cough. At the same time, it seems to indicate the beginning of a possible writing activity and her aspiration for creativity: "I was using my left hand and I drew a line from left to right" (p. 37).[13] Here we are confronted with a reversal of the usual metaphor of male writing through the mutilation of the female body.[14]

In numerous passages of Cixous' play, Dora's homosexual desire for Frau K. is explicit, but such scenes remain totally unseen by Freud, the character, who does not take them into consideration. Insofar as all the male characters in the play appear to be excluded from this relationship, it becomes privileged in the eyes of the spectators. Frau K. occupies a position symmetrical with that of Herr B. or Freud, for her behavior toward Dora is basically seductive, while at the same time she adopts an attitude of sexual denial and parental distance. As with Freud, Frau K. holds the key to a specific knowledge which Dora longs to share, namely the knowledge of the "infinite resources" (p. 41) of the female body and of a culture which traditionally belongs to women: "Tell me more, tell me everything, everything. . . . Everything women know: how to make jam, how to make love, how to make up their faces, how to make pastry, how to adopt babies, how to cook meat, how to dress fowl" (p. 42).

Taken as a whole, the structure of Dora's desire would appear to correspond to the psychoanalytic theory of pre-Oedipal bisexuality, with Dora identifying with both parental figures and simultaneously desiring both. But the play also differs from psychoanalysis in its presentation of female desire in two ways. First, this desire does not seem to be in any way related to Oedipal castration—penis envy—as it is described by Freud. Neither Dora nor Frau K. shows evidence of domination, possession, sorrow, or fear concerning their own "lacks." The scenes between the two women do not borrow from male erotic strategies. Their desire is expressed through various images (white skin, smiles, the faint sound of kisses) and the need to hear the other's voice, all of which point to the dispersed, fragmented nature of female sexuality. Rather than aiming to control, Dora's gaze seems to seek fusion with that of the other ("Look at me! I would like to step into your eyes" [p. 41]) and

complete identification through symbiosis with the body of the mother: "It looks like a cave! Where are you? It looks like a cave; it's me! Me inside myself, in the shadow. In you" (p. 42). The displacement which is carried out here forms a refusal of traditional Oedipal castration and a more elaborate development of pre-Oedipal castration through birth and the mirror stage, which indicate the progressive severing of the girl from the mother. Luce Irigaray has also stressed this displacement by insisting on the paramount importance of the girl's pre-Oedipal ties.[15]

In her psychoanalytic reading of the play, Sharon Willis accurately comments on the fact that the filmed sequence of the Madonna evokes the ambivalence of the mirror stage, since by gazing at the Other maternal figure, Dora is fascinated by her own image of the features of the infant Jesus/Dora (pp. 40–41).[16] This ambivalence, which is described by Lacan in more neutral/masculine terms, results from the simultaneity of the imaginary wholeness (identification) and the anguish arising from the severance and compelling lack enforced by the gaze. In Cixous' play the gaze is that of a woman, and it is the double image reflected through the mirror which arouses the desire to embrace the Other and merge with her (p. 41). Severance and autonomy are immediately imposed by the attitude of Frau K., who, "distant, ephemeral, close, inaccessible," "says no with a gesture, with her whole body" (p. 41). This theatricalization, which establishes a bond between the mirror stage and female homosexuality, acts as a *mise-en-abîme* for Cixous' play, as a signifying practice to produce a female subject which proves to be more in keeping with the internalization of the mother in women. In this respect *Portrait* has its proper place in a new corpus of plays by women which focus on the relationship between mothers and daughters and require psychological interpretation. Some of these plays, such as *'night, Mother* by Marsha Norman,[17] make use of realistic theatrical conventions which perpetuate voyeurism to some extent and do not allow for recognition of the unconscious. This explains their failure on the level of feminist aesthetics and also their commercial success. Cixous can be credited with having made female desire an integral part of the functioning of theatricality. This desire must therefore be relived by female spectators as anamnesis, the recollection of a relationship deeply buried in the female memory.

The second difference in *Portrait* in relation to psychoanalytic theory lies in Dora's homosexual desire, which expresses itself very clearly and almost confidently. If Dora's homosexuality is considered to be a conscious or semiconscious phenomenon, her neurosis (if it *is* neurosis)

cannot be caused by the repression of the "negative" Oedipus, unless the almost complete lack of affection on the part of the real mother is what truly prevents Dora from being able to choose between a male and female object of desire. But nothing of this nature is implied in the play, which casts some doubt on the supposed pathology of Dora's condition and does not claim to solve the mystery of her hysteria. But if we interpret the entire play as a type of therapy or a different kind of treatment allowing Dora to express her forbidden desire, her departure and rebellion may be considered as both a cure and a condemnation of Freud's own block and inability to perceive Dora outside of his own desire. In fact, the script of the play is left open to various interpretations, encouraging the spectators to fill in its gaps and apparent contradictions.

For female spectators, identification possibly takes place through simultaneous recognition and denial, an attitude which perpetuates that which we have in dreams.[18] We both recognize and fail to recognize Oedipus: as we enter into Dora's hysteria, we both alter and rebut it. We well know that we are Dora without being able to accept being her. Perhaps it is through the split within ourselves that we create ourselves and begin to understand ourselves as female subjects. Thus, Cixous' work recalls the production of meaning advocated by Teresa de Lauretis for the study of film: "For the theory and the practice of women's cinema, this (the production of meaning) would entail a continued and sustained work with and against narrative, in order to represent not just the power of female desire but its duplicity and ambivalence."[19]

But, according to de Lauretis, a work must never lose sight of the fact that the spectators are also social beings living in the real world, who are part of history. The question I would now like to raise concerns the political status of *Portrait* as a play which addresses a precise group of spectators. It is a question which is always primary in any so-called political theater. The large number of contemporary plays presenting historical or legendary characters such as witches, the Virgin Mary, Violette Leduc, Simone Weil, Edith Piaf, Aurora Leigh, or Mary Shelley,[20] bears witness to women playwrights' interest in situations and social conflicts which serve as vehicles for revealing or denouncing patriarchal ideologies. As a historical figure Dora has acquired considerable importance for feminists because she tends to illustrate both the link between femininity and hysteria and the bond between psychoanalysis and female hysteria. Cixous' play seems to occupy a strategic position because it stands at the junction of the two currents of interest which I mentioned at the beginning: one is centered on the notion of female sexual-

ity and challenges psychoanalysis; the other examines the sociopolitical problems encountered by women and puts an emphasis on studying patriarchy.

As far as the relationship between feminism and psychoanalysis is concerned, *Portrait* offers an imaginary compromise between two ideologies which are difficult to reconcile. The author appears to use a subversive type of mimicry consisting of borrowing and adopting certain psychoanalytic presuppositions—the decentering of the subject and its alienation in language,[21] the absence of a female subject, sexual difference, and the Oedipus complex—with a view to changing them, diverting them from their orthodox meaning, and refuting them. It is therefore a strategy similar to that adopted by Luce Irigaray, who speaks out against the psychoanalytic institution from within that very institution.[22] It is through the opening of theatricality onto the unconscious and an attempt to arrive at an original portrayal of female bisexuality that Cixous builds an imaginary bridge between what is said in the institution and what women wish to change about the institution. This compromise, reached through art and the imaginary world, mirrors certain typical feminist contradictions. One can recognize here the functioning of ideology (Althusser) in literature as Etienne Balibar and Pierre Macherey have described it: "We shall say that literature begins with the imaginary solution to incompatible ideological contradictions, with the representation of such a solution. . . . For literature to exist, the very terms of these contradictions (therefore their contradictory ideological elements) must first be articulated in a special language, a language of "compromise," projecting the anticipated fiction of their impossible conciliation."[23]

We have seen that, in *Portrait,* the problematic of female bisexuality is based on a return to the mother and the development of a pre-Oedipal relationship which aims at overthrowing the Law of the Father. An economy such as this not only remains imprisoned in binarism but is also dependent to a certain extent on the essentialism inherent in any feminist venture focusing on the "feminine" and the "maternal." But the greatest danger underlying the concept of bisexuality is that, as it probably claims to be universal, it tends to ignore the female Other, that is, all those women who may feel oppressed by such a notion. Insofar as the play interpellates its audience on an ideological level, it is obviously addressed to white women in the Western world: intellectual, cultivated, bourgeois women living at the end of the twentieth century. But it would also appear to be addressed to heterosexuals for, as Domna Stanton has justly observed, "the metaphorization of the mother/daughter relation"

which is prevalent in feminist writings and theories of difference "has provided an important vehicle for speaking the lesbian relationship in an enduringly homophobic hegemony."[24] Stanton also points out that this metaphorization may also satisfy the conservative and fundamentalist tendencies often allied with reactionary politics and should therefore prompt us to question the notion of difference "as the privileged construct of modernist masters."[25]

Stanton's assertion may appear radical, but it is relevant to a great deal of feminist writing. It is true, however, that in *Portrait* the notion of desire informing bisexuality subsumes the categories of heterosexual and homosexual. But our societies neither perceive nor treat sexuality according to the concept of desire. For the majority of feminists, the ideological grounds for despising or devaluing homosexuality seem unacceptable, and the admission of lesbians to cultural and social representations, which is forcefully repressed, constitutes an important political project. On the one hand, Cixous' play brings to the fore the complete blindness of men to lesbian eroticism and frees its representation from the voyeurism and sadomasochistic violence which so often appear in its male theatrical images (I am referring, for example, to such plays as Genet's *Maids* or *Balcony*). The homosexual sequences in *Portrait* serve to specularize the prevailing ideology: a refusal on the part of the audience to see and hear women in deeds and speeches which have remained so far unrepresented on account of their autonomy in relation to the masculine gaze and authority. But, on the other hand, these sequences also imply a certain amount of heterosexual coercion, for the erotic ambivalence of Frau K. and her rejection of Dora confirm the heterosexual model and sanction the preservation of partriarchy. Without this heterosexual coercion, Cixous' play could not have been performed at the Théâtre d'Orsay in 1976.[26] This contradiction between a repressed lesbian economy and the overpowering omnipresence of the heterosexual pattern is often a part of the appropriation which feminists make of psychoanalytic theory. The hostility of certain radical feminists, like Monique Wittig, to any type of "feminine" project based on psychoanalysis is therefore understandable.[27] At this level Cixous' play may seem paradigmatic of the disagreement among feminists on the concept of the "feminine."

In its social representation of the family and patriarchy, *Portrait* seems to be more homogeneous. The social situations which provide the basis for the interpersonal relations in the play are those of the nineteenth century and boulevard theater. Both male characters, well-to-do bourgeois, are alienated from their wives ("my wife means nothing

to me," they both say repeatedly), and the adulterous bond between Frau K. and Herr B. explains the erotic behavior of Herr K., who seduces his maid and attempts to seduce Dora. To the question asked by Freud, "But who stands for whom in this story?" (p. 53), Dora substitutes a more pertinent question: "Who betrays whom in this story?" (p. 53). Dora is in actual fact betrayed by her father, Herr K., and Frau K., who join against her in lies and rejection. Toward the end of the play she realizes that she is expected to collapse, either in hysteria or in an adulterous relationship with Herr K.: "If I weren't there to fall, how would they walk?" (p. 59). The analogy she establishes in her dream between Freud's other patients (pp. 57–58) and household employees (*employées de maison*) is revealing because Dora is literally "employed" by all the others in order to maintain the status quo between the two families and perpetuate both the taboo of incest and the preservation of patriarchy. The sympathy which is thus constructed around the solitude and oppression of Dora has an unquestionable social basis and appeals to a larger audience which need not agree with psychoanalysis. But we may wonder if Dora succeeds in going beyond the status of a victim and whether the play manages to produce a political "we," even divided.

In her revolt Dora appears completely isolated. Her dream of her grandmothers who, unimpressed by the "wedding procession" (*"cortège de la conjugalité"*) of the four parents, "are choking with laughter," their mouths stuffed with cake (p. 48), reveals a deep need on her part to join a community of women whose pleasure, laughter, and love are not turned into guilt. In the same way, after the imaginary death of Freud, Dora's fantasized dance with the other "servants" suggests a similar longing to become part of a women's group. But in these two episodes Dora feels awkward and fails to integrate into the two groups. In *Feminist Theatre*, Helen Keyssar devotes a whole chapter to the theme of "Communities of Women in Drama," which marks women's self-awareness and passage to action.[28] For such a community to exist, two women suffice provided that, united by solidarity, they stand up against common oppression. In *Portrait* it does not seem that Dora's two dreams could possibly interpellate female spectators as political subjects. Here we are faced with the same situation as in *L'Histoire terrible mais inachevée de Norodom Sihanouk roi du Cambodge*,[29] where the world of generosity, cooperation, understanding, and cheerful spontaneity created by the four female characters—Queen Kossomak, Madame Mom Savoy, Madame Khieu Samnol, and Madame Lamné—against a background of fierce political struggle seems to have no impact on the course of his-

tory. In *Portrait,* as in *Sihanouk,* we are presented with an apolitical female oasis which remains marginal and inefficient. Whereas in *The Conquest of the School at Madhubai*[30] the relation of tenderness between Pandala and Sakundeva changes into a powerful political coalition, a social force which can negotiate with the power of men in order to obtain the right to an education, in *Portrait* the protagonist remains the prisoner of her solitude, despite her final departure. This is also the case with several other plays by women which, focused on family relations, do not go so far as the idea of a collective rebellion.[31] On the other hand, plays which succeed in portraying a female subject in the plural often tend to overlook the unconscious dimension of theater and human relations. It is also hard for such plays to avoid falling into the trap of didacticism, which is that of all political theater.[32] Cixous' play represents an interesting, although difficult, attempt to produce an unconscious female subject which may also be perceived as social and historical.

In its privileged position among the present tendencies of female theater and in its complex aesthetic and psychoanalytic problematic, *Portrait* reflects, in an original way, the dilemmas and contradictions of contemporary Western feminists. It also bears witness to the difficulty of creating a new form of feminist theater within institutions founded on both the division and repression of women.[33] The double reading of *Portrait of Dora* which I have proposed has tried to arrive at a synthesis between the notion of subject derived from psychoanalysis and that which, born of a Marxist approach, considers literature and theater as constructs well rooted in history and the ideology of gender.[34] Such a synthesis,[35] which I believe essential to my own feminist reading, is itself problematic, for no work of art lends itself easily to such a double critical strategy.

Notes

I wish to thank Pat Brückmann and Barbara Godard for reading my text and suggesting improvements.

1. This essay is a slightly modified version of a paper read in French at the Hélène Cixous Symposium held in Utrecht in June 1987. Most of my quotations of the play come from *Portrait of Dora* in *Benmussa Directs,* trans. Anita Barrows (London: John Calder, 1979). My remarks on the stage directions of the play are based on the original French text: Hélène

Cixous, *Portrait de Dora* (Paris: Edition des femmes, 1976), which reflects Simone Benmussa's scenography. Some of these stage directions have now disappeared from the last French edition: Hélène Cixous, *Théâtre* (Paris: Edition des femmes, 1986). For quotations from the first French version, I shall indicate the date (1976) before the page number.

2. Among the best-known critics associated with *Screen* are Laura Mulvey, Claire Johnston, and Stephen Heath.

3. See Kaja Silverman, *The Subject of Semiotics* (New York: Oxford University Press, 1983), and Teresa de Lauretis, *Alice Doesn't: Feminism, Semiotics, Cinema* (Bloomington, Ind.: Indiana University Press, 1984).

4. See *Standard Edition of the Works of Sigmund Freud,* ed. James Strachey (London: Hogarth Press, 1953), vol. 7, pp. 1–122.

5. See Teresa de Lauretis, the chapter entitled "Desire in Narrative," pp. 103–57.

6. This expression appears many times in Luce Irigaray, *This Sex Which Is Not One,* trans. Catherine Porter (Ithaca, N.Y.: Cornell University Press, 1985).

7. Hélène Cixous, "Aller à la mer" (trans. Barbara Kerslake), *Modern Drama* 27, no. 4 (December 1984), 547.

8. See Anne Ubersfeld, *Lire le théâtre* (Paris: Editions sociales, 1977), and my own article, *"Didascalies* as Speech Act" (trans. Fiona Strachan), *Modern Drama* 25, no. 1 (March 1982), 25–35.

9. This idea is widely accepted by feminists working on film. It is less prevalent in feminist criticism of theater. It is clearly stated by Cixous in "Aller à la mer" and also appears in Jill Dolan, "The Dynamics of Desire: Sexuality and Gender in Pornography and Performance," *Theatre Journal* 39, no. 2 (May 1987), and in Ann Wilson, "The Daring Eye: The Politics of the Gaze in Feminist Performance," unpublished paper. It is also suggested in Marie-Claire Pasquier, " 'Mon Nom est Persona': Les Femmes au théâtre," in *Stratégies des femmes* (Paris: Edition Tierce, 1984), p. 260. In his 1983 Montreal production of *Portrait* (Théâtre Ubu), Denis Marleau was intent on avoiding the usual voyeurism of theatrical audiences: "I did not want the spectator to be the mere receiver of strong emotions or to be reduced once more to a voyeuristic position," he said. See Line McMurray, "Dora réécoutée," *Spirale,* June 1983.

10. In Freud's *Dora* a close link is established between Dora's cough, leukorrhea, or "white flowers," and the pearls or jewels offered by Herr B.

11. For a study of women's theatrical companies, see Monique Surel-Tupin, "La Prise de parole des femmes au théâtre," in *Le Théâtre d'intervention depuis 1968,* vol. 2, ed. Jonny Ebstein and Philippe Ivernel (Lausanne: L'Age d'homme, 1983), 56–77, and Jane Moss, "Women's Theater in France," *Signs* 12, no. 3 (1987), 548–67, on French theater; Dina Luise Leavitt, *Feminist Theatre Groups* (Jefferson, N.C.: McFarland, 1980), on American theater; and Helene Keyssar, *Feminist Theatre* (New York: Grove Press, 1985), on both American and English female groups.

12. On the various meanings of the door, see the remarkable article by Martha Noel Evans, "*Portrait de Dora:* Freud's Case History as Reviewed by Hélène Cixous," *Sub-Stance* 11, no. 3 (1983), 68–69.

13. I am using my own translation of the French text: "Et je tirai comme un trait de gauche à droite" (1976, p. 27) because the published translation leaves out the image of writing.

14. See Michelle Coquillat, *La Poétique du mâle* (Paris: Idées/Gallimard, 1982), and Susan Gubar, " 'The Blank Page' and the Issue of Female Creativity," in *Writing and Sexual Difference,* ed. Elizabeth Abel (Chicago: University of Chicago Press, 1982).

15. Luce Irigaray, "Psychoanalytic Theory: Another Look," in *This Sex,* pp. 34–67.

16. Sharon Willis, "Hélène Cixous's *Portrait of Dora:* The Unseen and the Un-Scene," *Theatre Journal* 37, no. 3 (October 1985), 296–97.

17. Marsha Norman, *'night, Mother* (New York: Hill and Wang, 1983).

18. It is Octave Mannoni's theory, which he applies to both dreams and theatrical reception in *Clefs pour l'imaginaire ou l'outre scène* (Paris: Seuil, 1969). See his two chapters "L'Illusion comique" and "Le Théâtre et la folie."

19. de Lauretis, *Alice Doesn't,* p. 156.

20. These characters appear, respectively, in each of the following plays: the witches in *Vinegar Tom* by Caryl Churchill; the Virgin Mary in *Les Fées ont soif* by Denise Boucher; Violette Leduc in *La Terre est trop courte, Violette Leduc* by Jovette Marchessault; Simone Weil in *Approaching Simone* by Megan Terry; Edith Piaf in *Piaf* by Pam Gems; Aurora Leigh in *Aurora Leigh* by Michelene Wandor; and Mary Shelley in *Blood and Ice* by Liz Lockhead.

21. In her article on *Portrait of Dora* (see n. 12), Martha Noel Evans rightly shows how the use of pronouns and prepositions is indicative of the fluidity and decentering of the notion of identity.

22. Irigaray, *This Sex,* p. 145: "I am trying to interpret the traditional operation of the analytic institution starting from what it fails to grasp of female sexuality, and from the masculine homosexual ideology that sustains it. And, in particular, from its relation to power."

23. Etienne Balibar and Pierre Macherey, "Sur la littérature comme mode idéologique: Quelques hypothèses marxistes," *Littérature,* no. 13 (February 1974), 38.

24. Domna C. Stanton, "Difference on Trial: A Critique of the Maternal Metaphor in Cixous, Irigaray, and Kristeva," in *The Poetics of Gender,* ed. Nancy K. Miller (New York: Columbia University Press, 1986), p. 177.

25. Ibid.

26. For details on this production, see "Stage Work and Dream Work," in *Benmussa Directs,* pp. 9–19.

27. See Monique Wittig, "The Straight Mind," *Feminist Issues* 1, no. 1 (Summer 1980), 103–11.

28. See the chapter entitled "Communities of Women in Drama," pp. 126–45.

29. Hélène Cixous, *L'Histoire terrible mais inachevée de Norodom Sihanouk roi du Cambodge* (Paris: Théâtre du Soleil, 1985).

30. Hélène Cixous, *The Conquest of the School at Madhubai,* trans. Deborah Carpenter, *Women and Performance* 3, no. 1 (1986), 59–96.

31. This is the case with *Calm Down Mother* by Megan Terry, *'night, Mother* by Marsha Norman, and *Crimes of the Heart* by Beth Henley.

32. There is a certain degree of didacticism in all the plays by Michelene Wandor and in Ntozake Shange's *for colored girls who have considered suicide when the rainbow is enuf.*

33. The problems encountered by British women in theater have been well documented in the "Special Issue on Women and Theatre" of *Drama, the Quarterly Theatre Review,* no. 152 (Spring 1984), 4–29.

34. For a theory of gender as an ideological system, see Teresa de Lauretis, *Technologies of Gender* (Bloomington, Ind.: Indiana University Press, 1987).

35. Anne Ubersfeld has proposed a similar synthesis in her approach to drama and theater in *Lire le théâtre,* and in her dual reading of Victor Hugo's plays (Marxist and psychoanalytic) in *Le Roi et le bouffon* (Paris: Joseph Corti, 1974). Her approach, however, is not a feminist one.

Staging Sexual Difference: Reading, Recitation, and Repetition in Duras' *Malady of Death*

Sharon A. Willis

Duras is hardly a "new" woman playwright. She first published in 1943; her accelerated output in recent years has roughly coincided with her first widespread popular reception in the United States as well as in France. Nor is she primarily known for her dramatic productions, at least in the English-speaking world. Rather, her theater has tended to arise as a consequence of her other literary work, in critical reformulations that change the stress of problems and scenes already presented in narrative form. Further, some of the earlier plays are more widely known in the form of published scripts that prolong them after they are no longer theatrically produced. Most recently, however, Duras' texts have appeared under a rubric which blends genres, as in *texte-théâtre-film* or, simply, *récit,* a term which has no exact English equivalent but is used in textual studies to convey the sense of "story" as opposed to "discourse": what is told, what is narrated. It is this mixing of textual categories, this refusal of boundaries, that may be Duras' point of insertion in postmodern textual and reading formations, a grounding she may share with "new" woman playwrights.

As complicated as Duras' relation to textual boundaries is, her relation to constructions of "Woman" and to recent theoretical discourses surrounding women's literary production is even more complex. While she contends that there is a specificity to feminine writing, for her this specificity is an essential one. This essentialist position may be the basis of her antagonistic stance with respect to feminist theoretical discourses and their political implications. Nevertheless, her interest for and influence upon overtly feminist literary, critical, and theoretical enterprises is powerful. It resides in her compelling and often disturbing textual work on sexual difference, upon its figurations as a site of textual con-

flict and resistance. This site of resistance, then, is the focus of this essay.

Duras' texts always remember. Disjunctive and repetitive, they insist on reproducing uncannily accurate, though fragmentary, memories drawn from previous texts; these "remembered" fragments from somewhere else produce the choppiness and hesitancy in the narratives. To read them one must sift through layers of interference; one must reconstruct the narrative in more than one register. Recalling other occurrences of the repeated scenes and figures that interweave her texts, our readings both reconstruct past texts and build another narrative of this memory; there is a story *between* the texts.[1] On the other hand, our reading process also segments the narrative according to its interferences, moments of repetition, similarity, and recall; that is, the narrative's memory dis-members the text. Reading, then, both dis-members and re-members.[2] It would be possible to say that a reading of more than one of Duras' texts necessarily entails this double labor of recognition and distinction, of reconstructing, or reproducing and separating, keeping apart.

In a sense Duras' texts are always based in an irretrievable absence, another space beyond their boundaries—a previous text partially re-called, another genre or form, or the scene of reading itself—a scene the writing can never fully embody, articulate, or occupy. At the same time, her texts tend to *thematize* this absence as loss or violent separation and to do so on a particular ground, that of sexual difference. In their obsession to figure the absence and the loss in which they are "grounded," Duras' texts of the eighties operate performatively to stage absence and disappearance. They produce particularly compelling intersections of "sexual difference" with "remembering" and "reading," since all three terms are staged as both delirious repetitions and obsessive efforts to differentiate. Meanwhile, these recent works steadfastly erode the integrity of genre. As novel, *récit* (this is the most recent designation which appears on the title pages), film, or theater, each text *appeals* to another scene of representation, another genre, often mixing one in with another. That is, each text exhibits a fundamental dependence on an outside against which it defines itself, while refusing consolidation within a particular genre. Consequently, the instability of differentiations and borders is reproduced at the textual boundary itself.

The Malady of Death, presented as a novel written in the second person, opens with the line, "You wouldn't have known her, you'd have seen her everywhere at once" (p. 7). This narrative recounts nothing but the sexual interactions of a woman character and a man character, "you," who pays her to spend a set number of nights with him. The text

ends with a kind of "post-face" in which Duras provides some sugges-
tions about staging this text as a play.

> *The Malady of Death* could be staged in the theater. . . . Only the
> woman would speak her lines from memory. The man never would.
> He would read his text, either standing still, or walking about around
> the woman.
> The man the story is about would never be represented. Even when
> he speaks to the young woman, he does so through the man who reads
> his story.
> Acting here is replaced by reading. I always think that nothing can
> replace the reading of a text, that no acting can ever equal the effect
> of a text not memorized.
> <div align="right">(p. 56)</div>

> Je crois toujours que rien ne remplace la lecture d'un texte, que rien
> ne remplace le manque de mémoire du texte, rien, aucun jeu.
> <div align="right">(*La Maladie de la mort,* p. 59)</div>

As Duras envisions it staged, this play would be split between theatri-
cal performance and reading—the young woman's part would be acted
while the man's story would be read by an actor whose very act of read-
ing, in its literalness, would figure the absence of that character. So
reading and acting would coexist, split the stage, constituting two mu-
tually interfering registers. Reading and acting would both support and
resist each other. On the level of the two bodies before us onstage,
however, a question arises: what is the status of the actors? Which one
would call attention more compellingly to the art of acting? And how
would we calculate or stabilize the space between acting and reading?
How would we describe the difference?

Yet there is another equally fascinating question involving memory
and reading. Careful attention to the English and French versions of the
text yields a slight but powerful difference of sense here. The French
could be translated as "I still think that nothing replaces the reading of
a text, nothing replaces the text's lack of memory, nothing, no acting."
On this reading the text is taken to replace acting's memorized recita-
tion. But as a substitute for memory in the form of memorization, the
text here is a memory with no memory of itself; that is, it is memory
only when actualized, figured in the literal reading that is staged. On
this level the staged event would be organized as a coexistence and con-
flict between two kinds of spoken text, recitation and reading, and be-
tween two kinds of memory, memorization and writing.[3]

At the extreme, memorization might be opposed to writing in the fol-
lowing way. Memorization would imply a prior reading internalized,

now independent of the text, which it reproduces entirely in the mental images it stores for repeated restoration in oral performance. Writing, meanwhile, would look like an externalized form of memory, replacing "natural" recall. However, memorization itself remains a technique with a long history (as in the classical opposition between writing and oratory). As examined by Ellen Burt in "Poetic Conceit: The Self-Portrait and Mirrors of Ink," it constitutes a metonymic displacement on the level of the signifier:

> An orator who wants to remember a speech memorizes neither the words, nor yet the argument. Instead, by means of an elaborate and apparently uneconomical process, he recodes the words or *res* (things or subjects of his speech) in a series of images. . . . These images, like dream images, are formed as rebuses, as riddles, to be read off. . . . The images themselves get their content by a process of semanticization of the signifier. . . . The displacement of meaning away from the signified, and the subsequent construction of an image from the signifier, is what allows each image to be read so easily.
>
> (pp. 23–24)

Considered this way, memorization would be itself a work of writing, inscription, as well as perpetual rereading. The coexistence of writing and memorization in Duras' text, then, figures a memory autonomous of the subject's recollection, autonomous of a relation to the past. It thus maintains the simultaneity of memory and the event or discourse it recalls. Within this conjunction it is impossible to distinguish original from copy, production from reproduction. Furthermore, Duras insists that "the two actors should speak as if they were reading in separate rooms, isolated from one another. The text would be completely nullified if it were spoken theatrically" (p. 57). In other words, the dialogue read and recited would be staged as autonomous monologues. There is no exchange between these levels of reading/acting; there is only separation and interference. This radical separation of competing "interpretations" (in the sense of an actor's interpretation of a role), or readings, is staged on the axis of sexual difference, by a woman and a man.

But if this text is designed to stage radical separation and interference effects, it also stages absence. "You" is never onstage. He is replaced by a partial stand-in, another man who reads the story for him. Or is it *to* him, since "you" necessarily evokes the sense of direct address, posing as the addressee of the speech? This unseen protagonist also figures a whole set of absences: the absence of memory from the text, the actor's necessary absence from the scene in which he is cast as a reader, the actress' absence from his reading, the characters' absence from themselves.

Finally, there is the written text's absence to itself at the moment it is staged. It is never entirely *there* where it is read and performed simultaneously; indeed, it is this simultaneity that renders both versions of it partial and supplementary.

We might find the same "absenting" effects in the conditional mode that opens the text and continues to haunt Duras' concluding intervention, as well as my own writing here. How, we might well ask, could one stage the conditional mode? Isn't this mode profoundly alien to theatrical representation? Is the stage perhaps even hostile to the conditional, on the level of its representation, if not its dialogue? The conditional, it seems to me, can be spoken onstage but never *acted*, owing to the resistant presence of the actor before us.

This text's highly unstable figuration would be founded on two unfigurable elements. Hovering between two nonsituations—as the future of the past and the mode of wish, hypothesis, and desire—the conditional mood destabilizes the temporality of both stage and reading. Similarly, the sheer resistance of the stubbornly nontheatrical reader, the *literal* reader onstage, signals an unfigurable absence. But these instabilites call up others: the reader/spectator's position is disrupted by several competing appeals. "You," to whom the reading addresses itself, is absent, just as we are. How can we avoid slipping into the posture of the addressee from time to time? On the other hand, how can we coincide with that position, particularly if we remember our own gendered bodies and if we are female? How can we determine the space and the temporality of our absence from this scene when one actor performs exactly as we have performed or are performing—as readers?

Such destabilization of reader/spectator position is coherent with and implicated in this text's shifting and contradictory framing effects. These range from the splitting of the stage between reading and recitation, to the unanchored direct address, to two contradictory, mutually exclusive positions, and to the intervention of the author's discourse which prolongs the text's work beyond its ending, both by repeating its conditional mode and by reframing it as a play. Thus, the text we have just read as a novel demands an immediate rereading that casts it in another frame altogether.

This kind of intervention is an effect repeated and transposed in most of Duras' recent work. *Savannah Bay,* a play organized around a conversation between two women, questions one character's inability to remember and opens with a brief author's preface written in direct address to "you." Madeleine, an elderly actress, remembers almost nothing; memories of her life have been replaced by the memorized scripts

she has played, and even these are only partially recalled. The other character is an unnamed young woman whose role consists in trying to restore Madeleine's story. She recites bits of the *récit* of Madeleine's life, telling the story as, we presume, Madeleine had once told it to her. Memory, then, comes back to the actress not as proper to her or continuous with her lived life but from elsewhere, from outside, as already "told," read, and memorized by another.

But here the conjunctions and distinctions between repetition of a story and its recitation are impossible to establish. We never know if the story that is being told is that of the "life" or of a "role." The "originary" moment already seems to be representation and performance. Further, because Madeleine was originally played by Madeleine Renaud, the actress as *acted* became overly coincident with the actress acting. The "Madeleines" were both too close together and too far apart. The character was too close to the historically bound actress who played her. Meanwhile, the speech of the real, historical actress betrayed the figure she played; her *good* memory was essential to this staging of theater's nightmare, the failure of memory. Oblivion seemed to have a memory, one that was quite explicitly supplied through an elsewhere, beyond the stage, which nonetheless constantly invaded the scene.

Invasion is also the text's point of departure since, before any staging, there is the author's discourse about it, posed in direct address.

> Tu ne sais plus qui tu es, qui tu as été, tu sais que tu as joué, tu ne sais plus ce que tu as joué, ce que tu joues, tu joues, tu sais que tu dois jouer, tu ne sais plus quoi, tu joues.

> You no longer know who you are, who you have been, you know that you have played, you no longer know what you've played, what you play, you play, you know you must play, you no longer know what, you play. (p. 7)[4]

This play opens with a description addressed to the main character/ actress concerning the inability to distinguish between the playing and the role. She is told she cannot remember *what* she plays, only *that* she plays it. But then the status of acting is as unstable as the distinction between the two Madeleines; for to play a role demands a differentiation (between one's private memory and the script, between the acting subject and the subject acted) as well as a recognition of that difference, which is the space of interpretation.

Here we are confronted with a text whose frame is ruptured by this authorial intervention, one that simultaneously reframes, preinterprets the text, and produces interferences which constitute a space of inter-

pretation. And where are we in the space of interpretation? Once again, direct address is split between us, the real actress Madeleine Renaud, and the actress staged. At the same time, this preface becomes a sort of memory that will haunt the play, a memory whose recall will persist within *our* interpretation. Our reading, then, occupies the space of interpretation opening into the text. Because it is disturbed by reframing, by a discourse that is both inside and outside it, the scene of representation is dependent upon and conditioned by a voice from elsewhere, by another scene. Similarly, our reading is haunted by this voice, by a direct-address "you" that is aimed elsewhere, and by its own construction as the play's absent space—an outside incorporated.

When framing effects focus on the incorporation of an absent outside space, that absence evacuates interiority, dissolves a stable border separating inside and outside. Such a gesture conditions *L'Homme atlantique,* a novel that narrates the making of a film in the future, future anterior, conditional, and past tenses. Not only is the film's temporality distorted, destablized, but its character is addressed only as "you" and is unequivocally designated as a man. The opening lines inscribe absence and forgetting as future events, but in a future tense that can also be read as injunction: "Vous ne regarderez pas la caméra. . . . Vous oublierez. . . . Que c'est vous, vous l'oublierez. . . . Vous oublierez aussi que c'est la caméra" ("You will not look at the camera. . . . You'll forget. . . . That it's you, you will forget. . . . You'll also forget that it's the camera" [p. 7]).

The scene to be filmed is nothing but the process of forgetting—the self-forgetfulness of the subject viewed. "Vous regarderez ce que vous voyez. . . . Vous essaierez de regarder jusqu'à l'extinction de votre regard" ("You will look at what you see. You will try to look as far as the extinction of your gaze" [p. 8]). Here the text splits its address in a radical disjunction. "You" is the subject framed, but it is also the potential spectator who is invited into a split look: one that is looking both at what she/he sees and at the gaze itself. This splitting produces stunning coincidences: "Vous êtes le seul à tenir lieu de vous-même auprès de moi dans ce moment-là du film qui se fait" ("You are the only one to take the place of yourself for me in that moment of the film that is being made" [p. 10]). Here the text's insistence on the unity and specificity of the "you" only serves to underline its impossibility. "You" is divided by the process of taking the place of itself as its own stand-in and by its coincidence with an ambient, anonymous, floating addressee constructed through the direct address and the unsituated phrase "that moment of the film."

Our implication emerges fully at a slightly later point in the text: "Vous êtes sorti du champs de la caméra. Vous êtes absent. Avec votre départ votre absence est survenue, elle a été photographiée comme tout à l'heure votre présence" ("You have left the camera's field. With your departure, your absence has occurred, it has been photographed as your presence just was" [p. 15]). We are indeed outside the frame, held beyond it, but pulled into it, as the text speaks of a film that might be/ might have been—a film of passage outside the frame. It is impossible to situate our own relation to the frame, to refuse fully or to occupy fully the "you," determined textually as a male lover. Here again the text depends upon the absences it perpetually evokes. First, it stresses the absence of a visual level—the work is characterized as a *récit;* it is a purely imaginary film, a blind film. It also obsessively recalls the subject's absence from the visual field. But *who* is the subject? The character "you" or the spectator "you"? It is impossible to separate or distinguish our absence from his.[5] The spectator position, then, is split, ruptured, contradictory, caught between two appeals in the lure of an impossible sight—our own look. At the same time, the film inscribes the passage of a subject and a look beyond its frame.

If *L'Homme atlantique* thematizes a passage beyond the frame, a passage which then reverberates on the performative level through this disconcerting plurality of the lure posed by "you," *The Malady of Death* performs its "passages" in quite another way. The primary textual event, breaking the repetitive series of the indistinguishable nights, is the young woman's departure. Previously the text has repeated the fragmented dialogue, the man's explorative looking at the woman, his demands, and their lovemaking in such similar terms that we can only punctuate the flow of erotic exchanges through the text's long silences. Duras writes in her post-face: "There should be great silences between the different paid nights, silences in which nothing happens except the passage of time" (p. 58). Consequently, we must endure the passage, the loss of voice, where our desire is suspended in an anxiety structured around these repeated, premonitory losses, each of which might prove to be final. The differentiation between nights is produced as absence, loss, a break in the theatrical passage which burdens us with the passage of our own time as well.

The final loss, the one event of the text, is told as follows: "One day she isn't there anymore. You wake and she isn't there. She has gone during the night. The mark of her body is still there on the sheets" (p. 51). It is to be performed, according to Duras' suggestions, in such a way that we as readers/spectators experience the same abrupt break

as the man does, the same sudden loss: "The young woman's departure isn't seen. There should be a blackout when she disappears, and when the light comes up again there is nothing left but the white sheets in the middle of the stage and the sound of the sea" (pp. 59–60). Like the man, we miss the moment of her passage off-scene, the passage that changes everything. As Duras envisions it, the young woman should be lying on the same white sheets as when the play opens: "The stage should be low, almost at floor level, so that the young woman's body is completely visible to the audience" (p. 56). We have been placed, then, at the man's level, investigating this body before us. As we have shared the privilege of sight with him, we now share its loss.

The exchanges between these two figures are now organized around the question of love and death. The man hires the woman to pass these nights with him because "he cannot love," because he has never been with a woman, and, he implies, he wants to see if he can love. What he discovers instead is his malady. Rather than produce love in him, the woman will produce only the recognition of his illness, his death, and his difference.

Death and difference are inextricably bound here, but in a curious way. "You stop looking. Stop looking at anything. You shut your eyes so as to get back into your difference, your death. . . . You don't love anything or anyone, you don't even love the difference you think you embody" (pp. 32–33). While death might be constructed as what is most alien to, most utterly, radically different from life, it is also bound to the indifferentiation of death and life—too much or too little difference. But the complexity of this problem lies elsewhere as well. Death and difference share a trait; neither can ever be embodied. The malady of death that the woman first sees in the man without naming it, and which she later names, continually circulates in discourse, as if it exceeded character boundaries. It is in her look that he sees his own death, in his look that she sees his death, and, finally, in her body that he sees death inscribed. Which is to say that death *is* nowhere but is bound to the look of the other, bound into the gaze upon the other.

There is more to the malady, however. "You ask: 'why is the malady of death fatal?' She answers: 'Because whoever has it doesn't know he's a carrier, of death. And also because he's likely to die without any life to die to, and without even knowing that's what he's doing' " (p. 19). It is as if death were separated from its own fatality, at the same time that it can not be fully separated from life. Thus, the text arrives at an unresolvable problem: how can these terms be differentiated?[6] Can one fix their difference in representation?

When the woman is gone, "the difference between her and you is confirmed by her sudden absence" (p. 52). *A* difference, then, only gets established by an absent term, in and through representation. This loss generates a story, but one we do not hear, told in a bar the following day. Only its telling is described; the story is never told. "At first you tell it as if it were possible to do so. Then you tell it laughing, as if it were impossible for it to have happened" (p. 53). Indeed, this whole text is founded on the impossibility of telling: telling the story, telling the difference, telling a death.

Love, difference, and death, all unsituated, seem to emerge only as passages through a space that confuses "before" and "after," in which no punctual event can occur, no narrative is possible. "Even so, you have managed to live that love in the only way possible for you. Losing it before it happened" (p. 55). This whole text is founded on the reading and recitation of what cannot be narrated or even held in view, held in frame, since the text is reframed immediately in the post-face.

The impossibility of love, which would depend on a sufficient or stable difference between these two figures, is replicated in our inability to attain a stable differentiation from the "you." But how, within this space of indifferentiations, are we to account for the sexual difference that organizes the whole textual scene—the exchange between the man and the woman? How are we to account for the weight of sexual difference as it imposes itself in our reading? In a text which demonstrates that neither death nor difference can be punctually or permanently embodied, the body nevertheless remains in the resistant presence of actors' bodies and in the site of reading itself. The "identificatory" lure of the direct-address "you" meets resistance or interruption when it is occupied by the gendered body of the reader, who might find her body interfering here. Or, should she separate her reading from her body, she does so only through a gesture that then forces her to recognize a division within reading—either she reads from and through a gendered body or her reading is disembodied.

Finally, there is another crucial difference to be accounted for: that of the actor reading the text and of the silent, unseen man whose story is told. Since his place onstage is occupied by a stand-in, the man is also split, utterly noncoincident with himself. He is both the central figure and an absent third. But the spectator is also an absent third: the absent, abstracted addressee and voyeur exploring the woman's body staged for our look and for the man's story read alongside it. But this problem of differentiation is contagious on the larger textual level, for this sexual scene is repeated in several other texts. This drama of failed

exchange between a man and a woman, where the man dominates a nearly silent, abandoned woman, first appears in a short text, *L'Homme assis dans le couloir* (written in the late fifties or early sixties and later re-written and published in 1980). At that time, Duras writes, she made a number of discoveries about her text. That is, the new text is a completely redone version based on what she read in the old text. "Then I found out that the lovers were not isolated, but seen, doubtless by me, and that this seeing ought to be mentioned, integrated into the action" (Lydon, p. 269).

Here again is a third term, another subject whose ambiguous voyeurism haunts the text. This text is a short narrative of a sadistic sexual scene in which the woman performs fellatio on the man, who then urinates on her, steps on her, kicks her, makes love to her, and finally, at her request, beats her. During the first sequence of events, the narrator makes her only intervention in the scene: "I speak to her and tell her what the man is doing. I tell her what is happening to her. What I want is for her to see" (Lydon, p. 270). We are made aware that our view of this scene is focalized by an "I," who is a woman ("I see that other people are watching, other women" [Lydon, p. 275]). But the relation of this woman narrator to the scene observed is impossible. Her voyeuristic distance is undermined by the movement of narrated discourse. Yet even here, entering the scene, she only does so to narrate, to tell the woman what we already know—what is happening to her. The relation between knowing and seeing is rendered ambiguous. At the end she says, "I see nothing of her except her motionlessness. I haven't a clue; I don't know a thing; I don't know whether she is sleeping" (Lydon, p. 275). In this discourse that inverts and destroys the equation of seeing with knowing, what is the place of the partially absent third for whom the scene is staged? What is our place as readers?

This question has gained a particular urgency, given that the text has been disturbing to many feminist readers because it figures a fantasy of a woman voyeur watching the beating of another woman. Consequently, it operates on a split feminine identification. But even this split identification is unstable, since the text implies a circulation of positions akin to that of the fantasy structure Freud examines in "A Child Is Being Beaten." In this regard, Mary Lydon's contention that *L'Homme assis* produces a "linguistic subversion of sexual identity," where "the 'pure' sexual difference, the difference between the sexes that the narrative of *L'Homme assis dans le couloir* might be thought to impose is contaminated, subverted at the textual level, the level of the signifier," is crucial to a reading that would be equal to the text's complexities

(Lydon, 264 and 265, respectively). Not only are the referentially gender-bound words used in the text undermined by their linguistic genders in French, but the text's recapitulation of Freudian fantasy structure indicates that position and gender do not remain fixed or coherent with each other.[7]

A reading of Freud's essay on the sadistic fantasy, "A Child Is Being Beaten," reveals a circulation of positions through grammatical structures of pronouns whereby the subject of the fantasy is not fully inside it, not fully outside, not permanently located in active or passive position, and not bound to gender position. (Freud's remarks reveal that the girls' fantasies about a child being beaten are composed of several phrases between which subject and object are transformed. Genders are conferred upon them in the following sequence: a child is being beaten; my father is beating the child, who is a boy; I am being beaten by my father). What is crucial in this reading of fantasy structure is that gender is circulating, constructed in the telling or representation. It cannot be anchored to activity or passivity, since even these are seen to be positions, postures established in relation to each other.

L'Homme assis is conditioned by a structure whose circulating positional effects are reproduced in *The Malady of Death,* a text than can be read as its reenactment, its rereading of *L'Homme assis. The Malady* displaces these positions to locate a third term offstage as the central one, while playing on a structure of voyeurism whose mediation through reading is literalized here.

This reenactment itself becomes a grounding, a kind of original trauma repeated in a later text, *Les Yeux bleus cheveux noirs,* which once again stages a series of paid nights between a man and a woman. Again there is an absent third male, but this time he is the lover the man has lost—and, as the text will later reveal, the one the woman has lost also. The discursive exchanges of these nightly encounters are organized around repeated *récits* and descriptions of this missing lover as well as of another man the woman sees during the daytime. What the "lovers" in question exchange, then, is stories about departed lovers. Again the woman is nude, this time veiling her face in black silk; again the man hits her. Again the figures are brought together and held apart by a story exchange.

The reenactment that has been so central a feature of Duras' work strikes a resonance with Freudian psychoanalytic studies of recollection and repetition, specifically, as detailed in "Further Recommendations in the Technique of Psychoanalysis: Recollection, Repetition, Working Through." In Freud's later work on therapeutic technique, he recog-

nizes that what the analysand cannot recollect will be acted out in repetition which does not know itself as such; that is, in repetition which replaces remembrance. In the analytic situation the goal of "working through" is achieved through the construction of an artificial repetition, the transference of the forgotten past onto the current analytic scene.

Repetition, then, is reframed when it is inserted into the analytic situation. Within this frame the analysand can *read* his own memory, lost to him, in the unconscious reproduction or replaying which has replaced it. Ideally, then, one remembers by reading one's own performance in the analytic situation. It is the reproduction which is supposed to revive memory—that is, the reproduction generates the "original" memory as its own production. Thus, the scene of psychoanalytic interpretation is also a stage. The analytic situation is the theater in which the subject's drama of repetition is reframed, set off from life, so that it may be read and analyzed. Transference effects, then, include the transfer of repetitions of the unremembered past into the analytic space as well as the performance of past conflicts upon the relation with the analyst, as in transference love and hate. Transference is a matter of performance, reading, and interpretation.

Duras' works ask us to consider the metaphoric and metonymic relays of transference which may be at work in our reading and interpretation of the reading and performance that they stage. Grounded in the fundamental imbrication of production and reproduction, where reproduction/repetition is posed as the "originary" moment, Duras' work confuses internal and external textual boundaries. It dissolves the borders between repetition as memory and repetition as forgetting, between reading as interpretation and reading as performance. Within the performative space itself, it rejects a division between the performance on the stage and the spectator/reader's performance.

Les Yeux bleus cheveux noirs textually actualizes the problem of confused borders between narration and performance. This text begins and ends with a discourse attributed to *l'acteur,* "the actor," someone whose situation in (or in relation to) the text and its story is never specified. He operates as a kind of internal gaze from elsewhere, an incorporated frame. " 'Une soirée d'été,' dit l'acteur, serait au couer de l'histoire" (p. 9). This is the first line of the text, which will end with several passages spoken by the actor:

C'est la dernière nuit, dit l'acteur. Les spectateurs s'immobilisent et regardent dans la direction du silence, celle des héros. L'acteur les désigne du regard. . . . Leur regard est effrayé . . . toujours cou-

pable d'avoir été l'objet de l'attention générale, celle des actuers sur la
scène et celle des spectateurs dans la salle.

It's the last night, says the actor. The spectators are immobilized and
look in the direction of the silence, that of the heroes. The actor indi-
cates them by a look. . . . Their gaze is frightened . . . still guilty of
having been the object of general attention, that of the actors on stage
and of the spectators in the house. (pp. 159–60)

In this continuous undifferentiated look, shared by spectators and
actors, it is impossible to separate the house from the stage. Such in-
differentiation is reproduced in the continual reenactment of the text's
performance:

La salle serait dans le noir, dirait l'acteur. La pièce commençerait sans
cesse. A chaque phrase, à chaque mot.

Les acteurs pourraient ne pas être nécessairement des acteurs du
théâtre. Ils devraient toujours lire à voix haute et claire, se tenir de
toutes leurs forces exempts de toute mémoire de l'avoir jamais lu,
dans la conviction de n'en connaître rien, et cela chaque soir.

The house would be in the dark, the actor would say. The play would
begin continually. At each phrase, at each word.

The actors might not necessarily be stage actors. They should al-
ways read loudly and clearly, making every effort to remain free of
all memory of having read it, with the conviction of not knowing any-
thing about it, and this, each evening. (p. 49)

This theatrical reading asserts a radical separation between repetitions
that do not know themselves as such, and which is articulated as a
separation of staged reading from knowledge and memory. The status
of reading here is always in question and under transformation, as is
evident in the final indifferentiation, established in several registers:
those of the reading, the performance, and the gaze surrounding this
scene:

L'écoute de la lecture du livre, dit l'acteur, devrait toujours être égale.
Dès qu'entre les silences la lecture du texte se produirait, les acteurs
devraient être suspendus à elle et, au souffle près, en être immo-
bilisés . . .

Les acteurs regarderaient l'homme de l'histoire, quelquefois ils re-
garderaient le public.

Des événements qui seraient survenus entre l'homme et la femme,
rien ne serait montré, rien ne serait joué. La lecture du texte se pro-
poserait donc comme le théâtre de l'histoire.

Listening to the reading of the book, says the actor, should always be
the same. When, in between the silences, the reading happens, the

actors should be suspended upon it, and except for their breathing, completely still . . .

The actors would look at the man of the story, sometimes they would look at the audience.

Of the events which would have occurred between the man and the woman, nothing would be shown, nothing would be acted out. The reading of the text would offer itself, then, as the story's theater.

(p. 38)

This maneuver supports the overall textual strategy, which inverts conventional relations of reading to script, where the script is conceived as outside of and prior to theatrical performance. Here the narrative is the theater of its own performance; it is thus split by the intrusion of an elsewhere. Its destabilized boundaries are replaced by perpetual reframings which produce a mobility of address that entails continual reconstruction of the spectator/reader position.

In their obsessive restaging of a scene of sexual desire and violent separations, Duras' recent works suggest that sexual difference is never stable nor in place; indeed, they suggest that it has no place. Rather, it is perpetually staged and restaged, read, reread, and constructed, just as it is constructed on the sites of reading mapped by these textual performances.

Notes

1. Indifferentiation is contagious. It is obliquely connected to critical issues surrounding these texts. It would be fair to say, I think, that Duras' critics frequently suffer from an inability to separate their discourse from that of the texts. This inability is expressed through meditations on her texts which mimic their style, which reproduce, in an attenuated form, the textual gestures they attempt to analyze. As such, Duras' texts threaten to leave us speechless or reduced to the "already said."

2. I want to express my appreciation to my colleague David Pollack for reminding me, in reference to a different subject, of the possibilities in the pair remembering/dismembering. He suggests this might provide an interesting opposition from which to consider structures of the gaze, particularly as it is organized around sexual difference.

3. Such conflict between levels and modes of discourse has long been thematized within Duras' work. More recently, however, these resistances have been increasingly produced on the performative level. One of the earlier emergences of such a struggle appears in *Le Camion* (Paris: Minuit, 1977), a film-text which stages a conversation between a long-distance truck

driver and a woman passenger as they follow his highway route. In this case the actors are never photographed in the truck. Rather, we see shots of a truck rolling down a highway, crosscut with scenes of the two actors, Duras herself and Gérard Depardieu, as they sit in her house and read their lines from scripts. The film itself is framed by Duras' discourse about it, a discourse which often enters the diegesis and which is cast in the conditional.

4. Unless otherwise stated, all translations are my own. Here I have tried to maintain the repetitive minimalism of the passage by using only one verb, however awkward, for acting. *"Jouer"* and "to play" are roughly correspondent in that they are both more normally connected to the noun "role," as "to play a role."

5. I have considered these issues and some of these texts in somewhat sketchier detail and within a different framework in the last chapter of *Marguerite Duras: Writing on the Body* (Urbana and Chicago: University of Illinois Press, 1987).

6. See Jacques Derrida, *La Carte postale* (Paris: Flammarion, 1980), for an explanation of Freud's writing on the repetition compulsion in *Beyond the Pleasure Principle,* where the theoretical enterprise dedicated to distinguishing and mapping the interactions of the pleasure principle and the death drive founders on its own discovery that these two principles keep turning into each other. They remain inextricable from one another, an imbrication which is replicated in the relation of representation to the unrepresentable.

7. The comments which follow were inspired by Mary Lydon in a conversation following a reading of her translation of *L'Homme assis* and of a critical analysis of the text. It was she, I believe, who originally suggested that I look at "A Child Is Being Beaten" in relation to this text.

Bibliography

Burt, E. S. "Poetic Conceit: The Self-Portrait and Mirrors of Ink." *Diacritics* 2, no. 4 (1982), 17–38.

Duras, Marguerite. *L'Homme atlantique.* Paris: Minuit, 1982.

———. *La Maladie de la mort.* Paris: Minuit, 1982.

———. *The Malady of Death.* Translated by Barbara Bray. New York: Grove Press, 1986.

———. *Savannah Bay.* Paris: Minuit, 1983.

———. *Les Yeux bleus cheveux noirs.* Paris: Minuit, 1986.

Freud, Sigmund. "A Child Is Being Beaten." In *Sexuality and the Psychology of Love,* edited by Philip Rieff, pp. 107–32. New York: Macmillan, 1963.

————. "Further Recommendations in the Technique of Psychoanalysis: Recollection, Repetition, Working Through." In *Therapy and Technique,* edited by Philip Rieff, pp. 157–66. New York: Macmillan, 1963.

Lydon, Mary. "Translating Duras: *The Seated Man in the Passage." Contemporary Literature* 24 (1983), 259–75.

From Split Subject
to Split Britches

Sue-Ellen Case

Plays, practice, and criticism inhabit a common field in contemporary feminist production. The historical bond between feminist political practice and critical theory has created the sense that a feminist field or ambience can embrace aesthetic, political, and critical modes of production. The old patriarchal notions of inheritance and influence give way to a new sense that art and life may not be two distinct phenomena, followed by critics the way Mother Courage followed the war. Rather, the representation of women on the stage, the experiences of women in real life, and the discursive knowledge about women exist in a contiguous relationship with one another. They nourish and adjust one another within their specific historical moment. Such a healing of the art-life-criticism schism is the inheritance of a movement that focused on "consciousness-raising" and "the personal is the political." This new field theory enables the critic to perceive recent plays by women playwrights, recent feminist theory, and recent discoveries in critical methodology as interactive and interdependent within the last two decades of the liberation of the feminine gender.

Within this new field theory of feminism, the term *subject position* has come to signify an important move for women that is incorporated in the creations and explorations of theorists, artists, and critics alike. Several plays by contemporary women playwrights construct women in this subject position, providing new images of women and their experiences along with new structures for their representation. These plays dramatize the difference between women as objects (sexual objects, etc.) and women as subjects of the drama. At the same time they alter the structure of the subject position from its old appearance as protagonist to new forms of the subject's appearance and development. This innovation participates both in advances in feminist social practice

and in recent explorations in feminist thought. In social practice women have agitated to occupy the subject position in their struggle for economic independence. Rather than being the objects of exchange[1] or the recipients of patriarchal charities, they have sought to become the subject that makes transactions, much the way the subject moves the verb in a sentence. This move is contiguous with their new position onstage. Likewise, in feminist theory, the project to move women into the subject position of philosophical, linguistic, psychoanalytic, and symbolic systems in general participates in this same field of endeavor.

However, this feminist field is not a homogeneous one. Inner dynamics exist that sometimes resemble internecine nodes of contradiction and debate. The notion of a subject position is a destabilized one, animated by older debates about form and content, material base and essentialist assumptions, and even positions that are characterized by national borders. Because some readers of this present volume may not be familiar with the notion of the subject position and its historical development in feminist circles, I think a brief and perhaps oversimplified excursion into its theory, preceding its description in specific plays, may provide such readers with access to the contemporary feminist playing field.

Here the term *subject position* derives from feminist uses of semiotic and Lacanian notions of the subject. The formulation of a subject position eschews the former Cartesian conflation of the subject position in a linguistic or symbolic system with a "self." The term *position* foregrounds the structural role of the subject-in-discourse, alienating it from its traditional adumbrations of the personal. Descartes also linked that position with a certain epistemology in his "cogito," a link that Lacanian psychoanalytic theory exposes as structural contortions or sutures on the pseudoseamless surface of discourse that cloak the essentially split, alienated structure of the subject from itself.

The notion of the subject position is thus both deconstructive and constructive. Originally, it was developed as a deconstructive device by male authors who employed it to break with the epistemological and ontological foundations of idealism, but who retained its patriarchal bias. Much of the "feminist"[2] theory of the subject position has been developed by French authors who have deconstructed the theories of Derrida, Lacan, Lyotard, Blanchot, and others to accommodate the presence of gender inscription in theoretical models.[3] These French theoreticians insert a new notion of woman-as-subject into psychoanalytic, deconstructive, and poststructuralist strategies. Their realm is pure theory, deriving from and correcting influential contemporary theo-

ries that retain patriarchal prejudices, in spite of their liberating and deconstructive projects. In contrast, the Anglo-American tradition of feminist thought consistently places theory and literary texts in relation to social practice and the "real lives" of women. Though American feminists are receptive to French theory, they are frustrated by its seemingly hermetic and formalistic nature.[4] This theory is so complex and dependent on its earlier models that it is difficult to expropriate elements from it for the purpose of social or critical application without misreading its meanings. Therefore, the critic finds herself so caught up in the internal structures of the theory that she cannot bring it into relationship with current political objectives.

Nevertheless, for the critic to remain within the exclusivities of either of these two traditions creates something like a form and content split. Typically, the Anglo-American feminist critic explicates texts in terms of images of women and narratives that either replicate, deviate, fictionalize, debase, or ignore the "real" experiences of women. In this way she deals primarily with the content of plays, noting the positive or negative implications of the narrative (e.g., the negative plot line illustrates the oppression of the female protagonist and kills her in the end), or the positive and negative content in the image of the woman (e.g., she is a whore, witch, bitch, etc.). She establishes this positive-negative charge by comparing it with the ways in which real women experience life or real men misperceive them. Moreover, the context she employs for this analysis is one of two economic and social conditions. This kind of political analysis is reminiscent of the content analysis Marxist critics used before the discoveries of the Frankfurt school, concentrating on the positive image of the proletarian hero and the constructive plot line of the social realist drama. Like Marxist criticism, this content analysis illustrates the materialist base in the play. It provides for a discussion of class, economic exploitation or independence, and a historical frame, which is relatively absent in the French theoretical models. However, the French theoretical contribution allows the feminist critic to pursue an analysis of the formal elements of plays. More importantly, the French theories critique the overall operations of the system of representation, discourse, and cultural production. While the Anglo-American framework is "real life," the French one is the system of representation.

At this point in history, most Anglo-American critics perceive the vital interaction between these two realms: how a tradition of the representation of women creates their social condition and vice versa. Hence,

the feminist field theory begins to emerge. From the perspective of this field, the oppression of women appears as twofold: material oppression and oppression in representation. Thus, the form and content split begins to disappear. As symbolic systems masculinize the subject (perhaps most simply demonstrated by the use of the "universal" pronoun "he" for the subject of action), structuralizing male dominance in systems of thought, so do male images of the subject and female images of the object masculinize the content. Furthermore, male ownership in the economic realm and male authority in the social one along with these structural and thematic elements of representation codetermine the position of women in society. Art is no longer a "mirror" of life but an active force in social manipulation, while real life is no longer merely the image one sees in the mirror of art but the social structure that organizes its form.

Thus, moving women into the subject position in any realm is contingent upon their position in the others. Making a woman the subject of the drama implies her position in the system of representation, both structurally and thematically, as well as her social and economic position in the culture at large. In order to account for the revolutionary move for women from the object position to the subject position in the drama, I will break with the orthodoxy of the French theoretical model, using its terminology and concerns for a critical application to the drama. In fact, some of the Lacanian terms, still laden with patriarchal bias, will become neologisms for critical notions that account for women as subjects. At the same time, by placing theoretical concerns in conjunction with the social concerns of Anglo-American feminist criticism, I will illustrate a way in which class and form, content and social structure cohabit the feminist field.

In recent plays by women playwrights, three kinds of subject positions emerge: the split subject, the metonymically displaced subject, and the collective subject. All three types have appeared in plays written within the last two decades of feminist development. At the same time, theoretical and critical explorations of women in the subject position have discursively developed these same structural positions. Though there is no chronological or developmental sequence in the appearance of these positions, I have organized them to move from the simplest to the most complex. The split subject seems an apt place to begin, since that notion underpins much of the understanding of the subject position in general. In appropriating the term *split subject* from Lacanian discourse, I will employ it in order to maintain its references to the psychoanalytic

critique while employing it also as a neologism for a certain literary device.

The Split Subject

For the classical Lacanian male subject, the split of the subject is between his subject position in discourse and his subjectivity, or self in reality. Though the male subject appears as a single, unified position in the discourse, such as the protagonist, the Lacanian system reveals a split between that socially constructed, autonomous, continuous "subject" of discourse and actual subjectivity. In fact, as the subject of discourse appears, the "real" subject "fades" away. The construction of this subject of discourse occurs in what Lacan calls "the mirror stage." The metaphor of mirror works as a social reflection, in which the infant sees the structure of a whole self, as a baby might learn to see "himself" in a mirror. When he enters the system of representation, he does so in this unified form, becoming the traditional subject of discourse. While he gains access to symbolic systems, he loses access to the immediate satisfaction of his desires, but not the drives of those desires—thus, the notion of the split subject. This subject of discourse, then, travels through symbolic systems endlessly seeking the satisfaction of his desires in surrogate symbols, alienated from his actual subjectivity. Systems of representation can then be read as his itinerary of desire.[5] Ironically, male poststruturalist criticism and postmodern literature are decentering the subject, vacating that position, at the same point in history in which women seek to inhabit it.

This notion of the split subject is based upon certain premises about the psychosexual development of the male child, including ideas about the phallus and the working out of the Oedipal process. Lacan's split subject is constructed upon a development and a physiology the female child does not share. Therefore, when she looks in this mirror, when she enters the system of representation, she does so as a cultural male. Because the subject of discourse or representation is gendered as male, women cannot inhabit the position in the same way unless they do so as male-identified subjects. That is, insofar as women have identified with men in order to enter representation at all, the system works the same way. Yet, if I might expand Lacan's metaphor in order to include the possibility of the female subject, "she" also sees in that mirror that she is a woman. At that moment she further fractures, split once as the male-identified subject and his subjectivity and split once more as the

woman who observes her own subject position as both male-identified and female. She acts in the system in the male position, but she also marks that position with her own female action. This produces a double split for the woman subject: she is split in the way the Lacanian subject is split, but she is also split in the discourse. She cannot appear as a single, whole, continuous subject as the male can because she senses that his story is not her story. Yet she entered the doors of discourse in male drag. This contradiction produces the split-subject-in-discourse. To amend Lacan, I would like to use this term *split subject* to represent this new position for women in discourse. Here it means that when women enter the subject position in discourse, they split the subject of discourse (while still maintaining the classical, Lacanian split). The following plays exemplify the use of this split subject in the system of representation as well as dramatize its inner tensions.

In *The Abdication* (1969) by Ruth Wolff, the subject of the drama, Queen Christina of Sweden, is split into three parts: the mature Christina and her childhood selves, Chris and Tina. Tina represents the "meek and docile" side of Christina, while Chris is the "more jaunty side," entering in drag as a young man.[6] Scenes with Chris, Tina, and Christina play simultaneously upon the stage, dramatizing the interactions among the parts of the split subject. The split subject represents an ambivalence about power: Tina and Chris fight over the symbols of the queen, while the mature Christina watches, caught up in a present-time dialogue with a member of the Vatican. A similar split subject appears in Marsha Norman's *Getting Out* (1978), in which the mature Arlene appears in the present time, recently released from prison, while her younger self, Arlie, simultaneously plays scenes from her childhood and her time in prison. Arlie is played as a tomboy who seeks out conflict, and Arlene is portrayed as a recently converted young woman who seeks to appease the system and her mother. Likewise, in *Giving Up the Ghost* (1986) by Cherrie Moraga, the main character is split into Marisa, a "Chicana in her late 20s" (the present time), and Corky, "Marisa's younger self, at 11 and 17 years old."[7] The focus of this subject is upon sexuality. Marisa seeks to resolve her lesbian sexuality in the present, while Corky represents her earlier male identification in *"cholo"* drag. *Blood Relations* (1979) by Sharon Pollock is a play about Lizzie Borden. Lizzie is sometimes played as Lizzie and sometimes played by an actress/friend, while Lizzie looks on. In some scenes Lizzie plays her own maid to the actress/friend who is playing Lizzie. The younger Lizzie is rebellious and brash, while the present-day Lizzie is more accommodating.

All of these plays represent the woman in the subject position as a split subject. Moreover, these split subjects share many similar attributes. They present the contemporary subject who is attempting to adapt to social codes after undergoing a chastening socialization process: Christina in the Vatican, Arlene on parole, Marisa attempting to become less alienated from her ethnic identity, and Lizzie after her murder trial. At the same time they provide an image of an earlier, often male-identified rebellious subject. The split subject in these plays illustrates the way in which women as subjects alter the structure of the subject position by splitting what had formerly been represented as a whole. The prevalance of younger, male-identified selves parallels the notion of women entering the system of representation as men. In order to inhabit the subject position, they entered as male-identified. Yet the mature subjects, identified as women, must struggle with that earlier identification, both to overcome it and to retain its power. The mature women, placed within the context of chastening institutions of socialization, distance themselves from their entrance into the system, while still maintaining themselves in the subject position. Lacan was therefore correct in describing the subject as male, caught up within his psychosexual development. In *Giving Up the Ghost* Moraga dramatizes explicitly the psychosexual dimension of the struggle. All of these plays, by placing the subjects in the context of social institutions, illustrate the Lacanian sense that the subject of symbolic systems is a socially contructed one, alienated from pure subjectivity. Yet they add another dimension to Lacan's system: the split between a feminine consciousness and its male-identified symbolic role.

These examples may also be read as dramatizations of women's struggle with cultural ownership. Phrased in this way, the elements of a social, material analysis and those of a formal one come easily into relationship with one another. After all, the subject owns the drama in the same way as the subject owns property or social authority. The subject's experience defines the parameters of the dramatic field. Other characters become relegated as objects of her affections, hostilities, losses, and triumphs. Traditionally, this subject position has been gender marked by the prevalence of male protagonists. The male subject's ownership of the play mirrored the male's ownership of property rights in the culture at large. The recent rise of women playwrights and feminist perspectives on the lives of women emerges from a long history of women as objects in the male subject's drama. Against that historical backdrop, the female subject, as created by women playwrights in the

"age of feminism," assimilates the owner position of the subject with some trepidation and ambivalence. Looking back at traditional dramas, the woman subject steps onto the stage with a leftover feeling that she has no right to it. She might own the drama as a male-identified woman, but she is amazed to see a female face in the "mirror" of symbolic systems.

In his book *Saint Genet,* Jean-Paul Sartre describes a similar split subject in the works of Genet, relating it to his ambivalence about ownership. Sartre suggests that Genet's experience as an orphan, taken in by surrogate families, may have produced a split in Genet's personality as well as in his works: "Genet transfers to himself the owner's gestures and sensations so as to identify himself with the latter by an effort of mind. He takes in order to convince himself that he has the right to take; he eats as an actor eats on the stage; he is playing at possession; he embodies the owner as Barrault embodies Hamlet. However, he makes, at the same time, a considerable effort to be his own audience so as to catch himself in the act of possessing."[8] This dynamic might also describe the woman as split subject of the drama. She takes the subject position, still convincing herself that she has the right to it, and she is her own chastened audience for her earlier, brash entrance into the system. This multinomial position marks her ambivalence in taking the role, raises the issue of her right to it, and marks her observation of herself in such a position. As she watches her younger, male-identified self, which is judged as guilty by social institutions, she resembles the thief Genet as Sartre describes him: "He is obliged, by error, to use a language which is not his own, which belongs only to legitimate children. Genet has neither mother nor heritage—how could he be innocent? By virtue of his mere existence he disturbs the natural order and the social order."[9]

This assimilation of the role of the owner of the drama onstage coincides with women's social move toward financial independence and social authority. In fact, within the content of these plays, these women are involved in a move for independence. They bear the emotional scars of "getting out" of the old object position and "getting in" to the subject position. Arlene, Christina, Marisa, and Lizzie Borden struggle for independence from the judgments of the courts, the penal system, the church, and the restrictions of an ethnic community. They provide images of women in transition from their social and cultural inheritance of repression to the liberation of self-definition. In this way the Anglo-American feminist criticism and the French theoretical one merge to

describe the double oppression and liberation of women as inscribed in plays written during the first seventeen years of the feminist movement.

The Metonymically Displaced Subject

The split-subject-in-discourse seems a stable, simple structure compared with the metonymically displaced one. In this mode the subject further fractures into multiple displacements across the stage and is transmutable during the course of the play. Rather than inhabiting a stable, split position, it may move from position to position through the dynamic of displacement, leaving only its itinerary as a sign of its presence. In fact, in several of the plays that exhibit this device, the subject position is not always an incarnate one. The subject may be located in offstage voices or voice-overs. Several recent plays by women playwrights exhibit the appearance of the metonymically displaced subject. Perhaps three of the richest are *The Portrait of Dora* (1976) by Hélène Cixous, *The Singular Life of Albert Nobbs* (1977) by Simone Benmussa, and *India Song* (1972) by Marguerite Duras.

The Portrait of Dora locates this subject within the setting of Freudian analysis, problematizing the presence of the desiring female subject within the patriarchal operations of Freudian psychoanalysis. Cixous depicts Freud's misrepresentation of his patient and foregrounds the limitations of his method when confronting a female subject. To do this she has chosen to dramatize one of Freud's case histories in which he admitted his own defeat. While Freud is portrayed by a single character, Dora, the female subject, is drawn by displacing the subject position through memories, characters Dora invokes, and voice-overs of her internal monologue. In *The Singular Life of Albert Nobbs,* Albert's subject position is likewise constructed by a character onstage, voice-overs of her own inner monologues, and even the voice of the narrator who describes her. These plays suggest a sample of works a reader might consider for the construction of this subject position. However, because of the complexity of this construction and the dense, opaque nature of the theoretical apparatus, I would like to focus this section on the close reading of *India Song* as a single text that illustrates the metonymically displaced subject position. Once more, I consider it necessary to provide a condensed exposition of certain elements within the Lacanian system before proceeding to their actual application to the text.

The mechanism of displacement is usually tied to the object position.

Since, in the Lacanian system, the subject in discourse lacks access to the actual satisfaction of his desire, a metonymic displacement of that desire substitutes for that lack. There is a similarity between the trope of metonomy and the dynamic of displacements in that both exploit "relationships of contiguity between things."[10] The prohibited object of the subject's desire is metonymically replaced by an uncensored one through displacement. Kaja Silverman, in *The Subject of Semiotics*, illustrates this process by examples from Proust's *Remembrance of Things Past*. She traces Swann's metonymic displacement of his desire for Odette through his attachment to Vinteuil's sonata, Odette's apartment, her clothing, and the street on which she lives. Silverman cites the scene in which Swann first kisses Odette, "after virtually ravishing the flowers she is wearing."[11] Odette's absence is the motor for Swann's desire that moves him through attachments to places and things contiguously associated with her. In the Lacanian system this process is much more complicated, implying a certain relationship to the pre-conscious, the unconscious, the veiled phallus, and other related processes. However, for the purpose of this essay, perhaps this example can serve to illustrate how displacement works.

India Song incorporates the metonymic displacement of both the object of desire and the subject position. The basic metonymic trope is the story of Anne-Marie Stretter—the object of desire, metonymically displaced by her lovers' memories of her and their attachments to places and things related to her. Yet the desiring subject, unlike Swann, is not represented by one subject position. Rather, the desiring subject of Stretter moves through four voices-overs, onstage characters, and off-stage voices. Within the gendered drama of desire, structural relationships are altered by female inhabitants of subject positions and determinedly fixed by male ones. The subject positions are inhabited by members of both sexes, whose genders mark their relationship to subject-object relations.

In this play absence reigns supreme, driving the play through contiguous positions of the desiring subject. The basic framework of the drama is constructed by the multiple subject position of four voices numbered 1 through 4. Stretter and the other characters onstage never speak; they stand as mute monuments of others' desires.[12] Voices 1 and 2 carry much of the narrative of the play. Duras introduces them in this way:

> Voices 1 and 2 are women's voices. Young. They are linked together by a love story. Sometimes they speak of this love, their own. Most of the time they speak of another love, another story. But this story leads

us back to theirs and vice versa . . . the women's voices are tinged with madness . . . most of the time they are in a state of transport, a delirium, at once calm and feverish. . . . They are most immediately present when they veer toward their own story—that is, when, in the course of a perpetual shifting process, the love story of *India Song* is juxtaposed with their own.[13]

Voices 3 and 4 enter in the third section of the play. They are men's voices. "The only thing that connects them is the fascination exerted on them by the story." Voice 3 has forgotten most of the story, and Voice 4 "has forgotten it the least" (p. 105). Duras stresses the subject as position by developing not characters for these voices, but relative positions in relation to the story. In her description of Voices 1 and 2, her indication of the "perpetual shifting process" and "juxtaposition" suggests the process of metonymic displacement as a key to the construction of the piece.

Since Stretter's voice is mostly silent and her body often immobile and inaccessible, the sounds of rain, distant voices, and music metonymically displace her as the object of desire, projecting the subject position outward through the four voices and the audience as well. Like Vinteuil's sonata to Swann, the pervasive sound of the India Song recalls the passion and desire aroused by the story of Stretter. Yet the India Song is not the property of one character's desire but permeates the play, affecting characters onstage, the voices, and the audience at large. The drama is implied as the audience enters into the atmosphere of desire. Subject positions occur at interstices of memory, sensual affect, and the sight of Stretter. This is composition by contiguity. Because the play hinges upon voyeurism, created through voices watching the silent Stretter, invisible to her and aroused by the sight of her, the audience enters into this dynamic as another voyeur, caught up in the drama not only through empathetic relationships to the multiple character positions but also by its own voyeuristic relationship to Stretter, until the song, the sights, the street noises, and the sight of Stretter work on it in the same metonymic fashion as on the other characters. Duras notes that the stage "plays the part of an echo chamber. Passing through that space, the voices should sound, to the spectator, like his own 'internal rending' voice" (p. 49). Duras may even have created the spectator as a subject position.

Subject positions are also represented by characters onstage who act out the metonymic displacement of the object of desire. One such character enters, suffused by his love for Stretter but shut out of her world. He discovers her bicycle standing near the tennis courts. Duras describes

his stage action in a lyric description of displacement. The lyricism is an affect in the drama, marked by a division into poetic lines. It is constructed like a *tirade* of desire: "The man is beside the bicycle. / Puts out his hands. Hesitates. / Then touches it. / Strokes it. / Leans forward and holds it in his arms. / Stays clasping Anne-Marie Stretter's bicycle—frozen in this gesture of desire" (p. 39). During this time Stretter is asleep onstage. As he bends over the bike, she sits up, watching him caress it. The focus moves from watching him to watching Stretter watch him. In this scenario of desire the displacement of the subject position moves back and forth across the stage.

The feminist interest in this play and its utilization of this theoretical apparatus lies in the gender of the object of desire and in the gender marking of the subject positions. Duras creates each subject position solely through its desire for the object. In this way she focuses the dramatic experience on both the subject and the object. The object of desire is a woman. It is her nude body, her particular kind of inaccessibility and seductive quality, that yields the metonymic displacement. Duras foregrounds the tradition of this construction of woman in the object position by heightening every traditional sign in that system. Her nudity, the stage images of men caressing her while she remains immobile, the image of the man with the bicycle, the dislocation of her story from her voice to those of others, all foreground the traditional gender role of that object. She yields meaning and discursive subjectivity to the subject, but is exiled from that condition. Her appeal lies in the profusion of signifying networks established by her inaccessibility. She is immobile and silent, bound and gagged, forced to yield. The object reality of Stretter is also built into the narrative. When the play begins, Anne-Marie Stretter is dead; during the course of the play she slowly comes to life, and at the end she commits suicide, remaining a corpse onstage.

The Lacanian system is aligned with this stage tradition of woman as object. Sharing the patriarchal bias of the stage tradition and working in the order of discourse found in the patriarchal culture at large, the Lacanian subject position is gender marked as male. His desire, codified by the Oedipal process, is for the female. Women, then, are locked into the object position, and Lacan specifically noted that it is women who inspire metonymic displacement. He cites "certain passages of Tolstoy's work; where each time it is a matter of the approach of a woman, you see emerging in her place, in a grand-style metonymic process, the shadow of a beauty mark, a spot on the upper lip, etc."[14] Because of the supremacy of the family unit in the Freudian-Lacanian Oedipal process and the heterosexist bias, the male necessarily desires

the female and places her in the system as "other." Duras foregrounds both the "otherness" and the gendered object position of Stretter.

However, Duras transposes this female object into the context of an unusual subject position—the lesbian desiring subject of Voice 2. The representation of lesbian desire in *India Song* controverts both the patriarchal and the heterosexist biases in the psychoanalytic system. It is this desire that motivates the interaction between Voices 1 and 2, establishing the quality of their presence. Yet the expression of lesbian desire is not reciprocal; when Voice 2 professes her passion for Voice 1, she meets with no response. The silence of Voice 1 propels both voices back into the story of Stretter. It is as if the daring, revolutionary lesbian subject position is repressed by the silence of Voice 2 and replaced by the representation of woman-as-object. Voice 2: "I love you so much I can't see any more, can't hear . . . can't live. . . . *No answer.*" Then the India Song is heard again in the background, and the sounds of Calcutta and the characters onstage become animated (p. 18).

Nevertheless, Duras pointedly contradicts the representation of the woman-object with this position of the lesbian subject. At one point Stretter slowly strips off her clothes, revealing her nude body: *"She freezes. Head thrown back. Gasping for air. . . . Stays like that, upright, exposed. Offered to the voices. (The voices are slow, stifled, a prey to desire—through this motionless body.)* Voice 2: (*smothered outburst*) How lovely you look dressed in white" (p. 27). The contrast between Stretter's nude body and Voice 2's description of Voice 1 as dressed in white moves the subject position away from a voyeuristic, scopophiliac adoration of the object to the disembodied expression of passion for the other, invisible female subject. The nude-dressed contradiction underscores the separation of these two states. Moreover, it is clear that Voice 2 is not obsessed with Stretter's story but uses Voice 1's relation to it as a device for liberating the articulation of her own desire. Whereas the object position sets off a chain of metonymic displacements in the subjects who are obsessed with it, Voice 2 explicitly expresses her desire directly to Voice 1. At best, the lesbian subject disrupts the heterosexist subject-object tableau on the stage: "Voice 2: I love you with a desire that is absolute. *No answer. Silence. The hand of Michael Richardson—the lover—immediately stops caressing the body, as if arrested by what Voice 2 has just said"* (p. 33).

When the male Voices, 3 and 4, enter in part 3 of the play, this direct desire is gone. The male voices retain the focus on Stretter, lodging her securely in the object position. They differ from one another only in their degree of accuracy in recalling the story. Most of their dialogue is

taken up in telling the story or speculating about characters, events, and locations within the story. They seem particularly absorbed in the facts surrounding the male characters who desire Stretter ("All trace of him disappears in 1938. He resigns the consular service. The resignation is the last thing on the file"); the geographical locations of the events ("In front, the landing stages. The boats go to and from the South Pacific. Behind, there's a yachting harbor," "They're alluvial islands, formed by the Ganges mud"); the weather ("Now that the mist has come the wind has dropped"); and the physical plants in which some scenes are set ("The water sprinklers in the English quarter," "The factories. The middle zone"). These male voices have an entirely different tone than the preceding female ones. They exhibit a distant relationship between voices and a kind of factual, expository relationship to the story. The female voices cease before the final section of the play in which Stretter dies. The description of her death is left to these men. The death of the object is compounded by its stable position within these voices.

Duras has organized a distinct difference between the gendered subject positions, underscored by having women speaking with women and men with men. The men remain in the tradition of male/subject and female/object, while the women complicate that dynamic. When women inhabit the subject position in this play, the position alters. Duras carefully genders the structural positions of the play.

The formal procedures in Duras' play may be gender marked as feminine writing, eschewing the more potent trope of metaphor for metonymy. This implies that style itself may be gender marked and the very structure of *India Song* may be a feminine one. In other words, the author/subject inscribes the written text with her gender. The concentration of metonymies suggests a feminine author of the composition. Jane Gallop, in *Reading Lacan,* argues that metaphor, as a more potent form in Lacan, has associations that are phallic, whereas metonomy's association with lack, latency, and passivity resembles Freud's "dark continent" of female sexuality, becoming the "dark continent" of rhetoric."[15] Gallop also perceives, from within the Lacanian system, an association of metonymy with "servitude," "social censorship," and "oppression." "Feminine metonymy has tricks and detours that, according to Lacan, allow it to 'get around the obstacles of social censorship.' "[16] This affixes a political, social motivation to style, conflating the feminine inscription in representation with its position in the social situation. The saturation of *India Song* with metonymic displacement marks a female subject as its creator.

Gallop later problematizes her own interpretation of this trope of metonymy, stating that it implies a "pathology of interpretation."[17] What within psychoanalytic terms may be a pathology, within social terms may be a polemic or a politic. A feminist reading that establishes tropes and styles as gender marked, privileging, in this case, the feminine mark on the writing, is polemical. This feminist project, reifying masculine and feminine (or patriarchal and feminist) bipolar oppositions, may fall back into the phallic mode. Nevertheless, it is at this point in history, it may be argued, that the mark of a woman writer (herself a new kind of subject) necessarily appears as difference and opposition to historical tradition. Duras' own division of subject positions into two sets of voices, masculine and feminine, certainly duplicates that division. It also foregrounds the division, making visible the invisible patriarchal mark on stage style and the potential of the feminist or gynecocentric one.

Within its use of formal devices, *India Song* displays a feminist potential in its construction of subject positions and a feminist critique in its object position. The gender critique of woman as object also includes a consciousness of class and race in the figure of the Beggar Woman. In this way the use of the formal device is wedded to the social message. Whereas Stretter and her friends compose what Duras refers to as "white" India, the Beggar Woman represents the poverty and pain of the other India. She plays as a kind of "double" to Stretter, but is a very different kind of object, with a different set of metonymies. Her figure is contiguous with reports of myriad fires, burning leprous bodies. Her story is one of begging for food or of abandoning and selling her children. The subjects who are obsessed with telling Stretter's story evade the Beggar Woman's. Whereas Stretter inspires desire, the Beggar Woman inspires fear and disgust. In her endnotes, Duras remarks: "The story is a love story immobilized in the culmination of passion. Around it is another story, a story of horror—famine and leprosy mingled in the pestilential humidity of the monsoon—which is also immobilized, in a daily paroxysm" (p. 146). The Beggar Woman also has a song that haunts the play, metonymically replacing her as object. Her song is in a foreign tongue, drifting in from outside the rooms, where the dying and starving wait for charitable handouts from the white colonialists who inhabit the interiors. The Beggar Woman is the object of poverty and caste, outside lyricism and love, outside the discourse of desire and the operations of internal psychodynamics.

In the contemporary drama the Beggar Woman is a more familiar character in socially committed plays and criticism than in love stories, or plays of obsession and desire. Duras portrays her as the double of

this privileged world; she is the demarcation of desire's limits. Perhaps this dramatic world of obsessive displacements of desire is a flight from her existence. The title *India Song* refers to both the chic tune played for white India and the Beggar Woman's song outside the window. The social, material critique accompanies the structural innovations of the play, both focusing on the female gender.

Although the above examples illustrate innovations in the structure of the drama contiguous with the feminist movement of women into the subject position, they all still exist within the traditional institution of the theater. These plays retain the traditional function of the text, written by a playwright and performed by actors for an audience seated in a traditional theater structure. Though they challenge the subject position interior to texts, they do not challenge the institution of theater and its practices. In other words, they do not alter the structure of the subject position within the overall practice of the theater. For that kind of move I will abandon the reading of texts for an exploration of a theater company that has created a new subject position for women vis-à-vis both the stage and the streets. This company splits more than the subject of the written text.

Split Britches

The name of this company, Split Britches, connotes the split pants of both poverty and comedy, the splitting of male gender wear, and suggests puns such as split bridges/split breaches. The company consists of three women: one heterosexual Jewish woman, one "butch" working-class lesbian mother, and one southern, working-class "femme" lesbian. It is housed at the WOW Cafe—a three-story walk-up loft in the Lower East Side of New York. In the Lower East Side, its members play out their own ethnic, regional, class, and sexual identities on the stage and in the streets.

The butch and femme play out their roles on the streets, dressing in thrift-store attire that accents the pop representation of their sexual roles. At the same time they parody male-female gender representation in the media. On a given day the butch may be wearing a man's blue suit from the fifties—the kind of suit that shines in the sun—complete with shirt and tie. She may also imitate the walk and gestures of the kind of man who would have worn such a suit. She disrupts the image with earrings, pant legs that are too short, and a flamboyant, Elvis-style haircut. The femme might be wearing turquoise high heels, a turquoise

cocktail dress (also from the fifties), and a turquoise feather boa. Her colors complement the blue of her partner's suit. She, too, may imitate the walk and gestures of the woman who might have worn such a dress. She disrupts the image by relating to her lesbian escort and by wearing the dress in wrinkled, dirty condition, with no nylons and dirty shoes. They transport these same costumes onto the stage, replete with gestures and characterization, as part of one of their performances. Their local audiences are familiar with their roles both on the street and on the stage, connecting the public persona with the character or drawing connections between stage and street, public self and theatrical character. Onstage, these costumes and gestures last only a short while, as part of a series of images the actors assume and then shed. Or, in some of their plays, these costumes remain on the actor, overlaid with other costumes, until the audience perceives layers and layers of differing gender wear, differing period pieces, differing ages, and differing class and ethnic accoutrements.

The company's production of *Beauty and the Beast* provides a clear example of this technique. During the course of the play, some of the roles played by the femme include a Salvation Army officer, the character of Beauty, Katherine Hepburn, and Lady Macbeth. Some of the butch roles are an old woman, sometimes allied with the Salvation Army, the Beast, Perry Como, and James Dean. The Jewish actress takes on the characters of a rabbi, a Jewish stand-up comedian, a ballerina representing Beauty, and Beauty's father. At one point the butch is wearing the dress of the old lady, the cape of the Beast, and Perry Como's sweater, while the Jewish actress is wearing the clothes of the rabbi, a tutu, and, at one point, a dress hanging around her neck on a hanger.

Who is the subject of this drama? At times, during musical numbers and in narrated transitions, it seems to be the actor. She is the site where all of these personae collect. Yet the actor is also her character on the street. At what point does she become an actor? What is the difference between an actor, a celebrity, a social role, and a self-conscious system of gestures? From this perspective, acting, in the traditional sense of taking on a character, learning lines, and so forth, may have become a trope. Within this new sense of a "field theory," the sense in which Split Britches operates, acting is certainly a trope that becomes foregrounded in the company's work along with gender, class, and sexual role. Insofar as personal material is also spoken in the text, at what point is the actor "in" any character?—especially since each character simply overlays those that have come before. Moreover, since the scenes

are shared, monologues follow one another with no through-line or narrative development, and characters transform, the question arises: whose play is it? Which character is the owner of the play, the protagonist, the "lead," the subject of the drama? If there is something like a subject position in this kind of performance, it is that of a collective subject.

The notion of the collective subject is the most radical concept in recent work on women in the subject position. Many feminists consider it to be the most forward-looking construction in the feminist field. Rachel Blau DuPlessis, in *Writing Beyond the Ending,* places the collective subject as the final strategy in her book. She suggests that a collective subject can mark a work with multiplicity rather than the old protagonist-antagonist polarization.[18] In other words, the collective subject leaves behind the bipolar structure of the drama, abandoning the patriarchal stricture that "drama is conflict." The collective subject alters the internal structure of the position as well. DuPlessis describes a kind of "transpersonal protagonist"[19] or characters who represent a "compendia of typical traits" establishing "a dialogue with habitual structures of satisfaction, ranges of feeling, and response."[20]

The actors in Split Britches provide a compendium of traits in their transformable characters. These traits or images evoke their accompanying "habitual structures" of response. For example, the image of Perry Como evokes the conditions of his performances in the fifties—the social function of the smooth, slow voice and the relaxed, domestic image he projected. By choosing images from mass culture, Split Britches foregrounds the social role and its reception in the culture. At one point in the play, as Beast is dying, she/he tells the audience not to believe in such actions—on the stage or staged in real life by actors such as Ronald Reagan, who was shot but heroically survived. The rapid succession of characters alienates the audience from any empathetic relationship to a single character, the former notion of the subject, placing the reception in the critical realm of aesthetic and social representations. Unlike the women in the early movement who used the slogan "take back our bodies," these actors ransom theirs to the system of representation.

In a recent article Teresa de Lauretis identifies the collective subject as the only possibility for liberating, radical change based on its heterogeneity.[21] Rather than presenting a single, whole protagonist, who functioned in earlier works to represent "Woman" as a homogeneous category, she describes the collective representation of "woman as a social subject and a site of difference," emphasizing the "heterogeniety in the female social subject."[22] Split Britches, with its different ethnic, sexual, and class identities played out on the stage and the street, maintains

the heterogeneity of the collective subject at its core. The lesbian/ heterosexual, Christian-Jewish differences animate the narrative and the transformation of characters. Near the beginning of *Beauty and the Beast,* the Jewish woman, in the clothes of a rabbi, rants and raves at the audience about the treatment of Jews on the stage and in real life, while the two other actors sing a Salvation Army song in the background. Later, the lesbian couple kisses, while the heterosexual woman looks on. This dynamic of difference suits the more recent developments in the feminist social movement. Whereas in the earlier years women were regarded as similar to one another but different from men, in recent years the focus has been an internal one, noting the differences among women of class, "race," and sexuality.

Split Britches retains the class critique at the center of its work in many different ways, but perhaps the most consistent image of its dedication to "poor" theater is its location at the WOW Cafe.[23] Here both the subject and the audience for Split Britches are poor. One of the members remarked that she regretted hanging the traditional black curtains as backdrops for some of their performances. Though the curtains are necessary for better acoustics, they literally cover up the real estate. The condition of the loft as well as its Lower East Side location portray the real setting for the company's performances. Its thrift-store costumes, painted window-shade sets, and cardboard props match this poor aesthetic. So do the personal lives of the performers and audience. As one member of the café noted, the performances and the performance space are important because of the real estate problem of poor people in New York. Because people cannot bear their small, dingy apartments, they look for somewhere to go, to be with other people and to have a good time. The WOW Cafe provides this opportunity.

Finally, the collective subject of Split Britches actively drives the audience away from empathetic processes. In the company's direct insults to the audience, it compounds the relationship between character and actor, personal role and social role. It abandons the psychological base of empathy and character development for the silly spur, the throwaway antiaesthetic, the poor person's disruption of dominant media images. Setting this dynamic within the lesbian context of sexual and social relationships, particularly the butch-femme parody of gender roles, the subjects of Split Britches do more than split. They appear and do not appear in fractionalized segments of character and self. They accumulate vortices of representation and reception of gender throughout several historical periods while retaining a contemporary setting in social class and ethnic identity. They question the subject's ownership of the

drama, the theater, and real estate from the perspective of the disenfranchised. They break with the institution of compulsory heterosexuality. In final insults to their audience, they even disrupt the closure of applause.

After tracing the complex project of the construction of the subject position within the feminist field, I find myself with ambivalent feelings about constituting a conclusion to this study. All my traditional training urges me to construct some kind of closure for this review. Yet the splitting, fracturing, displacing, and collective nature of the material seems to contradict that motive. Moreover, since this essay is also set within a specific historical period of the feminist field project, any closure would be one of formally closing off these ideas from their social process. Rather than closure, perhaps I could simply break with the reader. As in the ending of *Beauty and the Beast,* I could simply alienate the audience. Perhaps Split Britches' finale could serve here: "A you're an afoscotan, B you're a belly button, C you're a canteloupe with arms . . . F you're a fairy in my arms . . . PQ principle of queerness . . . RST respectably disgusting . . . U you pick your nose in bed . . . V you're a vomit-head, WXYZ. I love to go through / the alphabet with you / to show you how you sicken me."[24]

Notes

1. For a complete discussion of woman as object of exchange, see Gayle Rubin, "The Traffic in Women: Notes toward a Political Economy of Sex," in *Toward an Anthropology of Women,* ed. Rayna Reiter (New York: Monthly Review Press, 1975).

2. Although the term *feminist* is common among Anglo-American critics, it has been rejected by French theorists who developed these ideas. For a full discussion of this issue, see Alice A. Jardine, *Gynesis* (Ithaca, N.Y.: Cornell University Press, 1985).

3. A brief discussion of this revision process may be found in Linda Hutcheon, "Subject in/of/to History and His Story," *Diacritics* 16, no. 1 (Spring 1986), 78–91.

4. See Jardine, *Gynesis,* for an elaboration of this point.

5. For an explanation of Lacan's "subject" accompanied by examples from film and literature, see Kaja Silverman, *The Subject of Semiotics* (New York: Oxford University Press, 1983); for Lacan's own description of the "fading subject" in English translation, see *Ecrits: A Selection,* trans. Alan Sheridan (New York: Norton, 1977).

6. Ruth Wolff, *The Abdication*, in *The New Women's Theatre*, ed. Honor Moore (New York: Vintage, 1977), p. 385.

7. Cherrie Moraga, *Giving Up the Ghost* (Los Angeles: West End Press, 1986), p. 1.

8. Jean-Paul Sartre, *Saint Genet: Actor and Martyr*, trans. Bernard Frechtman (New York: Pantheon, 1963), p. 13.

9. Ibid., p. 7.

10. Silverman, *The Subject of Semiotics*, p. 111.

11. Ibid., p. 119.

12. See Elin Diamond, "Refusing the Romanticism of Identity: Narrative Interventions in Churchill, Benmussa, Duras," *Theatre Journal* 37, no. 3 (October 1985), 283–85.

13. Marguerite Duras, *India Song* (New York: Grove Press, 1976), pp. 9–10. All following quotations from the play are from this text.

14. Jacques Lacan, *Seminar III*, quoted in Jane Gallop, *Reading Lacan* (Ithaca, N.Y.: Cornell University Press, 1985), p. 126.

15. Gallop, *Reading Lacan*, p. 127.

16. Ibid., p. 129.

17. Ibid., p. 131.

18. Rachel Blau DuPlessis, *Writing Beyond the Ending* (Bloomington, Ind.: Indiana University Press, 1985), p. 181.

19. Ibid., p. 185.

20. Ibid., p. 179.

21. Teresa de Lauretis, "Aesthetic and Feminist Theory: Re-Thinking Women's Cinema," *New German Critique* 34 (Winter 1985), 164.

22. Ibid., 168.

23. For a history of the WOW Cafe, see Alisa Solomon, "The WOW Cafe," in *The Drama Review: Thirty Years of Commentary on the Avant-Garde*, ed. Brooks McNamara and Jill Dolan (Ann Arbor, Mich.: UMI Research Press, 1986), 305–14.

24. Scripts of *Beauty and the Beast* are unavailable. All references and quotations here are taken from a videotape of the production.

Susan Glaspell's Contributions to Contemporary Women Playwrights

Linda Ben-Zvi

The name Susan Glaspell is followed in her biographical sketches by some of the most illustrious credentials in all of American theater history: cofounder of the Provincetown Players, the seminal American theater company; prodigious playwright, who contributed eleven plays to the Provincetown theater in its seven years of existence, surpassed only by Eugene O'Neill, who wrote fourteen under the aegis of the group;[1] talented actress, praised by the visiting French director Jacques Copeau for her moving depiction of character;[2] director of her own plays, including *The Verge,* one of the first expressionist dramas seen on the American stage; winner of the Pulitzer Prize for drama in 1931 for her play *Alison's House,* only the second woman to be so honored; head of the Midwest bureau of the Federal Theatre Project in Chicago in the thirties, credited with reviewing over six hundred plays and instrumental in the production of several important works by black playwrights; significant influence on others, particularly Eugene O'Neill, who she brought to the Provincetown theater in the summer of 1916 and with whom she continued to have a close personal and professional relationship until her departure for Greece with her husband in 1923, thus ending the original Provincetown experiment.[3]

Few have been so successful in so many areas of theater, yet, ironically, few have so completely disappeared from the dramatic canon as Susan Glaspell. Critics in her own period such as Heywood Broun, Ludwig Lewisohn, Isaac Goldberg, and Barrett Clark praised her and O'Neill for creating an indigenous American dramatic idiom, experimenting with new forms and new subject matter, and leading the way for those who followed.[4] Yet while O'Neill's reputation grew over the years, Glaspell was virtually ignored by subsequent critics.[5] In the forty years following her death, only one book devoted to her dramas and novels and only one biographical essay on her life appeared.[6] And with

147

the exception of her first one-act play, *Suppressed Desires,* which has remained a standard work for amateur theater companies, her other writings—six one-act and six full-length plays and eleven novels—were allowed to go out of print.[7]

Interest in Glaspell and her work began to resurface only in the last ten years, when research devoted to women writers uncovered her masterpiece *Trifles,* and the play, along with the short story version, "A Jury of Her Peers," began to appear in anthologies of women's writing, particularly Mary Anne Ferguson's popular *Images of Women in Literature* and Judith Barlow's drama collection *Plays by American Women: The Early Years.*

While feminist criticism has brought Glaspell's name back from the dead and uncanonized, it has not yet produced studies of Glaspell's contributions to dramatic writing. Most discussions of her plays concentrate on them as documents of female exploitation and survival.[8] Certainly, they are important because they are among the first modern writings to focus exclusively on female personae, but they go even further. They offer a new structure, a new dramatic language appropriate to their angle of vision, and a new depiction of character which accommodates the experience of the central figure they delineate, a woman seeking her way in a hostile and often unfamiliar world.

Glaspell's relevance to women playwrights is particularly important because she illustrates in the body of her works the kinds of questions they must face, questions of form determined by the sensibility that the plays embody. Glaspell was among the first writers to realize that it was not enough to present women at the center of the stage. If there were to be a radical break with plays of the past, women would have to exist in a world tailored to their persons and speak a language not borrowed from men. She shared this awareness with her contemporary Virginia Woolf, who, in a 1920 essay, described the problems of female representation on the stage:

> It is true that women afford ground for much speculation and are frequently represented; but it is becoming daily more evident that lady Macbeth, Cordelia, Clarissa, Dora, Diana, Helen, and the rest are by no means what they pretend to be. Some are plainly men in disguise; others represent what men would like to be, or are conscious of not being; or again they embody the dissatisfaction and despair which afflict most people when they reflect upon the sorry condition of the human race. (p. 65)

Glaspell's women *are* what they seem to be: tentative and often halting, trying to find themselves and their voices. Her explorations on the

stage are similar to those described by the critic Susan Rubin Suleiman in her 1986 essay entitled "(Re)Writing the Body: The Politics and Poetics of Female Eroticism":

> Women, who for centuries had been the *objects* of male theorizing, male desires, male fears and male representations, had to discover and reappropriate themselves as *subjects*. . . . The call went out to invent both a new poetics and a new politics, based on women's reclaiming what had always been theirs but had been usurped from them; control over their bodies and a voice with which to speak about it. (p. 65)

Glaspell, seventy years earlier, was aware of both responsibilities. She offered a form, a poetics, and a politics which Suleiman and others writing today describe as vital to female-centered art. Glaspell saw that if the world portrayed is the world of women—if the locus of perception is female—then her plays would have to strive for a shape which reinforces this new vantage point and a language which articulates it. And while her particular experiments may at first glance seem removed from those of women writing in modern and postmodern modes of the sixties, seventies, and eighties—who employ transformations, nonrepresentational situations and characters, fragmented temporal and spatial distinctions—they are in fact part of the same ongoing search for dramatic means to depict female experience. A study of Glaspell's works thus provides illustrations of how women can function as protagonists and how structures, language, and subject matter can act as extensions of such women-centered drama.

Pioneer Roots

When Susan Glaspell first came to New York with her husband George Cram Cook in April 1913, she was disturbed by the theater she saw. In *The Road to the Temple,* her biography of Cook, she writes, "Plays, like magazine stories, were patterned. They might be pretty good within themselves, seldom did they open out to—where it surprised or thrilled your spirit to follow. They did not ask much of you, those plays." Like O'Neill and the other contributors to the Provincetown Players, she was conscious of the limitations of traditional dramatic form. The Dublin-based Abbey Theatre had toured America in 1911 and had shown the possibilities of dramas not limited to narrowly defined shapes. Yet Glaspell's desire to smash existing structures stems from more than the contemporary abhorrence of limitation, permeating the society in which she

moved: Greenwich Village in the first decades of the century. To understand Glaspell's work with form and language, it is necessary to understand something of her biography. Her wish to see plays which "open out" and require the audience "to follow" springs most directly from her pioneer roots.

Susan Glaspell was born in Davenport, Iowa, in 1876,[9] a grandchild of one of the early settlers of the territory. When asked to compile notes for a biographical sketch, she wrote, "Though my home has for some years been in the East, almost everything I write has its roots in the middle west; I suppose because my own are there."[10] In an essay for *Twentieth Century Authors* she repeats this idea: "I have never lost the feeling that is my part of the country" (pp. 541–42).

The impetus for pioneers such as her ancestors, that thing that made them leave comfortable homes for unknown places, continually puzzled Glaspell and became the central motif in all her writing. In *The Road to the Temple* she asks, "What makes a man who has an orchard or a mill in Massachusetts or New York where there is room enough for him . . . get into a covered wagon and go to Indians, rattlesnakes, to the back-breaking work of turning wilderness into productive land." "They go to loneliness and the fears born in loneliness," she says of these pioneers. Young enough herself to remember her grandmother's stories, Glaspell also recognized the difficulty facing the following generations. How do those who come after retain the pioneering spirit? In *Inheritors,* her historical drama, the protagonist Madeline Morton says to her college professor Dr. Holden, "Just a little way back—anything might have been. What happened?" He answers (speaking with difficulty), "It got—set too soon." Unlike O'Neill, who attributed America's failure to an inability of the country to "set down roots," Glaspell saw roots as dangers, marks of fixity and stagnation, usually leading to stultifying institutions against which her characters struggle, much as their pioneering forebears did, in order to move into a new sphere, if not of place then of spirit.

While Glaspell indicates that both men and women need constantly to question institutions and to change them and themselves if both become too rigid—a situation she describes in *Inheritors*—it is to her women characters that she usually attributes this desire for change. It is they who seem to suffer most from the fixity of society. Glaspell continually sunders the stereotype of women desiring stability and the comfort of place. Her works stand in juxtaposition to arguments such as the one set forth in Leslie Fiedler's *Love and Death in the American Novel,* where women are depicted as perpetuators of the status quo, those

agents of society against whom male characters battle by going down the Mississippi, into the wilderness, on the road. Invariably in the world Glaspell describes, it is the women, not the men, who want to "lit out," for fixity impinges more directly on them than on the men.[11] As figures of power—American versions of Ibsen's "pillars of society"—the male characters in Glaspell's works have most to lose by change, they hew most closely to routine, and allow virtually no freedom to the women with whom they live. Glaspell's women, for the most part, are required to uphold traditional patterns and remain in place—both physically and mentally.

Mrs. Peters in *Trifles* is typical of such personae. She is described as "married to the law," and expected as such to mouth the ideas of her husband, the sheriff, to trace his conservative path, reflecting his opinions and his decisions. Mr. Peters and the men in the play are untouched and unchanged by the events they witness at the scene of a murder; they are "the law," and the law, Glaspell indicates, is a fixed thing incapable of dealing with either nuances of a case or variations of human behavior. Mrs. Peters, however, assimilates the evidence she stumbles across; she "opens out" into new areas of self-awareness. It is her emancipation which becomes the central theme of the play, overshadowing the murder investigation, the ostensible subject of *Trifles*.

In *The Verge*, Glaspell's expressionist masterpiece, her protagonist Claire Archer experiments with plants in an attempt to move vicariously in new directions that have not been attempted before. Her "Edge Vine" timidly clings to the familiar patterns of the species, and she destroys it. It is to the plant she calls "Breath of Life" that she next turns, hoping that in its courageous "thrusting forward into new forms" it will enter worlds which she too wishes to know. When asked why she breeds new plant forms that do not seem "better" than the familiar varieties, she attempts to explain: "These plants (*beginning flounderingly.*)—perhaps they are less beautiful—less sound—than the plants from which they diverged. But they have found—otherness. (*Laughs a little shrilly.*) If you know what I mean?" When her husband tries to stop her words as he has tried to stop her experiments, she continues excitedly, "No; I'm going on. They have been shocked out of what they were—into something they were not; they've broken from the forms in which they found themselves." In Claire's own life, "form" takes the familiar configurations: wife, mother, friend, lover. She too would move outward, but she is kept back by a circle of men appropriately called Tom, Dick, Harry—friend, lover, husband—and by her sister and child. "Out there—lies all that's not been touched—lies life that waits. Back here—the old

pattern, done again, again and again. So long done it doesn't even know itself for a pattern," Claire says to those who thwart her in her desires.

In *Inheritors,* again woman is shown as pioneer, this time not seeking emancipation from conventional gender roles or attempting exploration into unknown areas, but seeking the reinstatement of democratic values which have been subverted in succeeding generations. Madeline Morton, the protagonist, refuses to believe that the practices of America in 1920, with its Red-baiting, condemnation and imprisonment of conscientious objectors, and limitations on freedom of speech, are correct. An "inheritor" of the pioneering spirit of her grandfather, she alone questions the values of the "100 percent Americans" whose jingoism reflects the period in which the play is set and in which it was written.

Pioneer Form

The image of pioneering is a recurrent one in all of Glaspell's plays; it shapes all her writing. Yet what makes her significant as a model for modern women playwrights is less the paradigm itself than the fact that Glaspell creates a form which reinforces it. Like modern playwrights such as Beckett and Pinter, she recognizes that it is not enough to have subject matter discuss new ideas; a playwright must also offer a dramatic form appropriate to the ideas expressed. The impossibility of logic and linearity cannot be adequately shown in a conventional three-act play which abides by the laws of time and place; so, too, the desire of women characters to break the rules of their societies cannot be depicted in plays which follow conventional rules. The form of a Glaspell work becomes an extension of the theme: each play attempts to break with the formulaic conventions of dramaturgy so pervasive during her period and to offer possible new structures to shape the explorations of her female personae.

Nothing in a Glaspell play is linear. Plots do not have clearly defined beginnings, middles, and ends; they self-consciously move out from some familiar pattern, calling attention as they go to the fact that the expected convention will be violated, the anticipated order will be sundered. If the play seems to be a traditional detective story, as in *Trifles,* the emissaries of the law—the men—will not be the focus of attention. The center of interest, instead, will be the women, those peripheral, shadowy figures in the play who have come on the scene to accompany their husbands and each other.

The notion of linearity in Glaspell's plays is always connected with suppression and with social institutions which have become rigid and confining. For example, the men in *Trifles* walk and talk in straight lines, crisscrossing the scene of the murder as they crisscross the facts of the murder case. When Mr. Hale, a witness to the murder scene, relates his story, he is chided by the district attorney to recount just the facts. "Well Mr. Hale, tell just what happened when you came here yesterday morning." Whenever Mr. Hale veers in the slightest way from the straight narrative line, the county attorney returns him to the narrow parameters of the discourse. "Let's talk about that later, Mr. Hale. I do want to talk about that, but tell now just what happened when you got to the house." In his insistence on the limitations of discourse, the attorney makes clear that he is able to proceed only in prescribed ways. It is significant that Mr. Hale is not part of the legal system; he seems less confined by the narrowness of the lawmen and more in spirit with the freer, unstructured methods of the women, one of whom is his wife. Yet because of his sex, Mr. Hale is afforded the privileges of the men. He is not confined to the kitchen, but follows the attorney and the sheriff around the house seeking clues which will help convict Mrs. Wright, the woman accused of strangling her husband.[12]

Unlike the men, Mrs. Hale and Mrs. Peters show flexibility in their actions and their words. They are limited by the patriarchal power structure clearly working within the scene Glaspell describes, but they are free in the limited confines of the kitchen where the play takes place. One of Glaspell's radical departures is to place the action in the kitchen, one of the few plays of the period to follow *Miss Julie* in doing so. But unlike in Strindberg's play, there are no men in this female province to control the action. Here the women freely retrace the steps of Mrs. Wright.[13] Slowly, almost without volition, they piece together the motive for murder, quilting a pattern of awareness as they randomly move across the stage and speak about the events of the case.

The central image Glaspell chooses for this play is quilting, and, like quilters, her female characters carefully sew together disconnected pieces, making new patterns out of old materials, intuitively sifting through the details around them without any preconceived pattern limiting their actions. It is they who solve the case, not the lawmen who are committed to set ways of investigation.

The dichotomy Glaspell presents is between male fixity—the fixity of a society gone rigid—and female exploration at the outskirts of that society in the world of women, among "trifles." She underlines this

dichotomy by offering a form which has the same randomness and openness as the quilting process itself, in apposition to the constrained, formalized actions of her male characters.

Even more innovative is Glaspell's manipulation of point of view. What she is able to do in this play and in her other works is to force the audience to share the world of her women, to become fellow travelers with her pioneering protagonists. While the men in *Trifles* are almost immediately shunted offstage and only appear as they traverse the playing area of the kitchen, the women remain stationary. It is with them that the audience—men and women—remain, not privy to the conversations of the men, not afforded their mobility. The audience is therefore forced to see the world through the eyes of Mrs. Hale and Mrs. Peters. As a bond is gradually forged between the women and the absent one for whom they act as surrogates and judges, a bond is gradually created between the women and the audience who has gained some insights into their female world and has—at least for the duration of the play—seen as they see. When, at the end of the work, Mrs. Hale places the box containing the strangled bird into her pocketbook in order to destroy the incriminating evidence which provides the only motive for murder, the audience generally applauds her gesture and by so doing becomes itself an accessory to the act.[14]

By placing women at the center of the drama and the audience captive in the kitchen with them, Glaspell does more than merely upend the conventional detective format or offer an unusual locale for a play—at least in 1917. She actually overturns the very hierarchical values of the society she depicts. The men in the play chide "the ladies" for being concerned with the "trifles" of the farm kitchen: the unbaked bread, dirty towel rack, and sewing left undone. Yet Glaspell indicates during the course of the play that such "trifles" can reveal truths, that the concerns of women may have as much significance as the "facts" of men.

She overturns both conventional dramatic form and conventional gender demarcations and values in her other plays as well. In *The Outside* men again play the seemingly active agents. They are lifesavers who attempt to resuscitate a drowning victim. And again—as in *Trifles*—men are unsuccessful; their attempts to save life fail. But as they go through the motions of resuscitation, two women—a maid and her employer—watch silently and themselves perform another kind of "lifesaving." As in *Trifles,* once more Glaspell depicts the inarticulate power of women to understand the shared experiences of other women, unstructured by language but nevertheless communicated through mutually shared pain. Using single words, pauses, and broken sentences, the maid, Allie Mayo,

reaches out to the other woman, Mrs. Patrick, drawing her back to the life she has rejected. Little outward action occurs, but once more Glaspell indicates that events of great moment may take place in near-silence among those not accustomed to heroic deeds; individuals may be saved by a few well-chosen words, by a gesture, by "trifles," as well as by physical valor.

In *The Verge* Glaspell's protagonist is less fortunate than the two women in *Trifles* and *The Outside;* she is afforded no victory in her quest for freedom. Unable to move "outside," like the plant she has cultivated, Claire Archer reverts to one of the two traditional ends for women who would break with societal restrictions. She lapses into madness, a variation on the suicide that so often is the end of pioneering women, at least in literature in the early part of twentieth century. Glaspell's great accompishment in this play is to provide a perfect dramatic structure to shape her hero's efforts. Antedating O'Neill's *Hairy Ape* by several months, she creates one of the first expressionist settings in American theater.[15] The play has an odd, open-ended shape to it, depicted visually on the stage by the two playing areas: the narrow, low greenhouse in which Claire works and the tower—*"a tower which is thought to be round but does not complete the circle,"* the stage directions say. Claire calls it her "thwarted tower." Both areas are lit in special ways. In act 1, patterns are superimposed on the greenhouse *"as if—as Plato would have it—the patterns inherent in abstract nature and behind all life had come out."* Periodically, light from a trapdoor illuminates the laboratory. The interior of the tower in act 2 is dark and brooding, lit by an old-fashioned watchman's lantern whose "innumerable pricks and slits in the metal create a marvelous pattern on the curved wall—like some masonry that hasn't been."

The form of the play is also experimental. Beginning like a conventional comedy of the twenties—weekend guests discomforted because the heat in the house has been diverted to the plants in the greenhouse—the play moves in act 2 to a psychological investigation of Claire that stands in odd juxtaposition to the levity and ambiance of act 1. Yet this discontinuity between acts seems to be Glaspell's way of once more having form reinforce theme. Repeatedly in act 1 Claire is chided by the men around her to be "cheerful," "witty," "fun." Enforced gaiety is what Claire wishes to escape as much as she wishes to escape the restrictive roles of traditional womanhood. By contrasting the style and mood of the laboratory scene with the introspective world of the tower, Glaspell indicates the forces working on her protagonist. Only in her tower home is Claire relatively free to pursue a course not dictated by

others. However, there are still stairs which lead up to her haven, more often trod than the parallel stairs which lead from her laboratory down to a temporary, subterranean refuge. She may escape down the latter, but she cannot avoid the intrusions of those who will ascend the former.

In act 3, again in Claire's laboratory, as she waits for the unveiling of her new plant form, the tensions between the two styles of the preceding acts and the two venues explode in violence. Using the same ending that O'Neill will employ in *The Hairy Ape*—the hug of death— Glaspell has her protagonist strangle Tom, the man who presents the greatest obstacle to her freedom. She then concludes her play with Claire lapsing into insanity, what appears to be the only refuge from the world depicted in the play. Conflating the initial comedy of manners and the psychological investigation, Glaspell creates a play which fits no simple category, a fitting structure for a protagonist who wishes to escape easy classification.

Pioneer Language

Glaspell's plays foreground women and provide open, unrestricted, asymmetrical dramatic structures in which women operate. The same can be said for the language characters use. Repeatedly, Glaspell connects language to action. Since her women are exploring new areas of their lives, they find traditional language unsuited to their needs. They may be women unused to speech or women all too aware that the words they speak do not express their thoughts. In either case the results are the same. Her characters are virtually inarticulate, or are rendered so because of the situations in which they find themselves. The most common punctuation mark she uses is the dash. It is used when the character is unsure of the direction in which she is going, as yet unprepared to articulate consciously a new awareness or unwilling to put into words feelings and wishes which may collapse under the weight of words.

One of Glaspell's most important contributions to drama is to place these inarticulate characters in the center of her works, to allow them to struggle to say what they are not sure they even know. While O'Neill's personae usually end statements with exclamation points, Glaspell has the courage to allow her women to trail off their words in pauses, devices against the tyranny of language. And while those inarticulates O'Neill does present are unable to speak because of the limits of their class or education, Glaspell's women, despite their class, share the limitations of their gender and find speech difficult. It fails to describe the

new areas into which they are attempting to move and is often perceived as the language of male experience.

In many ways Glaspell's recognition of the inherent connection between female independence and language makes her a forerunner of contemporary feminist critics who see language at the heart of any possible realignment of the sexes. While Glaspell did not write essays about the subject, her plays speak to the same concerns that occupy feminist critics such as Julia Kristeva, Hélène Cixous, and Luce Irigaray.[16] And while Glaspell's struggles to create a female language do not go as far as those espousing *écriture féminine* would probably accept, they are predicated on some of the same beliefs: that women's subjugation in society is connected to the subjugation imposed by language.

Prefiguring psychoanalytic critics such as Irigaray, Glaspell actually offers on the stage the absent woman—woman as void—against whom male characters react, upon whom they impose a shape—much as Woolf described—making of the absent woman a kind of palimpsest upon which to inscribe their own identities, desires, and language. Bernice in the play of that name, Alison in *Alison's House,* and Mrs. Wright in *Trifles* are all hovering presences who never appear. Since they are not physically present, their voices are co-opted by males who speak for them. This dramatic depiction of woman as void is one of Glaspell's most innovative and modern techniques, employed by contemporary women playwrights as well as by feminist critics.

One of the most direct examples of male usurpation of female speech appears in *Trifles,* which begins with Mr. Hale acting as the spokesperson for the absent Mrs. Wright. Her words come through his mouth. The women present say nothing as the voice of man speaks the words of woman. Only when the women are alone does sound come, and it is—and remains—a halting sound. Yet as the awereness of their shared subjugation develops, the women begin to seek a verbal form for this knowledge. Appropriately, it is a language of stops and starts, with lacunae—dashes—covering the truths they still cannot admit or are unused to framing in words. What the audience sees and hears are people learning to speak, constructing a medium of expression as they go. The way is not easy, and the language they frame is awkward. But it is clearly their language, no longer the words of others which they have been taught to speak.

One of the most effective moments in the play, a point of anagnorisis, is when Mrs. Peters recalls the time when she too felt powerless, like Mrs. Wright, and she too had murder in her heart: "When I was a girl—my kitten—there was a boy took a hatchet, and before my eyes—

and before I could get there—if they hadn't held me back I would have—hurt him." Unwilling or unable to say more, Mrs. Peters talks in half sentences, covering her growing awareness in pauses more telling than the words she actually employs. The sentence becomes a verbal concomitant to the patchwork investigation the two women have conducted in the kitchen.

In another section of *Trifles,* Glaspell points directly to the connections between quilting and growing awareness, doing so through seemingly flat, banal phrases. Three times during the course of the play, the women discuss the stitches Mrs. Wright has used for her work. The first time the men overhear them and laugh when Mrs. Hale asks, "I wonder if she was goin' to quilt it or just knot it." Several minutes later the question turns to a qualified statement when Mrs. Peters says, "We think she was going to—knot it." The last words of the play, after the women have hidden the evidence and silently rebelled against their husbands, are Mrs. Hale's: "We call it knot it." From interrogative to qualified statement to assertion—the sentences mark the changes in the women, changes the men overlook because they do not hear the import of the words the women use. To the men, the words refer to "trifles"; the language is foreign, the shape of the sentences irrelevant. That seems to be Glaspell's point. The women speak in a different voice, to use Carol Gilligan's apt phrase. There is the voice of law and fact and the voice of connection and caring.[17] The two voices do not hear each other. What is important, however, is that the audience, who has begun to decipher the words of women, can understand the import of the lines as the men with whom these women live cannot. The audience has begun to listen to, if not to speak in, "a different voice."

Glaspell employs other alterations of language in *The Verge.* In that play Claire Archer suffers from too many words, other people's words. When she desires to express her own ideas, she finds herself unable to do so because the words she must use are already misshapen by the uses others make of them. "I'm tired of what you do," Claire tells her fatuous sister,

> you and all of you. Life—experience—values—calm—sensitive words which raise their heads as indications. And you *pull them up*—to decorate your stagnant little minds—and think that makes you—And because you have pulled that word from the life that grew it you won't let one who's honest, and aware, and troubled, try to reach through to—what she doesn't know is there.

Unsure of what she seeks, Claire realizes the dilemma she faces: the language which is her only means of investigation is the language of

those she would leave behind. It is against the fixed forms of the society which Claire inveighs, just as it is against the imposition of an alien language which she struggles.

To compound the problem, Claire also recognizes that when trying to give voice to ideas which are still inchoate, she forces upon them a pattern that limits the exploration itself. "Stop doing that!" she demands of language, "—words going into patterns; They do it sometimes when I let come what's there. Thoughts take pattern—then the pattern is the thing." Here Glaspell refers not to the limits women experience speaking the language of men but to the limits of language itself.

Pioneer Subject Matter

Claire Archer is one of the first female characters in drama whose main concern is to create a new language and whose failure illustrates the difficulties in doing so. Sixty years later, in his play *Not I*, Samuel Beckett would place a gaping mouth eight feet above the stage and reenact a similar struggle for articulation of self—and a similar failure. By making language the primary focus of the struggle for selfhood, Glaspell is radically expanding the possibilities of thematic material for theater and the uses of stage language.

Further, Glaspell was one of the first women playwrights to present female personae engaged in violent acts: killing a husband offstage in *Trifles,* strangling a lover onstage in *The Verge.* Glaspell's choice of subject matter in both plays may not seem shocking or innovative in the contemporary period, where a playwright depicts a woman taking the grotesque shape of a circus freak and having her genitals excised (Joan Shenkar's *Signs of Life*); or examines lesbianism, homosexuality, and masturbation as liberating alternatives to, or perhaps direct results of, colonial values and mores (Caryl Churchill's *Cloud Nine*); or describes the ritual slaughter of a random male (Maureen Duffy's *Rites*); or depicts lady mud wrestlers performing in a bar in New Jersey (Rosalyn Drexler's *Delicate Feelings*); or makes Joan of Arc and Susan B. Anthony fellow travelers (Lavonne Mueller's *Little Victories*). Yet, in her own period, Glaspell's material was culled from events and subjects considered sacrosanct, controversial, and—in the case of *Inheritors*—subversive. Her first play was *Suppressed Desires,* written in collaboration with her husband, George Cram Cook. It parodied a movement which her own circle of friends in Greenwich Village took most seriously: psychoanalysis. "You could not go out to buy a bun

without hearing of someone's complex," Glaspell wrote about her first days in New York in 1913. Blind adherence to analysis becomes the comic subject of the play, subtitled *A Freudian Comedy*. It was one of the first plays written in America to employ, albeit sarcastically, the new theories Freud introduced to the country only a few years before in his Clark University lectures.[18]

Glaspell consistently wrote about controversial topics throughout her career, sometimes treating them to ridicule, sometimes offering them a platform for development. For example, her last play for the Provincetown theater, *Chains of Dew* (1922), has as its protagonist a young woman named Nora (the name probably borrowed from Ibsen) whose mission is to spread news about contraception and who in the process radicalizes the women with whom she comes into contact in the play and, by extension, those in the audience.

Glaspell's most challenging use of subject matter, however, comes in the play *Inheritors*. In order to appreciate the risks taken in this work, it is necessary to have some idea of the climate in which the play was written in 1920. In 1917, as a result of Woodrow Wilson's declaration of war—an act Glaspell and her friends vigorously opposed—Congress passed the Selective Service Act, which required general conscription for eligible males, exempting only those who on narrowly specified grounds opposed all wars. Others resisting the draft for moral or political reasons were tried as deserters, and when convicted often faced brutal treatment. Along with conscription, Congress also enacted laws intended to quell dissent about the war. The Espionage Act, on pain of a ten-thousand-dollar fine and twenty years in jail, made it illegal to refuse duty or impede recruitment in the military. The appended Sedition Act went further and prohibited uttering, printing, or writing any disloyal, profane, or scurrilous language about the form of government in the United States. Various alien laws made it a crime, punishable by deportation, to speak out against America or any of its allies.[19]

During the postwar period the theater was generally silent about such abuses in society. Burns Mantle's *Best Plays of 1920–21* lists such hits as *Good Times* and *Irene*. Glaspell's *Inheritors* was the exception to this escapist fare. It directly condemns the treatment of conscientious objectors after the war, the deportation of aliens and strikebreakers, and the abridgment of personal freedom of speech. The play also makes direct references to the excessive patriotism which persisted after the end of the war. "That's the worst of a war—you have to go on hearing about it for so long," and "Seems nothing draws men together like killing other men," and "The war was a godsend to people who were in

danger of getting on to themselves" were lines still liable to bring Glaspell—like her protagonist—a possible fine and jail sentence under the espionage and sedition laws. Glaspell's friends Big Bill Haywood, head of the Wobblies, Emma Goldman, and Jack Reed had already experienced the effects of the repression. Yet Glaspell went ahead with her play, which was well received and may have had some part in reversing the climate of the period. It is interesting to note that as a mark of the universality of the issues Glaspell raises, the Hedgerow Theatre of Moylan, Pennsylvania, headed by Jasper Deeter, an original member of the Provincetown Players, performed the play every year from 1923 to 1954, except during the war.[20] When the play was revived by the Mirror Repertory Company in New York in 1983, the critics all mentioned one point: the picture of the past which it offers is as valid in the eighties as it was for Glaspell's audience in 1921.

Glaspell's focus on contemporary issues—either to mock them or to promulgate them—follows a tradition among women playwrights which goes back as far as Mercy Otis Warren and forward to Megan Terry and Maria Irene Fornes. Yet when Terry wrote *Viet Rock* in the sixties and Fornes wrote *The Danube* and *The Conduct of Life* in the eighties, they risked far less censure or danger than Glaspell faced in her own stand against a repressive society.

As important as her political positions were in keeping alive the tradition of outspoken women playwrights, Glaspell is probably most important to women writers as an example of someone who dared to give dramatic shape to the struggles of women. The two women in *Trifles* can be prototypes of Everywoman; Claire Archer can be a fictional surrogate for feminist ideologues who are presently engaged in altering language to fit their own needs and possibilities. Certainly, Glaspell is not the only woman playwright who provides a her/story from which others may draw sustenance. Those writers represented in Barlow's collection—Mowatt, Crothers, Gale, and Treadwell—as well as innovators such as Gerstenberg and those many, until recently anonymous black women playwrights of the twenties and thirties, offer a body of works that open up the range of experimentation for the present group of women playwrights.[21]

I would argue that having read the work of Glaspell and other women writing at the beginning of the century, one has a better idea of the ongoing movement which is American women's drama. There is the shadow of Glaspell and the others behind such experiments as the Women's Project of the American Place Theatre, which one of its participants described as giving to women "a place to raise their voices

without apology" (p. 13). While Helene Keyssar in *Feminist Theatre* is correct in saying that it was only in the late sixties that playwrights *"in significant numbers* became self-consciously concerned about the presence—or absence—of women as women on stage" (p. 1, my italics), there were women much earlier in the century, and before, who shared these concerns and wrote plays which led the way. Susan Glaspell was one of the most important of these pioneering playwrights. Although she has been ignored by those who shape the canon, she should not be ignored by those who are attempting to reconstitute it.

Notes

1. Over the seven-year period in which the original theater company functioned, there were one hundred original American plays produced by fifty playwrights, thirty-three of them women. See Helen Deutsch and Stella Hanau, *The Provincetown: A Story of the Theatre,* and Robert Karoly Sarlos, *Jig Cook and the Provincetown Players: Theatre in Ferment.*
2. Sarlos reports that Copeau was " 'touched to the depth of his soul' by Susan Glaspell's acting in her own play, *The People.* Copeau confessed that 'the simplicity of her presence' made him understand as no previous experience has 'the importance of relinquishing current theatre techniques, even at the price of a prolonged period of groping' " (p. 73).
3. See Linda Ben-Zvi, "Susan Glaspell and Eugene O'Neill," *Eugene O'Neill Newsletter 9: Special Issue on O'Neill and Women* (Fall, 1982), 15–24; and Linda Ben-Zvi, "Susan Glaspell, Eugene O'Neill, and the Imagery of Gender," *Eugene O'Neill Newsletter 11* (Spring 1986), 22–27.
4. See Isaac Goldberg, *The Drama of Transition* (pp. 472–81); Ludwig Lewisohn, *Drama and Stage* (pp. 102–10) and *Expressionism in America* (393–98). For an annotated bibliography of the critical responses to Glaspell's plays and those of other Provincetown members, see Gerhard Bach, *Susan Glaspell und die Provincetown Players.*
5. Among contemporary critics only C. W. E. Bigsby discusses Glaspell as an equal to O'Neill and as a writer whose works deserve serious attention. See C. W. E. Bigsby, *A Critical Introduction to Twentieth-Century American Drama,* vol. 1, *1900–1940* (pp. 25–35). Bigsby has also recently edited a collection of Glaspell's plays (*Trifles, The Outside, The Verge,* and *Inheritors*).
6. See Arthur Waterman, *Susan Glaspell,* and Marcia Noe, *Susan Glaspell: Voice from the Heartland.*
7. Glaspell's one-act plays are *Suppressed Desires* (written with George Cram Cook), *Trifles, The People, Close the Book, The Outside, Woman's*

Honor, and *Tickless Time* (written with Cook). Her full-length plays include *Bernice, Inheritors, The Verge,* and *Chains of Dew* (all written for the Provincetown Players); *The Comic Artist* (written with Norman Matson in 1928); and *Alison's House* (written in 1931 and awarded the Pulitzer Prize in that year). Thanks to Bigsby's collection, Glaspell's major plays are once more available.

8. See Annette Kolodny, "A Map for Rereading: Gender and the Interpretation of Literary Texts," in *The New Feminist Criticism; Essays on Women, Literature, and Theory* (pp. 46–62).

9. Although Glaspell listed her birth year as 1882 in biographical articles, she was actually born July 1, 1876. The Scott County Registrar's office lists no birth certificate for Glaspell, but the Iowa census of 1880 notes a four-year-old Susie Glaspell, a five-year-old Charles, and a one-year-old Frank, children of Elmer and Alice (Keating) Glaspell residing at 502 Cedar Street, Davenport, Iowa. Also, a diary of Glaspell's aunt on file at the Berg Collection of the New York Public Library, which houses both Glaspell's and Cook's papers, indicates that on the alleged date of her birth in 1882, the entire Glaspell family, including Susie, came to visit. Finally, Drake University, where Glaspell received a Ph.D. degree, lists her age at the time of her admission in 1897 as 21.

10. This description is found in Glaspell's papers in the Berg Collection.

11. It is interesting to note that while O'Neill gives lip service to freedom—"and at last be free, on the open sea, with the trade wind in our hair" (from his first poem)—a close study of his works indicates that he places his characters in closed spaces and has them yearn for fixity and home. For example, on the fictional steamer *Glencairn* the playing areas are closed, cramped quarters, with small, crowded bunks and foreshortened spaces. In *Bound East for Cardiff* and *In the Zone,* action is confined to the forecastle. While *The Moon of the Caribees* is set on deck—one of the few sea plays that is—only a small strip of it is seen, and the action always seems to move below, out of sight. The best example of the freedom of sea life metamorphosing into the fixity of home is found in *The Hairy Ape,* where Yank, while ridiculing the idea of home, shows how he has made a new home of his furnace world. He spends most of the play attempting to regain this home after he is ousted from it. Progressively in O'Neill's later works, his male characters seek surrogate homes and indicate that freedom, for them, is not as important as the security of home. A comparison of the plays of O'Neill and Glaspell indicates how the traditional stereotypes of male freedom and female domesticity are destroyed. See Linda Ben-Zvi, "Freedom and Fixity in the Late Plays of Eugene O'Neill," *Modern Drama* 31: *Special Centenary Issue on O'Neill* (May 1988), 16–27.

12. To get a strong sense of the physical linearity that exists in the work, see the film version by the director Sally Hackel, entitled *A Jury of Her Peers.*

13. It is possible to see *Trifles* as an answer to *Miss Julie,* a play Glaspell

would have known. There are several parallels that indicate she may have had the play in mind when she wrote her own "woman's version." In both plays the female character has a pet bird that is killed by a man. In *Miss Julie* Jean kills Julie's bird before sending Julie off to her own death. In *Trifles* the woman takes revenge for the destruction of her pet and for her own death of the spirit by killing her husband by slow strangulation, the appropriate act to fit his crime.

14. When I was organizing a special session on Glaspell for the Modern Language Association, I received a letter from a professor at an eastern law school telling me that he taught *Trifles* to new first-year law students because of the audience's pardoning of an illegal act.

15. See Linda Ben-Zvi, "Susan Glaspell and Eugene O'Neill," and "Eugene O'Neill and the Imagery of Gender," in *The Eugene O'Neill Newsletter*. In both articles I agree that Glaspell's *Verge* is an important influence on O'Neill's *Hairy Ape*. At the time he was composing his play, O'Neill was meeting his neighbor Glaspell every afternoon after working on his manuscript, his wife Agnes reports. As an indication of how completely O'Neill critics ignore Glaspell and her influence on O'Neill, it is interesting to note that not one has ever mentioned the striking similarities between the two plays and the fact that O'Neill was in such close association with her during its composition. They prefer to cite such speculative sources as the film *The Cabinet of Dr. Caligari* and the play *From Morn to Midnight,* works O'Neill knew less well than he knew *The Verge*.

16. For a sampling of French feminist criticism, see Elaine Marks and Isabelle de Courtivrons, eds., *New French Feminisms: An Anthology*. For a sample of American feminist criticism, see Elaine Showalter, ed., *The New Feminist Criticism: Essays on Women, Literature, and Theory*.

17. Carol Gilligan, *In a Different Voice*. Gilligan's discussion of the differences between male and female language and approaches to problem solving is directly connected to *Trifles,* which clearly reinforces Gilligan's observations.

18. For a discussion of Glaspell's use of Freudianism on the stage, see W. David Sievers, *Freud on Broadway*.

19. To get an idea of the climate in America after the First World War, see Frederick C. Giffin, *Six Who Protested;* Burl Noggle, *Into the Twenties;* Zachariah Chafee, *Freedom of Speech;* and H. C. Peterson and Gilbert C. Fite, eds., *Opponents of War: 1917–1918.* In the last book the authors list a celebrated case of a conscientious objector named Fred Robinson who was mistreated long after the war. Glaspell's character Fred Jordan may have been based on Robinson.

20. Former actors associated with the Hedgerow Theatre gave a reading of *Inheritors* at the Modern Language Association meeting in Los Angeles in 1982. Organized by Gail Cohen, the production included Hedgerow alumni Henry Jones and the late Richard Basehart.

21. In the past few years, several books devoted to black women play-

wrights have appeared. In 1988 Beacon Press brought out the plays of Marita Bonner, edited by Joyce Flynn and Bonner's daughter, and New American Library published an anthology of black woman playwrights entitled *Nine Plays by Black Women,* edited and with an introduction by Margaret B. Wilkerson.

Bibliography

Bach, Gerhard. *Susan Glaspell und die Provincetown Players: Die Anfänge des modernen amerikanischen Dramas und Theaters.* Frankfurt-am-Main: Lang, 1979.

Ben-Zvi, Linda. "Susan Glaspell and Eugene O'Neill." *Eugene O'Neill Newsletter 9: Special Issue on O'Neill and Women* (Fall 1982), 15–24.

———. "Susan Glaspell, Eugene O'Neill, and the Imagery of Gender." *Eugene O'Neill Newsletter 11* (Spring 1986), 22–27.

———. "Freedom and Fixity in the Late Plays of Eugene O'Neill." *Modern Drama 31: Special Centenary Issue on O'Neill* (May 1988), 16–27.

Bigsby, C. W. E. *A Critical Introduction to Twentieth-Century American Drama.* Vol. 1, *1900–1940.* Cambridge: Cambridge University Press, 1982.

———, ed. *Plays by Susan Glaspell.* Cambridge: Cambridge University Press, 1987.

Chaffee, Zacariah. *Freedom of Speech.* New York: Harcourt Brace, 1921.

Deutsch, Helen, and Stella Hanau. *The Provincetown: A Story of the Theatre.* New York: Russell and Russell, 1931.

Fiedler, Leslie. *Love and Death in the American Novel.* Rev. ed. New York: Stein and Day, 1966.

Giffin, Frederick C. *Six Who Protested: Radical Opposition to the First World War.* Port Washington, N.Y.: Kinnekat Press, 1977.

Gilligan, Carol. *In a Different Voice.* Cambridge, Mass.: Harvard University Press, 1982.

Glaspell, Susan. *Inheritors.* Boston: Small, Maynard, 1924.

———. *The Outside* in *Plays.* Boston: Small, Maynard, 1920.

———. *The Road to the Temple.* New York: Frederick Stokes, 1927. Rev. 1941.

———. *Suppressed Desires* (with George Cram Cook) in *Plays.*

———. *Trifles* in *Plays.*

Goldberg, Isaac. *The Drama of Transition.* Cincinnati: Stuart Kidd, 1922.

Keyssar, Helene. *Feminist Theatre.* New York: Grove Press, 1985.

Kolodny, Annette. "A Map for Rereading: Gender and the Interpretation of Literary Texts." In *The New Feminist Criticism,* edited by Elaine Showalter, pp. 46–62. New York: Pantheon, 1985.

Kunitz, Stanley J., and Howard Haycraft, eds. *Twentieth Century Authors.* New York: H. W. Wilson, 1942.

Lewisohn, Ludwig. *Drama and the Stage.* New York: Harcourt, 1922.

―――. *Expressionism in America.* New York: Harpers, 1932.

Marks, Elaine, and Isabelle de Courtivrons, eds. *New French Feminisms: An Anthology.* Amherst, Mass.: University of Massachusetts Press, 1980.

Miles, Julia, ed. *The Women's Project.* New York: Performing Arts Journal Publications and the American Place Theatre, 1980.

Noe, Marcia. *Susan Glaspell: Voice from the Heartland.* Macomb, Ill.: Western Illinois Monograph Series, no. 1, 1983.

Noggle, Burl. *Into the Twenties.* Urbana, Ill.: University of Illinois Press, 1974.

Peterson, H. C., and Gilbert C. Fite, eds. *Opponents of War: 1917–1918.* Madison, Wisc.: University of Wisconsin Press, 1957.

Sarlos, Robert Karoly. *Jig Cook and the Provincetown Players: Theatre in Ferment.* Amherst, Mass.: University of Massachusetts Press, 1982.

Showalter, Elaine, ed. *The New Feminist Criticism.* New York: Pantheon, 1985.

Sievers, W. David. *Freud on Broadway.* New York: Hermitage House, 1955.

Suleiman, Susan Rubin, ed. *The Female Body in Western Culture.* Cambridge, Mass.: Harvard University Press, 1986.

Waterman, Arthur. *Susan Glaspell.* New York: Twayne, 1966.

Woolf, Virginia. *Women and Writing.* Edited by Michele Barrett. New York: Harcourt Brace, 1979.

Still playing games: Ideology and Performance in the Theater of Maria Irene Fornes

W. B. Worthen

> Isidore, I beg you.
> Can't you see
> You're breaking my heart?
> 'Cause while I'm so earnest,
> You're still playing games.
>
> *Tango Palace*

A clown tosses off witty repartee while tossing away the cards on which his lines are written; a love scene is played first by actors and then by puppets they manipulate; the audience sits in a semicircle around a woman desperately negotiating with invisible tormentors: the plays of Maria Irene Fornes precisely address the process of theater, how the authority of the word, the presence of the performer, and the complicity of the silent spectator articulate dramatic play. Throughout her career Fornes has pursued an eclectic, reflexive theatricality. *A Vietnamese Wedding* (1967), for instance, "is not a play" but a kind of theater ceremony: "Rehearsals should serve the sole purpose of getting the readers acquainted with the text and the actions of the piece. The four people conducting the piece are hosts to the members of the audience who will enact the wedding" (p. 8). In *Dr. Kheal* (1968) a manic professor addresses the audience in a form of speech torture; the stage realism of *Molly's Dream* (1968) rapidly modulates into the deliquescent atmosphere of dreams. *The Successful Life of Three* (1965) freezes the behavioral routines of a romantic triangle in a series of static tableaux, interrupting the actors' stage presence in a way that anticipates "decon-

167

structive" theater experiments of the seventies and eighties.[1] And the "Dada zaniness" of *Promenade* (1965; score by Al Carmines)—a musical parable of two Chaplinesque prisoners who dig their way to freedom—brilliantly counterpoints Brecht, Blitzstein, Bernstein, and Beckett, viewed "through Lewis Carroll's looking-glass."[2]

Despite their variety, Fornes' experiments share a common impulse: to explore the operation of the mise-en-scène on the process of dramatic action. Rather than naturalizing theatrical performance by assimilating the various "enunciators" of the stage—acting, music, set design, audience disposition—to a privileged gestural style encoded in the dramatic text (the strategy of stage realism, for instance), Fornes' plays suspend the identification between the drama and its staging.[3] The rhetoric of Fornes' major plays—*Fefu and Her Friends* (1977), *The Danube* (1983), and *The Conduct of Life* (1985)—is sparked by this ideological dislocation. At first glance, though, to consider Fornes' drama as "ideological" may seem capricious, for Fornes claims that except for *Tango Palace* her plays "are not Idea Plays. My plays do not present a thesis, or at least, let us say, they do not present a formulated thesis" ("I write these messages" [p. 27]). But to constrain theatrical ideology to the "thesis play"—as though ideology were a fixed body of meanings to be "illustrated" or "realized" by an "Idea Play" or an "ideological drama"—is to confine ideology in the theater too narrowly to the plane of the text.[4] For like dramatic action, theatrical action—performance— occupies an ideological field. Performance claims a provisional "identity" between a given actor and dramatic "character," between the geography of the stage and the dramatic "setting," and between the process of acting and the play's dramatic "action."[5] The theater also "identifies" its spectator, casts a form of activity within which subjective significance is created. In and out of the theater, ideologies function neither solely as "bodies of thought that we possess and invest in our actions nor as elaborate texts" but "as *ongoing social processes*" that address us, qualify our actions with meaning, and so continually "constitute and reconstitute who we are" (Therborn, pp. 77–78). Whether the audience is explicitly characterized (as in Osborne's *The Entertainer* or Griffiths' *Comedians*), symbolically represented (as by the spotlight in Beckett's *Play*), or mysteriously concealed by the brilliant veil of the fourth wall, performance refigures "who we are" in the theater. Our attendance is represented in the "imaginary relationship" between "actors," "characters," and "spectators," where ideology is shaped as theatricality (Althusser, p. 153).

Trained as a painter, Fornes is, not surprisingly, attracted to the visual

procedures of the mise-en-scène. Her interest in the stage, though, stems from a theatrical rather than an explicitly political experience, Roger Blin's 1954 production of *Waiting for Godot:* "I didn't know a word of French. I had not read the play in English. But what was happening in front of me had a profound impact without even understanding a word. Imagine a writer whose theatricality is so amazing and so important that you could see a play of his, not understand one word, and be shook up" (Cummings, p. 52). The theatricality of *Godot* is deeply impressed on Fornes' pas de deux, *Tango Palace* (1964). Like Beckett, Fornes contests a rhetorical priority of modern realism: that stage production should represent an ideal "drama" and conceal the process of performance as a legitimate object of attention. An "obsession that took the form of a play" (Cummings, p. 51), *Tango Palace* takes place in a stage utopia, decked out with a chair, secretary, mirror, water jug, three teapots, a vase, and a blackboard—theatrical props rather than the signs of a dramatic "setting." The rear wall contains Isidore's "shrine," an illuminated recess holding his special props, as well as Isidore himself: a stout, heavily rouged, high-heeled, androgynous clown. The stage is Isidore's domain: when he gestures, his shrine is lit; at another gesture, chimes sound. To begin the play, Isidore creates his antagonist—Leopold, a handsome, business-suited man delivered to the stage in a canvas bag. Isidore introduces him to the set and its props ("This is my whip. [*Lashing* LEOPOLD] And that is pain [p. 131]), choreographs his movements, and gradually encourages him to play the series of routines that occupy their evening. Like Isidore's furniture, their mutual performances are classical, "influenced by their significance as distinct types representative of the best tradition, not only in the style and execution but in the choice of subject" (p. 130). Isidore's stage is a palace of art, its history contained in its accumulated junk: "the genuine Persian helmet I wore when I fought at Salamis" (p. 132), a "Queen Anne walnut armchair. Representing the acme of artistic craftsmanship of the Philadelphia school. Circa 1740," a "Louis Quinze secretary" (p. 130), a "rare seventeenth-century needlework carpet," a "Magnificent marked Wedgwood vase," a "Gutenberg Bible" (pp. 136–37). Consigned to the stage, where behavior becomes "acting," where objects become props and history a scenario for role-playing, Isidore and Leopold engage in a fully theatricalized combat, rehearsing a series of contests ordered not by a coherent plot but by the violent, sensual rhythms of the tango.[6]

Although the events of *Tango Palace* often seem spontaneous, they are hardly improvised; the play pays critical attention to the place of the

"text" on the stage. The dramatic text is usually traced into the spectacle, represented not as text but as acting, movement, speech, and gesture. The text of *Tango Palace,* though, is assigned a theatrical function, identified as a property of the performance. For Isidore's brilliance is hardly impromptu; his ripostes are scripted, printed on the cards he nonchalantly tosses about the stage.

> These cards contain wisdom. File them away. (*Card*) Know where they are. (*Card*) Have them at hand. (*Card*) Be one upon whom nothing is lost. (*Card*) Memorize them and you'll be where you were. (*Card*) . . . These are not my cards. They are yours. It's you who need learning, not me. I've learned already. (*Card*) I know all my cards by heart. (*Card*) I can recite them in chronological order and I don't leave one word out. (*Card*) What's more I never say a thing which is not an exact quotation from one of my cards. (*Card*) That's why I never hesitate. (*Card*) Why I'm never short of an answer. (*Card*) *Or a question.* (*Card*) Or a remark, if a remark is more appropriate. (pp. 133–34)

Isidore at once illustrates, parodies, and challenges the absent authority of the text in modern performance: "Study hard, learn your cards, and one day, you too will be able to talk like a parrot" (p. 135). *Tango Palace,* like Beckett's empty stages and Handke's prisons of language, explores the rich tension between the vitality of the performers and the exhausting artifice of their performance, the impoverished dramatic conventions, false furnishings, and parrotlike repetition of words that are the only means of "life" on the stage. Yet Isidore's text also suggests the inadequacy of this dichotomy by demonstrating how the theater insistently textualizes all behavior undertaken within its confines. The more "spontaneously" Leopold struggles to escape Isidore's arty hell, for instance, the more scripted his actions become: "LEOPOLD *executes each of* ISIDORE'S *commands at the same time as it is spoken, but as if* HE *were acting spontaneously rather than obeying*":

> ISIDORE AND LEOPOLD: Anybody there! Anybody there! (*Card*) Let me out. (*Card*) Open up! (*Card*) (p. 136)

Even burning Isidore's cards offers no relief, since to be free of the text on the stage is hardly to be free at all. It is simply to be silent, unrealized, dead:

> LEOPOLD: I'm going to burn those cards.
> ISIDORE: You'll die if you burn them . . . don't take my word for it. Try it.
> (LEOPOLD *sets fire to a card.*)

What in the world are you doing? Are you crazy?
(ISIDORE *puts the fire out.*)
Are you out of your mind? You're going to die.
Are you dying?
Do you feel awful?
(ISIDORE *trips* LEOPOLD.)
There! You died. (p. 139)

Tango Palace dramatizes the condition of theater—the dialectical tension between fiction and the flesh—and implies the unstable place of theater in the world that surrounds it, the world that Leopold struggles to rejoin. The theater can offer only illusion, not the gritty reality, the "dirt" that Leopold wants: "What I want, sir, is to live with that loathsome mess near me, not to flush it away. To live with it for all those who throw perfume on it. To be so dirty for those who want to be so clean" (p. 157). Isidore's "cave," like Plato's, can only provide illusion, yet in *Tango Palace*—as in any theater—artifice is inextricably wrought into the sense of the real. Even Leopold's final execution of Isidore serves only to extend their mutual struggle, for Isidore's impossibly stagey death is followed naturally by his equally stagey resurrection, as he returns dressed like an angel, carrying his stack of cards and beckoning to Leopold; "LEOPOLD *walks through the door slowly, but with determination.* HE *is ready for the next stage of their battle*" (p. 162).

Tango Palace provides a vision, an allegory perhaps, of how the stage produces a reality, but produces it as image, performance, theater. Since *Tango Palace,* and especially since *Fefu and Her Friends,* Fornes' plays have become at once more explicitly political in theme, more rigorous in exploring the ideological relation between theatrical and dramatic representation, and more effectively engaged in repudiating the "burden of psychology, declamation, morality, and sentimentality" characteristic of American realism (Marranca, p. 70). Indeed, Fornes' recent work frequently frames "realism" in an alienating, critical mise-en-scène that alters our reading of the performance and of the drama it sustains. *The Danube,* for instance, presents a love story between an American businessman and a Hungarian working girl. This parable of East-West relations develops the tentative romance against a distant background of European conflict and against the immediate physical debilitation of the cast, who seem to suffer from radiation sickness: they develop sores, become crippled, feeble, ragged, and ashen. Although many scenes in *The Danube* are minutely "realistic" in texture, the play's staging intervenes between the spectator and the conventions of realistic performance

by interrupting the defining moment of realistic rhetoric: the identifica-
tion of stage performance with the conventions of social behavior. The
play is staged on a platform—not in a stage "room"—held between four
posts that serve an openly theatrical function: postcardlike backdrops
are inserted between the rear posts, a curtain is suspended from the
downstage pair, and between scenes smoke is released from holes in the
platform itself. In its proportions the set is reminiscent of a puppet thea-
ter, and much of the action seems to imply that the characters are
manipulated by an outside agency. And, as in *Tango Palace,* the text of
The Danube is again objectified, held apart from the actors' charismatic
presence. In fact, it was a "found object" that stimulated Fornes' con-
ception of the use of language in the play:

> Fornes was walking past a thrift shop on West 4th Street, saw some 78
> rpm records in a bin, liked the way they looked even before she knew
> what they were . . . so she bought one for a dollar. Turns out it was
> a language record, the simplest sentences, first in Hungarian, then in
> English. "There was such tenderness in those little scenes," she re-
> calls—introducing people, ordering in restaurants, discussing the
> weather—"that when the Theater for the New City asked me to do
> an antinuclear piece, I thought of how sorrowful it would be to lose
> the simplest pleasures of our own era." (Wetzsteon, p. 43)

Many scenes of *The Danube* open with a language-lesson tape re-
cording of the opening lines of stage dialogue: we hear the mechanical
inflections of the taped English and Hungarian sentences and then the
actors onstage perform the same lines in character, naturally.[7] On the
one hand, this technique emphasizes the elocutionary dimension of lan-
guage, how speech is already textualized in the procedures of social ac-
tion—*"Unit One. Basic sentences. Paul Green meets Mr. Sandor and
his daughter Eve"* (p. 44); *"Unit Three. Basic sentences. Paul and Eve
go to the restaurant"* (p. 49). Yet although the tape recordings under-
score the "text" of social exchange, the actors' delivery—insofar as it
is "naturalistic," spoken "with a different sense, a different emphasis"
(p. 42)—necessarily skews our attention from the code of social enact-
ment to the "presence" or "personality" it seems to disclose. Onstage,
The Danube suspends the identification between language and speech.
The performance dramatizes the problematic of "social being," the dia-
lectical encounter between the individual subject and the codes of his or
her realization, the "intersection of social formations and . . . personal
history" (de Lauretis, p. 14). In fact, to speak in an "unscripted" manner
is simply to act incomprehensibly, to forego recognition. The characters'
infrequent, trancelike monologues are not only spoken out of context,

they are apparently unheard by others on the stage.[8] We see the characters physically deteriorate, but they repeatedly deny that their illnesses are out of the ordinary; when they speak textbook patter, they can be realized as "social beings," but when they attempt to speak expressively, they speak to no one, not even to themselves. To be known in *The Danube* is necessarily to "talk like a machine," say only what the "machines" of language and behavior permit one to say (p. 62).

The Danube discovers "the poisons of the nuclear age" in the processes of culture (Rich). The machine of language and the cognate conventions of social life—dating, work, medicine, international relations—represent and so inevitably distort the human life they sustain, the life that visibly decays before our eyes. This is the point of the two brilliant pairs of scenes that conclude the play. In scene 12 Paul's illness finally drives him to the point of leaving Hungary and Eve; the scene is replayed in scene 13, as *"Paul, Eve, and Mr. Sandor operate puppets whose appearance is identical to theirs."* Scenes 14 and 15 reverse this procedure, as scene 14 is played first by puppets and then repeated in scene 15—culminating in Eve's poetic farewell to the Danube and a blinding flash of white light—by the actors. Like the tape recordings, the puppet scenes disrupt the "natural" assimilation of "character" to the actor through the transparent gestural codes of social behavior. Like the language they speak, the gestures that constitute "character" are shown to be an autonomous text, as effectively—though differently—performed by puppets as by people. The proxemics of performance are shown to occupy the "intersection" between individual subjectivity and the social codes of its representation and recognition. Conventions of politics, codes of conduct, and systems of signification frame the platform of social action in *The Danube;* like invisible hands, they guide the human puppets of the stage.

The formal intricacy of *The Danube* opens a dissonance between speech and language, between the bodies of the performers and the gestures of their enactment, between life and the codes with which we conduct it. This somber play typifies Fornes' current investigation of the languages of the stage, which are given a more explicitly political inflection in *The Conduct of Life*. Set in a Latin American military state, *The Conduct of Life* prismatically reflects the interdependence of politics, power, and gender. The play takes the form of a loose sequence of negotiations between Orlando (a lieutenant in the military) and his wife, Leticia; his commander, Alejo; a domestic servant, Olimpia; and Nena, a girl Orlando keeps in a warehouse and repeatedly rapes. Husband and wife, torturer and victim, man and woman, master and servant: from

the opening moments of the play, when we see Orlando doing jumping jacks in the dark and vowing to "achieve maximum power" by being "no longer . . . overwhelmed by sexual passion" (68), the play traces the desire for mastery through a refracting network of relations—work, marriage, career, politics, sex.

Rape is, however, the defining metaphor of social action in the play, and the warehouse scenes between Orlando and Nena emblematize the play's fusion of sexual and political relations. Alejo may be rendered "impotent" by Orlando's vicious torturing of an opponent (p. 75), but torturer and victim are bound in an unbreakable embrace. Indeed, Orlando speaks to Nena much as he does to justify his regime: "What I do to you is out of love. Out of want. It's not what you think. I wish you didn't have to be hurt. I don't do it out of hatred. It is not out of rage. It is love" (p. 82). Orlando's rhetoric is chilling; that this "love" should be reciprocated measures the accuracy of Fornes' penetrating examination of the conduct of social power. Late in the play, Nena recounts her life—sleeping in the streets, living in a box with her grandfather ("It is a big box. It is big enough for two" [p. 83])—and how she came to be abducted by Orlando. She concludes:

> I want to conduct each day of my life in the best possible way. I should value the things I have. And I should value all those who are near me. And I should value the kindness that others bestow upon me. And if someone should treat me unkindly, I should not blind myself with rage, but I should see them and receive them, since maybe they are in worse pain than me. (pp. 84–85)

Rather than taking a resistant, revolutionary posture, Nena accepts a Christian humility, an attitude that simply enforces her own objectification, her continued abuse. Beaten, raped, owned by Orlando, Nena finally adopts a morality that—grotesquely—completes her subjection to him and to the social order that empowers him. Indeed, when Leticia learns how to conduct her own life—by killing Orlando—she also reveals how inescapably Nena's exploitation lies at the foundation of this world: she hands the smoking revolver to Nena, who takes it with *"terror and numb acceptance"* (p. 88).

Finally, *The Conduct of Life* uses the disposition of the stage to reflect and extend this vision of social corruption. The stage is constructed in a series of horizontal, tiered planes: the forestage area represents the living room; a low (eighteen-inch) platform slightly upstage represents the dining room; this platform steps up (eighteen inches) onto the hallway; the hallway is succeeded by a three-foot drop to the basement, in which are standing two trestle tables; a staircase leads to the platform

farthest upstage, the warehouse. The set provides a visual emblem of the hierarchy of power in the play. More significantly, though, the set constructs a powerful habit of vision for the spectators. The living and dining rooms—those areas of public sociability where Olimpia serves coffee, Leticia and Orlando discuss their marriage, Olimpia and Nena gossip while preparing dinner—become transparent to the audience as windows onto the upstage sets and the occluded "setting" they represent: the warehouses and basements where the real life of this society—torture, rape, betrayal—is conducted.

As in *The Danube,* the staging of *The Conduct of Life* dislocates the familiar surfaces of stage realism. On occasion, however, Fornes renders the ideological process of theater visible not simply by disrupting familiar conventions but by dramatizing the audience's implication in the conduct of the spectacle. Indeed, Fornes' most assured play, *Fefu and Her Friends,* explores the ideology of stage gender through a sophisticated use of stage space to construct a "dramatic" relation between stage and audience. The play conceives the gender dynamics implicit in the realistic perspective by disclosing the gendered bias of the spectator's interpretive authority, "his" transcendent position above the women of the stage. The play opens at a country house in 1935. The title character has invited a group of women to her home to rehearse a brief series of skits for a charity benefit to raise money for a newly founded organization. In the first scene the women arrive and are introduced. Many seem to have been college friends, two seem to be lovers, or ex-lovers. Much of the action of the scene centers on Julia, who is confined to a wheelchair as the result of a mysterious hunting accident: although the bullet missed her, she is paralyzed from the waist down. In part 2, Fornes breaks the audience into four groups that tour Fefu's home—garden, study, bedroom, and kitchen: "These scenes are performed simultaneously. When the scenes are completed the audience moves to the next space and the scenes are performed again. This is repeated four times until each group has seen all four scenes" (p. 6). In part 3 the audience is returned to the auditorium. The women rehearse and decide the order of their program. Fefu goes outside to clean her shotgun, and suddenly a shot rings out; Julia falls dead, though again she does not seem to have been hit.

In the theater, the play examines the theatrical poetics of the feminine not only as "theme" but in the structuring of the spectacle itself, by unseating the spectator of "realism" and dramatizing "his" controlling authority over the construction of stage gender. Early in the play, for instance, Fefu looks offstage and sees her husband approaching: "FEFU

reaches for the gun, aims and shoots. CHRISTINA *hides behind the couch.*
She and CINDY *scream. . . .* FEFU *smiles proudly. She blows on the*
mouth of the barrel. She puts down the gun and looks out again" (p. 9).
As Fefu explains once Phillip has regained his feet, "It's a game we
play. I shoot and he falls. Whenever he hears the blast he falls. No mat-
ter where he is, he falls." Although Phillip is never seen in the play, his
attitudes shape Fefu's stage characterization. For as she remarks in her
first line in the play, "My husband married me to have a constant re-
minder of how loathsome women are" (p. 7). The shooting game pro-
vides an emblem for the relation between vision and gender in *Fefu,* for
whether the shells are "real" or "imaginary" ("I thought the guns were
not loaded," remarks Cindy; "I'm never sure," replies Fefu [p. 12]), the
exchange of power takes place through the "sighting" of the other.[9]

The authority of the absent male is everywhere evident in *Fefu,* and
particularly is imaged in Julia's paralysis. As Cindy suggests when she
describes the accident, Julia's malady is a version of Fefu's "game": "I
thought the bullet hit her, but it didn't . . . the hunter aimed . . . at
the deer. He shot":

> Julia and the deer fell. . . . I screamed for help and the hunter came
> and examined Julia. He said, "She is not hurt." Julia's forehead was
> bleeding. He said, "It is a surface wound. I didn't hurt her." I know
> it wasn't he who hurt her. It was someone else. . . . Apparently there
> was a spinal nerve injury but the doctors are puzzled because it
> doesn't seem her spine was hurt when she fell. She hit her head and
> she suffered a concussion but that would not affect the spinal nerve.
> So there seems to be no reason for the paralysis. She blanks out and
> that is caused by the blow on the head. It's a scar in the brain. (pp.
> 14–15)

The women of *Fefu and Her Friends* share Julia's invisible "scar," the
mark of their paralyzing subjection to a masculine authority that op-
erates on the "imaginary," ideological plane. The hunter is kin to Julia's
hallucinatory "voices" in part 2, the "judges" who enforce her psychic
dismemberment: "They clubbed me. They broke my head. They broke
my will. They broke my hands. They tore my eyes out. They took away
my voice." Julia's bodily identification is broken down and reordered
according to the "aesthetic" canons prescribed by the male voice ("He
said that . . . to see a woman running creates a disparate and incon-
gruous image in the mind. It's antiaesthetic" [pp. 24–25]), the silent
voice that characterizes women as "loathsome." This internalized "guard-
ian" rewrites Julia's identity at the interface of the body itself, where the
masculine voice materializes itself in the woman's flesh. Other women

in the play envy "being like a man. Thinking like a man. Feeling like a man" (p. 13), but as Julia's coerced "prayer" suggests, to be subject to this representation of the feminine is to resign humanity ("The human being is of the masculine gender"), independence ("The mate for man is woman and that is the cross man must bear"), and sexuality ("Woman's spirit is sexual. That is why after coitus they dwell in nefarious feelings" [p. 25]). The subliminal masculine voice inscribes the deepest levels of psychological and physiological identification with the crippling gesture of submission:

> (*Her head moves as if slapped.*)
> JULIA: Don't hit me. Didn't I just say my prayer?
> (*A smaller slap.*)
> JULIA: I believe it. (p. 25)

Fornes suggest that "Julia is the mind of the play," and Julia's scene articulates the shaping vision of *Fefu* as a whole, as well as organizing the dramatic structure of part 2. In the kitchen scene, for instance, Fornes recalls Julia's torture in Paula's description of the anomie she feels when a relationship breaks up ("the break up takes place in parts. The brain, the heart, the body, mutual things, shared things" [p. 27]); the simultaneity of the two scenes is marked when Sue leaves the kitchen with soup for Julia. Sue's departure also coordinates Julia's prayer with the concluding section of the kitchen scene. Julia's submission to the voice in the bedroom is replaced by Paula and Cecilia's suspension of their unspoken love affair: "Now we look at each other like strangers. We are guarded. I speak and you don't understand my words" (p. 28). This dramatic counterpoint invites us to see Paula and Cecilia's relationship, Cindy's violent dream of strangulation (in the study scene), Emma's thinking "about genitals all the time," and Fefu's constant, nightmarish pain (in the lawn scene) as transformations of Julia's more explicit subjection.

The action of *Fefu and Her Friends* takes place under the watchful eyes of Phillip, of the hunter, of Julia's "guardians," a gaze that constructs, enables, and thwarts the women of the stage: "Our sight is a form they take. That is why we take pleasure in seeing things" (p. 35). In the theater, of course, there is another invisible voyeur whose performance is both powerful and "imaginary"—the spectator. *Fefu and Her Friends* extends the function of the spectator beyond the metaphorical register by decentering "his" implicit ordering of the theatricality of the feminine. First performed by the New York Theater Strategy in a SoHo loft, the play originally invited the spectators to explore the space of

Fefu's home. In the American Place Theatre production, the spectators were invited, row by row, to different areas of the theater—a backstage kitchen, an upstairs bedroom, the garden and study sets—before being returned to the auditorium, but not to their original seats.[10] At first glance, Fornes' staging may seem simply a "gimmick," a formalist exercise in "multiple perspective" something like Alan Ayckbourn's *Norman Conquests*.[11] Yet Ayckbourn's trilogy—each play takes a different set of soundings from the events of a single weekend—implies that there could be, in some mammoth play, a single ordering and relation of events, one "drama" expressed by a single plot and visible from a single perspective. In this regard the structure of *The Norman Conquests,* like its philandering hero, Norman, exudes a peculiarly masculine confidence, "The faith the world puts in them and they in turn put in the world," as Christina puts it (p. 13). Despite Fornes' suggestion that "the style of acting should be film acting" ("Interview," p. 110), *Fefu and Her Friends* bears little confidence in the adequacy or authority of the single viewing subject characteristic of both film and fourth-wall realism. In this sense, *Fefu* more closely approximates the decentering disorientation of environmental art than "some adoption by the theater of cinematic flexibility and montage."[12] Different spectators see the drama in a different sequence, and in fact see different plays, as variations invariably enter into the actors' performances. Fornes not only draws the audience into the performance space, she actively challenges and suspends the epistemological structure of realistic vision, predicated as it is on an invisible, singular, motionless, masculine interpreter situated outside the field of dramatic *and* theatrical activity. By reordering our function in the theatrical process, *Fefu* reorders our relation to, and interpretation of, the dramatic process it shapes.[13]

As Cecilia says at the opening of part 3, after we have returned to the auditorium, "we each have our own system of receiving information, placing it, responsibility to it. That system can function with such a bias that it could take any situation and translate it into one formula" (p. 29). In performance, *Fefu and Her Friends* dramatizes and displaces the theatrical "system" that renders "woman" visible: the predication of feminine identity on the sight of the spectator, a "judge." Fornes regards traditional plot conventions as naturalizing a confining set of feminine roles: "In a plot play the woman is either the mother or the sister or the girlfriend or the daughter. The purpose of the character is to serve the plot" ("Interview," p. 106). In this sense Fornes' theatrical strategy may be seen as an attempt to retheorize the interpretive operation of theatrical vision. Fornes replaces the "objective" and objectify-

ing relations of masculine vision with the "fluid boundaries" characteristic of feminist epistemology.[14] As Patrocinio Schweickart argues, summarizing Nancy Chodorow and Carol Gilligan, "men define themselves through individuation and separation from others, while women have more flexible ego boundaries and define and experience themselves in terms of their affiliations and relationships with others" (Schweickart, pp. 54–55). The consequences of this distinction have been widely applied and have become recently influential in studies of reading, studies which provide an interpretive analogy to the action of Fornes' dramaturgy. Schweickart suggests that in a feminist, reader-oriented theory, "the central issue is not of control or partition, but of managing the contradictory implications of the desire for relationship . . . and the desire for intimacy" (p. 55). David Bleich, surveying actual readings provided by his students, suggests that "women *enter* the world of the novel, take it as something 'there' for that purpose; men *see* the novel as a result of someone's action and construe its meaning or logic in those terms" (p. 239).[15] Writing the play, Fornes sought to avoid "writing in a linear manner, moving forward," and instead undertook a series of centrifugal experiments, exploring characterization by writing a series of improvisational, extraneous scenes (Cummings, p. 53). But while Fornes again disowns political or ideological intent ("I don't mean linear in terms of what the feminists claim about the way the male mind works," she goes on to say), her suspension of plot organization for a more atmospheric or "environmental" procedure articulates the gendered coding of theatrical interpretation. Perhaps as a result, the staging of *Fefu* challenges the institutional "objectivity" of theatrical vision. For the play not only realizes Julia's absent voices, it casts us as their speakers, since we enact the role of her unseen, coercive tormentors. The play reshapes our relation to the drama, setting our interpretive activity within a performance structure that subordinates "plot" to "environment" and that refuses our recourse to a single, external point of view.

The "educational dramatics" of *Fefu and Her Friends* not only alert us to the paralyzing effect of a patriarchal ideology on the dramatic characters; they also imply the degree to which this ideology is replicated in the coercive "formula" of realistic sight.[16] As Emma's speech on the "Environment" suggests ("Environment knocks at the gateway of the senses" [p. 31]), the theatrical activity of part 2 reorders the traditional hierarchy of theatrical perception—privileging the drama to its performance—and so suspends the "objective" absence of the masculine eye. *Fefu* criticizes the realistic theater's order of subjection, an order

which, like "civilization," is still "A circumscribed order in which the whole has not entered"; even Emma's "environment" is characterized as "him" (p. 32). In *Fefu and Her Friends,* vision is achieved only through a strategy of displacement, by standing outside the theatrical "formula" of realism in order to witness its "bias." The play undertakes to dramatize both the results of that bias—in the various deformations suffered by Julia, Fefu, and their friends—and to enact the "other" formula that has been suppressed, the formula that becomes the audience's mode of vision in the theater. To see *Fefu* is not to imagine an ideal order, a single, causal "plot" constituted specifically by our absence from the performance. For *Fefu and Her Friends* decenters the absent "spectator" as the site of authentic interpretation, replacing "him" with a self-evidently theatricalized body, an "audience," a community sharing irreconcilable yet interdependent experiences. The perspective offered by the realistic box set appears to construct a community of witnesses, but is in fact grounded in the sight of a single observer; the realistic audience sees with a single eye. *Fefu* challenges the "theory" of realistic theater at its source by dramatizing—and displacing—the covert authority of the constitutive *theoros* of naturalism and the social order it reproduces: the offstage man.[17] In so doing, *Fefu* provides an experience consonant with the play's climactic dramatic event. Much as we are returned to the auditorium in part 3, to assume the role of "spectator" with a fuller sense of the social legitimacy embodied in that perspective, so Fefu finally appropriates the objectifying "bias" of the unseen man in order to defend herself—and free Julia—from its oppressive view. Fefu cleans the play's central "apparatus" and then assumes the hunter's part, the "sight" that subjects the women of the stage:

> (*There is the sound of a shot.* CHRISTINA and CECILIA *run out.* JULIA *puts her hand to her forehead. Her hand goes down slowly. There is blood on her forehead. Her head falls back.* FEFU *enters holding a dead rabbit in her arms. She stands behind* JULIA.
>
> FEFU: I killed it . . . I just shot . . . and killed it . . . Julia.
>
> (p. 41)

Despite the success of *Fefu and Her Friends* and of several later plays—*Evelyn Brown* (1980), *Mud* (1983), *Sarita* (1984)—addressing gender and power issues, Fornes refuses to be identified solely as a "feminist" playwright (Cummings, p. 55). Spanning the range of contemporary theatrical style (experimental theater, realism, "absurd" drama, musical theater, satiric revue), Fornes' drama resists formal or thematic categorization. What pervades her writing is a delicate, some-

times rueful, occasionally explosive irony, a witty moral toughness replacing the "heavy, slow, laborious and pedestrian" didacticism we may expect of "ideological" drama. Brecht was right, of course, to encourage the members of his cast to play against such a sense of political theater: "We must keep the tempo of a run-through and infect it with quiet strength, with our own fun. In the dialogue the exchanges must not be offered reluctantly, as when offering somebody one's last pair of boots, but must be tossed like so many balls" (Brecht, p. 283). Like Brecht's, Fornes' theater generates the "fun," the infectious sophistication of a popular art. Juggling the dialectic between "theater for pleasure" and "theater for instruction," Fornes is still—earnestly, politically, theatrically—"playing games."

Notes

1. Fornes describes *The Successful Life of Three* as arising from her association with the Actors Studio: "The first play that I wrote that was influenced by my understanding of Method was *The Successful Life of Three*. What one character says to another comes completely out of his own impulse and so does the other character's reply. The other character's reply never comes from some sort of premeditation on my part or even the part of the character. The characters have no mind. They are simply doing what Strasberg always called 'moment to moment.'" Insofar as Fornes applies acting exercises to the techniques of dramatic characterization, she seems accurately to have evaluated her relationship to Strasberg: "I was very impressed with Strasberg's work as an actor's technician or a director's technician but I would completely ignore anything he would say about aesthetics" (Cummings, p. 52).

2. See Barnes; Stephen Holden compares the play to Bernstein's *Candide,* Beckett, and Carroll; and Daphne Kraft describes the play as a hybrid of "Marc Blitzstein's 'The Cradle Will Rock' and Leonard Bernstein's 'Candide.' "

3. See Pavis, p. 44.

4. See Bigsby, p. 23, and Terry Eagleton's suggestive account of the relation between text and production in *Criticism and Ideology* (pp. 64–68).

5. On "identification" and ideology, see Burke, p. 88 and *passim*.

6. Martin Washburn suggests not only that Fornes has "absorbed the continental traditions" but that "Isidore may actually represent the toils of continental literature which the playwright wants to escape."

7. It should be noted that some scenes have no taped opening, some have a tape recording of the opening lines only in Hungarian, and some scenes

proceed throughout in this manner: English tape, Hungarian tape, actor's delivery.

8. As, for instance, when a waiter delivers a sudden, trancelike tirade: "We are dark. Americans are bright.—You crave mobility. The car. You move from city to city so as not to grow stale. You don't stay too long in a place. . . . Our grace is weighty. Not yours. You worship the long leg and loose hip joint. How else to jump in and out of cars" (p. 52).

9. The gun business derives from a joke, as Fornes reports in "Notes on Fefu": "There are two Mexicans in sombreros sitting at a bullfight and one says to the other, 'Isn't she beautiful, the one in yellow?' and he points to a woman on the other side of the arena crowded with people. The other one says, 'Which one?' and the first takes his gun and shoots her and says, 'The one that falls.' In the first draft of the play Fefu explains that she started playing this game with her husband as a joke. But in rewriting the play I took out this explanation" (p. 38). It's notable that the gun business dates from Fornes' original work on the play in 1964, as she suggests in "Interview," p. 106.

10. Although he seems to have disliked leaving his seat, Walter Kerr offers a description of the procedure of the play; see his review of Fefu and Her Friends. Kerr's painful recollections of his displacement are recalled several months later, in "New Plays Bring Back Old Songs." See also Pat Lamb ("at stake here is the quality of experience, of life itself"); and the unsigned review of Fefu and Her Friends in the Village Voice, May 23, 1977 ("this enclosed repetitiveness sums up entire trapped lifetimes").

11. In Ayckbourn's trilogy the same romantic comedy is replayed three times. In Table Manners the audience witnesses a series of misadventures transpiring over a country-house weekend and hears about a variety of off-stage events; in Living Together these offstage events and others are drama-tized while we hear about (and recall) the now-offstage events of the first play; in Round and Round the Garden the material from the first two plays is now offstage, and we witness a third series of scenes.

12. Stanley Kauffman's reading of the play's filmic texture is at once shrewd and, in this sense, misapplied: "I doubt very much that Fornes thought of this four-part walk-around as a gimmick. Probably it signified for her an explanation of simultaneity (since all four scenes are done simul-taneously four times for the four groups), a union of play and audience through kinetics, some adoption by the theater of cinematic flexibility and montage. But since the small content in these scenes would in no way be damaged by traditional serial construction, since this insistence on reminding us that people actually have related/unrelated conversations simultaneously in different rooms of the same house is banal, we are left with the feeling of gimmick."

13. As Richard Eder remarked of the bedroom scene, "Julia is lying in bed, and we sit around her. Our presence, like that of the onlookers in Rem-

brandt's 'Anatomy Lesson,' magnifies the horror of what is going on." See also Feingold.

14. For this phrase I am indebted to my colleague Joan Lidoff.

15. In terms of the theatrical structure of *Fefu and Her Friends*, it is also notable that Bleich's male students not only tended to "see" the novel from "outside" its matrix of relationships but tended to privilege the "plot" in their retellings: "The men retold the story as if the purpose was to deliver a clear, simple structure or chain of information: these are the main characters; this is the main action; this is how it turned out. . . . The women presented the narrative as if it were an atmosphere or experience. They generally felt freer to reflect on the story material with adjectival judgments, and even larger sorts of judgments, and they were more ready to draw inferences without strict regard for the literal warrant of the text, but with more regard for the affective sense of human relationships in the story" (p. 256).

16. Emma's speech on acting is taken from the prologue to Emma Sheridan Fry, *Educational Dramatics*. Elsewhere in the book Fry defines the "dramatic instinct" as the process that relates the subject to its environment: "It rouses us to a recognition of the Outside. It provokes those processes whereby we respond to the attack of the Outside upon us" (p. 6).

17. As Jane Gallop describes it, "Nothing to see becomes nothing of worth. The metaphysical privileging of sight over other senses, oculocentrism, supports and unifies phallocentric sexual theory (theory—from the Greek *theoria*, from *theoros*, 'spectator,' from *thea*, 'a viewing'). *Speculum* (from *specere*, 'to look at') makes repeated reference to the oculocentrism of theory, of philosophy" (pp. 36–37).

Bibliography

Althusser, Louis. "Ideology and Ideological State Apparatuses." In *Lenin and Philosophy and Other Essays*, translated by Ben Brewster. London: NLB, 1971.

Ayckbourn, Alan. *The Norman Conquests*. Garden City, N.J.: Doubleday, 1975.

Barnes, Clive. Review of *Promenade*, by Maria Irene Fornes. New York *Times*, June 5, 1969, 56.

Bigsby, C. W. E. "The Language of Crisis in British Theatre: The Drama of Cultural Pathology." In *Contemporary English Drama*, edited by C. W. E. Bigsby, pp. 10–51. New York: Holmes & Meier, 1981.

Bleich, David. "Gender Interests in Reading and Language." In *Gender*

and Reading, edited by Elizabeth A. Flynn and Patrocinio P. Schweick-art, pp. 234–66. Baltimore: Johns Hopkins University Press, 1986.

Brecht, Bertolt. *Brecht on Theatre.* Edited and translated by John Willett. New York: Hill and Wang, 1964.

Burke, Kenneth. *A Rhetoric of Motives.* Berkeley: University of California Press, 1969.

Chodorow, Nancy. *The Reproduction of Mothering: Psychoanalysis and the Sociology of Gender.* Berkeley: University of California Press, 1978.

Cummings, Scott. "Seeing with Clarity: The Visions of Maria Irene Fornes." *Theater* (Yale) 17, no. 1 (Winter 1985), 51–56.

de Lauretis, Teresa. *Alice Doesn't: Feminism, Semiotics, Cinema.* Bloom-ington, Ind.: Indiana University Press, 1984.

Eagleton, Terry. *Criticism and Ideology* [1976]. London: Verso, 1978.

Eder, Richard. "Fefu Takes Friends to American Place." New York *Times,* January 14, 1978, 10.

———. Review of *Fefu and Her Friends,* by Maria Irene Fornes. *Village Voice,* May 23, 1977, 80.

Feingold, Michael. Review of *Fefu and Her Friends,* by Maria Irene Fornes. *Village Voice,* January 23, 1978, 75.

Flynn, Elizabeth A., and Patrocinio P. Schweickart, eds. *Gender and Reading.* Baltimore, Md.: Johns Hopkins University Press, 1986.

Fornes, Maria Irene. *The Conduct of Life. Plays.*

———. *The Danube.* In *Plays.*

———. *Dr. Kheal.* In *Promenade and Other Plays.*

———. *Fefu and Her Friends.* In *Wordplays: An Anthology of New American Drama.* New York: Performing Arts Journal Publications, 1980.

———. "I Write These Messages That Come." *Drama Review* 21, no. 4 (December 1977), 25–40.

———. "Interview." *Performing Arts Journal* 2, no. 3 (Winter 1978), 106–11.

———. *Molly's Dream.* In *Promenade and Other Plays.*

———. "Notes on *Fefu.*" *SoHo Weekly News,* June 12, 1978, 38.

———. *Plays.* New York: Performing Arts Journal Publications, 1986.

———. *Promenade.* In *Promenade and Other Plays.*

———. *Promenade and Other Plays.* New York: Winter House, 1971.

———. *The Successful Life of Three.* In *Promenade and Other Plays.*

———. *Tango Palace.* In *Promenade and Other Plays.*

———. *A Vietnamese Wedding.* In *Promenade and Other Plays.*

Fry, Emma Sheridan. *Educational Dramatics.* New York: Lloyd Adams Noble, 1917.

Gallop, Jane. "The Father's Seduction." In *The (M)other Tongue: Essays in Feminist Psychoanalytic Interpretation,* edited by Shirley Nelson Garner, Claire Kahane, Madelon Sprengnether. Ithaca, N.Y.: Cornell University Press, 1985.

Gilligan, Carol. *In a Different Voice: Psychological Theory and Women's Development.* Cambridge, Mass.: Harvard University Press, 1982.

Holden, Stephen. Review of *Promenade,* by Maria Irene Fornes. New York *Times,* October 25, 1983, C8.

Kauffman, Stanley. Review of *Fefu and Her Friends,* by Maria Irene Fornes. *New Republic,* February 25, 1978, 38.

Kerr, Walter. Review of *Fefu and Her Friends,* by Maria Irene Fornes. New York *Times,* January 22, 1978, D3.

———. "New Plays Bring Back Old Songs." New York *Times,* June 13, 1978, C1, C4.

Kraft, Daphne. Review of *Promenade,* by Maria Irene Fornes. Newark *Evening News,* June 5, 1969, 74.

Lamb, Pat. Review of *Fefu and Her Friends,* by Maria Irene Fornes. *Chelsea Clinton News,* January 19, 1978.

Marranca, Bonnie. "The Real Life of Maria Irene Fornes." In *Theatrewritings.* New York: Performing Arts Journal Publications, 1984, pp. 69–73.

Pavis, Patrice. "On Brecht's Notion of *Gestus.*" In *Languages of the Stage: Essays in the Semiology of the Theatre.* New York: Performing Arts Journal Publications, 1982, pp. 37–49.

Rich, Frank. Review of *The Danube,* by Maria Irene Fornes. New York *Times,* March 13, 1984, C13.

Schweickart, Patrocinio P. "Reading Ourselves: Toward a Feminist Theory of Reading." In *Gender and Reading,* ed. Elizabeth A. Flynn and Patrocinio P. Schweickart, pp. 31–62. Baltimore, Md.: Johns Hopkins University Press, 1986.

Therborn, Göran. *The Ideology of Power and the Power of Ideology.* London: NLB, 1980.

Washburn, Martin. Review of *Tango Palace,* by Maria Irene Fornes. *Village Voice,* January 25, 1973.

Wetzsteon, Ross. "Irene Fornes: The Elements of Style." *Village Voice,* April 29, 1986, 42–45.

The Play of Letters: Possession and Writing in *Chucky's Hunch*

Timothy Murray

> One of the qualities of artistic writing that is conscious of its
> enigma, is that it draws every interpretative reading towards that
> revised enigma, as if into a trap, and that the writing infects the
> interpretation with the writing-effect from which it emanates: its
> madness.
>
> <div align="right">DANIEL SIBONY[1]</div>

A curious and contradictory writing strategy motivates the "play"
Chucky's Hunch. Rochelle Owens pens a compelling and disturbing
contemporary performance by silencing dramatic dialogue and minimiz-
ing theatrical action, those two very tangible attributes of occidental
drama that lend shape to heroic characters and theater's many primal
scenes. Although Chucky himself enunciates the terrors of sexual trauma
and what he calls "reptile age fears," his author limits his theatrical
properties to the echoed monologue of twelve letters already written to
Elly, the second of Chucky's three wives. These epistles are supple-
mented in performance by two other texts. First, a taped narration of a
"primal scene" in which a copulating bestial couple, a snake and a por-
cupine, devours Chucky's dog in the course of a love ritual. Second, a
supplementary epistle from Chucky's mother to Elly. This letter recalls
Elly's earlier "loss" of Chucky's unborn baby and confirms the death of
the dog Chucky had grown to cherish "just like a little child, my son, and
Ma's grandchild" (p. 20).[2] Similar accounts of loss doubled by the
wounds of representation surface throughout this spoken performance.
Reliving the broken memories of the unfulfilled American dream,
Chucky's letters recount the disruption of his fragile life brought about
not only by the unnatural death of his dog but also by an added in-
stance of Oedipal displacement—the erotic love affair of Chucky's 85-

year-old mother with the 82-year-old Chester Nickerson. The complex memory of doubled Oedipal threat prompts Chucky to recount his subsequent epic journey into upstate New York's "forest primeval" to avenge the ritualistic slaughter of Freddy. This scenario is accompanied by other graphically violent tableaux inscribed throughout the play's primary scene of textuality, the series of Chucky's misogynistic love letters, replete with the best of the epistolary genre's incompatible narrative impulses—vengeance and nostalgia, defiance and desire.[3]

The tableaux of writing—the enunciative acts of writing and reading—constitutes the source of this play's primal attraction. But this maddening scene remains for Chucky to be significantly different from earlier exemplars of theater's enigmatic writing effects. Deprived of the authorial dignity of a Faust or a Marat, Chucky is never staged "in the act of writing the letters." Nor does he share the cunning dialogic strategies of a Hamlet or an Oedipus, since his female interlocutor remains absent and silent, as if, Derrida might say, Chucky's letters never reached their destination or as if, Lacan might retort, they were meant to be received back again by the sender "in reverse form"—"in sufferance."[4] Indeed, it is much like the patient limited to verbal abreaction in the analyst's office that Chucky reproduces—this time for his audience—the bizarre combination of familial psychosexual encounters and complex oneiric scenarios that find themselves inscribed in the figure of letters to his "lost wonder," to his "ex"-communicant. And even more to the point of evoking Owens' contradictory writing strategy, it is much like the analyst caught in the maddening throes of countertransference that the audience, continually assaulted by the repugnant images of Chucky's strongly willed misogyny, must either leave the theater of analysis or sit back anxiously, helplessly, and ambivalently *wanting* (wishing/lacking) to help Chucky achieve dramatic fulfillment, what he terms as "a clear and urgent purpose as if I'm going to find something or someone that is necessary to the continuation of my being" (p. 25).[5]

While the maddening contradictions behind Owens' seductive writing strategy are many, the primary one continually positions Chucky's silent and disgusted interlocutors, Elly and the spectatorial recipients of his letters, vis-à-vis a crisis of reception posed by his narrative presence—whether or not to pledge to filling, which here can only mean "being," Chucky's lack. In the terms posed by *Chucky's Hunch,* this crisis involves not only our interpretive relationship to the history of Western drama but our position vis-à-vis the primal scenes of psychosexual narrative per se, intertextual fragments ranging in allusion from

Oedipus, Hamlet, and Frankenstein to the fictional memories of Proust, Freud, and maybe even Bellow. At stake in viewing, which means reading, *Chucky's Hunch* is the realistic yet *unwanted* possibility of enunciating the sick phantasm of subjectivity that falls between the fissures of Chucky's epistolary presentations. Still, it is the ideological hollowness of the phantasm itself that Rochelle Owens lays bare through the enigmatic writing effects of her epistolary drama.

Self-Restoration

> Death is a displaced name for a linguistic predicament, and the restoration of mortality by autobiography (the prosopopeia of the voice and the name) deprives and disfigures to the precise extent that it restores. Autobiography veils a defacement of the mind of which it is itself the cause.
>
> PAUL DE MAN[6]

Owens' layered text openly stages the spectacle of representation's fissure, its *mise-en-abîme*. This maddening gap is especially apparent in view of the relation of *Chucky's Hunch* to its shifting epistolary conditions, to its intertexts which become fused as "writing" in Chucky's creative consciousness. Take, for example, the text's enunciative foundation—the melancholic voice of autobiography, replete with poignant reminders of Chucky's rapidly declining condition. His nostalgic recollection of potency—"I used to be able to fuck a lot. . . . I'm going to be fifty soon, and my teeth are rotting away. Heaven help me" (p. 13)—is echoed in the text by his displaced acknowledgment of intellectual slippage: "Shucks, look what you got me doing—complaining about the conditions of my life. Now don't tell me to see a shrink because I tried it. It didn't work! I know, my perceptions at times are completely messed up" (p. 14). This messed-up novelist and unsuccessful artist, now specializing in "bird-feeder constructions," spends most of his epistolary energy laying out his skewed perspective of the conditions of his life. He begins by recounting his coexistence with his 85-year-old mother "in a rotting prerevolutionary house in a remote part of upstate New York." Under the roof of their "dilapidated dream house," the feeble mother and her psychotic son are virtually unable to distinguish between material and psychological dissolution resulting partly from age and partly from the haunting phantasm of an absent father:

The old woman just lies in bed fifteen hours a day. I can't blame her—what the fuck is there to get up for? Last night I got smashed and I was stalking through the old house with a hammer in my hand. The furnace was on the blink and I was trying to fix it but I also knew that old Ma was kinda scared of me. We'd had a fight. She gets mad because she has to help support me on her Social Security checks. She says I'm just like George. You remember who he was—my father! Well you know I never knew my father. He was no good and old American, as Ma says, and I'm an awful lot like him and she sure stresses the word "awful." (p. 12)

A good portion of the narrative of *Chucky's Hunch* is fueled by the writer's autobiographical attempt to right the awful wrongs of memory, whether they be the failings of George the "no good and old American" father or those of Chucky his phallic double. Just as Chucky equates the coming of "a new day" with his plans "to renovate this beautiful old church in town," his letters stand forth as a concerted effort to restore his ruined life through the narrative recapitulation of the "bad end" of a "blue-eyed boy." Yet, in *Chucky's Hunch,* the narrative result is itself a disfiguration. Recalling Victor Frankenstein, the character who surfaces most often in Chucky's many allusions to prose fiction, Chucky is continually frustrated by his multiple attempts to give purpose to his life by recreating existence from the ashes of the past. To cite one of the more obvious examples, the reader need only recall Chucky's anecdote of the sudden failure of his business venture to profit from recycled antiques: "In 1961, I went into the antique business. Yeah, I knew that would make you laugh—but I had a little antique shop—and then everything started to fall apart—I mean the bottom of my life was starting to drop out" (p. 14). Chucky's is a narrative in which everything he (re)creates eventually turns on him, from his own entropic image to his epistolary phantasm of the female interlocutor who laughs derisively at everything he recounts.

By the conclusion of his weary tale, following his unsuccessful quest to destroy the "deadly duo" that beheaded his "son," Chucky's narrative displays more of an empty shell of self than any positive substance: "I felt so wrong in the scheme of things. . . . I used to wonder why the bloodhounds hadn't picked up my scent. I used to wonder that—but now I know. I'm wasted—and the dogs have given up on me" (pp. 25–26). So it goes throughout *Chucky's Hunch* that the writer's attempt to account for creative restoration in his life leads inevitably to further mental and, often, physical disfiguration. Chucky's narrative of auto-

biographical waste promises substantive renewal only in the future of performance, and then only as the hollow echo of a textual phantom. In Paul de Man's words, "the restoration of mortality by autobiography (the prosopopeia of the voice and the name) deprives and disfigures to the precise extent that it restores. Autobiography veils a defacement of the mind of which it is itself the cause."[7] The exchange of autobiographical restoration for ontological fulfillment leads Chucky headlong down representation's bottomless pit, the catastrophic doubling of life with letter, of subject with object, in which sender and receiver are virtually indistinguishable.

Throughout his letters Chucky counters his autobiographical reality by remembering his hopes to be recognized as an "immortal artist." His nostalgic missives to Elly recall his earlier sense of artistic purpose. "Somehow I always felt that I deserved a better name than loser in my life. I mean I had more options than you twenty years ago. I was the one with the superior intelligence and the physical strength. I was the artist and you were just a pretender" (p. 19). For Chucky, to be an artist means to be a subject, a master of cultural and sexual superiority whose phantasm of strength will be doubled in the Other as mere copy, pretense, or lack. The artist is a lasting source of potency whose image casts doubt on the authenticity of the Other, whose position in the world necessarily leads to the sort of unequal relation depicted twenty years earlier by Chucky in a self-referential mosaic: "The knight with his lovely lady. He was playing the lute—and she sat there next to him— with an empty smile" (p. 14). Whether reminiscent of an illuminated manuscript or the painting *American Gothic,* similar imagistic traces of an empty lady in view of her phallic master appear throughout Chucky's epistles.

> Between the phonies—I repeat the phonies of the art world scene and you [Elly]—it's a wonder that the magic christian ever got out alive!"
> (p. 14)

> Don't put me down, Della. I can still show you a thing or two. The magic christian is still as beautiful as Michelangelo's David. (p. 17)

Elly stands forth textually not only as either a phony or a misguided spectator of Chucky's aesthetic "show" but also in relation to the constancy and beauty, indeed, the immortal potency of "the magic christian." In Chucky's letters the image of his magic christian stands forth lasting and rigid, much like the towering figure of Michelangelo's *David,* whose self-referentiality eclipses the many Christian icons of the nurturing mother that grace the adjoining galleries of the Accademia. Still, the

fact that Chucky's potency must be qualified as being merely aesthetic directs us back to the import of the drama, that it need be understood as a play of letters. Regardless of the immortal potency with which Chucky wishes to fuel the image of the magic christian, its only true position of strength remains to be that of a recycled textual figure. In one context it recalls Shakespeare's misogynistic references to "marble-constancy" in *Macbeth* and *Antony and Cleopatra,* in which the traces of potency remain at the end of these plays only as monuments of dissolution and the death drive. In another context, that of Michelangelo's *David,* not to mention his controversial nude sculpture, *Risen Christ,* the image of the magic christian brings to mind the phallic phantasm nurtured by fine art's earliest fixations on the sexuality of Christ. This is the figure carefully traced by Leo Steinberg in *The Sexuality of Christ in Renaissance Art and in Modern Oblivion.* A lengthy citation of Steinberg's study should provide a tangible framework for understanding Chucky's trope of the magic christian:

> As a symbol of postmortem revival, the erection-resurrection equation roots in pre-Christian antiquity: it characterized Osiris, the Egyptian god of the afterlife, represented with his restored member out like a leveled lance. And the ithyphallus as emblem of immortality haunts later Mediterranean mysteries honoring Bacchus. The prevalence of such symbolism accounts perhaps for the readiness with which Christian theology associated the penis in its circumcision with resurrection.
>
> In Western literature, the *locus classicus* for our metaphoric equation is Boccaccio's *Decameron,* the tenth tale of the third day, where the sexual arousal of the anchorite Rustico is announced, with blasphemous irony, as "la resurrezion della carne." The context of the novella makes Boccaccio's wording—the resurrection of the flesh following its mortification—an apt and effective pun. But this same "pun," now deeply serious, lurks in the greatest 16th-century representation of the *Raising of Lazarus*—Sebastiano del Piombo's colossal painting in London, composed with the assistance of Michelangelo: Lazarus' loincloth, which in the preparatory drawing dips unsupported between the thighs, appears in the painting firmly propped from below—a sign of resurgent flesh.[8]

Resurgent flesh. This is the image that motivates Chucky's writing as well as his art. His turn to the phallic pen in an effort to maintain his fragmented mosaic of self reveals the currency of the magic christian as the echo of a writing effect. In one letter remarkable for its ugliness, Chucky's boasts how his recent sexual exploits lead to his recollection of the earlier eroticism of his ex-wife.

I still get horny. The other night I took a package of beef kidneys that were supposed to be for the cats, yup, we have two of them running around. I let the kidneys get at room temperature, then I wrapped them in a pair of panties and somehow managed to work myself up into a state of sexual desire—and came into the kidneys. Pretty depraved, right? Do you remember during the fifties you used to wear your dark red lipstick over your lipline, a fat round arc that glistened— you were stacked like a brick shit-house. (p. 15)

The juxtaposition of these two memories highlights the narcissistic depth of Chucky's sexual desires. He transforms all figures of desire into passive, glistening objects awaiting the depraved arrival of his resurgent flesh. The ultimate effect of this transformation is to subject all of his partners of desire, lovers and readers, to Chucky's version of their lack of—and desire for—his potent flesh. The reader thus joins Elly as the embodiment of Chucky's repeated writing effect. "But just remember that I was more intelligent than you!" he reminds Elly, "I WAS MORE INTELLIGENT THAN YOU! Boy, I got you worked up. This time I really gotta rise outta you" (p. 14). Here, as throughout Chucky's letters to Elly, the image of her "rise" can be said to function only as the doubled phantasm of Chucky's desire for textual mastery through phallic aggression. Elly's imagined appropriation of this rise is but the personification of Chucky's wish for supreme potency.

Still, personification is, at least in this context, a rhetorical condition that defies fulfillment.[9] By subjecting Elly to his conditions of rhetorical selfhood, Chucky not only delimits the potential for any extensive interpersonal communications with his ex-wife but also reasserts indirectly her authority to dismiss his conditions of being, to reject his style and method. As a result, Chucky makes himself more a slave to communication with his departed lover than her master in any form.

The inequity of such thwarted power relations demystifies Chucky's textual exploits, which are misogynistic as well as bigoted. Owens' text continually reveals the impotency of Chucky's efforts to posit his self-worth in relation to a necessarily inadequate Other. Whereas *Earwax of America's Minorities* is the bizarre and demeaning title he proclaims for his "next book," he dreams up another title in his opening inscription of a letter to Elly: "How's that for a title of a book I'm going to write? 'Dear Lying Eyes.' You know the trouble with you is you won't answer any of my letters. What's the matter—are your fingers too greasy to hold a pen? I bet you've become a woman's libber since I went out of your life, Della. But we can always talk about it if you want in some low-down hotel room" (p. 17). While writing is inevitably linked by

Chucky to the release of his magic christian, fucking is related to his own neuroses, equating sexual parity with deceit and "dirty" sex. These problematic relations surface again in the narrative frame with which he announces his book about American life, a book providing less of a metaphor for America than for Chucky's deep discomfort with America's layers of cultural otherness:

> I'm an artist, remember—an abstract expressionist that is. And you're just a housewife. I have this book that I've been working on a few years now. . . . It tells the way it is and was—it even goes into the American art world scene and I like to think that it's a metaphor for the American political scene as well. You have to be a hustler to make it big. Hey, have you heard the one about the ethnic who goes to get gas? Ah, you wouldn't get the gist of it—you just wouldn't get the gist. Speakin' of ethnics—the way these Portuguese here in town treat me when I go to their goddamned one and only bar—you'd think I was the local, I don't know what—pervert! I was talking to Marie the waitress about it the other night. Boy, I'd love to get into a knock-down drag-out fight with her. Prone position—we might really make some sense together. (p. 12)

About the only way for women or "ethnics" to make sense of Chucky is to acknowledge his desire "to make it big"—in the doubled phantasm of the prone/prose position. Still, this desire to effect sexual and racial dominance through epistolary/seminal exchange becomes the butt of Owens' contradictory writing effect. Chucky's aims are always already derailed by his texts' resistance to making his kind of sense.

Mastery of sense, he tells his addressee from the outset, entails the knowledge of language, the control of nomination:

> Dear Della, remember the Christmas when we hitchhiked across the country together? It was in 1958. Dig? And the young trucker asked us if we lived like that—picking up rides across the U.S.A. The joker was amazed, wiped out by our pre-hippy lifestyle. But he didn't know a thing about us because, and I must repeat, because we never told him our names! He who knows my name has power over me! Shit— I never wrote my name big enough for you—you refugee from Brooklyn. Ethnic! (pp. 11–12)

Power, in Chucky's mind, derives not only from the paternal or authorial right to confer an offspring's name but also from authoritarian knowledge and control over extant names, from the ability to check, verify, and thereby delimit identities (illustrated by the French noun *contrôle,* referring to the police check of identity papers). While Chucky's name, ironically, is not "big enough" to be possessed by Elly,

he has no difficulty endowing her with the nominal identity of division: "Ethnic." Here again, the enactment of power reveals itself as locutionary, as an effect/affect of writing and reading.

Oozing Signs, Early Memories

In his letters Chucky makes precise intertextual allusions to his bungled attempts to exercise influence through linguistic manipulation. Paramount is his paradoxical reference to a certain epistolary novel. He tells Elly, "You were just an unformed baby when I met you. I created you—you Frankenstein monster!" (p. 16). Much like Victor Frankenstein, Chucky attempts to maintain nominal control over his independent creation long after it has thwarted his uncertain expectations for its existence. He does so through his series of letters to Elly, all of which lapse into frustrated efforts to shackle the interlocutor with excessively demeaning labels: "Ethnic," "Ms. Housewife," "middle-class babe in woods," "bourgeois cunt," "ole rubber hammer," "female spider," "snap-hole," "Mr. Death," and the repeated nomination "Della-Fella." While Chucky's insistent return to such belittling names reveals his threatened defensiveness in the face of woman, the names themselves reveal the futility of his efforts to tame her with language. Take his equation of "Elly" and "Refugee." If elided to sound like "El-ugee," this would refer easily to Chucky's lamentable autobiography—the one in which he stars through countertransference as the protagonist, "Mr. Death." Indeed, the threat of the monster of difference, the "refugee," points to the deep significance of the name he repeats most earnestly, "Della-Fella." The *Oxford English Dictionary* defines *dell* as signifying "a deep hole, a pit" or "a deep natural hollow or vale of no great extent, the sides usually clothed with trees or foliage." This vaginal reference is accompanied by a variant definition suggesting the specific identification of "a young girl (of the vagrant class); a wench." "Della," then, functions as a condensed figure of vagina and wench (woman of [lower] class), the kind of figure that Chucky enjoys manipulating. On the face of things, "Fella" seems less easy to explicate. Its sense as "a peasant in Arabic-speaking countries" could well reinforce the class dimensions of Chucky's nominal control. Or it could simply be understood to reinforce Chucky's own castration anxieties by transforming Elly into a "Fella." A more perverse reading, but one that is perhaps more in keeping with the perverse spirit of *Chucky's Hunch,* would be to pun phonetically on "Fella." In the active world of Chucky's sexual

fantasies gone astray, one function of the unequal role of "wench," or "Della," might well be the performance of "Fella-tio." This playfully phallocratic association of "Della" with "Fella" is made even more credible, if not deadly serious, by the text's many references to Elly's sexual threat: "You used to have strong teeth, Della, big like a horse's. I can visualize you with your big teeth, smiling broadly at me, laughing your head off the way you always did whenever you became nervous" (p. 17). These threatened, toothy remarks are followed only a few sentences later by the revealing punch line, "Women with their sexual organs are the stronger sex" (p. 17).

In *Chucky's Hunch* even the letter writer's most condensed nominations generate an accumulation of what Lacan anxiously summarizes as "the castrating and devouring, dislocating and astounding effects of feminine activity."[10] Chucky's fears of the castrating woman place him once again in the complex position of being subject or slave to his own masterful phrase. Or as Chucky understands his position, "But then the female spider does devour the male. Right rubber hammer? How many men have you chewed up, you fat spider?" (p. 19). These bestial accusations not only underline Chucky's complex anxiety but also seem to answer in the affirmative an earlier, testy question posed by Lacan: "Even given what masochistic perversion owes to masculine invention, is it safe to conclude that the masochism of the woman is a fantasy of the desire of the man?"[11]

If the prior discussion has not allowed us to arrive safely at this conclusion, consideration of one more textual detail will clarify Chucky's displacement of his masochistic perversions onto his epistolary Other. In as much as his name giving and personifications reveal his strong discomfort with the female organ he so desires, his repeated references to his own scarred groin depict Chucky as the bearer of the icon of "the masochism of the woman." Preceding the memorable citation of Chucky's preference for beef kidneys, he elides his memory of Della with another telling remark: "I want to send you my book because you're in it too. It's about you, Della. The book's about you. Do you remember my old hernia operation? The fissure that I have on my side? It still oozes sometimes. My old hernia trouble. It sounds like a song. God what a disgusting mess I yam, I yam" (p. 15). It is his oozing fissure, his glistening fold, that reveals Chucky to be the ultimate bearer of the sign of the lack. "Is it any wonder that I suffer emotionally as well as sometimes oozing from the fissure in my side from the operation I was forced to have?" (p. 19). Even prior to the operation which he claims elsewhere to have desired and which was forbade at fifteen by

his mother's "Jehovah Witness phase," Chucky's herniated condition, not his resurgent flesh, is what caught the "painful" attention of his adolescent peers, "that year when the other boys in the locker room at school found out about my wearing a truss" (p. 19). There, in the steamy enclaves of adolescent virility, Chucky existed as the disgraced object of phallic vision and ridicule. For then, as happened later when Chucky witnessed the murder of his dog, his hernia left him "in much too weak a condition to defend myself." So it is that Chucky's letters reveal him to bear the painful memory and oozing sign of the masochistic flesh that he so desperately desires to displace onto the figure of woman.

Chucky's entrapment in this (un)desirable fold is made further evident, on an even grander scale, when his form of discourse—the letter—is placed generically in relation to the epistolary novel. Historically, the epistolary novel casts as its central character the spurned female, whose manipulation of the pen is more often than not a desperate substitution for both her lost father and her departed lover.[12] The position of the writer is here one of reflection instead of action, one of hopeful passivity instead of confident aggression. Also in this spirit of the epistolary romance, Chucky's drama of letters is "a slow motion affair" whose stress is placed not so much on captivating events as on the lingering pains of psychological trauma.[13] As a primarily psychological medium, the love letter reveals more about the frustrated desires of the writer than it possibly could about the wishes of the silent receiver. Roland Barthes describes the situation this way: "To know that one does not write for the other, to know that these things I am going to write will never cause me to be loved by the one I love (the other) . . . that it is precisely *there where you are not*—this is the beginning of writing."[14] It is also precisely there—at the beginning of writing—where the play *Chucky's Hunch* opens as well as ends: "What do you think of when you look at the old photographs of us together? Do you feel as though you walked away from a head-on collision? I talk to you—you refuse to understand. I loved the way you moved your body—and not once have I pitched woo with anyone but you, dear" (p. 26). A defiant question of understanding, an anxious expression of nostalgic desire, a vengeful hint that Chucky will not stop writing his tiresome letters—these are the narrative elements of epistolary literature that frame *Chucky's Hunch*.[15]

In terms of theatrical representation, the scope of the play remains limited by these narrative demands. The conclusion allows for no more action than is apparent from the outset: "I have an image of you in my

mind, poking like a finger under my eyelids. You're standing next to a vase filled with wildflowers. My ego is growing claws that are ready to tear off a piece of whatever I can get them into" (p. 26). As each successive citation of the text makes even more apparent, this is a play of the never-ending violence of the phallocratic, I should say, narrative mind.[16] In the tradition of epistolary narratives like Bellow's *Herzog,* Chucky's written outbursts are grounded in complex flashbacks that function as deceptive substitutions for the layers of repression he accumulates throughout a life of childhood trauma and three failed marriages.[17] There is the memory of when

> Ma and I did sit down together for a talk about the good old days when I would eat a whole head of lettuce all by myself at the age of twelve. And then the tale about the time a man tried to get into the house when Ma left me there alone. He was a genuine mid-Western pervert who probably wanted to assfuck a young boy and then cut his throat. Ma and I hugged each other real close after that story—we might have our differences but we still don't want any physical harm to come to Chucky. (p. 16)

Here memories of the "good old days" are interlaced with the safe recollection of a very bad tale. But Chucky reveals the imminent threat of sexual danger by speaking of Ma's concern for his safety. A similar attempt to displace fear with nostalgia occurs in the flashback to the time

> In 1958 when I was interviewed by that young twerp from the Columbia School of Journalism and he suspected that I was of a rebellious nature. And he told me, "We can't afford to have defiant characters in our midst." Hey, Della, did you think that I was a defiant character? I was really too much for you, wasn't I? From the very first day that I met you when I told you about my life with my first wife, Hettie, you thought of me as the sonovabitch in your life. (p. 15)

Typical of Chucky's prose style is the way his flashback to 1958 provokes obscure references to his life with Hettie and to his memory of how Elly responded to this tale. Chucky's own notion of his role in transferring past desires and memories into present text might even be said to stand out as the psychoanalytic key to reading *Chucky's Hunch*. For the most significant aspect of the flashbacks interspersed throughout the play is how they position Chucky as the startled recipient of his own memories, as the confused respondent to his own ugly tales, and even, for the spectator, as the phantasm of the analyst duped by the clouds of his own countertransference.

Consider the case of an early memory that not only haunts Chucky

but also stirs the unconscious of his literate spectators. "Sometimes I start thinking of when I was seven years old sitting on my grandmother's porch in Michigan, holding a glass of cold water and a chocolate nut cookie—and then I think of what Ma always says—how did I ever get out of the mid-West alive?" (p. 13). Chucky's self-conscious reference to the literary cookie of Proust suggests how the outer shell of his letter to Elly introduces a complex textual *mise-en-abîme* in which intertextuality works as both expression and displacement of earlier misunderstood events. In this particular example, the memorable image of the cookie is more significant to the narrative strategy and writing effect than is the traumatic event signified by its remembrance. The force with which Chucky's recollection of the cookie disrupts the narrative illustrates his tendency to get "sidetracked as usual" whenever discoursing on love and desire. "Oops, there I go again digressing—Ma says that I'm the most digressing person she's ever seen—and she ought to know after all the times we've digressed each other. But you know my story, dear Elly. I could tell Whatsis Face much more easily than I could tell you how women have always lorded it over me" (p. 14). By so falling into a digressive tailspin whenever warming up to the topic of sexual relations, *Chucky's Hunch* may well reveal the duplicitous narrative, not the threatening Other, to be the most effective force in demystifying the masterful illusion of the magic christian. In many ways Chucky's failure to manipulate textuality recalls the frustrated efforts of Proust's Marcel, the original custodian of the psychoanalytic cookie. As Leo Bersani explains Marcel's dilemma, the power surge of memory generated by writing will always disrupt the stable image of a textual self: "Desire makes being problematic; the notion of a coherent and unified self is threatened by the discontinuous, logically incompatible images of a desiring imagination."[18]

Primal Digressions

The writing strategy that most disturbs Chucky, the digression of flashback, is also the literary method with which he is most familiar. It is Chucky's repetition of cookie-triggered memories that favors the indiscriminate and often senseless trace of the involuntary over the coherency of narrative and self—those cultural simulacra of the magic christian. A poignant example occurs when Chucky acknowledges peering through the gap in his mother's window shade at her amorous tryst with Chester Nickerson. His description, only part of which I cite here, is classic in

the digressive way in which it moves from an account of his voyeuristic vision and its mixed emotional effect to an involuntary revelation of childhood memories and future fantasies:

> I was stunned! I could hardly believe my own eyes when I saw what went on between them. Ma sucking Chester's soft gray dick until it grew hard and then Ma sitting right smack on Chester's face, pulling at his hands with her arthritic fingers, clutching at his wrists while making low groans in the back of her throat. I admit that though I was jealous at what those two had between them, I was also furious. . . . They started to fuck with Ma on the edge of the bed and Chester standing in front of her. By that time the noise of their gasping was beginning to sound terribly loud and scary in my own ears and my anxiety was becoming more than I could bear and all I could think of was a glass of cold water and a chocolate nut cookie and being seven years old again. But then I had an image of burning the house down with them inside. (p. 21)

Flavored by Chucky's confused, Oedipal notion of what it is that he thought he saw or heard, his account is disquieting in its emotional fluctuation, from jealousy and fury to fright and anxiety. These emotions, on which I have already touched in summarizing the psychological territory of the epistolary novel, stand out here as the traumatic effects of experiencing the bare sights and especially the indiscriminate sounds of creation/destruction. Doubled by the oral performance of the letters from which they emanate, the sounds of love are lasting in their production of rhetorical effects, in their generation of resonant perlocutionary responses to a fleeting linguistic moment. The end of this attempt to recollect the senses does little, moreover, to contribute to the reconstitution of any "notion of a coherent and reconstituted self." Providing neither theatrical catharsis nor psychological resolution, Chucky's textual repetition of this real (or imaginary?) event catalyzes a free-for-all of literary flashback and projection—the senseless *mise-en-abîme* of Proust's cookie on the one hand, the hellish specter of the apocalypse on the other. These almost logically incompatible images of past and future work, in turn, to introduce more a scene of interpretive infelicity than one of narrative coherency. Here Chucky presents himself, not to mention the recipients of his letter, with the traumatic, indeed maddening, dilemma of reading.

Chucky's posturing throughout his letters is framed by similar scenes of uncanny digression, those which are both comforting and disturbing, those which position Chucky as both their creator and their victim, that

is to say, as their writer and their reader. For the spectator, a peculiar feature of *Chucky's Hunch* is how Chucky gathers momentum in writing/reading his tale at the precise moment in the story when he most dissolves as an active, dramatic agent. After he has disappeared into the forest primeval, after the search dogs have given up looking for his ghost, and after his mother has abandoned his memory by joining Chester Nickerson in a carnivalesque scene at a nearby Holiday Inn, we, the audience, continue to hear from Chucky. We continue to receive his accounts of these final moments when he acknowledges his enslavement in, and thereby subversion of, the narrative polarity of subject/object: "I'm here under the rocks with the bugs—being watched by the dragons and owls of hysterical imagination. Elly, if I've seen a weird thing—I mean something really weird—I might just chalk it up to being loaded or whatever, but if I see the weird thing again and again, well then I possibly might be correct in my perceptions. Right?" (p. 25). At issue in *Chucky's Hunch* is how the repeated enunciations of the writer effect a sort of psychoanalytic memory screen through which the text is both written and read, produced and received, first by the author/player and then by the spectator/reader. Throughout the course of the play, it becomes readily apparent that Chucky's tale is one of enslavement in the uncanny scene of libidinal creation.

Let me be more precise. What is repeated throughout this tale is not merely Chucky's belittling epistolary nominations of woman nor his unsuccessful attempts to displace the troubling Other with the artistic presence of his magic christian. All of these desperate acts are framed by digressions into a deeper, more problematic oenirical scene, one resonant in occidental literature since *Oedipus Rex* and *Hamlet,* the complex scene of primal fantasies. This is the scene described by Freud as comprising fantasies in which "the individual reaches beyond his own experience into primaeval experience at points where his own experience has been too rudimentary."[19] While Freud initially understood this to be a scene of multiple phantasies decisive in early life, comprising "the seduction of children, the inflaming of sexual excitement by observing parental intercourse, the threat of castration (or rather castration itself)," he later restricted the "primal" to the scene of the child's trauma, actual or imagined, of witnessing parental intercourse.[20] What is consistent throughout Freud's evolving version of the primal is not so much the object of trauma as the (ir)reality of the phantasm itself. Whether actual or imagined, the phantasm is equally traumatic. Taking Freud's point one step further, Ned Lukacher, in *Primal Scenes: Literature, Philosophy, Psychoanalysis,* dwells on the interpretive *aporia* subse-

quently generated by the primal's shifting between the actual and imagined:

> Rather than signifying the child's observation of sexual intercourse, the primal scene comes to signify an ontologically undecidable inter-textual event that is situated in the differential space between historical memory and imaginative construction, between archival verification and interpretive free-play. . . . The primal scene is the figure of an always divided interpretive strategy that points toward the Real in the very act of establishing its inaccessibility; it becomes the name for the dispossessive function of language that constitutes the undisclosed essence of language.[21]

Primal confusions of memory and construction, of the real and its literary dispossession, haunt the writer of Chucky's letters. In the wake of his confrontations with the primal, Chucky's individual responses are endemic of a much larger cultural lack displayed by Rochelle Owens, the cureless wound of interpretation as the primal effect of writing.

The most striking example of primal fantasy occurs when Owens side-steps her epistolary strategy to present the theatrical audience with the fable (I'm tempted to say the case history) of the snake and the por-cupine. On a formal level this primordial narrative spoken by a *"taped voice resembling that of a news broadcaster"* shifts the boundaries of enunciation established by Chucky's letters to Elly. This is a tale presented directly to the audience in the semifactual voice of documentary (if not clinical) omniscience. But not even the realistic frame of documentary containment diminishes the phantasmic depth of this primal tale:

> The snake and the porcupine had been a couple for five years. Spawned in the woods near Apple Valley, New York, they were a symbiotic entity, cunning, vicious, frightening, above all pragmatic during a killing. . . . This was an extraordinary pair, intelligent and prospering. During that first incredible encounter, the porcupine had dropped seventeen quills to the earth in fright because she had believed that the snake was going to sting her to death. He wanted only to touch her where there were no quills, to rub his length along her voluptuous roundness. With inscrutable thoroughness they smelled each other ravenously. . . . One of the most dramatic fights they had shared together was when they had seized a large husky and began to chew its head and neck so violently that the victim thrashed about wildly in an effort to escape. After the struggling had ended, the pair spent an hour swallowing their prey. All the while a man watched from a nearby bush, showing curiosity and agitation. When the pair

made especially violent movements he dashed away in terror only to return again to peer through the bush at the fascinating spectacle. After the meal the couple did a slipping and skidding and zigzagging dance that slowly progressed into copulation. (p. 18)

While this disembodied narrative accounts for the murder of Chucky's dog, it does more than function as an essential plot device. Addressed to the audience, it serves as an atavistic paradigm of the primal scene and its dangerous repetition. Replayed here are the sights and sounds of the first sexual encounter, in which primeval copulation is always already preceded by Oedipal violence, by the erotic dismemberment of a surprised husky who is represented throughout the play, it should not be forgotten, as the animistic double of Chucky, the voyeuristic son.

To some degree it could be said that this representation is made "safe" by the distancing conventions of the news broadcast. Within the framework of journalistic representation, the veracity of the tale stands no longer in doubt. In addition, we need only recall Brecht to understand how the strategy of reportage also aims at diminishing the evocation of pathos in order to stimulate the recipients' contemplation of their alienated reception of the report. How alienation is even conceivable in the face of the primal has been analyzed on a comparable front by Stephen Heath, in terms of the conventions of narrative film: "The narrative plays, that is, on castration known and denied, a movement of difference and the symbolic, the object lost, and the conversion of that movement into the terms of a fixed memory, an invulnerable imaginary, the object—and with it the mastery, the unity of the subject—regained. Like fetishism, narrative film is the structure of a *memory-spectacle,* the perpetual story of a 'one time,' a discovery perpetually remade with safe fictions."[22] There is little question that the fable of the snake and the porcupine stands out in *Chucky's Hunch* as a memory spectacle perpetually available to all takers. Still, this memorable spectacle remains safe only if its fiction *can* be separated from the phantasm of imaginative reconstruction through which the recipient becomes husky/Chucky. As elsewhere in *Chucky's Hunch,* the experience of the primal is presented here to be less the alienation of voyeuristic witnessing and its appropriation than the absorption of the conflicting emotions aroused by forbidden sights. This report of bestial and violent sexuality is said to speak to the deepest phantasms of the viewer, both terrorizing and fascinating him in the age-old tradition of a Tiresias who was punished, so the fable goes, for similarly peering at the copulation of two serpents.

The numbing effect of this universal scenario underscores the conditions of enunciation posed by all narrative accounts presented by

Chucky in the guise of the letter. Chucky is said to be entranced, to a similar but perhaps greater degree than is his audience, by the spectacle that so horrifies him. Chucky's repetitive and desperate attempts to re-constitute the subject through his belittling of the symbolic object—the lacking Other—return to him in digressive "sufferance," in reverse form. He performs onstage as the suffering voice projecting letters that are never answered—that is to say, that return, literally or imaginatively, to him to be read. And while the letters may underscore his distance from their subjected recipient, they also guard and reinforce his prox-imity to and interdependence on the object of his discourse.[23]

This paradox speaks to the scene of dramatic interpretation as well. Even though Chucky is the only character known to have actually pos-sessed or "read" these letters, their status as letters—that is, as texts—leaves them, like the disembodied voice narrating the primal scene, open to reception by all readers, by all viewers. In the words of Barbara Johnson, who comments on the transferential status of Poe's "Purloined Letter," "the letter's destination is wherever it is read: the place it assigns to its reader as his own partiality. Its destination is not a place, decided *a priori* by the sender, because the receiver *is* the sender, and the receiver is whoever receives the letter, including nobody. . . . As Lacan shows, the letter's destination is not its literal addressee, nor even whoever possesses it, but whoever is possessed by it."[24] (Dis)possession by the letter, by the primal scenes of textuality: this is the maddening enigma of Rochelle Owens' writing effect.

Rebirth or Lack?

Their "symbolic" exists, it holds power—we, the sowers of dis-order, know it only too well. But we are no way obliged to de-posit our lives in their banks of lack, to consider the constitution of the subject in terms of a drama manglingly restaged, to rein-state again and again the religion of the father. Because we don't want that. We don't fawn around the supreme hole. We have no womanly reason to pledge allegiance to the negative.

HÉLÈNE CIXOUS[25]

When read in the light of this Cixous epigraph, Rochelle Owens' text seems finally to do little more than reiterate the tale of the lack, albeit here a universal condition ironically symbolized by Chucky's oozing groin. Indeed, her text may be said to seduce its readers into the inde-fensible position of failing to articulate a positive female discourse, one

aiming to sidestep "allegiance to the negative." But it is perhaps too easy, so I want to argue in closing, to delimit *Chucky's Hunch* to the negative realm of the visible, to the terrain staked out by Chucky, its onstage character. For *Chucky's Hunch* is framed by subtle conditions of reception that shift the focus away from Chucky's vision of *his*tory to recall alternate scenes "indifferent" to the sustenance of this vision.[26]

First is the text's acknowledgment of the will of the patient, here Chucky or phallologocentrism per se, to speak itself into traumatic oblivion. One literary effect of *Chucky's Hunch* is to turn the tides on the tradition of the fictional epistle that has functioned historically to enslave its female characters in the Law-of-the-Father, in the discourse of the lack. Recalling the paradox of a similar epistolary text penned by a woman and cited by Owens, *Frankenstein,* it is the creator, Chucky, who exemplifies the status of the lack, not his uncontrollable creation, Elly.[27] By so restaging the paltry drama of the lack, Owens' play could be argued to do it permanent damage rather than reinstating it. This reversal stands out as a welcome and bold step, especially in the midst of recent American theater which continues to fawn around the supreme holes of the Shepards and the Mamets, those surprisingly successful dramatists who receive unending praise for reactivating the search for the lost father.

Second, framing all of Chucky's letters is the figure of silence. It is Elly's silence that so forcefully highlights the narrative failure of Chucky to rewrite the power of the magic christian. It is her silence, perhaps her indifference to the dilemma of Chucky, not her positive or negative response to it, that provokes so much ire in the man unable to control her through the conventions of dialogue. This is not to say that Owens' text allows her, or any recipient of the letter, not to be possessed by Chucky's writing effect. But the play suggests that silence may well be a strategy of strength in response to Chucky's ceaseless references to the past failures of his interlocutor. Such a hypothesis calls to mind the recent argument of Jean-François Lyotard regarding the incommensurability of political discourses. Lyotard chooses the word *différend* to signify "the case wherein the plaintiff is divested of the means to argue and becomes on that account a victim. . . . A case of *différend* between two parties takes place when the 'regulation' of the conflict which opposes them is done in the idiom of one of the parties while the injustice suffered by the other is not signified in that idiom."[28] Since dialogue in the discourse of the plaintiff will only aggravate the injustice, Lyotard recommends the development of new rules of language for the discourse of the *dif-*

férend. His description calls to mind Owens' writing effect of the silent Elly:

> In the *différend,* something asks to be put into phrases, and suffers from the injustice of not being able instantly to be put into phrases. This is when human beings who thought they could use language as an instrument of communication learn through the feeling of pain which accompanies silence (and of pleasure which accompanies the invention of a new idiom), that they are summoned by language, not to augment their profit by the quantity of information communicable through existing idioms, but to recognize that what remains to be phrased exceeds what they can presently phrase, and that they must be allowed to institute idioms which do not yet exist.[29]

The solution, according to Lyotard's argument, is one that accompanies "possession" of Chucky's text by Elly, by the audience. "To give the *différend* its due is to institute new addresses, new addressers, new significations, and new referents in order that the injustice find an expression and that the plaintiff cease to be a victim. This requires new rules for the formation and linking of phrases. No one doubts that language is capable of admitting these new families of phrases or new genres of discourse. Every injustice must be able to be phrased. It is necessary to find a new competence."[30] It may indeed be idealistic to assume that Elly's silence in *Chucky's Hunch* might be heard positively as the gesture of her own search for discourse. But it can be said, at least, that the play leaves Elly in the position of the *différend,* reading on her own, determining her own response to textual possession, indeed, to primal discourse per se.

Finally, *Chucky's Hunch* contains one example, if only a feeble one, of an attempt to find a new competence in discourse. This would be the sole example in the play of woman-to-woman correspondence represented by the letter from Marge Craydon (Chucky's Ma) to Elly. In terms of plot function, this letter might be explained as filling the gap in correspondence caused by Chucky's sudden disappearance into the forest primeval. But such a reading is negated by the resurfacing of Chucky's voice and letters in the scene immediately following this one. Even in Chucky's absence, his distant voice assumes the resurgent strength of dramatic narration.

To some degree this letter points more to the primal territory of the account of the snake and porcupine than to the political scene of injustice represented by Chucky's reading of his letters. For Marge's letter is performed by *"a very deep woman's voice offstage. Taped"* (p. 22).

So it is that the spectator might want for this letter to suggest a resonant, female "depth" that willingly surfaces only temporarily and only in the momentary absence of the pressures of the *différend*. The content of this letter, while not altogether different in tone from the mixed epistolary emotions of nostalgia and vengeance, differs significantly from Chucky's use of the epistle to exercise nominal control through textual creation. Here, in reporting the disappearance of her son, her offspring, Marge makes reference to her "memories of when I was a young mother-to-be." This letter is striking in its emphasis on the mysteries of childbirth, those resulting in "the miraculous coincidence that my boy and I were born on the same date" (p. 23). Even in the letter's more bitter communications, Marge juxtaposes the nurturing codes of maternity with the negative influence of paternity:

> I remember distinctly the desire to have a normal child and so I made sure that as soon as I found out I was pregnant, I would never wear a tight leather belt again that pressed my waist in; now I know, Elly, you always wore tight belts and I'm sure that is why you lost your baby, when you were married to Chucky. But these days I think it was definitely a good thing that Chucky never had a child because I'm convinced the reason for his terrible disturbances are due to the bad genes that he inherited from his father George whom I had to leave because I knew that he would be dangerous to Chucky sooner or later.
>
> (pp. 22–23)

Lamenting her daughter-in-law's maternal failure, Marge here evokes the *différend* by suggesting that both Elly's silencing of birth and her own flight from marriage were necessary strategies of eluding the violent failures of paternity. In the midst of its most contradictory moments, from Marge's fantasy of joining Chester Nickerson in amorous magazine photos to her defense of prayer in the schools, this letter is resplendent with examples of a woman-to-woman discourse unparalleled in Chucky's letters. To some extent this gesture made by one woman, a mother, to her daughter-in-law calls to mind Cixous' analysis of the writing effect of woman:

> Everything will be changed once woman gives woman to the other woman. There is hidden and always ready in woman the source; the locus for the other. The mother, too, is a metaphor. It is necessary and sufficient that the best of herself be given to woman by another woman for her to be able to love herself and return in love the body that was "born" to her. . . . The relation to the "mother," in terms of intense pleasure and violence, is curtailed no more than the relation to childhood. . . . Text: my body—shot through with streams of song; I

don't mean the overbearing, clutchy "mother" but, rather, what touches you, the equivoice that affects you, fills your breast with an urge to come to language and launches your force.³¹

Clearly, Rochelle Owens presents her audience with only a slight degree of any such feminine force; still, the degree itself could be argued to be almost inconsequential. For it is the symbolic value of measure, the Law-of-the-Father, that is here under review. Marked by a tone different from the "awful" judgment of the "old American father," this marginal letter, so out of place among Chucky's angry communications, equates the experience of writing with primal reflections on the female scene of creation.³² This is the enigmatic scene that stands aside—in-difference— from the dangerous inheritances of fathers and their maddening dramas. This is the scene "of woman's style" that Owens' anxious readers might want to remember amid the maddening spectacle of Chucky's phallic play of letters.

Notes

1. Daniel Sibony, "*Hamlet:* A Writing-Effect," in *Literature and Psychoanalysis, The Question of Reading: Otherwise,* ed. Shoshana Felman, *Yale French Studies* 55/56 (1977), 64.
2. Rochelle Owens, *Chucky's Hunch,* in *Word Plays 2: An Anthology of New American Drama,* ed. Bonnie Marranca and Gautam Dasgupta (New York: Performing Arts Journal Publications, 1982). All citations of *Chucky's Hunch* are from this edition.
3. Linda S. Kauffman, *Discourses of Desire: Gender, Genre, and Epistolary Fictions* (Ithaca, N.Y.: Cornell University Press, 1986), p. 26.
4. I refer to Lacan's and Derrida's differing readings of Poe's story, "The Purloined Letter." See Jacques Lacan, "Le Séminaire sur 'La lettre volée," in *Ecrits* (Paris: Editions de Seuil, 1966), pp. 11–61; Jacques Derrida, "Le Facteur de la verité," in *La Carte postale: De Socrate à Freud et au-delà* (Paris: Aubier-Flammarion, 1980), pp. 439–549. Both essays, along with Barbara Johnson's response (cited below), are included in John P. Muller and William J. Richardson, eds., *The Purloined Poe: Lacan, Derrida, and Psychoanalytic Reading* (Baltimore: Johns Hopkins University Press, 1988).
5. On the relation of transference and text, see Cynthia Chase, " 'Transference' as Trope and Persuasion," in *Discourse in Psychoanalysis and Literature,* ed. Shlomith Rimmon-Kenan (London and New York: Methuen, 1987), pp. 211–32, and "Anecdote for Fathers: The Scene of Interpretation in Freud and Wordsworth," in *Textual Analysis: Some Readers Reading,* ed.

Mary Ann Caws (New York: Modern Language Association, 1986), pp. 182–206; Michel de Certeau, *Heterologies: Discourse on the Other,* trans. Brian Massumi (Minneapolis: University of Minnesota Press, 1986), pp. 3–34; Peter Brooks, *Reading for the Plot: Design and Intention in Narrative* (New York: Random House, 1984), pp. 216–37; and Dominick LaCapra, *History and Criticism* (Ithaca, N.Y.: Cornell University Press, 1985), pp. 72–94.

6. Paul de Man, *The Rhetoric of Romanticism* (New York: Columbia University Press, 1984), pp. 80–81.

7. Ibid., p. 81.

8. Leo Steinberg, *The Sexuality of Christ in Renaissance Art and in Modern Oblivion* (New York: Pantheon/October, 1983), 86–90.

9. I trace the baroque theatricality of personification in *Theatrical Legitimation: Allegories of Genius in Seventeenth-Century England and France* (Oxford and New York: Oxford University Press, 1987), pp. 145–54.

10. Jacques Lacan, *Feminine Sexuality: Jacques Lacan and the école freudienne,* ed. Juliet Mitchell and Jacqueline Rose, trans. Jacqueline Rose (New York: Norton, 1985), p. 92.

11. Ibid.

12. Kauffman, *Discourses of Desire,* p. 34.

13. Janet Gurkin Altman, *Epistolarity: Approaches to a Form* (Columbus, Ohio: Ohio State University Press, 1984), p. 21.

14. Roland Barthes, *A Lover's Discourse,* trans. Richard Howard (New York: Hill and Wang, 1978), p. 100.

15. Kauffman, *Discourse of Desire,* p. 26.

16. In "A Loosening of Tongues: From Narrative Economy to Women Writing," *Modern Language Notes* 99, no. 5 (December 1984), 1141–61, Mária Minich Brewer analyzes the phallocratic structure of narrative, one grounded in the "desire of power (and power's desire)." The relation of narrative authority to the art of seduction is the subject of Ross Chambers' book *Story and Situation: Narrative Seduction and the Power of Fiction* (Minneapolis: University of Minnesota Press, 1984).

17. In *Epistolarity,* pp. 37–41, Altman provides a theoretical account of the role of the flashback in *Herzog.*

18. Leo Bersani, *A Future for Astyanax: Character and Desire in Literature* (Boston: Little, Brown, 1976), p. 84.

19. Sigmund Freud, *Introductory Lectures on Psychoanalysis,* ed. and trans. James Strachey (New York: Norton, 1966), p. 371.

20. Ibid.

21. Ned Lukacher, *Primal Scenes: Literature, Philosophy, Psychoanalysis* (Ithaca, N.Y.: Cornell University Press, 1986), p. 24. William Beatty Warner also provides an account of Freud's theory of the primal and its relation to literary theory in *Chance and the Text of Experience: Freud, Nietzsche, and Shakespeare's Hamlet* (Ithaca, N.Y.: Cornell University Press, 1986), pp. 37–111.

22. Stephen Heath, *Questions of Cinema* (Bloomington, Ind.: Indiana University Press, 1981), p. 154.

23. Discussion of this paradox is the focus of one of Derrida's "Envois," in *La Carte postale*, p. 34.

24. Barbara Johnson, "The Frame of Reference: Poe, Lacan, Derrida," *Literature and Psychoanalysis, The Question of Reading: Otherwise,* ed. Shoshana Felman, *Yale French Studies* 55/56 (1977), 502.

25. Hélène Cixous, "The Laugh of the Medusa," trans. Keith Cohen and Paula Cohen, in *New French Feminisms,* ed. Elaine Marks and Isabelle de Courtivron (New York: Schocken, 1981), p. 255.

26. In "Refusing the Romanticism of Identity: Narrative Interventions in Churchill, Benmussa, Duras," *Theatre Journal* 37, no. 3 (October 1985), 273–86, Elin Diamond outlines feminist strategies of theater in which a reshaped narrative text "insistently shapes or interrupts the dramatic present and thus alters audience perspective on the event."

27. The paradox of "feminine contradiction" in and around *Frankenstein* is the subject of Barbara Johnson's essay "My Monster/My Self," *Diacritics* 12, no. 2 (Summer 1982), 2–10.

28. Jean-François Lyotard, "The Différend, The Referent, and the Proper Name," *Diacritics* 14, no. 3 (Fall 1984), 5.

29. Ibid., p. 7.

30. Ibid.

31. Cixous, "The Laugh of the Medusa," p. 252.

32. Evoking the paradox of *Chucky's Hunch*—a play starring a man, about the decline of misogyny, and written by a female author—Johnson's essay "My Monster/My Self," 9–10, contemplates the implications of the feminine contradiction behind the authorship and content of *Frankenstein:* "It is perhaps because the novel does succeed in conveying the unresolvable contradictions inherent in being female that Shelley himself felt compelled to write a prefatory disclaimer in Mary's name before he could let loose his wife's hideous progeny upon the world. . . . How is this to be read except as a gesture of repression of the very specificity of the power of feminine contradiction, a gesture reminiscent of Frankenstein's destruction of his nearly-completed female monster? What is being repressed here is the possibility that a woman can write anything that would *not* exhibit 'the amiableness of domestic affection,' the possibility that for women as well as for men the home can be the very site of the *unheimlich.*"

Distraught Laughter: Monologue in Ntozake Shange's Theater Pieces

Deborah R. Geis

> . . . bein alive & bein a woman & bein colored is a metaphysical
> dilemma/ i havent conquered yet/ do you see the point my spirit
> is too ancient to understand the separation of soul & gender/ my
> love is too delicate to have thrown back on my face
> NTOZAKE SHANGE, *for colored girls who have considered*
> *suicide/when the rainbow is enuf*

Ntozake Shange's works defy generic classifications: just as her poems
(published in *Nappy Edges* and *A Daughter's Geography*) are also per-
formance pieces, her works for the theater defy the boundaries of drama
and merge into the region of poetry. Her most famous work, *for colored
girls who have considered suicide/ when the rainbow is enuf,* is sub-
titled "a choreopoem." Similarly, she has written *Betsey Brown* as a
novel and then again (with Emily Mann) in play form, and her first
work of fiction, *Sassafrass, Cypress & Indigo,* is as free with its narrative
modes—including recipes, spells, letters—as Joyce was in *Ulysses.* Per-
haps more so than any other practicing playwright, Shange has created
a poetic voice that is uniquely her own—a voice which is deeply rooted
in her experience of being female and black, but also one which, again,
refuses and transcends categorization. Her works articulate the connec-
tion between the doubly "marginalized" social position of the black
woman and the need to invent and appropriate a language with which to
articulate a self.

In their revelation of such a language, Shange's theatrical narratives
move subtly and forcefully between the comic and the tragic. A brief
passage from *for colored girls* underscores the precarious path between
laughter and pain which Shange's characters discover they are forced to
tread:

> distraught laughter fallin
> over a black girl's shoulder
> it's funny/it's hysterical
> the melody-less-ness of her dance
> don't tell nobody, don't tell a soul
> she's dancin on beer cans & shingles[1]

The images associated with the word *hysterical* in this passage show the multilayered and interdependent qualities of the "black girl's" experience: *hysterical* connotes a laughter which has gone out of control, a madness historically—if not accurately—connected with femaleness. Moreover, the admonition "don't tell nobody, don't tell a soul" suggests the call to silence, the fear that to speak of her pain will be to violate a law of submission. The onlooker will aestheticize the dance or call attention to its comic qualities rather than realize the extent to which the dance and the laughter are a reaction against—and are even motivated by—the uncovering of pain.

The key here is the complexity, for Shange, of the performative experience. In her plays, especially *for colored girls* and *spell #7*, Shange develops her narration primarily through monologues because monologic speech inevitably places the narrative weight of a play upon its spoken language and upon the performances of the individual actors. But she does not use this device to develop "character" in the same fashion as Maria Irene Fornes and other Method-inspired playwrights who turn toward monologic language in order more expressively to define and "embody" their characters both as women and as individuals. Rather, Shange draws upon the uniquely "performative" qualities of monologue to allow her actors to take on *multiple* roles and therefore to emphasize the centrality of *storytelling* to her work. This emphasis is crucial to Shange's articulation of a black feminist aesthetic (and to the call to humanity to accept that "black women are inherently valuable")[2] on two counts. First, the incorporation of role-playing reflects the ways that blacks (as "minstrels," "servants," "athletes," etc.) and women (as "maids," "whores," "mothers," etc.) are expected to fulfill such roles on a constant basis in Western society.[3] Second, the space between our enjoyment of the "spectacle" of Shange's theater pieces (through the recitation of the monologues and through the dancing and singing which often accompany them), and our awareness of the urgency of her call for blacks/women to be allowed "selves" free of stereotypes, serves as a "rupturing" of the performance moment; it is the uncomfortableness of that space, that rupture, which moves and disturbs us.

In "takin a solo/ a poetic possibility/ a poetic imperative," the open-

ing poem of *nappy edges,* Shange argues that just as the great jazz musicians each have a recognizable sound and musical style, so too should the public develop a sensitivity to the rhythms and nuances of black writers and that the writers themselves should cultivate "sounds" which distinguish them as individuals. She writes:

> as we demand to be heard/ we want you to hear us. we come to you the way leroi jenkins comes or cecil talyor/ or b.b. king. we come to you alone/ in the theater/ in the story/ & the poem. like with billie holiday or betty carter/ we shd give you a moment that cnnot be re-created/ a specificity that cannot be confused. our language shd let you know who's talkin, what we're talkin abt & how we cant stop sayin this to you. some urgency accompanies the text. something important is going on. we are speakin. reachin for yr person/ we cannot hold it/ we dont wanna sell it/ we give you ourselves/ if you listen.[4]

Although Shange's remarks were intended to address the larger issue of Afro-American writing, her words hold true for the speakers of monologue in her plays as well, for the monologue is another way of "takin a solo." For Shange's actors/characters (it is sometimes difficult to draw the distinction between the two, as the actors frequently portray actors who in turn portray multiple characters), monologues issue forth with the same sense that "some urgency accompanies the text" and that, in delivering the speeches, they are "reachin for yr person." In this respect the characters seem to aspire toward a specificity which would make them stand as if independent of their author. But the hallmark of the very "imperative" which Shange has announced in the first place is the unmistakable sense that all of the speakers' voices are ultimately parts of one voice: that of Shange, their creator and the play's primary monologist or storyteller.

All of Shange's theatrical pieces, even *a photograph: lovers in motion* and *boogie woogie landscapes,* unfold before the audience as collections of stories rather than as traditionally linear narratives; the events are generated less from actual interactions as they unfold in the "present" of the play (except perhaps in *a photograph*) than from the internal storytellers' *recreations* of individual dramas. The implied privilege of the storyteller to create alternate worlds, as well as the fluidity of the stories themselves and the characters in them, relies heavily upon the immense power that African and Afro-American tradition have assigned to the spoken word. According to James Hatch, Africans traditionally believe that "words and the art of using them are a special power that can summon and control spirit."[5] Furthermore, as Geneviève Fabre explains in *Drumbeats Masks and Metaphor:*

The oral tradition holds a prominent place in Afro-American culture. For slaves (who were often forbidden to learn to write) it was the safest means of communication. It provided basic contact with Africa as a homeland and a source of folklore, a contract also between ethnic groups unified under a common symbolic heritage, between generations, and finally, between the speaker and his audience. . . . Because the oral tradition has long remained a living practice in Afro-American culture, the dramatic artist has been tempted to emulate not only the art and techniques of the storyteller, but also his prestigious social function—that of recording and reformulating experience, of shaping and transmitting values, opinions, and attitudes, and of expressing a certain collective wisdom.[6]

Shange takes the notion of exchange and collectivity among storytellers even further in her use of the space in which her pieces are performed. Monologue creates "narrative space"; Shange depends upon the power and magic of the stories within her plays to create the scenes without the use of backdrops and other "theatrical" effects. *for colored girls* is the most "open" of the plays in this sense, as it calls for no stage set, only lights of different colors and specific places for the characters to enter and exit. *boogie woogie landscapes* conjures up the mental images of the title within the confines of Layla's bedroom: "there is what furniture a bedroom might accommodate, though not too much of it. the most important thing is that a bedroom is suggested."[7] Although the sets of both *spell #7* and *a photograph* are fairly specific (a huge minstrel mask as a backdrop and, later, a bar in lower Manhattan for the former; a photographer's apartment for the latter), they still call for this space to be reborn in different imaginary ways as the characters come forth and tell their stories.

for colored girls, Shange's first major theater piece, evolved from a series of poems modeled on Judy Grahn's *Common Woman.* The play received its first performances in coffeehouses in San Francisco and on the Lower East Side of Manhattan; eventually, it attracted critical and public attention and moved to the New Federal Theater, the Public Theater, and then to Broadway in 1976. *for colored girls* draws its power from the performances—in voice, dance, and song—of its actors, as well as from the ways it articulates a realm of experience which heretofore had been suppressed in the theater; the "lady in brown" speaks to the release of this suppression when she says near the beginning of the piece:

> sing a black girl's song
> bring her out

to know her self
. . . she's been dead so long
closed in silence so long
she doesn't know the sound
of her own voice
her infinite beauty

(pp. 2–3)

The instruments for releasing and expressing the "infinite beauty" of the "black girl's song" become the characters, who do not have names and specific identities of their own (except through their physical presences), but rather take on multiple identities and characters as the "lady in brown," "lady in red," "lady in yellow," etc. These "ladies" put on the metaphorical masks of various characters in order to enact the "ceremony" of the play, which gathers them together in a stylized, ritualistic fashion. The ritual is a religious one to the extent that the participants turn to the "spirit" which might be best described as the black female collective unconscious; it is a celebratory one in that their immersion in it is ultimately a source of joy and strength. In this sense the ritual is a festival that depends as much upon the bonds of the group as it does upon individual expression; Fabre makes this connection explicit when she says that "the group . . . takes possession of space and enlarges it to express communion."[8]

As the characters assume their different "masks," we see them enact a complex series of microdramas, some joyful and others painful. So it is that the "lady in purple" narrates the tale of Sechita, who "kicked viciously thru the nite/ catchin' stars tween her toes" (p. 26), while the lady in green "plays" Sechita and dances out the role. Both of these characters "are" Sechita, for the identity of this character within a character merges in the spoken narration and the accompanying movement. Yet it also becomes clear in the course of the play that these actors/ characters are *not* simply assuming masks or roles for the sake of a dramatic production; they must enact the "dramas" and wear the "masks" of black women every day of their lives. Shange has taken on the difficult task, then, of universalizing her characters in the play without allowing them to fall into roles that are essentially stereotypes. She discusses the need for this balance between the "idiosyncratic" and the "representative" in an interview with Claudia Tate:

> I feel that as an artist my job is to appreciate the differences among my women characters. We're usually just thrown together, like "tits and ass," or a good cook, or how we can really "f- - -" [*sic*]. Our per-

sonalities and distinctions are lost. What I appreciate about the women whom I write about, the women whom I know, is how idiosyncratic they are. I take delight in the very peculiar or particular things that fascinate or terrify them. Also, I discovered that by putting them all together, there are some things they all are repelled by, and there are some things they are all attracted to. I only discovered this by having them have their special relationships to their dreams and their unconscious.[9]

At times the storytellers within *for colored girls* seem to be putting on "masks" of humor which they wear, as part of the assumption of a role or character, in order to create a way of channeling the fear and anger they experience into the mode of performance. For instance, in one monologue the lady in red expresses the pain of a rejected love with a sardonic "itemization" of what she has been through:

> without any assistance or guidance from you
> i have loved you assiduously for 8 months 2 wks & a day
> i have been stood up four times
> i've left 7 packages on yr doorstep
> forty poems 2 plants & 3 handmade notecards i left
> town so i cd send to you have been no help to me
> on my job
> you call at 3:00 in the mornin on weekdays
> so i cd drive 27 1/2 miles cross the bay before i go to work
> charmin charmin
> but you are of no assistance
>
> (p. 13)

The disruptive power of this and other "comic" narratives in the play comes from the realization that what we are laughing at, though merely amusing and exaggerated on the surface, has an underside of bitterness and even torment. Often the shift from humor to pathos is so sudden that the effect is as if we have been slapped, which is precisely the way Shange describes the transition to the story on "latent rapist bravado" ("we cd even have em over for dinner/ & get raped in our own houses/ by invitation/ a friend" [p. 21]). Helene Keyssar points out in *The Curtain and the Veil* that the spectator is likely to overlook the pain in favor of the humor in the play's earliest vignettes, but as the work moves into such searing narratives as the lady in blue's story of an abortion, we begin to feel increasingly uncomfortable with our own laughter. The candor of the speakers combined with the persistent irony, says Keyssar, "prevents the display of emotion from becoming melodramatic and al-

lows the spectators a vulnerability to their own feelings that can renew their ability to act with others in the world outside the theater."[10] But there is also another way to view this generation of "vulnerability": as a result of the disjunction between the guise of humor and the realization that such moments in the play are actually imbued with pain and anger, the spectator experiences the feeling of having entered an uncomfortable "space" between the two strategies of performance. Like Brecht, Shange seems to believe that inhabiting such a "space" causes the audience to question its own values and beliefs; unlike Brecht, though, she engages the emotions directly in this process. She says in her interivew with Tate, "I write to get at the part of people's emotional lives that they don't have control over, the part that can and will respond."[11]

The most emotionally difficult (and most controversial) monologue in the play in terms of this vulnerability is the "Beau Willie Brown" sequence, the only story with a male protagonist. It concerns Beau Willie, a Vietnam veteran who beats up Crystal, the mother of their two children, so many times that she gets a court order restraining him from coming near them. When Beau Willie forces his way into Crystal's apartment and insists that she marry him, she refuses, and he takes the children away from her and holds them out on the window ledge. In the devastating final moments of the story, the lady in red, who has been telling the story, suddenly shifts from referring to Crystal in the third person to using "I":

> i stood by beau in the window/ with naomi reachin for me/ & kwame screaming mommy mommy from the fifth story/ but i cd only whisper/ & he dropped em (p. 63)

It is as if, in this wrenching moment, the lady in red has abandoned the sense that she is "acting out" a story; she "becomes" the character she has been narrating. As she closes the space between her role as narrator and the character of Crystal, this moment of the story itself brings to an end the distancing effect created by Shange's use of spectacle up to this point: the piece is no longer an "entertainment" but a ritualized release of pure feeling which is experienced rather than "performed."

Because of the resonance of the "Beau Willie Brown" story, *for colored girls* seems on the brink of despair; instead, though, the intensity and raw emotion of the lady in red's/Crystal's narrative serves to bring the women together and to acknowledge the strength they derive from each other. They characterize this final affirmation in religious terms, but it is a piety derived from within rather than from an outward deity:

> a layin' on of hands
> the holiness of myself released
> . . . i found god in myself
> & i loved her/ i loved her fiercely
> (pp. 66–67)

Janet Brown justly indicates the need for a movement toward such a resolution when she says that the "successful resolution to the search for autonomy is attributable first to the communal nature of the struggle."[12] However, these last two sequences of the play have come under fire by some critics because they feel that Shange had ultimately failed to translate the personal into the political. Andrea Benton Rushing criticizes Shange's isolation in *for colored girls* "from salient aspects of black literary and political history," the "shockingly ahistorical" way it seems to ignore "white responsibility for our pain," and its final "rejection of political solutions."[13] Similarly, Erskine Peters is appalled by the apparent manipulativeness of the "Beau Willie Brown" monologue:

> This climax is the author's blatantly melodramatic attempt to turn the work into tragedy without fulfilling her obligations to explore or implicate the historical and deeper tragic circumstances. There is a very heated attempt to rush the play toward an evocation of pity, horror, and suffering. The application of such a cheap device at this critical thematic and structural point is an inhumane gesture to the Black community.[14]

Rushing and Peters raise a valid issue when they say that *for colored girls* is not a direct and forceful indictment of white supremacist politics, at least not in as immediate a sense as *spell #7*. But Peters' accusation that Crystal's story constitutes a "cheap device" which turns the play into a pseudotragedy seems unfounded, for such an argument ignores the declaration of community which comes at the end of the play in response to the individual pain which reached its peak in the "Beau Willie Brown" narrative. Indeed, one might argue that the placement of this story before the play's closing ritual is Shange's attempt to avoid having the spectator convert the final moments into cathartic ones—for as Augusto Boal argues so convincingly in *Theater of the Oppressed,* catharsis can have the "repressive" or "coercive" effect of lulling the spectator into complacency.[15] Or, as Michael W. Kaufman says of the black revolutionary theater of Baraka, Reed, and others, "The very notion of catharsis, an emotional purgation of the audience's collective energies, means that theatre becomes society's buffer sponging up all the moral indignities that if translated into action could effect substantial change."[16]

If the ending of the play is dissatisfying because it seems to be administering a palliative to the audience, that is precisely the point: Shange is suggesting the sources of possible strength and redemption by having the characters *perform* the play's closing "ritual." But since the "Beau Willie Brown" story has closed the gulf between narrator and narrative, this final "performance" *cannot* be only a "show." Just as the "ladies" are no longer playing "roles," the spectacle of their concluding ritual automatically conveys a sense of urgency which—coupled with the sheer emotional impact of the "Beau Willie Brown" sequence—prevents the audience from experiencing the ending as cathartic.

Kimberly Benston discusses black American theater's movement away from European-American structures and toward African-rooted ones in terms of the shift from *mimesis*/drama to *methexis*/ritual. Not only, she claims, does the ritual create a sense of community, as we have discussed in *for colored girls,* but it also breaks down the barriers that have traditionally existed between the performers and the spectators.[17] This is perhaps why, in the opening of Shange's *spell #7* (1979), there is a "huge blackface mask" visible on the stage even while the audience is still coming into the theater. Shange says that "in a way the show has already begun, for the members of the audience must integrate this grotesque, larger than life misrepresentation of life into their pre-show chatter."[18] We might say that she thus attempts to erase distinctions between "play" and "audience": not only does the performance address the spectators, but in this case the spectators are also forced to "address" the performance. At the beginning of the play, the performers parade in minstrel masks identical to the huge one which looms overhead; they eventually shed their masks and pose instead as "actors" (or actors playing actors who, in turn, play at being actors), but the image of the minstrel mask is a sign that even modern black actors are still often conceived of as little more than minstrels. As the actor/character Bettina complains, "if that director asks me to play it any blacker/ i'm gonna have to do it in a mammy dress" (p. 14).

Shange, then, makes the minstrel-masking into a ceremony of sorts in the opening scene of *spell #7,* and the resemblance of the giant minstrel face above the stage to an African voodoo mask is wholly intentional. At the same time, though, the blackface masks that the actors wear at the beginning of the play also invoke the *travesty* of a ceremony, for the masks represent the "parts" each must play (in the Western tradition) in order to get a job. Shange connects this to her feelings about her own "masking" in an interview with Tate:

It was risky for us to do the minstrel dance in *spell #7*, but I insisted upon it because I thought the actors in my play were coming from pieces they didn't want to be in but pieces that helped them pay their bills. Black characters are always being closed up in a "point." They decided, for instance, that *spell #7* by Zaki Shange is a feminist piece and therefore not poetry. Well, that's a lie. That's giving me a minstrel mask. . . . We're not free of our paint yet! The biggest money-makers—*The Wiz, Bubblin' Brown Sugar, Ain't Misbehavin'*—are all minstrel shows.[19]

In the course of the play, though, the actors/characters also use "masking" in a different way; they try on various "masks" or roles, as in *for colored girls,* to perform the monologues and group pieces that provide both mirrors and alternatives for the various "selves" they create under pressure from a society governed by white values and images. So, for instance, one of the nameless and faceless performers behind a minstrel mask at the beginning of the play becomes the actor Natalie in the next scene, who in turn "becomes" Sue-Jean, a young woman who desperately wants a baby, as she and Alec (another of the "minstrels" revealed as actor/character) alternate in narrating her story while she mimes it out.

Unlike *for colored girls, spell #7* makes use of a central storyteller figure, Lou, who "directs" the monologues which are performed in the course of the play. It is appropriate that Lou is a magician, for even the title of *spell #7* (the subtitle of which is "geechee jibara quik magic trance manual for technologically stressed third world people") refers to magic making. In his opening speech, though, Lou warns of the power (and danger) of "colored" magic:

> my daddy retired from magic & took
> up another trade cuz this friend a mine
> from the 3rd grade/ asked to be made white
> on the spot
>
> what cd any self-respectin colored american magician
> do wit such an outlandish request/ cept
> put all them razzamatazz hocus pocus zippity-doo-dah
> thingamajigs away cuz
> colored chirren believin in magic
> waz becomin politically dangerous for the race . . .
>
> all things are possible
> but ain't no colored magician in his right mind
> gonna make you white

 i mean
 this is blk magic
 you lookin at
 & i'm fixin you up good/ fixin you up good & colored
 (pp. 7–8)

The image of the narrator as "magician" implies that the storytellers
themselves will be under the control of a certain "author"; yet as the
actors perform their pieces, the stories seem at times to slip away from
a guiding narratorial force and to become deeply personal. In a sense,
the performers threaten to overpower the narrator in the same way that
the third grader's request to be made white is beyond the power of Lou's
magician father: the stories take on a kind of magic which is indepen-
dent of their "director," and yet to enter this realm may be painful and
perilous. Lou, then, is like a surrogate author who is responsible for the
content of the play, but who also cannot fully control what happens to
it once the performers begin to take part.

Lou's position in relation to the performers is most fully evident
when, after Lily becomes wholly absorbed in her monologue about the
network of dreams she has built around her image of her hair, he stands
up and points to her. Shange indicates in the stage directions that Lou
"reminds us that it is only thru him that we are able to know these peo-
ple without the 'masks'/ the lies/ & he cautions that all their thoughts
are not benign, they are not safe from what they remember or imagine"
(p. 27). He says, partly to Lily and partly to the audience:

 you have t come with me/ to this place where magic is/
 to hear my song/ some times i forget & leave my tune
 in the corner of the closet under all the dirty clothes/
 in this place/ magic asks me where i've been/ how i've
 been singin/ lately i leave my self in all the wrong hands/
 in this place where magic is involved in undoin our masks/ i
 am able to smile & answer that.
 in this place where magic always asks for me
 i discovered a lot of other people who talk without mouths
 who listen to what you say/ by watchin yr jewelry dance
 & in this place where magic stays
 you can let yrself in or out
 but when you leave yrself at home/ burglars & daylight
 thieves
 pounce on you & sell your skin/ at cut-rate on tenth avenue
 (p. 27)

The "place where magic is" means, within the most literal context of the
play, the bar where the actors meet and feel free to try on various roles.

But it is also the theater, and the implication is that, as such, it is both a safe place and an unsafe place: certain inhibitions are lifted and certain feelings can be portrayed, but one risks vulnerability in exposing one's memories and emotions. Finally, "this place where magic is" marks the space in which the actor/writer/artist allows creativity to happen. The impulse to safeguard it—"lately i leave my self in all the wrong hands"—echoes the fear of loss which Shange turns into a similar set of metaphors in the "somebody almost walked off wid alla my stuff" poem in *for colored girls*. But something interesting occurs as the result of Lou's delivery of this speech: although he designs it to reinforce his power as the play's magician/narrator, its effect is to establish *him* as being in a position not altogether different from that of the other characters, for the speech reveals his vulnerability, his disguises and defenses, and his need to inhabit a "safe" place in which to create.

If Lou is indeed addressing the audience as well as Lily, the implication is that he is inviting the spectator to become similarly vulnerable. Not surprisingly, then, the play's two "centerpiece" monologues attempt—as in *for colored girls*—to take hold of the spectator in the gap that the performers create between the "safe" region of spectacle/ entertainment and the "unsafe" region of pain and emotional assailability. In the first of the two monologues, Alec tells of his wish for all of the white people all over the world to kneel down for three minutes of silence in formal apology for the pain that they have given to black people:

> i just want to find out why no one has even been able to sound a gong
> & all the reporters recite that the gong is ringin/ while we watch all
> the white people/ immigrants & invaders/ conquistadors & relatives of
> london debtors from georgia/ kneel & apologize to us/ just for three
> or four minutes. now/ this is not impossible. (p. 46)

Of course, the image is an absurd one, and Lou calls attention to this when he responds to Alec, "what are you gonna do with white folks kneeling all over the country anyway/ man" (p. 47). The humor in Alec's rather extreme proposal is undercut, however, by the suffering which stands behind such a request. Perhaps the most savage example of anger transferred to the realm of the comic, though, and one which cannot fail to disturb the audience, is Natalie's "today i'm gonna be a white girl" monologue. She takes on the voice of the vacuous and hypocritical "white girl" who flings her hair, waters her plants, and takes twenty Valiums a day:

> . . . i'm still waiting for my cleaning lady & the lady who takes care

of my children & the lady who caters my parties & the lady who accepts quarters at the bathroom in sardi's. those poor creatures shd be sterilized/ no one shd have to live such a life. cd you hand me a towel/ thank-you caroline. i've left all of maxime's last winter clothes in a pile for you by the back door. they have to be cleaned but i hope yr girls can make gd use of them. (p. 49)

Freud says in *Jokes and Their Relation to the Unconscious* that the ability to laugh at something is interfered with when the "joke" material also produces a strong affect and so another emotion "blocks" one's capacity to generate laughter;[20] for this reason, it is not surprising that the "white girls" in the audience at whom this monologue is aimed may feel too angry at Natalie's speech to consider it funny. Or they may laugh because they distance themselves from the reality of her words. Similarly, the very intensity of Natalie's emotions as she speaks this piece shows both the amount of pain which gradually interferes with her ability to sustain the joking tone of her own speech at the end and the intensified need for release through humor which her bitterness engenders. As Freud indicates,

> precisely in cases where there is a release of affect one can observe a particularly strong difference in expenditure bring about the automatism of release. When Colonel Butler answers Octavio's warnings be exclaiming 'with a bitter laugh': '*Thanks* from the House of Austria!' his embitterment does not prevent his laughing. The laugh applies to his memory of the disappointment he believes he has suffered; and on the other hand the magnitude of the disappointment cannot be portrayed more impressively by the dramatist than by his showing it capable of forcing a laugh in the midst of the storm of feelings that have been released.[21]

It is also striking that the play's final monologue, spoken by Maxine, comes forth because she is "compelled to speak by natalie's pain" (i.e., after Natalie delivers the "white girl" monologue [p. 49]). As in *for colored girls,* the play's penultimate sequence seems to be different in tone from the earlier monologues—and again, the effect is a closure of the "gaps" we have discussed. Here Maxine speaks of the way her world was shattered when she realized as a child that blacks were not exempt from the diseases, crimes, and so on, that white people experienced. She closes with a description of her decision to appropriate gold chains, bracelets, and necklaces as a symbol of "anything hard to get & beautiful./ anything lasting/ wrought from pain," followed by the shattering remark that "no one understands that surviving the impossible is sposed to accentuate the positive aspects of a people" (p. 51). Lou, as "direc-

tor" of the action, freezes the players before they can fully respond to Maxine's words, and he repeats the closing portion of his opening speech: "And you gonna be colored all yr life/ & you gonna love it/ bein colored/ all yr life." As the minstrel mask reappears above them, he leads the actors in the chant "colored & love it/ love it bein colored" (p. 52). Shange notes in the stage directions that the chant is a "serious celebration, like church/ like home" (p. 52). Her words are entirely appropriate to the dual nature of the ending: it is true that the characters are celebrating themselves, but the resonance of the preceding monologue, which was fraught with pain—as well as the overwhelming presence of the minstrel mask—recalls the anger and frustration which also underlie their chant. The characters, then, are imprisoned in the stereotypes and social position which the world has assigned to them, but like the women in *for colored girls* they call for unity as a source of strength. Their chant of "colored & love it/ love it bein colored" suggests that they intend to escape from their prison by redefining it so that it is no longer a prison. But the possibility remains that for the time being the escape may be only a partial one. As Shange writes in "unrecovered losses/ black theater traditions," the minstrel face which descends is "laughing at all of us for having been so game/ we believed we cd escape his powers."[22]

Spell #7's ultimate vision may be more cynical than that of *for colored girls,* but its call for redefinitions is one which echoes throughout Shange's theater pieces. She invites a reconsideration of role-playing which suggests that in the process of acting out the various "masks" that blacks/women are *expected* to assume, one undergoes an experience of interior drama. Liberated through monologic language and by dance, song, etc., which release different, richer, more complex characters and experiences, the very nature of role-playing has been appropriated as a tool for "performing a self." She sees role-playing as a way simultaneously to give her characters an archetypal fluidity and to confront role-oriented stereotypes. On some level Shange's characters are always aware that they are speaking to an audience; perhaps this emphasis is an acknowledgment of the sense that women—as John Berger discusses in *Ways of Seeing*—are always the objects of vision and so are constantly watching themselves being watched.[23] Rather than decentering the position of authorship in her plays by providing a sense that the characters are as if "self-created," though, Shange appears to share Michelene Wandor's view that deliberate attention to the author's role as "storyteller" provides a backbone, a controlling structure, for the play.[24] Interwoven with this is a revision of spectacle as a vehicle for

amusement; Shange's interpretation of "spectacle" insists upon questioning both the *mode* of performance which lures the audience's attention (as in the minstrel show at the beginning of *spell #7*) and the *subtext* of the spectacle itself. The monologue, then, is both an object for transformation and a means by which transformations can occur. Above all, Shange feels passionately that "we must move our theater into the drama of our lives."[25] Her works attempt to speak, in the way that she says Layla's unconscious does in *boogie woogie landscapes,* of "unspeakable realities/ for no self-respecting afro-american girl wd reveal so much of herself of her own will/ there is too much anger to handle assuredly/ too much pain to keep on truckin/ less ya bury it."[26]

Notes

1. Ntozake Shange, *for colored girls who have considered suicide/ when the rainbow is enuf* (1977; reprint New York: Bantam, 1981), pp. 1–2. Subsequent references to the play are to this edition and will be indicated in the text. N.B.: Shange's spelling, punctuation, and diction make up her unique style and have been reproduced as printed in the texts of her works.

2. Combahee River Collective, "A Black Feminist Statement," in *But Some of Us Are Brave: Black Women's Studies,* ed. Gloria Hull, Patricia Bell, and Barbara Smith (New York: Feminist Press, 1982), p. 15.

3. Cf. Alice Walker, "In Search of Our Mothers' Gardens," in *In Search of Our Mothers' Gardens* (New York and San Diego: Harcourt Brace Jovanovich, 1983), p. 237.

4. Ntozake Shange, *nappy edges* (London: Methuen, 1987), p. 11.

5. James Hatch, "Some African Influences on the Afro-American Theatre," in *The Theater of Black Americans,* ed. Errol Hill (Englewood Cliffs, N.J.: Prentice-Hall, 1980), vol. 1, p. 25.

6. Geneviève Fabre, *Drumbeats Masks and Metaphor: Contemporary Afro-American Theatre,* trans. Melvin Dixon (Cambridge, Mass.: Harvard University Press, 1983), p. 219.

7. Ntozake Shange, *boogie woogie landscapes,* in *Three Pieces* (New York: St. Martin's Press, 1981), p. 113.

8. Fabre, *Drumbeats Masks and Metaphor,* p. 226.

9. Claudia Tate, ed., *Black Women Writers at Work* (New York: Continuum, 1983), p. 153.

10. Helene Keyssar, *The Curtain and the Veil: Strategies in Black Drama* (New York: Burt Franklin, 1981), pp. 213–15.

11. Tate, *Black Women Writers,* p. 156.

12. Janet Brown, *Feminist Drama* (Metuchen, N.J.: Scarecrow Press, 1979), p. 129.

13. Andrea Benton Rushing, "For Colored Girls, Suicide or Struggle," *Massachusetts Review* 22 (Autumn 1981), 544, 546, 550. Certainly, it would be difficult for Rushing to make the same accusations of *spell #7*.

14. Erskine Peters, "Some Tragic Propensities of Ourselves: The Occasion of Ntozake Shange's 'for colored girls who have considered suicide/ when the rainbow is enuf,' " *Journal of Ethnic Studies* 6, no. 1 (Spring 1978), 82.

15. August Boal, *Theater of the Oppressed*, trans. Charles A. McBride and Maria-Odilia Leal McBride (New York: Urizen, 1979), p. 25.

16. Michael W. Kaufman, "The Delicate World of Reprobation: A Note on the Black Revolutionary Theatre," in *The Theater of Black Americans*, ed. Erroll Hill (Englewood Cliffs, N.J.: Prentice-Hall, 1980), vol. 1, pp. 206–7.

17. Kimberly W. Benston, "The Aesthetic of Modern Black Drama," in *The Theater of Black Americans*, ed. Erroll Hill (Englewood Cliffs, N.J.: Prentice-Hall, 1980), vol. 1, pp. 62–63.

18. Ntozake Shange, *spell #7*, in *Three Pieces* (New York: St. Martin's Press, 1981), p. 7. Subsequent references to the play are to this edition and will be indicated in the text.

19. Tate, *Black Women Writers*, p. 173.

20. Sigmund Freud, *Jokes and Their Relation to the Unconscious*, trans. James Strachey (New York: Norton, 1960), pp. 220–21.

21. *Ibid.*

22. Ntozake Shange, "unrecovered losses/ black theater traditions," in *Three Pieces* (New York: St. Martin's Press, 1981), p. xiii.

23. John Berger, *Ways of Seeing* (Middlesex: Penguin/BBC, 1972), pp. 446–47.

24. Michelene Wandor, *Carry On, Understudies: Theater and Sexual Politics*, rev. ed. (London: Routledge & Kegan Paul, 1986), p. 128.

25. Shange, "unrecovered losses," p. ix.

26. *Ibid.*, p. xiv.

Rites and Responsibilities: The Drama of Black American Women

Helene Keyssar

Plays by black American women suggest the potential power in the matching of theater and black consciousness. For the black woman playwright there is, if not a triple consciousness, then at least a complicated double consciousness in which she sees the world as an American *woman* and a black *woman*. From the beginnings of theater by black women playwrights through the present, this drama has tended to create stage worlds in which diverse voices and world views collide, polyphony is asserted and sometimes celebrated, and the different signifying systems of dance, music, performance transformations, and visual imagery are aggressively utilized.

Vivid but provocatively unacknowledged evidence of this inclination (perhaps this necessity) occurs in an early twentieth-century play (1916) by a black English teacher named Angelina Grimke. Entitled *Rachel,* after its central character, Grimke's drama is usually described (by both black and white critics) as a sentimental social protest drama, deliberately written as theatrical propaganda to dissuade whites from the persecution of black Americans and written specifically to urge whites to bring an end to the numerous lynchings of blacks occurring during the period when the play was written.[1] Critics such as James Hatch and Ted Shine allow that the play may have been conceived as well to provide black spectators with a positive self-image.[2] When *Rachel* is noted in histories of American drama, it is presented as a historical event: the "first" play by a black playwright performed by black actors for a white public and/or the first deliberate black propaganda play.

There are certainly unmotivated turns of plot, abrupt leaps of time, and self-conscious speeches of exposition in *Rachel,* but without dis-

crediting its importance as a first in theater history, the play seems to me far more interesting as a text of cultural history than has been acknowledged. While the drama does detail the murderous behavior of whites toward blacks and pays particular attention to the sufferings and humiliations of black children, an obvious source of sentimental appeal, the response of the central character to the situations and histories she encounters is anything but facile or maudlin. Early in the play eighteen-year-old Rachel declares that what she most wants in the world is to have and love lots of "little black and brown babies." By the end of the act 1, however, she has heard enough about her previously hidden heritage to counter her own longings and assert that it would be more merciful to black children and black mothers "to strangle the little things [black babies] at birth" than to let them suffer the continuous frustrations and humiliations she now perceives to be the inalterable condition of being black in the United States of America.

Focused on motherhood and what it means for a black woman and for black children, the play has Rachel speak variously and sometimes simultaneously as child to her own mother, as mother to her adopted son, Jimmy, and as a self-constructed spinster-virgin. Notably, this is not the familiar developmental change of role and voice we anticipate in "good" drama but is closer to a depiction of insanity or a representation of character that fits critical descriptions of "inconsistent" writing. The last two portrayals may be true, yet there is an at least equal and more important truth in the text's failure to resolve Rachel's double consciousness. The scene in which Rachel tells the man she loves that she will not marry him is characteristically demonstrative of her double consciousness of self and the world around her. Rachel's vacillation from "no" to "yes" to "no" again in response to her friend John's marriage proposal is not ordinary ambivalence: her "yes" is as impassioned as each of her "no's," and she rejects thought both in framing her "yes" and in finally proclaiming her "no." She is similarly double voiced in the climactic end of act 2, where she roughly tears the buds from the rose stems sent to her by John. The rosebuds, she makes clear, are her unborn children, and, as she deliberately aborts them, saying "I kill," she also speaks with tenderness of her victims and with grief of her loss:

RACHEL: Never to know the loveliest thing in all the world—the feel of a little head, the touch of little hands, the beautiful utter dependence of a little child?

If I kill, You mighty God, I kill at once—I do not torture.[3]

Metaphorically killing her unborn children, and, in her own mind, kill-

ing them again when she refuses to marry John, Rachel is polypho-nous—but she is not ambivalent. In neither case is she conflicted about what she desires or must do; from the moment she learns that her adopted son, like her father and brother before her and an older child who is a stranger to her, has been tormented by other children because he is black, she is determined to "kill" her unborn children. Because she retains her belief that "the loveliest thing of all the lovely things in the world is just being a mother," and because she takes as true prophecy a dream she once had in which she was told she was "to be a mother to little children," she perceives her avoidance of marriage and mother-hood as acts of abortion.

For Rachel abortion, as she conceives and enacts it, is the only act that will authenticate her double existence as woman and black person. Any other act would, for her, be a false resolution of her hybrid self. We see signs of the strains of that hybridization in act 1 in Rachel's discon-certingly naive expressions of surprise in response to stories of discrim-ination against "colored" people; in fact, reading the play, it is not clear in its first few scenes if Rachel and her mother are themselves "colored" or "white." By act 2, Rachel's speeches no longer suggest the spurious domination of the language of one ethnic group by the language of another. As a woman and as a black, Rachel's double voicedness be-comes only more resonant as the play concludes with the central charac-ter's farewell to the weeping voices of her unborn children, followed by her assurance to her adopted son that she is coming and that, finally, "Ma Rachel loves you so."

If we listen well, Grimke's *Rachel* teaches us to hear the dialogism in her central character's last words. Forty years later, in the next mile-stone of black women's drama,[4] Lorraine Hansberry's *Raisin in the Sun* (1958), the representation of what it means to love as a mother *and* to be a black American woman requires an even more hybrid form of discourse than in earlier years. Written in the political and cultural context of the integrationist movement, *A Raisin in the Sun,* like *Rachel,* is a social protest play intended to persuade white people that black people are not only good at heart but sufficiently like whites in their values and cultural practices that whites should "allow" blacks to be their neighbors. As in *Rachel,* motherhood is at the center of this appeal, but the leaks in the argument in *A Raisin in the Sun* are at once more threatening to the success of the plea and less apparent than in Grimke's earlier work.

A man, Walter Lee, is the central figure of the Younger family in *A Raisin in the Sun* and is also the play's protagonist, but the family

and the cultural conflicts of Hansberry's drama are dominated by women. As I have discussed in previous writings,[5] Hansberry's double assaults on racism and sexism may occasionally conjoin to win the applause of white and black women (just as they sometimes offended both black and white men),[6] but her criticisms of injustices to black men and of the subjugation of all women to men are often conceptually contradictory and at best are parallel thrusts in her dramatic strategy. Walter Lee suffers because the only work available to him as a black man (he is employed as a chauffeur) is demeaning; when, in his attempt to buy his own business, he is conned by "business partners" out of a substantial portion of a small family inheritance, he becomes so demoralized that he temporarily accepts a white man's blatantly racist offer to buy back the Younger family's newly purchased house in the white man's white neighborhood. From the beginning of the play, Walter Lee is in conflict with his mother over the use of the inheritance: Mama perceives the purchase of a house as the fulfillment of her version of the American dream, whereas Walter is convinced that once he is his own boss the other pieces of the dream—a gardener, physical comfort, good educations for his children—will follow. Walter's loss of the money he covertly invests in a liquor business and the opposition of the white community to the planned move of the Younger family into their neighborhood shatter both visions of "success," but Walter's suffering is so central to the dramatic action onstage that the social issues in these dreams become peripheral. The dramatic strategy of *A Raisin in the Sun* appears to support the notion, conventional in the fifties and sixties and subsequently challenged,[7] that black men were the key victims of white American racism and that the image and actuality of the black woman as the source of strength and endurance in the black family sometimes undermined the struggles of black men for self-respect. The play's conclusion, in which Walter regains his dignity by informing the white man that the Youngers have changed their minds and will move into their house in the white neighborhood, reinstates the black man as the center of family authority and as a heroic figure in American culture.

More than a decade ago, when I first attempted to write about *A Raisin in the Sun,* I found myself in a struggle with the text. The language, dramatic conventions, and structure of the drama were all easily accessible; onstage and on the page, the play appeared to be a straightforward, realistic family drama, intentionally familiar to whites like myself in both the cultural practices it displayed and the theatrical gestures it employed. I could only surmise that I was having difficulty saying

anything coherent or interesting about the play because I disputed its
undermining of the positive values of racial difference and because I
found its dramaturgy conventional and consistent with dramatic real-
ism's generally deadening contribution to modern theater.

It was the leaks in the play's ostensibly monologic discourse, the
flaws in the script's seemingly well-wrought fabric, that eventually en-
abled me to write about *A Raisin in the Sun*. It was not the social prob-
lems the play addressed but the problems of the playwright in address-
ing them that I came to find intriguing. Hansberry had constructed a
dramatic world in which the wit and charm of the characters distracted
the audience from the dangers and contradictions of the social world
they inhabited: we are led to applaud Walter's triumph over his own
humiliation, over white racism, and over the women around him be-
cause he is, in Arthur Miller's now-classical terms, a "modern hero"
struggling to transcend his own limitations and those of the society
around him.[8] The celebration of the Younger family and our own ap-
plause at the end of the play obscure the difficult questions that remain:
how are the Youngers going to pay the mortgage on their new house?
What reason is there to believe that the white neighbors will treat the
Youngers decently once the black family moves in? With much of the
money lost, how will Benethea, Walter's sister who wants to become a
doctor, pay for medical school?

Among those troublesome, marginalized issues, the pregnancy of
Walter's wife, Ruth, the topic of which is raised intermittently through-
out the drama, is especially disconcerting. Already the mother of a son
who is the focus of the family's dreams of the future, Ruth confirms near
the beginning of *A Raisin in the Sun* that she is pregnant, but her in-
clination is to have an abortion. Ruth conceals the knowledge of her
pregnancy from her husband and, much against the will of her mother-
in-law, makes plans for the abortion. Her motives are initially prag-
matic: she is employed as a maid and, especially after Walter is fired
from his job as a chauffeur, is the primary source of income for the
family; with Mama too old to work and sister Benethea studying for
medical school, the Youngers cannot afford for Ruth to be unable to
work and for the family to have another mouth to feed. In addition,
Walter's frustration with work and with the family's meager living con-
ditions has taken a toll on his marriage, and Ruth finds no joy in the
prospect of bringing another child into this grim and potentially explo-
sive world.

Ruth does not, in the end, have an abortion, and her fierce declara-
tion at the end of the play—"I'll strap my baby on my back if I have to

and scrub all the floors in America and wash all the sheets in America if I have to—but we got to move. . . . We got to get out of here"[9]— serves as the dramatic resolution to her previous conflict. But Hansberry has allowed Ruth to speak enough of her misgivings about bringing another black child into the world that in the festive ambiance of the play's ending, it is Ruth whose utterances are least convincing of all the characters'. Ruth's pregnant presence remains an unconcealable reminder of the double consciousness of black women that has been articulated on separate planes throughout the play. At other moments in the drama, Benethea and Ruth have both protested the mistreatment of women by men, and while Ruth is more accepting of a stereotypical wifely role than is her sister-in-law, the text as a whole has called into question the subordination of women and children to the desires of men.

Hansberry's last comment on Ruth is a stage direction that instructs the actress to *"bite her lip"* to demonstrate that she is constraining herself from *"exploding"* with pride in her husband. This contributes to the play's final dramatic focus on Walter's newfound manhood, but cannot entirely distract the audience from Hansberry's earlier arguments against the tyranny of the male ego. And Ruth's own projected image of herself scrubbing other women's floors with her baby on her back remains onstage as well, a disturbing reminder of what the days ahead may actually look like for this woman. Ruth's joy in Walter's reclamation of his self-respect and her relief in the knowledge that she will "get out" of the Youngers' cramped apartment and all it represents may distract her from the double meanings of the day's events. But they should not distract us from the dialogic understandings of this culture in this historical moment that *A Raisin in the Sun* establishes, even if the play accomplishes this despite its own more unified intentions.

A third milestone in black women's drama, Ntozake Shange's *for colored girls who have considered suicide/when the rainbow is enuf* (1975), attracted the attention of many critics in large part because it seemed to confront and transcend the contradictions and confusions in the double consciousness of black women that Hansberry had articulated but abandoned. Described by the author as a "choreopoem," *for colored girls* rejects the conventions of dramatic realism for a form of theater that makes its meanings as much from dance and the rhythms of verbal language as from semantic sources of signification. A primary example of the special application of transformational devices in feminist theatre,[10] *for colored girls* is a series of stories of the struggles, victories, and defeats of more than a dozen unnamed black women,

performed by seven actresses who move fluidly from choral roles as witnesses and commentators to individual narrators. Much of the hypnotic vibrancy of the production derives from the tension between the vulnerability of each woman when she stands alone to tell a particular story and the fortitude of the women when they stand and move as a community.

Shange subtly arranges the separate stories and dances of *for colored girls* to ensure that each tale or gesture interanimates others with which it is juxtaposed, a strategy comparable to that of montage in film: meanings derive from the collision of images and ideas at least as much as from each discrete image or assertion. Continuity in performances of Shange's score rests primarily on the constant presence and fluid transformations of all the women, as well as on the repetition of patterns of change in performers and modes of representation. A barely discernible chronological thread that unwinds the lives of black women from girlhood to maturity is present in the score, however, and it is not, I think, unimportant that the one vivid knot in this thread, a story that is also the climax of the piece, returns us to motherhood as a specific dilemma and source of enormous pain for black women.

No one who has seen *for colored girls* will have forgotten the narrative to which I refer—the story of Crystal, a black woman with two small children. The father of these children, Beau Willie, a Vietnam veteran whom Crystal refuses to marry, is violently desperate in both his need for his family and his need to destroy everything in a corrupt, unjust world that repeatedly confirms his impotence. Each of Beau Willie's visits to Crystal grotesquely combines courtship and physical assault. The narrator tells us that when Crystal informed Beau Willie of her pregnancy with his second child, he "most beat her to death," but "still crystal went right on & had the baby."[11] After the birth of this second child, "there was no air."

Crystal's mothering ends with neither an abortion nor a birthing, but with the deaths of both her children. Beau Willie has appeared on another of his visits, telling Crystal, the narrator recalls, that he just wants to hold his children and go on his way. Crystal resists, but finally releases both her son and daughter to their father, who then immediately holds the children hostage, hanging them out a fifth-story apartment building window while he demands that Crystal declare her intention to marry him. Shifting almost imperceptibly from the third person to the first person, the now-conjoined voices of Crystal and the narrator conclude the awful tale:

> i stood by beau in the window/ with naomi reachin for me/ & kwame
> screamin mommy mommy from the fifth story/ but i cd only whisper/
> & he dropped em[12]

In *for colored girls* the voices of young girls learning black history, of adolescents recalling the loss of virginity, of young adults taking responsibility for "their own stuff," sing and shout and laugh, weep and attack. In the end, however, the black mother has hardly any voice. Initially, she can tell her story only as about another; finally, she can only whisper. For Crystal, as for Rachel, Ruth, and many of their sisters in black feminist drama, it is possible in many circumstances to ignore, unify, or diminish the multiple points of view inherent in being a black woman, but a hybrid consciousness reemerges insistently for each of these characters in the presence of the possibility or actuality of motherhood. Each of these women characters partly shapes her understanding of herself as a woman in the context of her pleasure in reproducing and loving children, but each character simultaneously finds her understanding of herself as a black person to be deeply informed by her resistance to sustaining or reproducing the pain of being born black in America.

Somewhat paradoxically, despite the polyphonous structure of *for colored girls,* it is only in the last lines of Crystal's epeech and the concluding ritual of the women's laying on of hands that Shange's drama shifts from monologic to dialogic discourse. Although the audience hears diverse voices throughout the performance, each voice in itself asserts its unity and authority, and the orchestration of these varied voices, through both verbal and physical stage gestures, strives to emphasize commonality and deemphasize cultural dissonances. It is in the story of Crystal that, for the first time, several points of view—that of Beau Willie, Crystal, and the narrator—collide and intersect. In *for colored girls* this newly admitted dialogic discourse reveals "the ghost of another woman/who waz missin what i was missin."[13] The process of listening to the voices of other women, voices that speak from the same context and language system, finally allows each woman to admit her own double voicedness, to find "god in herself."

For Rachel in Grimke's drama and for Ruth in *A Raisin in the Sun,* the danger and burden of acknowledgment of each's own hybridization threaten the sense of responsibility to others and lead to acts that at least momentarily unify the self. Not unimportantly, both these characters define themselves in relation to men and to their own mother figures. In numerous other plays by black American women, including folk drama by women like Georgia Douglas Johnson, pedagogical works

such as Mary Burrill's dramatized argument for birth control, *They That Sit in Darkness* (1919), and the nine realistic dramas written by Alice Childress between 1950 and the late seventies, black women characters strain toward and against these same pillars of support and constraint. The triumph of Wilmetta, an early (1950) Childress character, is her escape from a self-definition informed by white America's notions of the black woman as the always-generous, nurturing mammy; Tommy, the central female character in Childress' 1969 drama, *Wine in the Wilderness,* resists fabricating a self based on white American cultural values, but becomes heroic only when she overcomes her attempt to speak in a voice that will please the man she loves.

These "landmarks" of black feminist drama—and more than a hundred other plays by black American women who have more than filled the gaps and continued beyond what these plays accomplish[14]—present a vision of a theater—and a world—informed by what Raymond Williams has called a "new tragic consciousness." This theater represents the position of "all those who, appalled by the present, are for this reason firmly committed to a different future: to the struggle against suffering learned in suffering: a total exposure which is also a total involvement."[15] To fulfill this vision, these dramas recreate worlds past and present in terms of a redefined notion of heritage and inspire our conviction that things could, indeed, be different.

The shift at the end of Shange's *for colored girls,* a movement away from attempts to recover authoritatively key historical moments in the lives of black women, suggests a distinctive and dangerous form for the contemporary black woman playwright's representations of this "new tragic consciousness." In this form of theater, the tragic potential in the double consciousness of black women is represented not to be resolved and unified but to be acknowledged and exploited as a resource for personal and cultural transformation. In reaching for such a theater, Shange has engaged in a process that, in the larger context of the feminist theater of whites and blacks, I have come to call "doing dangerous history." The common, emergent element in these feminist dramas is their insistence on dramatizing historical moments in which dominant concepts of gender are called into question.

The multiple consciousness of the black woman and the polyphony of the plays she has created specify and complicate the threats and the promises of such moments. The "danger" in the history reconstructed in these dramas is located in the absence of solace in the events of history. There is certainly no solace, for example, in Shange's story of Beau Willie and Crystal, whose tragedy is inseparable from America's

engagement in war in Vietnam and the nation's simultaneous disengagement in the civil rights movement at home. Similarly, the celebration of integration that I have remarked in *A Raisin in the Sun* is, at best, a momentary satisfaction. And even a redefinition of black womanhood, such as that explored in Alice Childress' *Wine in the Wilderness,* simultaneously reveals the sordid side of black urban riots and the temptations to which black women have yielded in such historical moments.

In black feminist drama, however, in contrast to the ambience of much white feminist drama, there is pleasure in the theatrical mediations of these threatening events, and there is inspiration in the confrontation with the real dangers that have existed and remain. This seems to me particularly evident in three plays, each of which is ostensibly focused on a single black woman: Adrienne Kennedy's *Owl Answers* (1965), Sonja Sanchez's *Sister Son/ji* (1969), and Ntozake Shange's *boogie woogie landscapes* (1981). In each of these one-act plays, an actress performs a series of transformations onstage before the audience, moving gradually back and forth among various characters, each of whom is a representation of a single woman. The woman in *The Owl Answers* is Clara Passmore and is also (and simultaneously) the Virgin Mary, the Bastard, and the Owl. The illegitimate daughter of a black woman and a white man, Clara grows up to become a teacher in Savannah, Georgia. She has been taught along the way that she is/must be Mary the Virgin and that her true parents are the Owls. Sanchez's Son/ji appears first onstage as an old black woman, seated before her dressing table; during the course of the play she transforms her "self" into a young college student, an adult mother and political activist, a pregnant woman, an aging mother of many, older children, and finally, again, a woman of "all the yrs she has gathered." The many personae of Layla, the "all-american colored girl" in Shange's *boogie woogie landscapes,* are represented by six performers who appear as the woman's "night-life companions" or dream memories. The several voices of each of these dramatic characters are in dialogue not only with each other but with particular moments in history and recurrent events in women's lives. "She who is" (who is Clara) in *The Owl Answers* journeys backwards in history in an attempt to recover the white cultural history of which she has been deprived because she was born to an unwed black mother. "She" speaks from a range of space-time locations—from the mystical context of the Virgin Mary, Chaucer, and Anne Boleyn's fourteenth-century England, early twentieth-century Savannah, contemporary Harlem. No one will hear any of the voices in which "she" speaks, and in her wanderings through the sources of her "self," Clara does not find

the conventional dramatic moment of recognition. She does, however, find more dangerous knowledge to complicate further her understanding of herself. Not unlike Crystal, who could only whisper, Clara, at the end of the drama, can no longer speak in a human voice. Unable to articulate the hybrid sound of virgin and whore, mother and child, black woman and white, "she" speaks in the end as an owl.

Son/ji speaks more specifically from and of contemporary black American history. As a sophisticated, urban college student, she speaks a hip, witty, sometimes romantic language, reaccentuated by a recollected dialogue in which she refuses to make love with her boyfriend because of religious scruples and fear of pregnancy. Transformed into a woman in her twenties during the 1960s, Son/ji's voice is a ventriloquism of the rhetoric of Malcolm X and other male leaders at a Black Power conference. But this voice, too, is dialogized by her pleas to her man to have some time together while their child is asleep and to "be getting ourselves together . . . away from drugs, weed, whiskey and going out on Saturday nites."[16] In her last speech, playwright, actress, and character address the audience in one voice, a perfectly constructed hybridization in which, in Bakhtin's terms, "only one language is actually present in the utterance, but it is rendered in the light of another language."[17] The "present" language of Son/ji at the end of the play is the literary language of white American culture, but the context of the entire play and its context in contemporary black American history animate the voice's challenge to the audience to "pick up the day and shake its tail." Layla, in Shange's *boogie woogie landscapes,* both begins and ends her dialogized "monologue" with challenges to the audience. "Dontcha wanna be music," she asks as she enters her bedroom, home from a night at the disco, and she repeats her question to us an hour later as she returns to sleep after a set of encounters with the stories and voices of her personal and cultural past. Like Son/ji and Clara, and like Crystal and Ruth and Rachel before them, Layla's voices are most diverse and conflicting when they are confronted with the double jeopardy of black motherhood. Layla encounters the world around her always as a black and as a female. In contrast to other representations of black women, however, she first transcends her sense of worthlessness as a black person and, in the strength she derives from that struggle, goes on to focus her attentions on what it means to be a woman.

What that means for Layla is to be drawn, like Rachel, to "the lil black things," to black children. But, unlike Rachel, Layla's response

to the anger and pain of that kind of loving is to rage at men, all men, who have made it impossible for women, black and white, to walk down the street in safety. Layla also gains strength from admitting all of the diverse "night life companions" to her consciousness. She sings the blues, but she also sings rock and roll, and she boogies. She speaks as a colored girl, a neo-afrikan lady, and a black woman and is not destroyed but invigorated by her metamorphoses. Perhaps ironically, she recalls Walt Whitman, rejoicing in containing multitudes. And, as from Whitman's white American voices a vision of a new America emerged, so, in Layla's black, feminist voices, we hear of a new America in which the language of the New York *Times* ("i've never seen the *times* dance"[18]) is replaced by headlines that report the celebration of a successful campaign against illiteracy, the deportation of all men to New Jersey during rape prevention month, and the denial of U.S. entry visas to white South Africans because the latter are war criminals. Nourished by her dialogized imagination, Layla invents new forms of discourse: parades of convicted rapists through Times Square, "person to person/block to block" conveyance of "news," a disco contest on the moon between Brezhnev and Carter, with Afghanistan for the prize.[19]

For Layla, the invention of new forms of language and the embrace of alternatives to the rhetoric of the New York *Times* are the political weapons to change current understandings of the world. She wishes for the ability to say "it wz gd to be born a girl everywhere."[20] It is insufficient, Layla urges, for each generation of women to struggle for it to be all right to be a woman, even if some of us now succeed. Clitoridectomies, antiabortion laws, and infibulation are dangerous words and weapons that must be articulated, acknowledged, and made obscene so that it becomes "gd to be born a girl." Layla uses the stage of her bedroom and Shange the stage of the theater to reanimate the worlds they perceive and to dramatize what it might look like to make new meanings within an understanding that no visions are complete, whole, or correct: "my tongue cluttered with syllables & desire/ even this has not come out straight/ so many days uprooted/ each time i fly i know again."[21]

boogie woogie landscapes, like *Sister Son/ji* and *The Owl Answers*, contributes to the revisions of history that have emerged from the modern women's movement in both written and performed texts. Yet, in contrast to the prevalent emphasis on the recovery of previously unheralded achievements of women, these dangerous history plays take the past as a warning that to transform ideas of gender and of race

requires radical changes in culture and consciousness. Sixty years ago a black woman playwright named Marita Bonner wrote an essay, "On Being Young—A Woman—and Colored," in which she described not only the experience identified in her title but the future as she believed it would be:

> So—being a woman—you can wait.
>
> You must sit quietly without a chirp. Not sodden—and weighted as if your feet were cast in iron of your soul. Not wasting strength in enervating gestures as if two hundred years of bonds and whips had really tricked you into nervous uncertainty.
>
> But quiet; quiet. Like Buddha . . . perhaps Buddha is a woman. . . .
>
> So you too. Still; quiet; with a smile ever so slight, at the eyes, so that Life will flow into and not by you. And you can gather, as it passes, the essences, the overtones, the tints, the shadows; draw understanding to your self.
>
> And then you can, when Time is ripe, swoop to your feet—at your full height—at a single gesture.
>
> Ready to go where?
>
> Why . . . Wherever God motions.[22]

Despite Shange's precise response to Bonner's earlier prophecy, the single gestures of black women sweeping to their feet onstage have been rare and isolated. Perhaps the difficulty is in the increasing knowledge of the complexity of the gesture. For while much feminist drama envisions the future as a new history, black feminist drama specifically recalls "societies that usedta throw us away/or sell us/or play with our vaginas"[23] and calls for a new international cultural history in which being born a girl—as well as growing up to be a woman—is a cause for celebration. Drawing on the broad and complex history of black feminist drama, a history that merits far more detailed telling, these plays have nonetheless begun to reverse the black male image of double voicedness as a prison. The challenge black women playwrights have set themselves is large: to present diverse but consanguine models of polyphonous worlds in which the passionate dancing and chanting of women provide an opportunity to make something happen. Black and white women—as well as black and white men—need many such opportunities.

Notes

1. Angelina Grimke, *Rachel,* in *Black Theater, U.S.A., Forty-Five Plays by Black Americans, 1847–1974,* ed. James V. Hatch with Ted Shine (New York: Free Press, 1974), pp. 137–72. See pp. 137–38 for an introduction to *Rachel,* which includes sources and comments on the play's original context and reception.

2. Ibid., p. 137.

3. Ibid., p. 161.

4. Lorraine Hansberry's *Raisin in the Sun* won the Drama Critics Circle Award for best play of the 1958–59 season, played on Broadway for two years, was subsequently made into a successful film, and later adapted into a Broadway musical. In addition to achieving this wide success in mainstream American culture, the various versions of the play, especially its original Broadway production, provided work and future access to theatrical positions for many black artists.

5. Helene Keyssar, *The Curtain and the Veil: Strategies in Black Drama* (New York: Burt Franklin, 1982). This book includes a chapter devoted to *A Raisin in the Sun* and the issues raised by what I call Hansberry's "ambivalent intentions." See also Helene Keyssar, "Black Drama: Reflections on Class and Class Consciousness," *Prospects, A Journal of American Studies,* no. 3 (1977), and Helene Keyssar, *Feminist Theatre* (London: Macmillan, 1984).

6. See, for example, various remarks criticizing Hansberry's treatment of men and of class conflict in Harold Cruse, *The Crisis of the Negro Intellectual: A Historical Analysis of the Failure of Black Leadership* (New York: Quill Press, 1967).

7. See Eugene Genovese, *Roll, Jordan Roll* (New York: Pantheon, 1974), especially pp. 450–58 and 482–519. See also Herbert G. Gutman, *The Black Family in Slavery and Freedom* (New York: Vintage, 1977); Carol B. Stack, *All Our Kin: Strategies for Survival in a Black Community* (New York: Harper and Row, 1975); and Joyce Ladner, *Tomorrow's Tomorrow: The Black Woman* (Garden City, N.Y.: Anchor Press, 1971). Drawing on a wide range of narrative and quantitative sources from both large plantations and small landholdings and from pre– and post–Civil War contexts throughout the South, Genovese, Gutman, and Stack, as well as other recent researchers, argue against the notions that prevailed until at least the mid-seventies of disorganization in the black family and the weakness of the black father/husband. Much of this earlier argument is established in E. Franklin Frazier, *The Negro in the United States,* rev. ed. (New York: Macmillan, 1964).

8. Arthur Miller, "Tragedy and the Common Man," in *Playwrights on Playwriting,* ed. Toby Cole (New York: Hill and Wang, 1978).

9. Lorraine Hansberry, *A Raisin in the Sun,* in *Black Theatre,* ed. Lindsay Patterson (New York: New American Library, 1971), p. 385.

10. I have discussed this at length in *Feminist Theatre.* I also treat the use of transformational devices and their relationship to ritual and feminist practices in *The Curtain and the Veil* and in "Hauntings: Gender and Drama in Contemporary English Theatre," in *Englisch Amerikanische Studien* 9 (1987).

11. Ntozake Shange, *for colored girls who have considered suicide/ when the rainbow is enuf* (New York: Macmillan, 1975), p. 56. All other citations and references to *for colored girls* are from this edition.

12. Ibid., p. 60.

13. Ibid., pp. 60, 61.

14. See bibliography in Keyssar, *The Curtain and the Veil.* This bibliography also appears as "An Annotated Bibliography of Black Drama with a Critical Introduction," *Bulletin of the New York Public Library* (Spring 1975). Also see, for works by black women playwrights written since 1975, my bibliography of feminist drama in *Feminist Theatre.*

15. Raymond Williams, *Modern Tragedy* (Stanford, Calif.: Stanford University Press, 1966), p. 54.

16. Sonia Sanchez, *Sister Son/ji,* in *New Plays from the Black Theatre,* comp. Ed Bullins (New York: Bantam Books, 1969), pp. 102–3.

17. M. M. Bakhtin, *The Dialogic Imagination,* ed. and trans. M. Holquist and C. Emerson (Austin, Tex.: University of Texas Press, 1981), p. 362.

18. Ntozake Shange, *Three Pieces* (New York: Penguin Books, 1982), p. 125.

19. Ibid., pp. 123–26.

20. Ibid., p. 136.

21. Ibid., p. 141.

22. Cited in Hatch and Shine, *Black Theatre, U.S.A.,* p. 201.

23. Shange, *Three Pieces,* p. 135.

The Art of Tina Howe

Judith E. Barlow

In a recent interview Tina Howe declared: "I have an obsession with art. It runs through all of my plays."[1] Her first two full-length works carry titles—*The Nest* and *Birth and After Birth*—that allude to creativity (nest building and childbearing), while the titles of the next three—*Museum, The Art of Dining,* and *Painting Churches*—are even more obvious in their references.[2] It is certainly not unusual for literary works to be self-reflexive, but the extent to which art and the artist are the subjects of Howe's work is remarkable, and such concerns have grown more central as her career progresses. Moreover, not only are most of Howe's artistic characters women, but she frequently writes about creativity in a particularly female context and using imagery drawn from women's experiences as child bearers and nurturers.

Howe focuses on art and artists, at times actually showing the creative process onstage: Steve Williams rearranging his soft sculpture in *Museum;* Ellen preparing her culinary masterpieces in *The Art of Dining;* Holly Dancer snapping photographs in *Coastal Disturbances;* Mags Church setting up the backdrop, posing her subjects, and wielding her pencil as she works on her parents' portrait in *Painting Churches.* In *Museum* we as the audience watch the characters form an "audience" for the artworks displayed, a sort of play-within-a-play design common in Howe's canon that makes us doubly conscious of the play itself as a work of art.[3] Crossing media boundaries, Howe conceives of her theater pieces as paintings—"an impressionist portrait" or a "Turner seascape."[4] This conception is clearest in her most recent work, *Coastal Disturbances,* less a classically structured play than a series of ten sharply realized paintings or photographs.[5]

Howe is a marvelously perceptive observer of contemporary mores, and much of the pleasure one receives from her plays comes from her

comic skewering of pretentious amateur art critics (*Museum*) and would-be aesthetes ordering wines whose French names they cannot pronounce (*Dining*). Whether she's portraying Paul and Hannah Galt moaning orgasmically over the Yuppie menu of their dreams or Gilda Norris settling in to copy one of Zachery Moe's blank canvases, Howe has a keen eye for what fools art (or what we are told is art) makes of us.

Howe's probing of the ways we "consume" art goes even deeper. For Howe viewers are not—or should not be—passive observers. When she writes that her aim is to have audiences "laughing themselves nearly to death, drenched in tears, rolling in the aisles, ambulances rushing to theatre doors,"[6] it is evident that for her art is not art *unless* it has an impact on the audience. The title of the exhibit in *Museum,* "The Broken Silence," is rife with irony. Painting and sculpture are *supposed* to be mute, and Howe has dubbed museums "temple[s] of silence."[7] Yet the measure of an artwork's greatness is precisely the degree to which it breaks the silence that separates creator and viewer by forging a bond— however fragile and transitory—between the two. Similarly, audiences must accept their role in the interaction among artist, creation, and consumer: the work of art is the product of both the painter who wields the brush and the viewer who sees the canvas through the unique prism of her or his perceptions. Audiences who fail to recognize this are as naive as the anthropologist couple in *Birth and After Birth* who consider themselves observers of foreign cultures but who—bearing cameras, chewing gum, and their own alien presences—alter irrevocably what they claim to be only watching and recording.

Museum, which chronicles the last day of a contemporary art exhibit, offers the greatest variety of ways of appreciating (or failing to appreciate) art; the play follows museum-goers—singly and in groups—as they adore, condemn, copy, mock, and interpret the artworks that evoke in them everything from fear to disdain to sexual pleasure. While Jean-Claude and Françoise recoil in aesthetic horror from Steve Williams' clothesline construction, Blakey moans ecstatically over it. While Bob Lamb dismisses Zachery Moe's white-on-white canvases as derivative, Liz marvels at how brilliantly they express the painter's unique childhood experience. Despite the presence of the guard, the patrons refuse to accept the invisible physical line between themselves and the art. Peter Ziff minutely defaces a painting, Tink Solheim snatches and caresses one of Agnes Vaag's statues, and the clothespins accompanying Steve Williams' clothesline keep disappearing into pockets and handbags.

The title of Howe's next play is *The Art of Dining,* as if consuming—

appreciating art—also required talent: Hannah Galt earns a round of congratulations after successfully negotiating the menu at The Golden Carousel and ordering her dinner. Howe is further concerned to erase the even bigger space that separates audience and play in the theater. Viewers of *Dining* are enveloped in kitchen aromas as dishes are actually cooked onstage, and stage directions for *Museum* instruct that the audience be urged to wander through the exhibit before the performance begins. Howe has said that ideally the set would "be a real art exhibit" in an actual museum: "there'd be this wonderful confusion of people saying, 'Have you gone to the museum to see *Museum*?' "[8]

"In a certain way, *Museum* is a play *about* criticism. Everybody entering the museum had a very strong point of view. I was making fun of that. I think it made the critics feel very self-conscious."[9] Howe's observation encompasses Cal in *The Art of Dining* as well as the characters in *Museum*. Cal and his wife, Ellen, are co-owners of The Golden Carousel, a recently opened gem of a gourmet restaurant in New Jersey. On one level Cal is simply a jealous husband frustrating his wife's attempt to express her creativity: chef Ellen grows more and more infuriated as all her lovingly gathered and prepared ingredients—hollandaise sauce, grapes, floating island—disappear down his gullet. Cal also represents the business side of the restaurant, as always anathema to the forces of artistic integrity. While Ellen struggles to feed the guests, Cal talks wildly of expanding the operation and books tables for ever-growing numbers of diners.

In still another light Cal is a savagely funny portrait of a critic. The artist, Ellen, is uncertain of her abilities and craves the reassurance and assistance of a sensitive audience. In an ideal relationship (which apparently they once had) artist and critic—artist and audience—have a mutually beneficial connection. Now, however, Cal has literally lost his taste; no longer able to distinguish cinnamon from salt, he consumes huge quantities and appreciates nothing.

Howe's ambivalent picture of Cal, who compulsively consumes Ellen's creations, indicates her awareness that although art cannot exist without an audience, art can also be destroyed by that very audience. In *Birth and After Birth,* a family play centering around a birthday celebration for a hyperactive four-year-old, young Nicky manages to dismantle his mother's carefully wrought party decorations in a matter of moments. Still, he is no match for Howe's far more devastating adult "deconstructionists." The notion of the destruction of art is almost a frame for *Museum:* the play opens as *"a voice sounding something like a combination of God and a newscaster"*[10] announces that a gunman

has shot at and destroyed Botticelli's famous *Birth of Venus.* Near the end of the play, balancing the ominous opening, is the dismantling of Steve Williams' clothesline: *"The bride's arm is pulled off with an awful rending sound,* . . . *the businessman's legs are severed;* . . . *the clothesline is almost picked clean. Only a few stray torsos, heads, and veils are left"* (p. 67).

And yet, ironically, the massacre of Williams' cloth figures is an act of tribute. The stage directions insist that the scene is *"not a mad scramble, but a communion, enacted with quiet reverence"* (p. 67). Julie Jenkins and Gilda Norris—photographer and sketcher, respectively— embrace the stuffed effigy of the artist and seem surprised when the figure begins to come apart, amazed that their ardor has destructive consequences. In this synthesis of an artist's greatest dream and greatest nightmare, Howe erases the line between adoration and demolition.

The destruction in *Painting Churches* takes another form when Mags recounts her childhood creation of a massive crayon mountain, her first work of art. In an act that in memory seems so violent Mags cannot even trust her own recollection ("where would you have ever gotten a blow torch?"), her mother, Fanny, flamed the creation into oblivion (p. 195). This is the beginning of a series of destructions: Fanny's attempt to disrupt Mag's first group show by disparaging the veracity of a portrait, her unsubtle put-downs of her daughter's career as a teacher in "that wretched art school" (p. 171). Wife of a prizewinning poet and mother of a professional painter, Fanny harbors the nonartist's jealousy of the successful creator. There is something both ludicrous and sad in Fanny's amateur masterpiece, a picture of Venice pasted to a lampshade, the bulb shining through pinpricks and cutout windows. Is it surprising that she chooses lampshades when her daughter is known for her splendid handling of light?

Perhaps cooking is the ultimate art, for the chef's creations are *meant* to be destroyed, must be consumed to be appreciated. Only in the consuming does food have value—a notion that obviously appeals to Howe a great deal. Yet there is a difference between savoring and destroying, as Ellen in *The Art of Dining* discovers when her culinary masterpieces are devoured prematurely by her unappreciative husband. Poor Lo, the amateur chef in *The Nest,* finds the monumental cake she has baked first mutilated by her roommates and guests, then unceremoniously shoved out a window—surely an inappropriate end for a pastry. Far happier is the fate of the crepes Ellen makes at the end of *Dining,* oversized wafers in a communion celebrated by chef and patrons together.

As this "communion" suggests, if Howe is turning a satiric eye on the

consumers of art, she is looking as well at those who create it. Despite the destruction wreaked by husbands and friends, audiences and critics, the artists persevere. What is the motivation behind the urge to create? What do these artists want?

The Nest, Howe's first produced full-length play, offers us one of the simplest answers. The vastly overweight Lo imagines that her cooking will win her admirers and friends. Afraid that her looks will never attract the man of her dreams, she hopes that her kitchen skills will, and she regales her roommates with a dramatic recitation of the goodies she has prepared for their male guests—a slightly off-key menu ranging from "artichoke hearts marinated in garlic butter" to fried rice to hot cross buns.[11] Similarly, Mags Church in *Painting Churches* reveals that she likes to paint portraits because she feels safe: the subject is revealed while the artist remains anonymous. Both women seek to hide behind their art, to gain through it the approval they themselves have been denied. Holly Dancer in *Coastal Disturbances* uses her art for protection even though she herself is an object of admiration. As the ardent lifeguard Leo pursues her around the stage declaring his passion, she resolutely keeps her camera between them, snapping away.

What both Lo and Mags learn, however, in very different ways, is that one cannot hide behind a work of art: indeed, the art is so close to the creator that the two are virtually identical—a sometimes dangerous situation. Dressed in her white gown, Lo "looks exactly like her cake" (pp. 3–16), and when her confection is pushed out the window, she makes a suicidal attempt to follow it. In *Birth* Sandy Apple winds up sharing a toy wagon with the gifts she has painstakingly wrapped— my "Mommy present" Nicky calls her[12]—while *Museum*'s Steve Williams includes a self-portrait on his clothesline. As Fanny tells her daughter, Mags must "see" her parents before she can paint them, and her painting will reveal just how much *she* has or has not succeeded in viewing them honestly. Holly Dancer is the one who states Howe's point most clearly. Revealing that she has lately been the subject of her own photography, Holly explains: "Sooner or later anyone who's into nudes ends up doing themselves."[13]

The creation of art is also an attempt to fulfill primal needs—needs as deep, Howe suggests, as hunger, sexual desire, and the urge to procreate. Ellen seems happy only when she is either cooking or—as at the beginning of *Dining*—enjoying the literal fruits of her labor. A horrified Tink Solheim recalls accompanying sculptor Agnes Vaag on an expedition to gather materials and discovering her artist friend "licking" the small carcasses—a disquieting image that recalls a mother animal clean-

ing her babies. Howe has said that Tink's speech "is really about the
artist's descent into his work. Museums are such temples of beauty I
felt it was important to show the anguish an artist goes through in
order to create."[14] Mags Church speaks of a deep *hunger* she had—a
hunger that, even when she was nine years old, could not be sated by
her mother's cooking, only by creation with her "own materials"
(p. 195).

For Howe, as for Freud, the roots of art reach to the deepest recesses
of human nature, and often to the savagery underneath the civilized
veneer. In *Museum* the catalogue photograph of Zachery Moe appears
to be that of a chimpanzee, *"une bête sauvage"* (p. 18). Agnes Vaag's
works are described as "menacing constructions made of animal teeth,
feathers," and other organic detritus (p. 10). While she cooks, Ellen
"dances around the pot, grunting and whipping her sauce" as if per-
forming some primal rite (p. 130). Although at one point she speaks
lovingly to the fish she is preparing, the scene ends as she ominously
sharpens her knife. There is an uncomfortable yoking in Mags' claim
that her parents promised: "You can paint us, you can dip us in con-
crete, you can do anything you want with us, just so long as you help
us get out of here!" (p. 168). Not surprisingly, Howe's most recent artist
figure—Holly Dancer in *Coastal Disturbances*—wants her work to re-
flect its visceral origins. She sees X rays as the logical "next step beyond
nudes," and hopes to use them to produce a "night blooming garden of
forbidden delights" (p. 75).[15]

At the same time that art grows out of the mysterious and nonrational
impulses in us all, art is also an attempt to counterbalance, mask, at the
very least protect us from those same impulses. Put another way, art is
both an outgrowth of the savagery that civilization is designed to deny
and a part of that very denial: like civilization, art is a means of giving
order to the chaotic. In *Painting Churches,* for example, Mags reveals
that she began forming her food into neat curlicues—the first step in her
journey toward portrait painting—because she was afraid of making a
mess at the table. Agnes Vaag takes scattered natural objects and forms
them into artificial, coherent constructions.

Howe's characters desperately invoke rituals—often in the form of
art—to protect themselves from the uncertainty and terror that lie at
the heart of existence. As Mircea Eliade has observed, the rituals of
primitive peoples function to wipe out time, to deny history, change, and
death in a repetition of a primordial action. Even for more "sophisti-
cated" societies, anniversaries, birthdays, and New Year's celebrations
perform similar functions: a temporary annihilation of the passage of

time, a brief return to the original moment being reenacted. Nicky's birthday party in *Birth* is an attempt to impose order on a family whose mother is physically disintegrating, whose son is repeatedly described as an animal, and whose father tries to escape the strictures of corporate life by riding naked in elevators. At the close of the play Sandy invokes her son's birth in a line that is poignant in its mixture of truth and wish: "Four years ago today, Nicky, you made us the happiest family in the world!" (p. 187). The conclusion of *Coastal Disturbances* finds M. J. and Hamilton Adams celebrating their anniversary as they always have, with a twilight picnic on the beach. In the ritual toast of champagne, the pair forget at least momentarily the betrayals and disappointments that have intervened in the decades since their wedding.

Eliade makes explicit the connection between ritual and art when he notes that primitive societies' "annual expulsion of sins, diseases, and demons is basically an attempt to restore—if only momentarily—mythical and primordial time, 'pure' time, the time of the 'instant' of the Creation. Every New Year is a resumption of time from the beginning, that is, a repetition of the cosmogony."[16] Howe deliberately reminds us of the connection between the Creator and the creator when she begins *Museum* with the announcement of the shooting of Botticelli's *Birth of Venus*. Shouting "Cursed is the ground for thy sake," the gunman confuses not only Venus with Eve but the image with the (real or mythic) original. Implicit in this confusion is the identification of the artist, Botticelli, with God.[17]

There is little doubt that art serves a redemptive function in Howe's world, even if the redemption is transitory. At the end of several of her plays, there are moments when art transports the characters beyond the fears and longings that mark and mar their lives. Not surprisingly, *Museum*—Howe's most loosely structured work—has a trio of epiphanies, one for each of the artists represented in the "Broken Silence" exhibition. At the play's conclusion, the dismantling of Williams' clothesline construction—a sort of mock human sacrifice—is balanced by Zachery Moe's deaf-mute parents ecstatically if silently rejoicing over their son's accomplishments. Several minutes earlier, perhaps the most stunning dramatic climax occurs when Tink Solheim finds the magic switch that causes a Bach toccata to pour from the base of Agnes Vaag's statue *The Holy Wars of Babylon Rage through the Night*. The religious nature of the moment is emphasized, indeed comically overemphasized, by the absurd title of the work, the stage direction that indicates everyone *"Slowly draws near the statue to worship,"* and Gilda Norris' recitation of the Gospel According to St. Luke (p. 59).

Equally striking—and more sustained—is the tableau that ends *Dining:* the restaurant customers gathered communally around the house special, flaming crepes, created and presided over by the female chef. Anguish about body size and food terrors disappear as everyone digs in and Elizabeth Barrow Colt, able to eat for the first time all evening, invokes memories of a primitive "shared . . . feast." The closing stage direction notes: *"Purified of their collective civilization and private grief, they feast"* (p. 150). This is, of course, not a permanent escape from fears of flab and failure, but art can protect us temporarily from the ravages of cold, time, and each other. The salvation, like the communion crepes, is wondrous but ephemeral.

Mags Church wants to freeze her parents on canvas, to halt for a moment their slide into an old age that renders her poet father unable to control his own body, much less words on a page. Her desperation is heightened because the painting must be completed before the house (and the familial rituals it echoes) is turned over to strangers. At the conclusion of *Painting Churches,* Fanny and Gardner finally see, and praise, Mags' portrait of them. As the curtain falls they dance to a Chopin waltz, imitating figures in a favorite painting, while Mags *"watches them, moved to tears"* and a car horn announces their imminent departure from the family home (p. 221). What Howe has said of this scene could, with slight revision, be applied to the endings of several other of her plays as well: "It's a great victory for Mags. I think it's one of those transcendent moments. It's as if they're stopping time. They're caught there. That's what a great painting does. It stops the flow. It pins you there. They got so caught up in the painting that time stopped, the decay stopped, and they became timeless."[18] She adds: "It lasts for one heartbeat, and then is gone. We all know it's a purely theatrical moment, which is why it's so precious."[19]

In her reference to theatricality, Howe brings us full circle: Mags Church's painting, which the audience never sees, is a metaphor for Howe's play, the portrait transformed into the tableau of characters onstage. In the neat collapse of art as subject into art as form, Howe draws the audience into the play at the same time she inexorably reminds us of the difference between the chaotic world in which we live and the world crafted by the dramatist.

Tina Howe has commented, "I write about women because that's what I know best."[20] A simple count of her plays would reveal a substantially greater number of female than male characters, but more important is the fact that the women are consistently the most interesting figures in

the works. Many are not simply artists, they are young artists beginning careers: Mags is about to have her first solo show, Ellen has opened her first restaurant, and Elizabeth Barrow Colt's forthcoming book seems to be her first publication. Agnes Vaag, more than a decade younger than the men with whom she shares the art show in *Painting Churches,* is still in her early twenties,[21] and Holly Dancer, Howe's most recent creation, is hoping that Andre Sor will mount what would apparently be her first major photography exhibit.

Some of the younger male characters in Howe's plays aspire to be artists, but talent seems to reside primarily in the female half of the Howe universe. Indeed, the male characters are often attracted to the women because of their talent, yet at the same time are jealous of their gifts. Cal obviously feels overshadowed by Ellen's culinary expertise in *Dining,* and both young men in *Coastal Disturbances* are drawn to Holly in part because of her creativity. On the comic (and grotesque) side is Leo's confession of his adolescent crush on an organist whose musical ability was enhanced by several extra fingers. More serious is Andre Sor's claim that he is attracted to Holly not only because she is beautiful but because she has the talent, "the transforming eye of the artist," that he has failed to inherit from his father (p. 80). What is true in *Painting Churches* seems true throughout Howe's canon: the mantle of Gardner Church is being passed on to a generation of women.

Four of Howe's plays have at their heart a speech that is essentially a dramatic monologue, a long and invariably horrifying seriocomic tale.[22] Each of these stories is told by a woman, each is about a woman, and each is related to the issue of female creativity. It is through these speeches that we begin to see the playwright's vision of what it means to be a woman artist, what it means to be a woman denied an outlet for her creativity, and the relationship between what is commonly thought of as "art" and women's other creative activities.

In *The Art of Dining,* Elizabeth Barrow Colt tells a two-part dinner-table story guaranteed to destroy appetites, a story about her mother. Angry at having to invent meals that her husband wolfs unthinkingly and her daughter spits into napkins, Elizabeth's mother turns suicidal, slicing herself into the dinners in a nightly bloodletting. On the one hand, the mother's attempt to barbecue herself in the oven—"I BET I WOULD HAVE TASTED DAMNED GOOD," she declares (p. 141)— may be just one more instance of creator-creation confusion, the artist's failure to distance herself from her work. But it is also the ultimate homemaker's nightmare—the hellish vision of any woman who has had to cook three meals a day for an unappreciative family. For Elizabeth's

mother cooking is a required chore, not a chosen vocation. The only "art" at which the mother becomes accomplished is self-destruction, and she is not even wholly successful there: her hat sizzles into oblivion, but she survives.

The narrator of this story is Elizabeth, herself an artist and heir of this mother. Whether from nauseating remembrances of childhood meals or a related fear of ever getting caught in the domestic cycle that trapped her mother, Elizabeth shuns food entirely. Her eating problems seem to run even deeper and to find a direct parallel in her art: she writes short stories just as she can be coaxed to take only small bites of dinner, as if a full-length novel, like a full-sized body, would occupy too much space. Howe concedes that eating is "a dangerous area" for her, and a whole treatise could be written on the role of food in her plays.[23] Moreover, the problems of Elizabeth and her mother, as well as Howe's comment, can be put in a larger context: how could eating not be a "dangerous" area for women when the first sin of which we stand accused in the Judeo-Christian tradition is biting into an apple?

Although Elizabeth narrates the tale, the audience is forced to make implicit comparisons between Elizabeth's mother and the central artist in *Dining*—Ellen. Both women preside over kitchens, both prepare food others will consume. The crucial difference, of course, is that Ellen is a chef who has *chosen* her métier—bass and duck are her preferred materials—and she receives the respect (and the financial rewards) accorded an artist. Elizabeth and Ellen almost meet when a disoriented Elizabeth wanders into the darkened kitchen in search of, appropriately, the ladies' room. The two finally come together when Ellen emerges from obscurity to preside over the flaming crepes. Elizabeth herself offers the benediction for this meal—this shared feast—and for the first time all evening she eats. The food that Elizabeth could not take from the hands of her tormented mother, a woman forced into a role she did not want, she willingly takes from a young woman artist who, like herself, has selected her own path.

In *Painting Churches* Mags recalls being banished from the family table for playing with her food. Unable to swallow what her mother cooked, Mags "satisfied" her hunger with crayons, creating a wax masterpiece that she describes in glowing culinary terms: "YELLOW: lemon curls dipped in sugar . . . RED: glazed cherries laced with rum" (p. 194). Fanny, brought up in a traditional world where women's only medium is food, believes that her daughter's monument is created out of uneaten dinners. Mags, however, knows better. Having rejected

her mother's conventional creative arena—the kitchen—Mags, like Elizabeth, "found [her] own materials" (p. 195).

Seemingly unrelated to these stories is Mia's account in *Birth and After Birth* of the Whan See parturition ritual that results in the baby's death and the mother's suicide. And yet, birth may well be Howe's model for all creative processes. At the very least, there are similarities between the birth experience recounted here and the artistic process presented throughout her plays. The child is produced in both pain and joy; there is pride in being a Whan See mother, for among their babies—as among artists' works—"only the strongest survive" (p. 166). The identification between creation and creator is tragically evident: just as Lo tries to follow her destroyed cake out the window, the Whan See mother identifies so closely with her offspring that she envisions her own death as the necessary response to the loss of her creation. Giving birth for the Whan See is at once a primitive experience—a natural action dangerous to both mother and child—and a communal ritual prescribed and witnessed by the whole clan. And the creation, the baby, is at the mercy of the "audience"; Mia believes she is to be only a witness, but finds herself deeply involved in the birth and destruction of the child.

Perhaps the richest of the Howe "arias" is Tink Solheim's story of her journey with Agnes Vaag to gather material for Vaag's sculptures. Tink concedes that the whole expedition confused her; so used to seeing Agnes with her hands full of carcasses and feathers, she "just assumed she always *had* these things, that they were part of her, not something separate she had to seek out" (p. 49). Regardless of whether Tink's story is "true," it, like the others, is not simply about art but is itself art: a deeply disquieting narrative with the foreboding, unreal quality of a fairy tale or (one hesitates to say it) a creation myth. The hunting is done in the dark woods, and the sounds that Tink hears are revealing: "slurping . . . licking . . . nibbling . . . kissing"—the primal sounds of eating, of sex, of a mother washing her newborn young. A stunning woman by day but an ominous hag by night, Agnes stands revealed in the light of the moon, traditional symbol of femininity and imagination. At once a mysterious being who creates beauty out of bones and a comic character who lugs blue suitcases through state parks, Tink's Agnes may very well be Tina Howe's archetypal artist.[24]

Notes

In the preparation of this essay, I am grateful to Roni Ginsberg and Richard Goldman for their helpful suggestions.

1. Kathleen Betsko and Rachel Koenig, "Tina Howe," in *Interviews with Contemporary Women Playwrights* (New York: Beech Tree/Morrow, 1987), p. 230. Howe also begins her essay "Stepping through the Frame" (*Art & Antiques* [January 1987], 89) with the comment "all my plays are about art"—the same statement Mimi Leahey quotes in her article, "Tina Howe: Writing a Totally WASP Play," *Other Stages,* January 27, 1983, p. 3.

2. *The Nest* may be considered Howe's first full-length play if we exclude a very early work that she says is "still in a dark drawer somewhere." Quoted in Preface to Howe's *Birth and After Birth,* in *The New Women's Theatre,* ed. Honor Moore (New York: Vintage, 1977), p. 101.

3. Howe says of *Museum,* "I've always conceived of the play as a work of art." Betsko and Koenig, *Interviews,* p. 229.

4. In "Stepping through the Frame," p. 90, Howe writes: "My last play was a muted impressionist portrait. It's time to tackle a Turner seascape complete with crashing waves and drop-dead sunsets." Although this article was published shortly *after* the opening of *Coastal Disturbances,* presumably *Painting Churches* is the "impressionist portrait" while *Coastal Disturbances* is the "Turner seascape."

5. The original Second Stage production—set on a small proscenium stage—conveyed the sense of snapshots or paintings better than did the subsequent production on the more open Circle in the Square playing area.

6. Quoted by Moore, *The New Women's Theatre,* p. 101.

7. Betsko and Koenig, *Interviews,* p. 225.

8. Ibid., p. 229.

9. Ibid., p. 230.

10. Tina Howe, *Museum* (1976), in *Three Plays by Tina Howe* (New York: Avon, 1984), p. 13. This volume also includes *The Art of Dining* (1979) and *Painting Churches* (1983). All future references to these plays are to this edition and will be given in the body of the text. Howe herself notes that the "rising menace" in *Museum* is the "hinge"—the structuring principle—of the play. See Betsko and Koenig, *Interviews,* p. 230.

11. Tina Howe, "The Nest," 1969. Unpublished manuscript, pp. 1–12 to 1–14.

12. Howe, *Birth and After Birth,* p. 106. All future references to *Birth and After Birth* are to this edition and will be given in the body of the text.

13. Tina Howe, *Coastal Disturbances* (New York: Samuel French, 1987), p. 23. All future references to *Coastal Disturbances* are to this edition and will be given in the body of the text.

14. Betsko and Koenig, *Interviews,* p. 229.

15. See Howe's foreword to *Three Plays*, where she wonders whether her next step might be a metaphorical exploration of "a whole new intestinal landscape" (p. viii).

16. Mircea Eliade, *Cosmos and History: The Myth of the Eternal Return*, trans. Willard R. Trask (New York: Harper & Row, 1959), p. 54.

17. In the Bible, God hurls this anathema at Adam, not Eve. Presumably, the gunman is either confused or is "correcting" God by placing the blame where he believes it belongs.

18. Quoted in Michael Brenson, "Art Given a Role in Tina Howe's Play," New York *Times*, February 18, 1983, p. C3.

19. Betsko and Koenig, *Interviews*, p. 232.

20. Betsko and Koenig, *Interviews*, p. 231. Throughout this interview Howe makes several interesting observations about her feelings toward men and women. She notes, "I've always preferred men to women because my father was very gentle and mild" (p. 227). Later she adds that she finds women "really awesome." "I think that's partly why I write female characters," she concludes, "they are capable of tremendous passion" (p. 235). See also Leslie Bennetts, "Tina Howe Writes a Love Story Set on a Beach," New York *Times*, November 16, 1986, sec. 2, p. 3. In this interview Howe says that she intended *Coastal Disturbances* to redress what she considers the negative way "men are perceived onstage these days in American theater." She readily acknowledges, however, that the play is written "from a woman's point of view."

21. Howe specifies in *Three Plays* that "as the years pass, the dates of the artists' births should be moved ahead to keep them suitably young." Howe has already done such updating; the version of *Museum* published in 1984 gives Vaag's birth year as 1960. The Samuel French edition, published in 1979, gives her birth year as 1954.

22. *Coastal Disturbances* contains a speech that is in several ways similar to those discussed here. Andre Sor recounts how his father, a Jewish diamond cutter who fled the Nazis, was forced to work as a handyman to support his family in America. He turned his creative talents to making magical clocks out of trash, his masterpiece an animated skyline clock that was so enchanting it helped his young daughter survive a serious illness. The story is, as Sor says, about "the transforming eye of the artist," and it is both poignant and imaginative. Still, the tale lacks the grotesque and pathetic elements that are such a wonderful counterpoint to the humor of Howe's best set pieces. The story's power is also diminished by the fact that Andre as a character is little more than a cliché—the urbane Jewish art promoter. Even Mia Freed and Tink Solheim, the least fully drawn of the women "speakers," are more freshly envisioned figures.

23. Quoted in Leahey, "Tina Howe," p. 3. See also Betsko and Koenig, *Interviews*, pp. 230–31, for Howe's comments about her attitudes toward food and eating.

Bibliography

Bennetts, Leslie. "Tina Howe Writes a Love Story Set on a Beach." New York *Times,* November 16, 1986, sec. 2, pp. 2, 18.

Betsko, Kathleen, and Rachel Koenig. *Interviews with Contemporary Women Playwrights.* New York: Beech Tree/Morrow, 1987.

Brenson, Michael. "Art Given a Role in Tina Howe's Play." New York *Times,* February 18, 1983, p. C3.

Brown, Janet. *Feminist Drama: Definition and Critical Analysis.* Metuchen, N.J.: Scarecrow, 1979.

Coven, Brenda. *American Women Dramatists of the Twentieth Century: A Bibliography.* Metuchen, N.J.: Scarecrow, 1982.

Eliade, Mircea. *Cosmos and History: The Myth of the Eternal Return.* Translated by Willard R. Trask. New York: Harper & Row, 1959.

Howe, Tina. *Birth and After Birth.* In *The New Women's Theatre,* edited by Honor Moore. New York: Vintage, 1977.

————. *Coastal Disturbances.* New York: Samuel French, 1987.

————. *Museum.* New York: Samuel French, 1979.

————. "The Nest." Unpublished manuscript, 1969.

————. "Stepping through the Frame." *Art & Antiques* (January 1987), 89–90.

————. *Three Plays by Tina Howe.* New York: Avon, 1984. (Includes *Museum, The Art of Dining,* and *Painting Churches.*)

Leahey, Mimi. "Tina Howe: Writing a Totally WASP Play." *Other Stages,* January 27, 1983, p. 3.

May, Hal, ed. *Contemporary Authors.* Vol. 109. Detroit: Gale Research, 1983, p. 212.

Simon, John. "Theater: The Powers that Will Be." *New York* magazine, December 22–29, 1986, pp. 96–97.

The Way Out, the Way In: Paths to Self in the Plays of Marsha Norman

Leslie Kane

. . . to have a self, to be a self, is the greatest concession made to man, but at the same time, it is eternity's demand upon him.

<div align="right">SOREN KIERKEGAARD[1]</div>

As a writer, you go in to the theatre to *search,* and if you do your work you find something. Or at least you identify the path.

<div align="right">MARSHA NORMAN, interviewed by Sherilyn Beard</div>

A playwright of power and perception, Marsha Norman dramatizes the personal crises of ordinary people struggling to have a self and be a self. "What interests me is survival," says Norman, "what it takes to survive. I find people very compelling who are at that moment of choice. Will they die or go on? If they go on, in what direction or for what purpose?" (Beard, p. 17). With honesty and compassion, Norman places her characters in critical situations where they are forced to make this decision. Be it a convicted murderer in *Getting Out* or a cancer surgeon in *Traveler in the Dark,* her characters are compelling, her focus on survival unwavering. The subject of survival and the serious-ness, sensitivity, and eloquence of its presentation have prompted critics in America and abroad to draw parallels between this contemporary American playwright and Samuel Beckett. Certainly, her focus on helplessness, autonomy, and isolation, as well as the predominance of waiting and the simplicity of dialogue, setting, and structure, may re-mind us of the great Irish writer. Images of entrapment and sickness, the use of couples, humor—however bleak—to undercut and under-

<div align="center">255</div>

score pain are additional qualities we have come to associate with Beckett's work.

Tom Moore, the director of *'night Mother* and *Traveler in the Dark,* sees her greatest affinity, however, to Chekhov, and this analogy can certainly be supported by the realistic detail, progression in time, use of confessions, sonatalike structure, and the awareness of the pain of solitude apparent even in Norman's one-act plays (Moore, p. 2). And comparisons can be drawn between Harold Pinter's and Norman's uses of intrusion, memory, betrayal, and the unreliability of truth. Norman, like Pinter, employs two silences: one silence is the absence of speech with which we are familiar, while the other, a torrent of speech, is a desperate attempt to "keep ourselves to ourselves" (Pinter, p. 25).

Parallels also abound between Norman and Sam Shepard, especially in the raunchiness and explosiveness of dialogue, the sense of the dramatic, the desire to say the unsayable, the portrayal of ambivalent familial relationships, and the use of familiar household items for symbol and stage business. Ironically, the titles of Shepard's plays might well be those of Norman's: *Buried Child, Curse of the Starving Class, A Lie of the Mind.* And one can identify analogues in the plays of Lanford Wilson, whose *Mound Builders, 5th of July, Hot'l Baltimore,* and *Serenading Louie* portray ruined expectations, failed relationships, the impact of the past on the present, and the difficulty, if not impossibility, of communicating our deepest fears.

But none of these men focuses as sharply as Norman does on mothering nor offers as many portraits of mother and child. Although Norman does not want her drama labeled "women's theater," Mel Gussow correctly observes that a primary theme of Norman's work, obvious in the title of her first play *Getting Out,* is the struggle of leave-taking, the severing of blood ties, marriage, and the past (p. 25). "There comes a moment," explains the playwright, "when we have to release our parents from our expectations." The ties that bind, stifle, and suffocate are many. From Norman's perspective "one of the problems for daughters and sons is that you come into life with an unpayable debt, the mortgage of all time" (Gussow, p. 39).

Such an emotionally charged comment invites questions about Norman's relationship with her own mother. While silent on that subject, the playwright speaks freely about growing up in a world of isolation and enforced good cheer. She was not permitted to play with other children nor watch television for fear that these influences might corrupt her. Recalling her disciplined fundamentalist Christian upbringing, Norman remembers: "My mother had a very serious code about what

you could and could not say. You particularly could not say anything that was in the least angry or that had any conflict in it at all" (Stone, p. 57). Beyond her mother's hearing, however, the future playwright would say: "I'd like to say this." In her work Norman powerfully and profoundly dramatizes "conversations people have, or would like to have, but don't for fear of what would happen if they did" (Brustein interview, pp. 1, 4). *Getting Out, Third and Oak: The Laundromat, 'night Mother,* and *Traveler in the Dark* reflect Norman's continuing concern with mother-child relationships, autonomy, and paths to self. Examined chronologically, these four plays manifest an impressive development of thought and technique.

Pressed by interviewers for influences on her drama, Norman cites several: her oppressive childhood, the plays of Sophocles, Plato's allegory of the cave, and her southern heritage. But Norman is the first to acknowledge that she had no intention of becoming a playwright, having neither role model nor encouragement. She attended a conservative Presbyterian school for women, Agnes Scott College, on a scholarship, majoring in philosophy, still one of her primary interests. While an undergraduate she worked as a volunteer in the pediatric burn unit of Grady Memorial Hospital in Atlanta, the first of several intimate exposures to life-and-death situations. Returning to Louisville after graduation, Norman worked with severely disturbed children at Central State Hospital. Both experiences deepened a sensitivity to pain already evident in the high school student who won her first literary prize for an essay entitled "Why Good Men Suffer." Norman began her playwriting career in 1976 when she was commissioned by Jon Jory, producing director of the Actors Theatre of Louisville, to write a play for the theater's festival of new plays. *Getting Out,* a hard-hitting, shocking drama about a convicted murderer, was a huge success. Subsequently produced at the Mark Taper Forum in Los Angeles and the Theatre de Lys in New York (where it ran for 237 performances), *Getting Out* was cited by the American Theatre Critics Association as an outstanding new play, won the George Oppenheimer Award, and earned the playwright the Outer Critics' Award for the best new playwright.

The central figure of *Getting Out* is in fact two characters: Arlene, a newly rehabilitated born-again Christian, and Arlie, her "unpredictable and incorrigible" younger self (p. 6). Largely based upon a severely disturbed girl at Central State Hospital, one the playwright remembers as "a kid who was so violent and vicious that people would get bruises when she walked in a room," Arlie is Arlene's memory of herself (Gussow, p. 34). So out of touch are Arlie/Arlene that they appear to be dif-

ferent people. *Getting Out* gains intensity from a confined setting, a cell-like one-room apartment with bars on the windows, in which Arlene's emotional and physical entrapment are reflected through volatile conversations with her mother, her former pimp, Carl, a retired prison guard, Bennie, and Arlie—all of whom want something from her. The authenticity of the dialogue and the broad range of emotions add credibility to Arlene's struggle to be free of her prison walls and her past.

Destructive by nature, Arlie has been known to pee in her mother's shoes, make bologna and toothpaste sandwiches for her father, and fling a neighbor's pet frogs into the street just to see them go "SPLAT." Relating this memorable event, Arlie recalls:

> Some of em hit cars goin by but most of em jus got squashed, you know, runned over? It was great, seein how far we could throw em, over back of our backs an under our legs an God, it was really fun watchin em fly through the air . . . all over somebody's car window or somethin. . . . I never had so much fun in my whole life. (p. 10)

Much of Arlie's life has been spent in reform and correctional institutions—Lakewood State Prison for forgery and prostitution and Pine Ridge Correctional Institute for the second-degree murder of a cab-driver in conjunction with a filling-station robbery. Her years of imprisonment have made her suspicious and guarded; her first hours of freedom are both tentative and terrifying, hopeful and disheartening. For Norman the issues of past, future, helplessness, and control are inextricably linked to how a person perceives herself. The relationship between mother and daughter is crucial and "predictive of how that daughter will experience herself, not only in relationship to her mother, but in relationship to the world" (Stone, p. 59). At the basis of that relationship is betrayal. Mothers in Norman's early plays provide neither protection nor guidance; they do not nourish with food or love. As early as her first play, *Getting Out,* the mother figure is an archetypal "bad" mother, cold and rejecting. On the day that Arlene is released from prison, her mother comes ostensibly to welcome her home—there has been no communication for eight years—but Arlene's attempts at reunion and reconciliation are rebuffed:

ARLENE: I didn't know if you'd come.
MOTHER: Ain't I always?
ARLENE: How are you? (*Moves as if to hug her.*
 Mother stands still, Arlene backs off.)
MOTHER: Bout the same. (*Walking into room.*)
ARLENE: I'm glad to see you. (p. 18)

Neither looking at Arlene nor responding to her comment, the mother dispassionately replies, "You look tired." Arlene has no doubt about her rejection.

While her mother appears generous by bringing Arlene colored towels, a teapot, and a bedspread to make the apartment more homey, her superficial warmth cools when the conversation turns to Joey, the son Arlene had to surrender while in prison. Anxious for news of him, Arlene is angry and hurt to learn that her mother has treated her young son as she has treated Arlene, with coldness and contempt. In retaliation for Arlene's criticism of her, Mother viciously attacks Arlene where she is most vulnerable: her appearance, her character, and her competence as a mother. Maliciously squashing Arlene's dream of having Joey live with her—as Arlie maliciously squashed the frogs—Mother wins this round of their ongoing battle with a spiteful quip: "Fat chance" (p. 21).

They join in making the bed, but the uneasy peace between them does not last for long. While energetically scrubbing the filthy apartment, Mother renews her attack. Hardened to her mother's criticism and desperately in need of her mother's kindness, Arlene does not rise to the challenge. Instead, she asks tentatively, "Maybe I could come out on Sunday for . . . you still make pot roast?" In the moment that it takes us to realize that an invitation home has not been forthcoming and that Arlene cannot even articulate and complete the request, Mother's curt response unequivocally communicates the rejection: "Sunday . . . is my day to clean house now" (p. 25). In that one word *now* Norman conveys how much the world has changed in Arlene's absence. Toting her cleaning agents, bug spray, and linens and scrubbing with great vigor, Mother metaphorically implies her desires to sanitize Arlene. But Arlie/Arlene is soiled beyond any whitewashing; certainly, she is not suitable to bring home while there are two children there she might contaminate.

Conflicting emotions of caring and betrayal erupt with Mother's discovery of Bennie's hat hidden under the bed. Screaming that she should not have come and that Arlene has not changed from the filthy "whore" she was, Mother furiously strips her bedspread from the bed, stuffs it into her basket, and heads for the door. Years of their relationship are telescoped in this moment. "Don't you touch me," hisses Mother as Arlene struggles with the murderous Arlie within: "No! Don't you touch Mama, Arlie. . . . No, don't touch Mama, Arlie. Cause you might slit Mama's throat" (p. 30–31). Clearly, Arlene's ambivalent feelings for her mother do not stem from tonight's encounter but from years of betrayals and rejections, not the least of which is Mother's lack of inter-

vention and protection when, as a child, Arlene was sexually assaulted by her own father. Rather than fully developed characters, men in *Getting Out* are symbols of abuse and authority. Her father, the school principal, the prison guard, Bennie, her pimp, Carl, and the cabdriver Arlie killed because he tried "to mess with" her collectively represent a threat to Arlene's survival and are responsible, at least in part, for her self-abusive behavior. Bennie, who has retired from Pine Ridge with the expectation of taking care of and moving in on Arlene, is a surrogate father. And if Arlene understands his motivations for driving her home from prison, setting up her apartment, running her a hot bath, and going out for fried chicken, she does not fully acknowledge his intentions until he grabs her and pins her on the bed. Sensing that she is trapped, Arlene (with Arlie turning on now) screams, "I'll kill you, you creep!" (p. 38). Despite her violent and powerful kicks, it is only by calling Bennie a rapist (which injures his pride and loosens his grip) that Arlene is able to break free.

But Arlene cannot break free of Carl so easily. His intrusion into her privacy and psychic space is far more insidious: he has been her pimp, with all the attendant implications of care and abuse that this implies. He is the reason she went to Lakewood Prison for forgery; he has fathered Joey. When Carl forces his way into Arlene's apartment, rummages in her purse and her trunk, the sexual imagery is subtle but intentional. Having made plans for them both, Carl once again threatens to overpower her:

CARL: . . . We be takin our feet to the New York streets. (*As though she will be pleased.*) No more fuckin' around with these jive-ass turkeys. We're going to the big city, baby. Get you some red shades and some red shorts an the john's be linin' up fore we hit town. Four tricks a night. (p. 32)

Norman effectively counters Carl's inviting proposition with Arlie's memories of droolers slobbering all over her, crazy drunks, and "sickos" tying her to the bed. Invading her mind as he is invading her stash of groceries, Carl struggles to shake Arlene, his meal ticket, from her resolve to go straight. Speaking on a level that she clearly understands, Carl says, "You come with me an you'll have money. You stay here, you won't have shit" (p. 56). When rejected by reformed Arlene, Carl, like Bennie, tries to overpower her physically, literally and figuratively putting on the squeeze. Norman's message is unmistakable: women can be autonomous only when they are free from such intimidation.

In the concluding moments of *Getting Out,* Norman offers the possi-

bility of hope to a struggling Arlene in the character of Ruby, a benevolent mother surrogate who is sharply contrasted with Arlene's own mother. An ex-con who lives in the same building and who scrapes out a respectable living as a cook, Ruby offers friendship and an example of behavior that may help Arlene find her own path to survival. Although Arlene is not yet ready to relinquish her illusions about freedom, Ruby gives her the advice that may pull her through this crisis: the sooner Arlene accepts how difficult it will be to be "outside," the better off she will be. This confidence, the first of many confessions in Norman's plays, establishes trust between two women. Arlene returns the trust by confessing her most brutal act, the murder of Arlie in prison. Convinced that it was Arlie who was making her evil, Arlene repeatedly stabbed herself with a fork, crying: "Arlie is dead for what she done to me, Arlie is dead an it's God's will" (p. 61). While Arlene weeps for her lost self, Ruby rocks her like a baby, smoothes her hair, and rubs her back, giving Arlene the warmth she so desperately needs. Norman maintains that Arlene can only survive if she accepts the killer Arlie, accepts her past, and builds a future on that acceptance (Stone, p. 58). As the play concludes, the two women make plans to play cards together later that evening. There is little doubt the playwright is betting on Arlie/Arlene's survival.

Written in 1978 while Norman was playwright-in-residence at the Actors Theatre, *Third and Oak: The Laundromat* is a minimalist gem. Confined to one act, one hour, one setting, and two women, the play quietly exposes the personal crises of ordinary people. Relying heavily on two types of silence, a character who is reticent and one who is loquacious but has repressed emotions, Norman dramatizes the thematic concerns of her first play. But here the tone is softer, the symbolism of confinement less obvious, the mother-daughter relationship more subtly realized, and the humor more poignant and pervasive. In this play Norman demonstrates the same ear for dialogue authentic to social status and psychological state that characterized *Getting Out*. But by stripping away the "razzmatazz" (Norman's term) of *Getting Out,* the playwright delicately paints a more convincing portrait of emotional paralysis.

In *Third and Oak* two strangers meet by chance in the laundromat at the unusual hour of 3:00 A.M. Alberta, a refined woman, retired teacher, and recent widow, has planned the trip to the laundromat in the middle of the night to wash her dead husband's shirts in privacy. Deedee, a boisterous young woman, has run impetuously to the laundromat to escape the loneliness of her apartment. While waiting for the wash to finish and for a light to come on in Deedee's apartment (indicating the

return of her profligate husband), Deedee and Alberta pass the time talking. A prominent clock underscores the passage of time.

The opening moments of the play are vaguely reminiscent of Edward Albee's *Zoo Story,* where a talkative stranger intrudes upon the privacy of another and forces conversation. In *Third and Oak* the crude and clumsy Deedee comically makes her presence known by backing into the laundromat, tripping over a wastebasket, and falling into her laundry as it spills out of her arms all around her. Reluctantly, Alberta initiates polite conversation, but excepts to avoid further communication by retreating into a magazine. While understanding Alberta's implicit message of rejection, Deedee nonetheless attempts to engage the older woman in conversation. After Alberta's initial coolness, their aimless conversation about doing the wash, the seven dwarfs, dead rabbits, late-night radio, and their respective marriages increasingly becomes more honest and intimate. Masterfully, Norman directs attention to the topic of infidelity that is gripping Deedee. Their mutual confessions—made credible because of the lateness of the hour, Deedee's childlike frankness, and her overwhelming need to talk—bring them closer to an awareness of their entrapment in lies: Deedee's that she can continue to deny her husband's infidelity and her loneliness, Alberta's that she can continue to deny the reality of her husband's death. Each woman helps the other face her crisis and find options for survival.

Repeating the paradigm employed in *Getting Out,* Norman provides us with two mothers: an indifferent, critical mother and a mother surrogate. Deedee depends on her mother—but the mother disappoints her, just as Deedee is a disappointment to her mother. "She don't ever say how she likes seeing me," Deedee tells Alberta, "but she holds back, you know." Rationalizing their lack of communication, Deedee explains: "I mean, there's stuff you don't have to say when it's family," but obviously she doesn't believe this herself (p. 7). Deedee's brief references to her mother implicitly convey all that she leaves unsaid. There is not much nurturing: her mother even charges her for soap. As anxious for her mother's approval as Arlene is for hers, Deedee confides in Alberta: "I wish Mom were more like you. . . . Smart. Nice to talk to" (p. 20). Norman believes that daughters have been betrayed by mothers with the false promise that they will find "a nice man" and that their lives will be "wonderful" (Stone, p. 59). Deedee *has* found a man, but he is in her words "a sonavabitch." If Joe were home, she "wouldn't have to be here in this crappy laundromat washing fuckin' shirts in the middle of the night!" (p. 16). Dirty shirts in *Third and Oak* carry metaphoric and thematic importance. Joe's shirts, which earlier in the evening came

tumbling out of her arms, continually remind Deedee of the "mess" her marriage is in. Joe is unfaithful. "Waitin' and waitin' in my night-gown," she admits, "I grabbed up all these clothes, dirty or not, and got outta there so he wouldn't come in and find me cryin'. . . . Well, (*Firmly*). I wasn't cryin' " (p. 19). Deedee is a picture of pain and confusion. Married for only two years, she loves Joe and is sexually attracted to him; she is unwilling to admit to her mother or to herself her mistake in marrying him. As her anger at being his maid and whore swells and the agony of his indifference and unfaithfulness intensifies, Deedee wants to hurt Joe, just short of confronting him with the truth. She knows that if she asks how long it will be before he stops coming home at all:

> . . . he'll say what do you mean don't come home at all and I'll have to tell him I know what you're doing, I know you're lying to me and going out on me and he'll say what are you gonna do about it. You want a divorce? And I don't want him to say that. (p. 21)

Like Bennie and Carl in *Getting Out,* Joe abuses Deedee with the promise of caring and the threat of intimidation.

While Deedee may be able to analyze her options and speak rationally about her marital situation with Alberta, what she feels is not rational at all. With Deedee's hilarious, heartbreaking expression of pent-up animosity, Norman breaks the tension and freezes the moment: "I hope he gets his shirt caught in his zipper. I hope he wore socks with holes in 'em. I hope his Right Guard gives out. I hope his baseball cap falls in the toilet. I hope she kills him" (p. 22). Although Alberta is shocked, Deedee is not ashamed of her feelings. Norman allows her to verbalize the unsayable in her own vernacular; the outpouring of suppressed emotion releases her from the deception she has been living. But she is not yet prepared to take the next step toward survival. Alberta encourages her to use her anger to break free of pain, paralysis, and Joe; Deedee has yet to understand that she does not have to accept a marriage in which she settles for so little. Earlier in the evening Deedee was able to name only six of the seven dwarfs; she had completely forgotten the name of Happy.

Deedee proves to be a surprisingly attentive and compassionate listener. Touched by Deedee's courage, Alberta confesses that her husband died months ago; she has been unable to let go of Herb or face the future alone. Finally, she has relinquished his dirty shirts, although she still cannot wash the one he died in. Unlike Deedee, who sees Joe's shirts as a symbol of the dirty sex he soiled their marriage with, Alberta

views Herb's dirty shirts as his only tangible remains. As Alberta re-
lates the precise details of Herb's death, she embarasses herself and
Deedee with the astonishing admission: "I found our beachball when I
was cleaning out our basement. I can't let the air out of it. It's his breath
in there" (p. 24). Jon Jory, artistic director of the Actors Theatre, calls
this "matchless Marsha Norman." The remark eloquently captures the
essence of loss. Mel Gussow said you could hear a collective sigh from
the audience (pp. 34–35). With an effective but nearly imperceptible
reversal from the opening moments of the play, Norman concludes with
a tableau: Alberta leaves Deedee alone in the laundromat drinking a
Dr. Pepper and enjoying the pleasures of solitude, probably for the first
time. The light has come on in her apartment, but Deedee is in no rush
to go home.

The dramatic formula of two characters, an evening of painful con-
fessions, confined space and time, symphonic structure, and pointed tab-
leau that Norman has utilized in *Third and Oak* anticipates the design
of *'night Mother*. Whereas *Third and Oak* offers Deedee and Alberta a
way out of deception and a way in to self, *'night Mother* will consider
the question of whether suicide is the way out or the way in.

After the success of *Getting Out* and *Third and Oak*, Norman's *Cir-
cus Valentine* was a dismal failure. Her subsequent plays were far more
successful: *Hold Up,* a sympathetic look at the Old West and its colli-
sion with the twentieth century, was produced at the Circle Repertory
Company in New York and the American Conservatory Theater in San
Francisco; *'night Mother,* her fifth play, premiered in December 1982 at
the American Repertory Theatre in Cambridge, Massachusetts, under
the direction of Tom Moore. Winner of the 1983 Pulitzer Prize in
drama, *'night Mother* relentlessly dramatizes Jessie Cates' attempts to
rationalize her suicide and her mother, Thelma's, attempts to forestall
it. A middle-aged epileptic living with her mother since her husband
left her, Jessie has only recently gained an awareness of the extent of
her unhappiness. Her decision reflects her need to control what her epi-
lepsy so aptly symbolizes: life out of control. For several months Jessie
has been planning what she terms "the other thing I'm trying" (p. 75).
The private night of conversation we witness is a necessary prelude to
suicide, bringing together and tearing apart a mother and daughter
whose relationship has been more intimate in name than in fact. Build-
ing to an inevitable conclusion, *'night Mother* faces the issues of bond-
ing, separation, and self with uncompromising honesty.

With a play stripped bare to one setting, one act, and two characters,
Norman establishes familiarity by using a realistic set and colloquial

speech—and then strips familiarity away. From the moment Jessie, efficiently collecting rubber sheets, towels, newspapers, and her father's gun, announces her intention to kill herself, Thelma, casually taking stock of dwindling Hershey bars and peanut brittle, encounters an unfamiliar, terrifying reality. The contrastive nature of the play is immediately apparent. Spare but lyrical dialogue is simultaneously trivial and profound, recognizable and bizarre, caring and hostile. The subject shifts from garbage pickup to jealousy, from extension cords to disappointing marriages, from Christmas lists to epileptic fits with unsettling authenticity. Language is used both as weapon and defense mechanism: what Jessie does not want to hear, she ignores; what Thelma hears, she attempts to rationalize. Paralleling Didi and Gogo in *Waiting for Godot,* Jessie and Thelma are respectively reticent and communicative, kinetic and quiescent.

As their battle of wills and wits ensues, Jessie profits from the element of surprise, psychological advantage, and extensive preparation, but Thelma proves a formidable opponent. Armed with reason, ridicule, threats, bribes, diversionary tactics (including making cocoa which both hate), sheer will, and physical confrontation, Thelma struggles to gain control of the situation and of Jessie. Instead of the usual television programs and manicure, Jessie has planned an agenda for this evening; the momentum and timetable are hers. Although unprepared, Thelma attempts a number of responses to the unacceptable pronouncement that her daughter intends to commit suicide. At first Thelma considers calling her son, Dawson, to disarm Jessie. Then thinking Jessie ill, she considers calling the doctor or an ambulance. Increasingly frustrated by her ineffectiveness, Thelma ridicules her daughter's competence, as Arlene's mother did in *Getting Out* and Deedee's mother did in *Third and Oak.*

> You'll miss. . . . You'll just wind up a vegetable. How would you like that? Shoot your ear off? . . . You'll cock the pistol and have a fit. (p. 17)

Her ridicule elicits no response; in fact, confused by Jessie's control, Thelma wonders if Jessie isn't just frightening her. Jessie's laugh warns Thelma of her seriousness, and she tries another approach. "It's a sin," she warns. "You'll go to hell" (p. 18). Again Jessie is undeterred. By the time Jessie loads the gun, Thelma, in stark contrast to Jessie, is hysterical. Her outburst would be funny but for the seriousness of the moment and the anxiety it reveals:

> You can't use my towels. . . . And you can't use your father's gun, either. . . . And you can't do it in my house. (p. 19)

With two clocks prominently displaying the passage of time, Thelma pleads for more time and more talk. Her efforts at playing psychiatrist, however, are unsuccessful; Jessie is interested in neither reevaluating her decision nor laying blame. Rather, she is committed to impressing upon Thelma that she is utterly without hope:

> I'm just not having a very good time and I don't have any reason to think it'll get anything but worse. I am tired. I'm sad. I feel used.
>
> (p. 28)

With humor and pathos Norman develops an intimacy and honesty never before shared. The night of conversation becomes one of confession as both women admit their failures and jealousies. As in *Getting Out* and *Third and Oak,* men have been sources of pain and disappointment. Thelma's husband was indifferent and Jessie's has deserted her. Jessie's brother, Dawson, is selfish and cruel and her son, Ricky, is a drug addict and petty thief. But it is Thelma's secrecy about Jessie's epilepsy that is the focus of this conversation. Jessie had been told that her first epileptic fit was the result of falling off a horse. In her efforts to protect Jessie and to deny her own shame and guilt, Thelma has not told anyone, not even Jessie's father, that she was born an epileptic. Thinking the epilepsy a punishment for not loving Jessie's father or wanting more children, Thelma concludes that "it has to be something I did . . . I don't know what I did, but I did it, I know" (pp. 71–72).

Thelma's confession evokes an anguished debate about bonding and separation, autonomy and control. Exasperated at the necessity of having to explain her need for separation to her mother after a long evening of explanations, Jessie explodes, "It doesn't have anything to do with you!" (p. 72). In her portrayal of the daughter's need to break free and the mother's to maintain connection, Norman poignantly conveys the agony of a mother unable to help her daughter or let her go. "Everything you do has to do with me, Jessie," she insists. "You can't do *anything,* wash your face or cut your finger, without doing it to me" (p. 72).

Indeed, suggests Jenny Spencer, "what Jessie ultimately demands from her mother seems both infantile and impossible: not only complete control over the evening, but her mother's unqualified love, undivided attention, unmitigated support, and, with it, at least collaboration in the suicide" (Spencer, p. 370). But if Jessie's intent this evening had also been to spare Thelma further suffering, she is unprepared for her mother's tenacity, fear, and the sheer enormity of her guilt. Their harrowing conversation reveals that for Thelma the little she has sus-

tains her; for Jessie the little she has indicates all that she does not have. And what she does not have is Jessie:

> It's somebody I lost . . . it's my own self. Who never was. Or who tried to be and never got there. Somebody I waited for who never came. And never will.
>
> (p. 76)

Tearing herself away from Thelma's maternal and physical grip, Jessie slips away into the bedroom without the promised farewell kiss. Thelma's screams of protest and pain follow her; but literally cut off from Jessie she is powerless to stop her. Her body crumbles against the door as if she too had been shot, confirming her previous statement about mutually felt pain. The technique of a concluding shot is by no means unique: Ibsen used it in *Hedda Gabler* and Miller used it in *Death of a Salesman*. But Jessie is not interested in dying "beautifully" nor in leaving a life insurance payoff. What Jessie is interested in is having a say about her life, and she has decided to say no. In this "waiting" play we have been expecting and dreading this shot, yet like Thelma we are shocked by its reality and by Jessie's courage. Marsha Norman's compassion for the survivor and her sensitivity to the guilt she experiences is conveyed through Thelma's heart-wrenching apology: "Jessie, Jessie, child . . . Forgive me. (*Pause*) I thought you were mine" (p. 89). In an exquisitely prepared moment the bewildered, devastated mother, gripping a cocoa pot, mourns the daughter she could not save and never knew.

The cathartic power of '*night Mother* is tremendous. We are Thelma trying to understand, placate, compromise, escape guilt, rely on reason and logic, and deny death. And we are Jessie wanting freedom from suffering, fighting against vulnerability, affirming individual choice and dignity. "We identify with Jessie not in her decision to die, but on the level of fantasy and desire, with the symbolic fulfillment suicide comes to represent when played out before the mother" (Spencer, p. 372). "A great cleaning out of your pockets," suggests the playwright, is what '*night Mother* is about (Christon, p. 1). In many ways '*night Mother* is the most Beckettian of Norman's plays. In his review of the London production, Benedict Nightingale observed that "one might defensibly see Jessie as a Beckett character who presses the logic of her predicament to a conclusion that her prototypes and counterparts inexplicably resist" (Nightingale, p. 38). Correspondences between this play and *Waiting for Godot* abound: the setting of one night in an isolated house on an isolated road; the use of the couple; absent characters made dramatically present; debilitating illness; conversation to pass the time while

waiting; the subject of suicide; the issues of passivity, helplessness, and survival; the concluding tableau.

'night Mother anticipates *Traveler in the Dark,* a play Norman concedes she could not have written earlier ("Playwright Marsha Norman," p. 13). In this work, which premiered at the American Repertory Theatre in February 1984 under the direction of Tom Moore, the playwright turns her attention to a modern crisis of faith, a debate between science and religion. The central character, Sam, a world-famous cancer surgeon who has saved thousands of lives, operates on Mavis, his nurse and childhood sweetheart, and finds her riddled with cancer he failed to detect in time. Overcome by grief, shame, and disillusionment, Sam leaves Mavis dying, bolts from the hospital, and flees to his boyhood home convinced that his life is empty. Feeling abandoned and betrayed by everything he has believed in—medicine, the power of the intellect, and himself—Sam is unable to put his "rationality," to use Norman's term, "against the face of death" (Christon, p. 1).

Traveler is beset by a number of weaknesses: the crisis seems too calculated; the dialogue is too often glib and unnatural; the wife and father are ill defined and one-dimensional; the reconciliation between father and son is artificial. Yet despite these problems, Norman has fashioned an intelligent play. She demonstrates her ability to extend insight into men that parallels her previously demonstrated insight into women (Henry, p. 101). Choosing a complex, eloquent character, a type she has previously avoided, Norman competently and convincingly portrays a man whose intellect cannot protect him from suffering. Since his mother's death, which occurred when Sam was twelve, he has rejected God and protected himself with a shield of logic. Mavis' imminent death triggers unresolved guilt concerning his mother's death; the shield shatters. As incapable of saving Mavis as Thelma was of saving Jessie, and similarly unprepared to cope with the death of a loved one, Sam, sick at heart, is thrust into a personal crisis. Norman elevates this play above the crisis of self explored in *Getting Out, Third and Oak,* and *'night Mother* to a higher philosophical plane. *Traveler*'s subject may be traced to the playwright's personal experience. "I went through the same bitter rebellion Sam goes through in the play," admits the playwright (*Patriot Ledger,* p. 13).

A logical progression from Jessie and Thelma's discussions on the quality of life and the reality of death, *Traveler* is a successor as well to *Getting Out* and *Third and Oak.* Norman employs a number of techniques used in the earlier plays: confined setting, focus on the moment of crisis, confession of secrets, bonding of mother and child, portraits of

failed relationships, humor to underscore and mitigate pain, absent characters dramatically realized. *Traveler* varies a number of these elements. Instead of the "couple" developed in *Third and Oak* and *'night Mother* (and used initially in *Getting Out* in one-on-one conversations between Arlene and her mother, Arlene and Bennie, and Arlene and Carl), the play now considers several independent "couples." There are two father-son relationships (Sam and his twelve-year-old son, Stephen, and Sam and his preacher father, Everett)[2] and two mother-son relationships (Stephen and Glory, Sam's wife, and Sam and his dead mother). Glory is compared to Sam's mother, Sam and Glory's marriage to that of his parents, and Sam's guilt and sense of insufficiency at the time of his mother's death to his guilt and impotence at Mavis'. Finally, there are two Sams, a young one, Stephen, exactly the same age Sam was when his mother died, and Sam, a middle-aged, self-destructive atheist in search of himself.

Having developed wise and caring mother surrogates in *Getting Out* and *Third and Oak*, Norman presents for the first time loving and supportive wives who are warm, affectionate mothers. Glory is a "lovely woman who," in Norman's words, "takes enormous pleasure in the smallest moments of her life" (act 1, p. 2). Her generosity and love are demonstrated by a freezer full of Fudgsicles awaiting Mavis, a bountiful picnic basket for the family, demonstrative affection for Stephen, and seemingly endless patience with Sam. Similarly, Sam's mother is remembered as a woman of warmth, humor, talent, and great patience. Everett fondly recalls that his wife would bake a batch of cookies, eat every one of them, and send the waxed paper to the intended recipient with the message that as soon as she went off her diet she would send another. And Sam remembers her as "the gingerbread lady" who had:

> Curly red hair and shiny round eyes and a big checked apron. Fat pink fingers and a sweet vanilla smell and all the time in the world. Sing to you, dance *with* you, write your name on the top of a cake.
>
> (act 1, p. 41)

As if in a time capsule, the memory of the twelve-year-old Sam, complete with smells, is precisely recovered.

Additionally, Norman departs in this play from the paradigm of situating the action within the confining space of the room, choosing instead the more expansive but equally metaphoric setting of an overgrown garden at Sam's boyhood home, whose crumbling wall is held together only by a large stone goose. It was in this garden that Sam spent his fondest moments with his mother, reading fairy tales, singing songs, and

discovering "witches fingers, dragon teeth and fallen stars" (act 1, p. 18). Evoking memories of Sam's youth, the garden, whose thematic importance becomes increasingly apparent, provides a credible setting for a long evening of conversation, confrontation, and confession. While Sam hides from the others the reason for Mavis' absence, he anxiously waits for and dreads (as we did the shot in *'night Mother*) the hospital's call confirming Mavis' death.

Seated on the crumbling wall reading an ancient copy of *Mother Goose*, Stephen is fascinated by a magical world where frogs turn into princes, houses are built without walls, and all the king's horses and all the king's men can put shattered eggs together again. Since his mother's death, Sam has rejected belief in magical tales, bringing up his son protected from lies, loss, and fairy tales, both Christian and Grimm's. The scientist and cynic knows that nothing can save Mavis. In fact, Sam's profane and savagely witty parody of God and the Bible provides some of the most biting observations in the play. God, suggests Sam, sets life up: "We live through it and He writes it down. What we know as civilization . . . is just God gathering material for another book" (act 1, p. 42). For Sam fairy tales dredge up painful memories of sitting by his mother's bed working puzzles and reading fairy tales in a vain effort to save her. Bitterly, he recalls the death of "the gingerbread lady": "We didn't call it dying. . . . we said God was missing her something awful and she just went on back where she belonged" (act 1, p. 41). Even now Sam is still haunted by what he perceives as his failure and still angry at the betrayal of a mother who left him with his father, who cared more for his flock than for Sam, and a God who took away his mother. "Our own version of the past," observes Norman, "as we are haunted by it, as we are held back by it, or in some way defined by it—is our own to escape or make sense of, or to triumph over, or to carry with us" (Stone, p. 58). Helpless to save Mavis, a devoted mother surrogate, Sam is overwhelmed by his past, his guilt, and his betrayal. "I can't save lives," mourns Sam:

> they're lost from the start. I can give them another trip to the dentist, maybe, another summer of reruns, maybe a flat tire for a little excitement on the road. But it's my victory, not theirs. My work saves *my* life. Or used to. Oh boy. Day after day, I've been real proud of myself 'cause I won one more round. Right? Wrong. Death wins. Death always wins. (act 2, p. 21)

Anguished by what he can neither control nor understand, Sam resolves to take Stephen and leave behind Glory, his work, and his past. Sam's marriage to Glory has been strikingly similar to that of his parents.

While Glory has been supportive, loving, and patient, Sam has been devoted more to patients than to family. Sam knows he must separate from Glory if he is to survive. Their argument over custody of Stephen deteriorates into a Strindbergian battle, more characteristic of Edward Albee than Norman, and is one of several times in this play that the playwright loses her natural voice. Sam's tirades are so caustic and abusive that he risks the continued sympathy of the audience. But Sam is able to regain this sympathy with his confession of frustration and weakness. His poignant admission of disappointment in marriage, in love, and in himself dramatically anticipates the admission of Sam's secret concerning Mavis' cancer. Sam has kept this secret from Glory and the others because he has been unwilling to concretize the thought. If he admits to Glory that Mavis is dying, then in his mind he is once again responsible for the death of a loved one. Sam must be able to accept his past and the present crisis and move beyond it or, as Norman has suggested, he will be unable to go on.

Sam is a pivotal character in three relationships. Through him Norman can focus upon *the self trying to be a self* in the context of husband, father, and son. Recalling men in previous Norman plays, Sam is abusive; his relationships are self-serving. His intellect, sharp tongue, and wit are lethal weapons. In his relationship with Everett, or what has passed for a relationship, Sam has harbored anger for thirty years, making Everett pay for his incompetence as a father and weakness as a man. Now, faced with the imminent death of Mavis, he runs home to ask Everett to preach at the funeral:

> A man I despise, will please commend the spirit of a woman I never knew, to the everlasting arms of a God for whom I have nothing but contempt. (act 2, p. 21)

Sam claims he does not understand his hypocritical behavior. Indeed, if he admits that he understands his motivation, then he must admit that he needs Everett and does not despise him. In his role as father, Sam appears to be loving, but in fact he is so self-absorbed that he does not even know Stephen's birthday. Selfishly, Sam has taken away Stephen's youth and dreams and replaced them with his own. When Sam plans to take Stephen away as his companion in crisis, he thinks little about the pain Stephen will experience being ripped away from his mother. If he understands his motivation in this plan, he might also have to face the fact that Mavis' death, recalling that of his mother, has prompted him to deprive Stephen of a mother's love. It is, however, as a husband that Sam is most abusive: he sees in Glory's goodness and love an opportu-

nity to absolve himself of his failures. Sam need not be unfaithful to a woman (as Joe and Cecil had been in *Third and Oak* and *'night Mother*); his work has been his mistress. Thinking himself superior in intellect and accomplishment, Sam's relationship with Glory is one of habit rather than affection.

But the male character Norman has created in this drama is far too complex to dismiss as abusive in the tradition of Arlene's pimp and Deedee's husband. Sam's abusive behavior gives him the opportunity to distance himself from others, a shield against further loss and hurt. Sam claims that he is a person he does not want to know. We know him, however, and we can identify with his confusion, impotence, and vulnerability. Sam's return to his boyhood home is as much a search for self as it is for what Norman calls "a point of light in a universal sky" (Christon, p. 1). He has spent all of his adult life rejecting the God of his preacher father; but faced with the arbitrary assignment of pain and the daily occurrence of meaningless death, Sam wants there to be a God. And he does not want God to be him. Having reached this point of self-awareness, Sam, like previous Norman characters, can free himself from self-flagellation and begin the process of renewal.

To provide an opportunity for Sam and his father to be alone, Norman dispatches Glory and Stephen off to the hospital. If we find the reconciliation between father and son too artificial and the circumstances too convenient to be credible, we do believe that Sam finds in Everett a caring, wise listener who comforts him in his grief, just as Ruby consoled Arlene in *Getting Out*. The playwright, in fact, has remarked that she was "surprised with the warmth" of the preacher, given her fundamentalist background and her own rebellion ("Playwright Marsha Norman," p. 13). But Everett is indeed warm and is finally able to do for his own son what he does best: comfort the suffering. With the stark intensity Norman achieved in *'night Mother,* the conclusion of *Traveler in the Dark* is simultaneously anguished and affirmative. Everett's prayer, symbolically delivered from atop the garden wall where Sam, and before him Stephen, had been seated, is eloquent in its simplicity. "Help thou our unbelief," he prays, as Sam, still very much in the throes of crisis, goes to Green River, a traveler in the dark hoping God will find him.

Criticism of *Traveler in the Dark* reflects a growing recognition of Norman's maturity. William Henry suggests that in "debating the issues of science and faith, love and self-knowledge, the rage to grow and the resistance to change," Norman has stretched herself beyond what he sarcastically refers to as "cocoa and marshmallows" (Henry, p. 101).

And Jack Kroll agrees that Norman seems to be "a natural lightning rod" for the crises that continue to assault our faith and hope (Kroll, p. 76). As Norman creates more harrowing crises, a keen sense for the dramatic continues to be refined. Marsha Norman admits to her own crisis of faith, but continues to be driven by the conviction that from darkness comes understanding. Quoting the poet Theodore Roethke, the playwright maintains: " 'You learn by going where you have to go!' " But with the honesty we have come to expect from her, she adds, "More and more it seems like a journey with detours" (Gussow, p. 38). If Norman, like the rest of us, keeps going on, a traveler in the dark, she appears nevertheless to have a clear view of the artistic road she intends to follow. It is to write about why women—and men—suffer.

Notes

1. This quotation was chosen by Marsha Norman and the staff of the American Repertory Theatre to appear in the playbill for the premiere of 'night Mother.
2. This is an example of Norman's linking her plays: Everett has just returned from a funeral he has preached where Thelma Cates has been in attendance.

Bibliography

Christon, Lawrence. "Norman Follows Her Star." Los Angeles Times, January 17, 1985, sec. 4, p. 1.

Gussow, Mel. "Women Playwrights: New Voices in the Theater." New York Times Magazine, May 18, 1983, pp. 22+.

Henry, William A. "Blasted Garden." Review of Traveler in the Dark, by Marsha Norman. Time, February 27, 1984, p. 101.

Kroll, Jack. "Modern Crisis of Faith." Review of Traveler in the Dark, by Marsha Norman. Newsweek, February 27, 1984, p. 76.

Moore, Tom. "Tom Moore Collaborates Again with Marsha Norman." Interview with Dana Persky. A.R.T. News, February 1984, pp. 2+.

Nightingale, Benedict. "Or Not To Be." Review of 'night Mother, by Marsha Norman. Canadian Forum, April 1985, p. 38.

Norman, Marsha. "An Interview with Marsha Norman." With Sherilyn Beard. Southern California Anthology. Los Angeles: University of Southern California Press, 1985.

————. *Getting Out*. New York: Dramatists Play Service, 1978.

————. "Marsha Norman Discusses Playwriting with Robert Brustein." *A.R.T. News*, February 1984, pp. 1+.

————. *'night Mother*. New York: Hill and Wang, 1983.

————. *Third and Oak: The Laundromat*. New York: Dramatists Play Service, 1978.

————. *Traveler in the Dark*. Original typescript produced at American Repertory Theatre, 1983.

Pinter, Harold. "Between the Lines." *Sunday Times* [London], March 4, 1962, p. 25.

"Playwright Marsha Norman—a Talent for Listening." *Patriot Ledger*, February 7, 1984, pp. 13+.

Spencer, Jenny S. "Norman's *'night Mother:* Psychodrama of Female Identity." *Modern Drama* 30, no. 3 (September 1987), 364–75.

Stone, Elizabeth. "Playwright Marsha Norman: An Optimist Writes about Suicide, Confinement and Despair." *Ms*, July 12, 1983, pp. 56–59.

Contributors

Enoch Brater is professor of English and theater at the University of Michigan in Ann Arbor. His published work includes *Beyond Minimalism: Beckett's Late Style in the Theater, Beckett at 80/Beckett in Context, Why Beckett,* and a coedited volume in the Modern Language Association series on world masterpieces entitled *Approaches to Teaching Beckett's "Waiting for Godot."* He is also the editor of *Theatre Journal* and the author of many essays in the field of drama study.

Judith E. Barlow is associate professor of English at SUNY-Albany. Her published works include *Final Acts: The Creation of Three Late O'Neill Plays* and the anthology *Plays by American Women: The Early Years.*

Linda Ben-Zvi is the author of *Samuel Beckett* in the Twayne Series on modern writers and is well known for her essays on such figures as O'Neill, Glaspell, and Pinter. She is professor of English at Colorado State University and editor of a forthcoming book on the role of women in Beckett's work.

Sue-Ellen Case has recently published *Feminism and Theatre.* A member of the Department of Drama at the University of Washington in Seattle, she is also the former editor of *Theatre Journal.*

Ruby Cohn, professor of dramatic art at the University of California-Davis, has most recently published *From "Desire" to "Godot": Pocket Theater of Postwar Paris.* Among her earlier studies are *Back to Beckett, Just Play: Beckett's Theater, Samuel Beckett: The Comic Gamut, Modern Shakespeare Offshoots, Dialogue in American Drama, New American Dramatists, 1960–1980,* and *Casebook on "Waiting for Godot."*

Elin Diamond teaches in the English Department at Rutgers University, New Brunswick, New Jersey. The author of *Pinter's Comic Play* and

the forthcoming *Feminist Restagings,* she has also published articles on drama and critical theory in *Theatre Journal, Modern Drama, Drama Review,* and *Art and Cinema.*

Deborah R. Geis is assistant professor of English at Queens College in New York. She completed her Ph.D. dissertation on the uses of monologue in American drama.

Leslie Kane teaches modern drama at the Massachusetts State College at Westfield. She is the author of *The Language of Silence: On the Unspoken and the Unspeakable in Modern Drama* as well as several comparative essays.

Helene Keyssar is on the faculty of Drama and Communications at the University of California–San Diego. Her books include *The Curtain and the Veil: Strategies in Black Drama* and *Feminist Theatre.*

Rosette C. Lamont teaches at Queens College and the Graduate Center of CUNY. Her published work includes *The Life and Work of Boris Pasternak, De Vive Voix, Ionesco,* and *Two Faces of Ionesco.* She edited a special number of the CUNY journal *Centerpoint* entitled "Women: The Dialectic of Public and Private Spaces" and has previously written on Cixous for the *Performing Arts Journal* and the New York *Times.*

Timothy Murray is the author of *Theatrical Legitimation: Allegories of Genius in Seventeenth-Century England and France* and the forthcoming *Machines of Visible Discourse: Writing the Death Drive of Vision.* He teaches in the Department of English at Cornell University.

Austin E. Quigley is professor of English and chair of the Department of English at the University of Virginia. He is the author of *The Pinter Problem, The Modern Stage and Other Worlds,* and several articles on modern drama and literary theory.

Jeannette Laillou Savona is professor of French at Trinity College, University of Toronto. Her publications include *Le Juif dans le roman américain contemporain* and *Jean Genet.* She edited a special issue of *Etudes littéraires* entitled "Théâtre et théâtralité" and coedited *Théâtralité, écriture et mise en scène.* She has also coedited the recent special issue of *Modern Drama* on "Women in the Theater."

Sharon A. Willis is the author of *Marguerite Duras: Writing on the Body.* She teaches at the University of Rochester and has published essays in *Diacritics, Style, Sub-Stance, Theatre Journal,* and *L'Esprit créateur.*

Katharine Worth is emeritus professor of drama and theatre studies at the University of London. Her published work includes *The Irish Drama of Europe, Oscar Wilde, Revolutions in Modern English Drama, Beckett the Shape Changer, Maeterlinck's Plays in Performance,* and the recent critical editions of W. B. Yeats' *Where There Is Nothing* and *The Unicorn and the Stars,* by Yeats and Lady Gregory.

W. B. Worthen is the author of *The Idea of the Actor: Drama and the Ethics of Performance.* He is on the faculty of the Department of English at the University of Texas in Austin.

Index